Narrating the City

Narrating the City

Mediated Representations of Architecture, Urban Forms and Social Life

Edited by
Ayşegül Akçay Kavakoğlu, Türkan Nihan Hacıömeroğlu and Lisa Landrum

Bristol, UK / Chicago, USA

First published in the UK in 2020 by
Intellect, The Mill, Parnall Road, Fishponds, Bristol, BS16 3JG, UK

First published in the USA in 2020 by
Intellect, The University of Chicago Press, 1427 E. 60th Street,
Chicago, IL 60637, USA

Copyright © 2020 Intellect Ltd
Paperback edition © 2023 Intellect Ltd

All rights reserved. No part of this publication may be reproduced, stored in a retrieval system, or transmitted, in any form or by any means, electronic, mechanical, photocopying, recording, or otherwise, without written permission.

A catalogue record for this book is available from the British Library.

Cover photograph: Michael C. Coldwell
Cover designer: Holly Rose
Copy editor: Newgen KnowledgeWorks
Production manager: Jelena Stanovnik
Typesetting: Newgen KnowledgeWorks

Hardback ISBN 978-1-78938-271-6
Paperback ISBN 978-1-78938-749-0
ePDF ISBN 978-1-78938-272-3
ePub ISBN 978-1-78938-273-0

Part of the Mediated Cities series. Edited by Graham Cairns.
ISSN 2058-9409

To find out about all our publications, please visit
www.intellectbooks.com
There you can subscribe to our e-newsletter,
browse or download our current catalogue,
and buy any titles that are in print.

This is a peer-reviewed publication.

Contents

Foreword vii
 François Penz

Introduction: Narrative Topographies of City and Urban Culture 1
in Moving Images in the Age of Digitalization
 Ayşegül Akçay Kavakoğlu, Türkan Nihan Hacıömeroğlu and Lisa Landrum

PART I: IDENTITY IN MEDIATED REALMS 9

1. Looking Up, Looking Down, Looking Awry 10
 Louis D'Arcy-Reed
2. Materiality and the Maternal: Spatial Politics and Agency of the Cinematic 28
Apartment in Japanese Horror Films
 Shana Sanusi
3. Tehran Has No Soul! 45
 Tania Ahmadi
4. The Unconscious and the City: A Neuropsychoanalytic 56
Exploration of Cinematic Space
 Susannah Gent
5. A Vision of Complexity: From Meaning and Form 76
to Pattern and Code
 Loukia Tsafoulia and Severino Alfonso

PART II: NARRATED DIVERSITY OF FILMIC 95
 URBAN CULTURE

6. Architecture of Constructed Situation: Understanding 96
the Perception of Urban Space through Media
 Katarina Andjelkovic

7.	Polyphonic Asia: Contemporary City Symphonies of Singapore and Seoul *Simone Shu-Yeng Chung*	112
8.	Cinema and the Walled City *Gül Kaçmaz Erk*	131
9.	Architectures of the Suspended Moment *Jean Boyd*	148

PART III: NARRATED MEMORIES OF MEDIATED URBAN LIFE 165

10.	The City Is a Changing Medium: Imagining New York and Los Angeles in Doug Aitken's Work *Gracia Ramírez*	166
11.	Loss in Space: Deconstructing Urban Rephotography *Michael Schofield*	181
12.	Filming Chinese Settlement in Malaysia: Cinematic Narrative and Urban Settings *Wang Changsong*	197
13.	Bringing People Together Now: Wong Kar-Wai and Hong Kong *Kimberly Connerton*	211
14.	Multimedia Architectures: Case Study – Heraklion, a History of a City *Giorgos Papakonstantinou*	225

Afterword: Neo-formalism and the Architectural Lessons of Film 242
 Graham Cairns

Authors' Biographies 245

Foreword

François Penz

Ever since the Lumière brothers trained their camera on La Place des Cordeliers in Lyon in 1895, cinema has shaped our collective urban imagination. For 125 years, film has relentlessly recorded large swathes of cities and urban spaces the world over. Filmmakers have observed, expressed, characterized, interpreted and portrayed hundreds of thousands of city streets and urban locations. All chapters in this book data-mine this formidable reservoir of knowledge and experience folded away and preserved in film. Cinema not only provides us with an accelerated education in complex situations but also has fundamentally transformed how we look at the world. Cinema metaphorized modernism and cities became more comprehensible. Cinema taught us how to look and interpret. The camera revealed, imagined and built what we could not ordinarily conceive; it overcame our natural blindness to our everyday life and environment. It created new geographies and new visions – it made us see the world differently; it liberated us.

However, it took quite some time for architects to theorize the relationship with cinema as it started only in the 1970s and 1980s with practitioners such as Bernard Tschumi and Jean Nouvel producing buildings directly influenced by cinematic montage. This direct translation from film to buildings has gradually subsided with time and was replaced, in the 1990s, by increasingly historical and theoretical work on the respective influence between cinema and architecture. And it was only in the late 1990s and early 2000s that the first scholarly explorations of cinema and cities started to emerge. This book is the latest offering in a distinguished line of cinematic urban studies. It is an opportunity to focus on the narrative element that provides the perceptual tools to grasp complex urban phenomena by specifying some key relations between perceptions, emotions and acts, which connect to fundamental ways of experiencing the world.

Central to this book is the wide range of disciplines represented. We are here exploring the boundaries of a field that is forever (re)defining itself – the broad study of cinema and the city is constantly shifting – under the influence of new technologies but also the opening and the availability of new archives. It requires an interdisciplinary approach to explore the turbulence at the boundaries of

disciplines seeking similar answers but from very different perspectives. This book also proposes a wide international perspective and as such it allows for a greater level of understanding and engagement among different cultures. The focus on narrative cinema opens up the path to an innovative reflection on the complexity of the urban environment. This book affords a palimpsest of stories that create spatial trajectories for the reader to find their itineraries, to travel to different places and cultures, past, present and future.

December 2019

Introduction:
Narrative Topographies of City and Urban Culture in Moving Images in the Age of Digitalization

Ayşegül Akçay Kavakoğlu, Türkan Nihan Hacıömeroğlu and Lisa Landrum

> *Narrative is present in every age, in every place, in every society; it begins with the very history of mankind and there nowhere is nor has been a people without narrative.*
> – Roland Barthes, *Narrative Theory*[1]

Narrative communication – in spoken, written, visual and mixed-media forms – is as old as civilization. Since the invention of the moving image in the late nineteenth century, film has become one of the main tools of constructing and construing narrative. The filmic medium was born when urban environments and social life were undergoing rapid changes. Correspondingly, the city became a primary subject and object of filmic medium. As the spirit of the era changed over the next century, the mediation of the city evolved from analogue to digital. This evolution has accelerated in the twenty-first century with the proliferation of image-making tools, affecting how we see the city and construct our understanding of urban culture. The moving image has become a medium that not only represents society but also directs it, influencing the way people experience daily life. The age of digitalization and computation transforms not merely the way images are produced, but also their essence. The filmic medium's transmutation via digital media opens alternative modes of seeing, experiencing and representing the city and urban life.

The city hosts endless narratives of its inhabitants within its dense settlement. Each mediation of the city created by its intricate relationship with moving images generates countless new narratives. And each narrative reconstructs the

city through its relationship with mediated mediums. Architect-filmmaker James Sanders defines this relationship as a quest: 'searching a complex web of linkages – physical, emotional, imaginative – between urban environments and those who inhabit them'.[2] The city becomes a narrator as well as a part of the narrative, representing the life within.

This book examines the overlapping notions of narrative, representation, moving image, city, architecture and digital media in both theory and practice. It reveals how film and related visual media offer insights on the city as a constructed object through images. It brings together filmmakers, architects, digital artists, designers and media journalists who critically reinterpret and create narratives of the city. Analysing a variety of international films and visual media in dialogue with emerging digital image technologies, authors explore the expanding range of 'mediated' narratives in contemporary urban culture. They identify how the narrative of the city creates cinematic – and ever more frequently digital – topographies of contemporary urban culture and architecture, re-presenting familiar cities, modes of seeing, cultures, social and identity questions in unfamiliar ways.

This filmic emphasis is placed into dialogue with a more diverse range of related visual media. It illustrates the overlaps between them and reveals how moving image technologies of all hues create unique visual topographies of contemporary urban culture and architecture.

In charting this expansion from the filmic to the new age of digital image making and alternative modes of image consumption, the book reveals new techniques of representation, mediation and the augmentation of sensorial reality for city dwellers. It also offers insights into critical societal issues through its emphasis on 'narrative' and spatial politics, as they are informed by and represented in various media. This book underlines the continued importance of filmic representations of the city and its narratives and identifies that traces of these representations are evident in a wide range of contemporary visual technologies and platforms. It crucially emphasizes that these expanded forms of visual representation have reflected and influenced broader culture and society for over a century – and continue to do so today. Specifically, the book discusses the mediated city images of urban life in the age of digitalization through the notions of cultural identity, diversity and memory. The reason for structuring a periphery around these notions is their relationship with narration. To understand the narrated topographies and their nature, first, the protagonist's identity – whether a human, city or environment – needs to be interrogated. Not only seeing but also experiencing the various identities clarifies how diversity changes this narration and how it transforms the way we perceive the story. Consequently, all these experiences turn into a memory.

INTRODUCTION

Accordingly, each notion defines the scope of one section to reveal the intricate relationship between the city and visual media.

The first section, 'Identity in Mediated Realms', is constructed around the question of place and ambiguities of the self and society. With examples from both traditional film and new digital media, chapters start from a psychoanalytical examination of the individual through storytelling, move through discussions on the representation of social classes and gender issues and end with interpretations of narrative experience of space and the city through digital representation. This section sets out relationships between urban representation and urban culture through mediated depictions of self and environment.

In the initial chapter, Louis D'Arcy-Reed examines the relationship between visual representations of city across different media and its users through the gaze of architecture and psychoanalysis. By questioning the incommensurability between protagonists and their environments in reality television and dystopian and horror movies D'Arcy-Reed discusses the concept of parallaxical identity in mediated cities portrayed in television and cinema.

In Chapter 2, Shana Sanusi focuses on the spatial politics of domestic spaces in relation to Japanese femininity in two Japanese horror films. Sanusi interrogates how living spaces influence the identity of its occupants and impose social ideologies on them through apartments and their environments.

Ahmadi Tania analyses the reciprocity of urban chaos and psychological turmoil through two Iranian films made before and after events of the 1979 Revolution and the Iran-Iraq War of the 1980s: *Tranquillity in the Presence of Others* (1973) and *Fireworks Wednesday* (2006). The distinct narratives reveal the persistent instability of life in metropolitan Tehran and the intertwining of personal memory and city.

Susannah Gent questions the self and environment and its changing nature through neuropsychoanalytic exploration of the cinematic space. The ultimate traditional perception of the camera as third eye view shifts into a self-exploration medium where the director utilizes her experiences as well as film as material during the investigation. She emphasizes the instincts and intuitive acts in her three essay films *Influence of Mars* (2017), *Unhomely Street* (2016) and *Psychotel* (2020) by underlining the film-maker's unconscious presence in the films in addition to the interior viewpoints of the characters.

In Chapter 5, Loukia Tsafoulia and Severino Alfonso investigate the history of visual perception and its evolution in design and art in order to discuss how roles of information, communication and the moving image shape the collective environment. Tsafoulia and Alfonso highlight the influence of data technologies and the effects of personal technology and social media on human experiences, interaction and perception with the environment and how they create new modes of

experiencing space. By analysing the multiscreen and multimedia films of Charles and Ray Eames, the authors focus on evolution in the conceptualization of vision, perception, cognition and creation of a new visual language.

The second section, 'Narrated Diversity of Filmic Urban Culture', presents a spectrum of various filmic and moving image representations that frame 'diversity' in the city via relationships of culture, place, space and architecture. Case studies examine both Western and Eastern approaches to narrating the city that reveal and explore how different cultures and peoples read media, places and technologies.

Katerina Andjelkovic investigates how media-saturated environments change society's perception of space and connection with reality. Various examples employing dialectic montage and space-time disturbances illuminate the argument, including works by Jacques Tati, David Lynch, Bull Miletic and the author.

Simone Shu-Yeng Chung extends the scholarship on city symphonies to two recent films exploring Singapore and Seoul: Tan Pin Pin's *Singapore GaGa* (2005) and PARKing CHANce's *Bitter, Sweet, Seoul* (2014). Chung shows how the audiovisual mosaic techniques of these filmic narratives reveal the linguistic hybridization, polyphony experience and sociopolitical complexity of global Asian cities.

Gül Kaçmaz Erk examines the filmic depictions of urban walls in divided societies to underline commonalities in various urban cultures hoping to contribute to the shared future of humanity. The chapter discusses the social and cultural behavioural actions of individuals and society to/against urban walls through an organized film season, 'Walled Cities' in Belfast, which grasps and interrogates a wide range of cultural and geographical diversity with the screened films/locations/directors, such as the United Kingdom, Turkey, Hungary, Greece, Cyprus, East Germany, Palestine, Spain, West Germany and France. Erk points out the spatial and political representative nature of the urban walls through the screened films in 2017, *Omar* (2013), *'71* (2014) and *Wings of Desire* (1987).

Jean Boyd sheds light on the mediation of the city operating within the metaphoric territories of light, space and time by referencing Henri Lefebvre's 'illuminating virtuality' notion. Boyd elaborates the discourse/relation/configuration of the individual and public through the artworks of David Claerbout's *The Algiers Sections of a Happy Moment* (2008) and Stan Douglas's *Mare Street and Pembury Estate* (2017). Both artworks are photographs, stills, extending the instants cinematically and driving the spectator into a dynamic virtual projection of the moments of the diverse urban culture.

The third section, 'Narrated Memories of Mediated Urban Life', is held together by concerns with 'memory'. Chapters interrogate spatiotemporal experiences of the city and urban life through the camera eye, screen-based dissemination and digital mediations, suggesting a need for new approaches to our understanding of how analogue and digital media engage with narrative construction. From

INTRODUCTION

documentation to experimental film-making, the authors invite readers into the realm of varied mediated memories of the city and how they affect our perception of urban environments.

Gracia Ramirez interprets two multimedia site-specific works of Doug Aitken, *Sleepwalkers* (2007) and *The Idea of the West* (2010), showing how each envisions the social imagination of New York and Los Angeles, respectively. Mixing techniques of high aesthetics and popular culture, and the spectacular and utterly banal, these architectural happenings compel citizen spectators to rethink the cities in which they are immersed.

Michael Schofield documents the photographic representations of shifting urban spaces throughout time. He tries to enlighten the past of the present by referencing Derrida's hauntology notion as a theoretical methodology in his practice. He describes the spatiotemporal nature of the rephotography and its stillness as a dynamic material, transforming into moving imagery while revealing the haunting traces of the past in the contemporary city. In other words, his works regenerate urban palimpsests by layering time not solely visually but also politically. By doing so, he creates a spatiotemporal memorial narrative of the city, drawing out the large-scale changes with urban transformations as well as the minors.

Wang Changsong examines three high-grossing Malaysian-produced Chinese-language feature films: *The Journey* (2014), *Ola Bola* (2016) and *Ah Beng the Movie: Three Wishes* (2012). By integrating aesthetic and philosophical experimentation with popular narratives and local cultural practices, these films demonstrate both the significant impact of Malaysian Chinese film-makers and the subtle relations among disparate social classes and generations.

In Chapter 13, Kimberly Connerton uses Wong Kar-Wai's films to discuss how spaces and architecture in films shape characters and connect the experiences with the audience. Connerton works through Wong's films *Chungking Express* (1994) and *In the Mood for Love* (2000) to analyse implications of the use of spaces in accordance with characters, disconnection of life in cities, and notions of slow film and slow architecture.

As the final writer of the third section Giorgos Papakonstantinou concentrates on space conception models in digital environment, discussing space, architecture and representation notions within a multimedia paradigm. Papakonstantinou interrogates how our spatiotemporal conception has changed in time and multimedia spaces have created an environment of communication and representation via a case study of the CVD-Rom Heraklion, the history of a city.

Compared to other visual narrative tools such as painting, filmic medium is a relatively new agency within narrative communication. It has adapted and eventually changed the way of seeing and thinking, even though the transformation

has taken time. First the perception of people towards the filmic medium had to go through changes. In his seminal essay 'The Work of Art in the Age of Mechanical Reproduction', Walter Benjamin describes the radical effect of filmic media on modes of thinking by highlighting the words of George Duhamel, 'I can no longer think what I want to think. My thoughts have been replaced by moving images.'[3] According to Benjamin the reason for Duhamel's reaction was the structure of the film. The scenes in a film rapidly change, not allowing the spectators to grasp and process them fully. It was generating a shock effect on spectators as Dadaism created a moral one.[4] In the introduction to his book *The Architecture of Image: Existential Space in Cinema*, architectural educator and author Juhani Pallasmaa defines this as the hallucinatory effect in a cinematic experience by also referencing Benjamin's quotation from Duhamel.[5] The physical shock transformed into hallucinations. In time people have adapted to the new ways of seeing and almost after two decades of Pallasmaa's explanation, with emerging alternative/hybrid modes of digital image making and consumption tools, the shocks and hallucinations have been absorbed into the new reality of everyday life. Mediated technologies still augment the representation of moving images. But now there is one significant difference: the audience is transformed into both the creator and the viewer. Consequently, the identities, diversities and memories of the generated images have become representatives of individual and social/public narrations. Building on these interdisciplinary approaches, *Narrating the City* carries out discussions around the subject of mediated representations of urban culture and offers a panoramic view of the issue.

NOTES

1. Roland Barthes, 'Introduction to the Structural Analysis of Narratives', in *Narrative Theory: Critical Concepts in Literary and Cultural Studies*, ed. Mieke Bal (New York: Routledge, 2004), 65.
2. James Sanders, 'Introduction', in *Celluloid Skyline: New York and the Movies* (London: Bloomsbury, 2002), 10.
3. George Duhamel, *Scènes de la vie future* (Paris, 1930), 52. Quoted in Walter Benjamin, 'The Work of Art in the Age of Mechanical Reproduction', in *Illuminations*, ed. Hannah Arendt (New York: Schocken Books, 1968), 238.
4. Benjamin, 'The Work of Art in the Age of Mechanical Reproduction', 238.
5. Juhani Pallasmaa, 'Introduction', in *The Architecture of Image: Existential Space in Cinema* (Helsinki: Rakennustieto, 2001), 25.

BIBLIOGRAPHY

Barthes, Roland. 'Introduction to the Structural Analysis of Narratives (1966)'. In *Narrative Theory: Critical Concepts in Literary and Cultural Studies*, Vol. 1, edited by Mieke Bal, 65–94. New York: Routledge, 2004.

Benjamin, Walter. 'The Work of Art in the Age of Mechanical Reproduction'. In *Illuminations*, edited by Hannah Arendt, 217–52. New York: Schocken Books, 2007.

Duhamel, George, *Scenes de la vie future*. Paris: Mercure de France, 1930.

Pallasmaa, Juhani. 'Introduction'. In *The Architecture of Image: Existential Space in Cinema*, 11–36. Helsinki: Rakennustieto, 2001.

Sanders, James. 'Introduction'. In *Celluloid Skyline: New York and the Movies*, 3–12. London: Bloomsbury, 2002.

PART I

IDENTITY IN MEDIATED REALMS

1

Looking Up, Looking Down, Looking Awry

Louis D'Arcy-Reed

Visual representation across differing media and mediums allows cities to become powerful backdrops in cinematic and television storytelling, where reality television, dystopian futures, superhero destruction and the traditional 'house of horrors' dominate screens. This chapter situates itself within the protagonists' behaviours becoming distorted, thereby questioning incommensurability between themselves and their environments, interrogating urban environmental cinematography decisions and the psychological emancipation of the city.

Three main contexts of media, including reality television, such as *The Apprentice*, (2006 - Present) *The Hills* (2006-2010) and *Keeping Up with the Kardashians* (2007 - Present), and dystopian movies, such as *Blade Runner* (1982) and its sequel *Blade Runner 2049* (2017), are considered in contrast to conventional horror films based in singular environments, such as *The Shining* (1980) and *Psycho* (1960). When analysing this media through the gaze of architecture and psychoanalysis, proposed by Bruno Latour, Alberta Yaneva and Slavoj Žižek, a discussion of parallaxical identities presents itself, where all incommensurability between environment and self can be alleviated, reducing the sense of tension enacted by the media's representation. Viewing such media representations of place affords thought-provoking perspectives between the city as a curated organism, much like film and television, and the hidden structures of antagonistic power struggles beneath the surface.

Framing the city through psychoanalysis of architectural antagonisms,[1] proposed by Žižek, enables the city on screen to act as both setting and backdrop for psychoanalytical anxieties to occur. In an era where movies and television are exposed to scandals of gender and race equality, issues of manipulation and diversity, the city on screen remains a narratively explicit arena to scrutinize. While this chapter deals with filmic and televisual fictions, the lessons from architectural narratives transcend beyond the screen, affording dialogues of urban environments and their settings to exist within the 'real'.

Proposing the quality of *parallaxical identities*[2] within our cities, where the implementation of architecture can severely reprimand, but also transform,

the identities of communities, builds upon the dichotomy of place across political and social spectrums. Transferring this notion into filmic representations, we can begin to interrogate how the city can become represented and characterized horizontally and vertically, corresponding to community behaviours and their activity, as highlighted by Latour and Yaneva's 'gull-in-a-flight'.[3] By extension, the urban fabric, or city, 'appears to be composed of apertures and closures, impending and even changing the speed of the free-floating actors'.[4] In contrast, horror films such as Hitchcock's *Psycho* and Kubrick's *The Shining* take place between two poles. As such, Žižek's proposal[5] is to resolve one's internal trauma through the creation of an architecturally utopian solution.

Reality television

An expansive genre, reality TV accounts for a variety of casts spanning from 'amateur' to the 'celebrity' as the subject base for the show. These shows chronicle a myriad of typologies that take place – from workplace docu-soaps and competitions, to 24/7 coverage and scripted-situational reality dramas. The shows have mass appeal, are cheap to make and bank on the stars' interaction, charisma and character to develop the narrative. Where complex television has increased the medium's tolerance for viewers to be confused, encouraging them to pay attention to comprehend the narrative,[6] reality television banks on a dedicated fandom and its formal place in scheduling as a 'light entertainment' show. However, reality TV is a genre of heavy-editing processes in post-production, where characters can easily be cast as the villain or hero. Most contemporary series also air a brief *recap* before each episode to summarize key events 'previously on' the series.[7] Irrelevant of time and place, the recaps are generally crafted by series producers who choose key moments they believe relevant for refreshing viewers' memories for upcoming storylines.[8] This leads to an interesting dynamic within these shows where the city acts as a backdrop or setting for the entertainment to take place.

MTV's *The Hills*[9] followed several young and affluent women embarking on their personal and professional endeavours[10] in and around Los Angeles (Figure 1.1).[11] The manipulation of place by MTV and its producers expanded upon the casts' privileged backgrounds, adding to the idea of wealth and entitlement by making the young stars seem even more privileged.[12] Other than just possessions, the cast were seen at fashion internships, shopping and dining, thereby creating further illusions of wealth and grandeur. MTV made sufficient efforts to now proclaim its stars as celebrities in their own rights with cast members becoming household names on the internet and in tabloids and fodder for

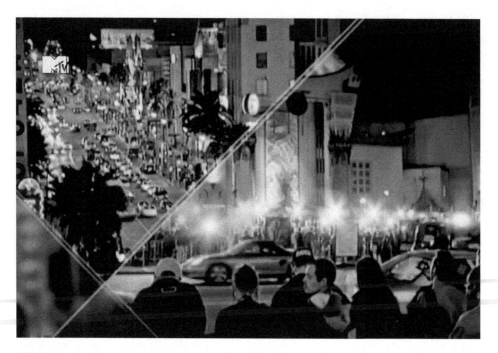

FIGURE 1.1: Title sequence screencap of *The Hills*. Hisham Abed and Jason Sands (dir.), *The Hills*, 2006. USA © MTV.

entertainment outlets such as TMZ or E! Network. Within the show, there is absolutely no reference to why such lavish resources are available to these young people, or where such objects come from.[13] Upon first viewing, the aesthetic style of *The Hills* looks strangely jarring.[14] Following a simple format for its running time, situations are spliced between camera quick-cuts and location filler shots, showing Los Angeles from the sky, day and night. These can immediately be categorized as montage; montage elevates an everyday, trivial object into a sublime 'Thing'. By purely formal manipulation, it succeeds in bestowing on an ordinary object the aura of anxiety and uneasiness.[15] What is often overlooked, however, is the way this transformation fragments the real into a cinematic reality, producing a surplus that is radically heterogeneous to cinematic reality, but nonetheless implied by it.[16] In this instance, the surplus caused by the show's montage acts as the backdrop for the drama, anxieties and relationship between observer and cast. The gaze upon the city as nothing but a montage equates to a gull-in-a-flight, where context could be done away with.[17] Instead, viewers become invested in the emotional stakes within the fictional frame.[18]

In the syndicated show *The Apprentice*,[19] contestants compete for either a cash investment or employment within the host's business. In America, the show was

hosted by billionaire Donald Trump (until his election),[20] while the UK version is currently hosted by Lord Alan Sugar.[21] The contestants are professional businesswomen and men, firmly in the 'yuppie'[22] mould, from various sectors who have been vetted and auditioned prior to filming.[23] Much like other talent/reality shows, the participants' egos and idiosyncrasies are cultivated through off-camera stings or candid moments during tasks, enabling the viewer to perceive contestants as antagonists, strategists or the typical yuppie. Paradoxically, the contestants are followed by the host's 'trusted allies' to assess and report on the contestants' misfortunes or lack of acumen[24] in a bid to 'level down' these (budding) upper-middle-class subjects by rendering them ordinary, denying the particular circumstances that provide the resources to access such entitlements.[25] Instead, the show borrows a narrative act from the producers of *The Hills* and constructs an arena of the relentlessly successful and entitled, yet still accessible. In this way, *The Apprentice* mirrors *The Hills* to perpetuate the neoliberal notion that individuals have access to social mobility[26] through being ordinary, while being able to succeed in wealth-driven tasks in 'dog-eat-dog' environments.

As with *The Hills*, *The Apprentice* also plays the city as setting and arena for the activity of contestants. Utilizing commercial architecture and skylines of New York and London to backdrop the competition and backstabbing, shots often pan from above, highlighting key cores of their fabric, known for wealth. Focusing on skyscrapers, luxury buildings and the feeling of exclusivity, the elitism proposed by this representation speaks of high power, high risk, greed and money. Often a new series has some kind of placement involving the newest architecture. The key factor is a disassociation between money and context. *The Apprentice* tells us that the only context worthwhile to our cities is the wealthiest, the newest or the phallically highest. The representation of an elitist ideology through sleek skyscrapers and exclusivity directly correlates with an incommensurability between the public and private spaces of our cities, where deprived areas become airbrushed out of urban fabric in favour of helicopter montage shots of the city's skyline. A notion that reframes our cities and reproduces, at the level of architecture, the usual split between subjective and objective dimensions.[27]

Worse still is the exclusive isolation of *Keeping Up with the Kardashians*[28] that utilizes a multi-camera format documenting members of the family (within the show, the wider Kardashian-Jenner clan) relentlessly. The show serves as a platform to gain access to the Kardashian family and the 'behind-closed-doors' of celebrity culture, circumventing business endeavours and the attending of exclusive functions. As transmedia icons, the Kardashians have a phenomenal fandom and history. Their father (the Kardashian sisters') gained fame as one of OJ Simpson's lawyers, and Kim Kardashian's fandom grew following a sex tape scandal in 2007, for which her mother Kris Jenner received money from

distribution rights. For all the otherworldly context of their thrust into the limelight, the fandom has developed sincere emotional attachments to characters designating particular figures as their 'TV boyfriends/girlfriends' or cultivating hateful (but often pleasurable) antipathy towards characters.[29] Serving to further the Kardashians' wealth and fame, the show exists within a cultural vacuum, devoid of the real world, where one travels by private jet, attends photo shoots or is subject to elaborate marriage proposals[30] at privately hired stadiums. An interesting dichotomy takes place; they live in the real world where there are real environments and recognizable places, but the same montage exclusivity filler shots exist. The Kardashians' bubble may or may not be a work of fiction as their immediate world, Los Angeles, but the gated celebrity communes serves as their setting. Compare the *Kardashians* and the upwardly mobile contestants in *The Apprentice*; the effect is a sealed-off world of upper-middle-class entitlement. This is never acknowledged and as a result, there is no friction with other class fractions. The screen presents this as the 'norm', whereas the young female cast of *The Hills* are free to make the appropriate (invisibly classed) choices that any 'decent' person might make.[31]

Context becomes non-existent again; there are no dramas except their own. Some may argue that this is to be expected, but recall the representation projected by montage filler shots; it moves at a pace and subverts normality into a realm of anxieties and struggles. Therefore the problems faced by the *Kardashians*, the contestants on *The Apprentice* or the staged drama of *The Hills* become an inversion of the real world, where the observer is obfuscated from the social anxieties of place. The elitist, exclusive and wealthy only begin to consider place as the gull-in-a-flight, where context is irrelevant and edited to contribute towards an incommensurability between the haves and the have-nots. The architecture of place in reality television affords a parallaxical identity to transform out of incommensurability. The panoramic, yet horizontal, looking awry factor transmitted via our screens presents a zonal environment given a fantasmic status, elevated into a spectacle, solely by being enframed.[32]

Dystopian visions

Future visions of dystopia often blur between reality and fiction, where the prevalence of simulacra is depicted on screens, mirroring relationships to the real world. Building on Fritz Lang's vision of the futuristic city in *Metropolis* (1927),[33] the release of *Blade Runner* (1982), directed by Ridley Scott, presents the future as a dystopian setting with conventional neo-noir motifs. The critical turn (by *Blade Runner* in particular) connects the alienated cityscape, which no longer represents

FIGURE 1.2: Cityscape of *Blade Runner*'s 2019 Los Angeles. Ridley Scott (dir.), *Blade Runner*, 1982. USA © Warner Bros.

a futuristic, utopian, urban fantasy, with questions regarding the essence of human subjectivity.[34]

In 2019 Los Angeles (Figure 1.2),[35] the population has removed itself in the midst of colonization off-world. Replicants are enslaved as off-world explorers and colonizers, 'retired'[36] if found on Earth. The backdrop of Los Angeles is an industrial wasteland.[37] The Tyrell Corporation[38] dominates the city from a fortressed pyramidal structure, surveilling its surroundings, with neighbours consisting of police department headquarters, industrial towers and angular high-rise buildings.[39] Upon viewing the film for only a few minutes, it is apparent that this future suffers from the effects of economic fragmentation, outsourcing, decentralization and surveillance,[40] whereas the remaining lower classes continue to live in cramped conditions, in run-down apartments from a bygone age, operate street-markets and trade within a complex fragmentation of ethnicities and language. As the film progresses, we are exposed to a postmodern portrayal of Los Angeles – one that fragments itself through the conflicting experience of space and time on varied scales.[41] Our distinction between humans and replicants, and their inherent lifespans, conflicts with the scalar quantity of space above and below; the new and privileged domain in the sky, as opposed to the crumbling and decaying lower class. Therefore, the domination of the controlling agency ensures a balance of order and disorder and, in the end, maintains the status quo of power relations.[42]

This feeling is further compounded by Los Angeles transformation into a globalized space of advertising,[43] where the hierarchy between above and below is characterized through an induced sort of information sickness.[44] Above the chaos and decay at street level, there exists a world of transporters and advertising screens selling the products of corporations such as Coca-Cola and Budweiser.[45] Replicated in its sequel *Blade Runner 2049* (2017, dir. Denis Villeneuve), the hierarchical advertising remains, with the addition of gigantic projections and AR imparted to street level. While the reach of corporations has finally consumed the street, the city remains fragmented and subject to its inherent presentation of above and below. Parallel this quality to contemporary Manhattan, where a duplex penthouse traded for $100.5 million, setting a record for the city.[46]

The resultant disparity between the vertical relationship determined by space and living quality is one that functions within neo-noir typologies, where relations to film noir is always divided, split between fascination and ironic distance: ironic distance towards its diegetic reality and fascination with the gaze.[47] Director Denis Villenueve's universe, expertly articulated by cinematographer Roger Deakins, layers aesthetics that flux between rich and dense, to sparse and decrypt. Multiple viewings only seek to highlight the depths within the world; how the light moves, how the holocaust sky seems at once dangerous and beautiful, and the fragrances of neon that embellish the urban environment, giving a vibrancy and life to what would be considered treacherous living.[48] The *Blade Runner* universe serves as a reminder of a resultant fragmentation of place by disaster or technological advancement, where fragmentation is not only a social construct, but also an environmental one where cities become a contrast of decay and exclusivity. One's gaze at what is presented on the screen is mimicked by the gaze from street to sky. Witness this quality in Deckard and K's traversal between planes. Not only is their isolation exacerbated by the disharmony of place, but their gaze wanders to the above, seeking resolution.

There is an argument that this domain implies Lefebvre's 'logic of visualisation',[49] embodying its intentions;[50] the corporations look to the sky and, therefore, off-world and reciprocate the advertisements selling off new lives off-world. Again, parallaxical identities form, which can be paralleled to other films such as *1984* (1984), *Batman* (1989) and *Ghost in the Shell* (1995). However, the most explicit depiction can be found in the movie adaptation of J. G. Ballard's novel *High Rise* (2015). The wealthiest live on the highest floors, while the lower classes live below, differentiated by floor number. As the building falls into disrepair and decay, the defence of the higher realm becomes a reality that determines the occupants' behaviours, and ultimately, destruction. These circumstances also build upon the work of Foucault, who developed a sense of the relations involved in one's habitus, such as power structures in environments, and the governance that

defines the state of one's existence. However, for the residents in *High Rise*, and the street-level inhabitants of the *Blade Runner* universe, they exist in the parallaxical identity grounded within the concept of what is taken as rational, the bearer of truth, rooted in domination and subjugation, and constituted by the relationship of forces and powers.[51] The hierarchical structures that define their home domain are nothing more than a mask of a parallaxical identity of space, exteriorized through architectural antagonism, and the dichotomy of vertical inequalities.

Antagonistic awry spaces

Comparing the preceding movies and television, we can see antagonisms becoming apparent, mainly through the eradication of contexts and the definitive break between above and below in dystopias. However, the singular environments within the horror genre of *Psycho* and *The Shining* afford a different perspective.

In *Psycho*, we witness the well-mannered Norman Bates, controlled by his mother who lives in the adjacent Gothic house on the hill, take a fancy to on-the-run Marion Crane only to abruptly murder her in the infamous shower scene. Hitchcock's films, such as *Rear Window*'s (1954) referential lines to watching and decoding visual action, or *Psycho*'s shocking murder of the presumed protagonist midway in the film, call attention to thwarted narrative expectations. This minimizes the long-term impact on viewers when compared to television fans, who fill the gaps between episodes analysing and theorizing.[52] *Psycho* elicits 'framing' of tracking shots, where instead of reproducing scenes of trauma through conventional 'zooming', Hitchcock demonstrates an inversion of the expected tracking shot. The subversive effect of the quick advancing shots is created by the way in which they frustrate, even as they indulge in one's desire to view the terrifying object more closely.[53] Audiences become observer and spectator to Norman's world, mirroring his secret voyeurism of Marion Crane in the shower, and the looming shadow of Mrs Bates from the house that dominates the horizontally laid-out Modernist motel; the characters become aligned with their settings and the architecture. For example, in the zenith of the movie, of cuts between Lila's approach and the façade of the Bates's house, the latter seems almost as sentient as the former[54] (Figure 1.3). Instead of the gaze erupting like a traumatic, disharmonious 'blot', there is the illusion of 'seeing ourselves seeing', of seeing the gaze itself.[55] The traumatic cuts, which lend to the illusion of Hitchcockian montage, elevate an everyday, trivial object into a sublime 'Thing'. By purely formal manipulation, it succeeds in bestowing on an ordinary object[56] the aura of anxiety and uneasiness.[57] It is crucial that Hitchcock shows the threatening 'Thing' (the house) exclusively from the point of view of Lila. If he were to have

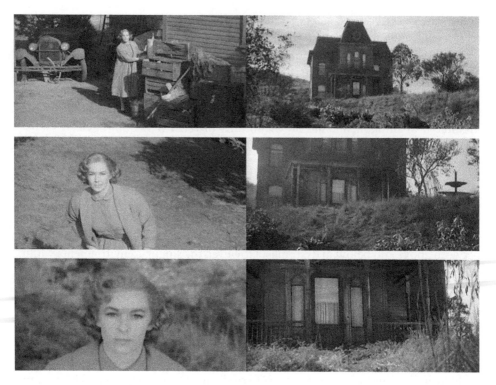

FIGURE 1.3: Hitchcockian montage and 'seeing ourselves seeing' in *Psycho*. Alfred Hitchcock (dir.), *Psycho*, 1960. USA © Paramount Pictures.

added a 'neutral' objective shot of the house, the mysterious effect would have been lost.[58] The effect for the audience is to syncopate their consciousness with Norman's, submitting to the boundaries imposed by the vertical house and the horizontal motel; facing an architectural antagonism and becoming split between the two houses.[59]

Žižek suggests that postmodernism seeks to obfuscate such splits, where the deployment of a postmodern architecture that combines the old home and the new motel into a hybrid configuration would alleviate Norman's compulsion to split,[60] or kill and run between the two poles.[61] Therefore, it is proposed that *Psycho* demonstrates parallaxical identities on screen, through boundaries represented vertically and horizontally that seek to remove the immediate contextual relationship that communities exist within. The spectacle gaze elicited only seeks to represent Žižek's idea of an antagonism between poles. In reality television, montage effects isolate exclusivity and project fantasmic status. Enframing 'reality' by omitting the real presents incommensurability between isolated wealth and the traumatic real world. Therefore, it becomes easier to look down.

In the case of dystopian visions, the idea of exclusivity and isolation reappears, but this time, the incommensurability spans environments and time. *Blade Runner*'s off-world colonization and globalized mega-structures serve to represent the gap between time left for those who stay in squalor and those who live comfortably with slaves and isolation. The mirroring is inherent in the protagonists where their isolation is not just xenophobic; it is environmental incommensurability between the streets and the sky. *High Rise* follows a similar track; the embodiment of utopian living descends into chaos once the antagonisms between the richer and poorer residents are exposed.

Compare these with *The Shining*, another iteration of incommensurability (Figure 1.4). In Stanley Kubrick's adaptation of Stephen King's 1977 novel, we follow Jack Torrance's descent into madness and murder, which is fuelled by his decision to relocate his family to the closed-for-winter Outlook Hotel as full-time live-in caretakers. The hotel, whose former caretaker's cabin fever had led to his eventual murder-suicide, serves as Jack's environment to exteriorize his

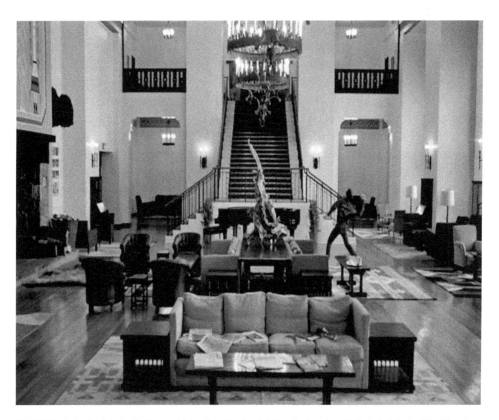

FIGURE 1.4: Jack's isolation within the Outlook Hotel. Stanley Kubrick (dir.), *The Shining*, 1980. USA © Warner Bros.

incommensurability of place in the shadow of the hotel's hierarchical spaces. Jack's isolation within the secluded and empty Outlook Hotel forms the backdrop for his murderous rampage as a result of incommensurability between his environmental isolation within grandiose space and personal longing for a collective hierarchy of place. Jack's mundane role as a caretaker, combined with his hallucinations and repressed desires, contribute to his disassociation of place. His isolation by his environment, and his access to community, only serves to present an architectural antagonism. His fantasies, coupled with his anachronistic and nostalgic[62] desire for a hierarchy, place Jack mentally unable to synthesize 'self', with his occupation of the empty and grandiose hotel. If Jack's environment were to be reconfigured, placing Jack's consciousness into a less-expansive and horizontal arrangement, his descent into madness might be alleviated; he might finish his book or continue to be the stable man at the start of the film. His context is repressed, requiring a hybrid configuration to bring about mediation of his mind and repressed desire. Much like Norman Bates, Jack Torrance is also the victim of a parallaxical environment between poles that exteriorize his mental anxieties. The difference is Jack's willingness to subscribe to an unexpected 'blot' caused by the hotel's seclusion and dissociation of space within a singular locale. For instance, Jack's initial visit to accept the role is surrounded within an active environment, and he remains ignorant of the manager's affirmation of the isolation during the winter period. Instead, Jack is seduced by his desire, revelling in his new environment, unaware of his egoistic motivations and the environment's incommensurability between the secluded domesticity of his family's quarters. Note that Jack becomes distanced and descends into madness while ignoring his writing – his responsibility and original aim – to wander and procrastinate in the grand spaces, mocking his isolated hierarchical position. The similarities in *Psycho* and *The Shining* not only expand upon an isolation of place but expose parallaxical identities' potential of encouraging anxieties between supposed *poles* or states of mind.

Lessons of parallaxical identities

Analysis of visual representations across television and film highlights a wider concern within the mediated city, and is a concern revealed within the vertical, horizontal and isolated dimensions of place. Incommensurability is exposed through parallaxical identities across extremes of fiscal extravagance and dystopian futures, demonstrating the challenge for architectural environments. Of course, the spectre here is economic overbearing, but *Psycho* and *The Shining* illuminate the parallaxical nature of architecture itself. It is not the aim of this chapter to proclaim that everyone will descend into madness in environments that

'split' in the Žižekian sense, but it illustrates that parallaxical spaces only seek to alleviate one's unconscious feelings of inequality and incommensurability. Where postmodernism obfuscates anxieties, the adoption of space would only form a temporary solution. For instance, the postmodern penchant for a multiplicity of spaces functions as pastiche that only seeks to expose further incommensurability between the conscious and unconscious. The utopian ideal enacted in the demographic nature of postmodern architecture allows a hierarchical order to materialize, underlying institutional goals of a state. Žižek builds on this notion by suggesting that it is not only the fantasy embodied in the mute language of buildings that articulates the utopia of justice, freedom and equality betrayed by actual social relations; this fantasy can also articulate a longing for inequality, for a clear-cut hierarchy and class distinctions.[63] The lesson from visual representations of the city redefines how the urban fabric determines incommensurability of place. The stars of *The Hills*, *The Apprentice* and *The Kardashians* all demonstrate the potential of circumventing their 'brand' from the trappings of the city's reality, obversely enacting an internal 'split' and parallaxical identity from the environment. Resistance against the gull-in-a-flight motion representation through montage, as per reality television, would promote context and anxieties to the forefront of identity. The alternative question for cities, however, is how to counter the defined split between those in power, or continue to allow an extreme dystopian display of hierarchical domination of sky and street? The lower-level split between street and sky can exist as aspirational, but it also defines one's ego and desire functions. *Blade Runner* and *High Rise* demonstrate poles that alienate, lending themselves to uncontrolled and complex organisms of fragmentation between consciousness and sanity. Jack Torrance and Norman Bates reflect such a split, even when the environment is reduced in scale; their anxieties manifest in extreme violence. However, the examples mentioned, across all of the genres, raise a pertinent question of contemporary architecture: 'What is the unconscious wish behind the architecture?' Without such concerns, cities run the risk of replicating parallaxical identities by foregrounding the idea of 'being' within divergent contexts that do nothing for psychical competencies and are subject to 'Things'. Where the risk of environments heavily imbued with montage-like effects, or extreme disparity between street and sky, is an exacerbation of people's anxieties or disassociation, a new breed of architecture that alludes to Žižek's postmodern resolution is key. Nonetheless, in resolving parallaxical inequalities, and identities, postmodern architecture must do more beyond a sense of 'stacking' or the conservative 'multiplicity of functions'. The cities' resolution is found within an expansion of Žižek's 'longing for inequality' comment, resisting the conventional ideology of postmodern architecture. Instead, the mediated city expands and resolves anxieties within Latour and Yaneva's[64] position 'to picture a building as a

moving modulator regulating different intensities of engagement, redirecting users' attention, mixing and putting people together, concentrating flows of actors and distributing them so as to compose a productive force in time-space'. To reimagine the role of architecture (and removing the ego so often attached) as without a representation of looking up, looking down or looking awry fosters new perspectives that reduce parallaxical identities. Activity and plurality within the fabric of the mediated city evolve, expand, remain democratic and perhaps, most importantly, reduce incommensurability. If one learns anything from media representations of place, it should be a concern for the between-the-lines clues and subtexts of whose city is portrayed on screen: is the audience 'seeing themselves seeing' or are they privy to a hierarchical display of place?

NOTES

1. Slavoj Žižek, *Enjoy Your Symptom!* (London: Routledge, 2008), 242.
2. The current research topic is part of a PhD study with the University of Derby.
3. Bruno Latour and Albena Yaneva, 'Give Me a Gun and I Will Make All the Buildings Move – an Ant's View of Architecture', *Explorations in Architecture – Teaching, Design, Research* (2008): 87.
4. Latour and Yaneva, 'Give Me a Gun'.
5. Žižek, *Enjoy Your Symptom!*, 242.
6. Jason Mittell, *Complex TV* (New York: New York University Press, 2015), 164.
7. Mittell, *Complex TV*, 187.
8. Mittell, *Complex TV*, 187.
9. Originally penned as a spin-off of *Laguna Beach: The Real Orange County*. Episodes are available at 'The Hills | Season 6 Episodes (TV Series) | MTV', *MTV*, 2018, http://www.mtv.com/shows/the-hills. The series ran from 2006 to 2010 and spanned 102 episodes across 6 seasons.
10. Laura Bly, 'The Real Laguna Beach Disdains Its MTV Image', *USA Today*, 2006, http://usatoday30.usatoday.com/travel/destinations/2006-03-02-laguna-beach_x.htm.
11. Placing the Southern California enclave front-and-centre for the cast's antics, which, to some local observers, shows that the town's portrayal as a capital of fabulousness is all too accurate. See Bly, 'The Real Laguna Beach Disdains Its MTV Image'.
12. Bly, 'The Real Laguna Beach Disdains Its MTV Image'.
13. Lisa Taylor, ' "I'm a Girl, I Should Be a Princess": Gender, Class Entitlement and Denial in The Hills', in *Reality Television and Class*, ed. Beverley Skeggs and Helen Wood (London: Routledge, 2012), 126.
14. Taylor, ' "I'm a Girl, I Should Be a Princess" '.
15. Slavoj Žižek, *Looking Awry* (Cambridge, MA: MIT Press, 1992), 117.
16. Žižek, *Looking Awry*, 116.

17. Latour and Yaneva, 'Give Me a Gun', 87.
18. Mittell, *Complex TV*, 128.
19. The UK show information can be found at: 'The Apprentice – About The Apprentice – BBC One', *BBC*, 2018, http://www.bbc.co.uk/programmes/articles/grTP6yCQz3zy3n3fhBR8QT/about-the-apprentice.
20. In some circles, it was rumoured Trump's political campaign was initially due to the show's flagging ratings in the United States and possible cancellation. Seeking publicity, Trump ran his campaign to secure further seasons. However, his campaign gained traction, leading to his election.
21. For this chapter, the UK and US versions will be addressed as their formats mirror each other and are both syndicated within the UK television schedules.
22. 'Yuppie' (young upwardly mobile professionals) canonized in the 1980s and 1990s by Gordon Gekko in *Wall Street* (1987), Patrick Bateman in *American Psycho* (1991 novel and 2000 film) or Allison Jones in *Single White Female* (1992). For further reading on yuppies today, see Teddy Wayne, 'The Tell-Tale Signs of the Modern-Day Yuppie', *New York Times*, 2015, https://www.nytimes.com/2015/05/10/fashion/tell-tale-signs-of-the-modern-day-yuppie.html.
23. The show follows a routine format every episode, where the contestants are assigned a task, split into teams, complete said task and return to the 'boardroom' to be fired or to advance to the next week. See the episode guide 'The Apprentice – Episode Guide – BBC One', *BBC*, 2018, https://www.bbc.co.uk/programmes/b0071b63/episodes/guide.
24. Often in close-up shots looking perplexed by the contestant's behaviour or through supercilious inquiry of decisions during the tasks.
25. Taylor, '"I'm a Girl, I Should Be a Princess'", 120.
26. Taylor, '"I'm a Girl, I Should Be a Princess'", 120.
27. Latour and Yaneva, 'Give Me a Gun', 82.
28. Over fourteen seasons, see: 'Keeping Up with the Kardashians', *E! Now*, 2018, http://www.eonline.com/now/keeping-up-with-the-kardashians.
29. Mittell, *Complex TV*, 128. The Kardashian-Jenner relationships have all been documented, and their beaus have all been portrayed as figures of love and hate. Over the series, we have had surprising insights into Kim and Kanye's relationship and eventual marriage; the failure of Khloé's marriage and divorce from basketball star Lamar Odom – generating a spin-off for two seasons; and finally, the rapper Tyga (27 at the time), who became the villain of the show due to his relationship with Kylie Jenner – controversially, she had been dating Tyga since she was 16, thereby not adhering to California's age of consent, which is 18.
30. See Sean Michaels, 'Kanye West Takes Over Stadium for Rap Proposal to Kim Kardashian', *Guardian*, 2013, https://www.theguardian.com/music/2013/oct/23/kanye-west-kim-kardashian-proposal-stadium-rap.
31. Taylor, '"I'm a Girl, I Should Be a Princess"', 127.
32. Slavoj Žižek, *Living in the End Times* (London: Verso, 2011), 259.

33. In 1927, *Metropolis* paved the aesthetic for cinematic future cities, complete with skyscrapers, flying cars, avenues and androids at the service of humans.
34. Barbara Mennel, *Cities and Cinema* (London: Routledge, 2008), 146.
35. With off-world being outer space (not defined in the film), all that remains on Earth is a population of lower-class workers, corporations and the manufacturers of replicants.
36. 'Retired' is the term coined by Blade Runners who hunt down the criminalized replicants and kill them.
37. Nezar AlSayyad, *Cinematic Urbanism* (New York: Routledge, 2006), 128.
38. The replicant creators.
39. Incidentally, the occupants of these higher structures are the only ones to see natural sunlight, as seen in Tyrell's offices when Deckard meets Rachael for the first time.
40. AlSayyad, *Cinematic Urbanism*, 130.
41. AlSayyad, *Cinematic Urbanism*, 135.
42. AlSayyad, *Cinematic Urbanism*, 135.
43. Peter Sands, 'Global Cannibal City Machines', in *Global Cities*, ed. Linda Krause and Petro Patrice (New Brunswick, NJ: Rutgers University Press, 2003), 135.
44. Michael Webb, 'Like Today, Only More So', in *Film Architecture*, ed. Dietrich Neumann (Munich: Prestel, 1999), 45.
45. AlSayyad, *Cinematic Urbanism*, 136.
46. C. J. Hughes, 'Midtown Manhattan: New Amenities and High-Rises Attract Residents', *New York Times*, 9 August 2017, http://www.nytimes.com/2010/02/28/us/politics/28health.html.
47. Žižek, *Looking Awry*, 112.
48. Louis D'Arcy-Reed, 'Why Blade Runner 2049 Is a Masterpiece of Modern Cinema', *Rogue's Portal*, 30 October 2017, http://www.roguesportal.com/why-blade-runner-2049-is-a-masterpiece-of-modern-cinema/.
49. See Henri Lefebvre, *The Production of Space* (Malden, MA: Blackwell, 2016).
50. Merrill Schleier, *Skyscraper Cinema* (Minneapolis: University of Minnesota Press, 2009), 59.
51. Eilean Hooper-Greenhill, *Museums and the Shaping of Knowledge* (London: Routledge, 1992), 9.
52. Mittell, *Complex TV*, 46.
53. Žižek, *Looking Awry*, 90.
54. David Sterritt, 'Registrar of Births and Deaths', in *Framing Hitchcock*, ed. Sidney Gottlieb and Christopher Brookhouse (Detroit: Wayne State University Press, 2002), 319.
55. Žižek, *Looking Awry*, 114.
56. In this case, the house being the dominating anxiety and the hotel as the setting for Norman's freedom.
57. Žižek, *Looking Awry*, 117.
58. Žižek, *Looking Awry*, 118.
59. Žižek, *Living in the End Times*, 257.

60. Žižek, *Living in the End Times*, 257. Žižek furthers his hypothesis that architecture today elicits 'zero institutions'; their meaning is to have meaning, to be islands of meaning in the flow of our meaningless daily existence.
61. Paraphrased from Žižek, *Living in the End Times*, 257.
62. Frederic Jameson, 'Historicism in The Shining', *Visual Memory*, 1981, 11, http://www.visualmemory.co.uk/amk/doc/0098.html.
63. Žižek, *Living in the End Times*, 255.
64. Latour and Yaneva, 'Give Me a Gun', 87.

BIBLIOGRAPHY

Abed, Hisham, and Jason Sands, dir. *The Hills*. MTV, 2006.

Al-Saati, Maha Zeini, David Botta and Robert Woodbury. 'Depictions of Architectural Spaces in Film'. *International Journal of the Image* 2, no. 3 (2012): 107–18. Art Full Text (H.W. Wilson), EBSCOhost (accessed 5 March 2018).

AlSayyad, Nezar. *Cinematic Urbanism*. New York: Routledge, 2006.

'The Apprentice – About The Apprentice – BBC One'. *BBC*, 2018. http://www.bbc.co.uk/programmes/articles/grTP6yCQz3zy3n3fhBR8QT/about-the-apprentice.

'The Apprentice – Episode Guide – BBC One'. *BBC*, 2018. https://www.bbc.co.uk/programmes/b0071b63/episodes/guide.

Bly, Laura. 'The Real Laguna Beach Disdains Its MTV Image'. *USA Today*, 2006. http://usatoday30.usatoday.com/travel/destinations/2006-03-02-laguna-beach_x.htm.

Burton, Tim, dir. *Batman*. Warner Bros, 1989.

Cramer, Ned. 'The Replicant City of Blade Runner 2049'. Architectmagazine.com, 2017. http://www.architectmagazine.com/design/editorial/the-replicant-city-of-i-blade-runner-2049-i_o.

Devonshire, Andy, dir. *The Apprentice*. BBC, 2012.

Gottlieb, Sidney, and Christopher Brookhouse. *Framing Hitchcock*. Detroit: Wayne State University Press, 2002.

Havva Alkan, Bala. 'Reading of the Architectural Identity via Cinema'. *CINEJ Cinema Journal* 4, no. 1 (2015): 79–109, 79. Directory of Open Access Journals, EBSCOhost (accessed 5 March 2018).

'The Hills | Season 6 Episodes (TV Series) | MTV'. *MTV*, 2018. http://www.mtv.com/shows/the-hills.

Hitchcock, Alfred, dir. *Psycho*. Paramount Pictures, 1960.

Hooper-Greenhill, Eilean. *Museums and the Shaping of Knowledge*. London: Routledge, 1992.

Hughes, C. J. 'Midtown Manhattan: New Amenities and High-Rises Attract Residents'. *New York Times*, 9 August 2017. http://www.nytimes.com/2010/02/28/us/politics/28health.html.

Jameson, Frederic. 'Historicism in *The Shining*'. *Visual Memory*, 1981. http://www.visualmemory.co.uk/amk/doc/0098.html.

Krause, Linda, and Patrice Petro. *Global Cities*. New Brunswick, NJ: Rutgers University Press, 2003.
Kubrick, Stanley, dir. *The Shining*. Warner Bros, 1980.
Lang, Fritz, dir. *Metropolis*. Universum Film, 1927.
Latour, Bruno, and Albena Yaneva. 'Give Me a Gun and I Will Make All the Buildings Move – an Ant's View of Architecture'. *Explorations in Architecture – Teaching, Design, Research* (2008): 80–89.
Lefebvre, Henri. *The Production of Space*. Malden, MA: Blackwell, 2016.
Mittell, Jason. *Complex TV*. New York: New York University Press, 2015.
Neumann, Dietrich. *Film Architecture*. Munich: Prestel, 1999.
Oshii, Mamoru, dir. *Ghost in the Shell*. Manga Entertainment, 1996.
Pratt, Geraldine, and Rose Marie San Juan. *Film and Urban Space*. Edinburgh: Edinburgh University Press, 2014.
Radford, Oliver, dir. *1984*. 20th Century Fox, 1984.
Rand, A. *The Fountainhead*. New York: Macmillan, 1986.
Ray, Chris, dir. *Keeping Up with the Kardashians*. E! Entertainment Television, 2007.
Robert, Hermanson. 'Phenomenological Depths: Surface and Flatness in Architecture and Film'. *International Journal of the Arts in Society* 6, no. 2 (2012): 39–52. doi: EBSCOhost.
Sands, Peter. 'Global Cannibal City Machines'. In *Global Cities*, edited by Linda Krause and Petro Patrice, 129–41. New Brunswick, NJ: Rutgers University Press, 2003.
Schleier, Merrill. *Skyscraper Cinema*. Minneapolis: University of Minnesota Press, 2009.
Scott, Ridley, dir. *Blade Runner*. Warner Bros, 1982.
Sertaç Timur, Demir. 2015. 'The City on Screen: A Methodological Approach on Cinematic City Studies'. *CINEJ Cinema Journal* 4, no. 1 (2015): 20–36, 20. Directory of Open Access Journals, EBSCOhost (accessed 5 March 2018).
Shonfield, Katherine. *Walls Have Feelings*. Palo Alto, CA: Ebrary, 2006.
Skeggs, Beverley, and Helen Wood, eds. *Reality Television and Class*. London: Routledge, 2012.
Sterritt, David. 'Registrar of Births and Deaths'. In *Framing Hitchcock*, edited by Sidney Gottlieb and Christopher Brookhouse, 310–22. Detroit: Wayne State University Press, 2002.
Vidor, King, dir. *The Fountainhead*. Warner Bros, 1949.
Villeneuve, Denis, dir. *Blade Runner 2049*. Warner Bros, 2017.
Wayne, Teddy. 'The Tell-Tale Signs of The Modern-Day Yuppie'. *New York Times*, 2015. https://www.nytimes.com/2015/05/10/fashion/tell-tale-signs-of-the-modern-day-yuppie.html.
Webb, Michael. 'Like Today, Only More So'. In *Film Architecture*, edited by Dietrich Neumann, 44–47. Munich: Prestel, 1999.
Wheatley, Ben, dir. *High-Rise*. StudioCanal, 2015.
Žižek, Slavoj. *Enjoy Your Symptom!* London: Routledge, 2008.
———. *Living in the End Times* London: Verso, 2011.
———. *Looking Awry*. Cambridge, MA: MIT Press, 1992.

Film List

1984. Directed by Oliver Radford, 20th Century Fox, 1984.
The Apprentice. Directed by Andy Devonshire, UK: BBC, 2006–.
Batman. Directed by Tim Burton, USA: Warner Bros, 1989.
Blade Runner. Directed by Ridley Scott, USA: Warner Bros, 1982.
Blade Runner 2049. Directed by Denis Villeneuve, USA: Warner Bros, 2017.
The Fountainhead. Directed by King Vidor, USA: Warner Bros, 1949.
Ghost in the Shell. Directed by Mamoru Oshii, Japan: Manga Entertainment, 1996.
High-Rise. Directed by Ben Wheatley, UK: StudioCanal, 2015.
The Hills. Directed by Hisham Abed and Jason Sands, USA: MTV, 2006–10.
Keeping Up with the Kardashians. Directed by Chris Ray, USA: E! Entertainment Television, 2007–.
Metropolis. Directed by Fritz Lang, Germany: Universum Film, 1927.
Psycho. Directed by Alfred Hitchcock, USA: Paramount Pictures, 1960.
The Shining. Directed by Stanley Kubrick, USA: Warner Bros, 1980.

2

Materiality and the Maternal: Spatial Politics and Agency of the Cinematic Apartment in Japanese Horror Films

Shana Sanusi

Introduction

Many Japanese horror films produced since the turn of the millennium have featured apartment spaces as a key setting to reflect on the social conditions of the post-economic bubble period. The cinematic presence of the apartment addresses culturally specific anxiety owing to the changes in gender, family and space caused by the burst of the bubble economy in the 1990s. The cramped interiority of contemporary high-rise apartments as well as older, government-owned *danchi*[1] complexes become a repository of horror and domestic unrest in films such as *2 LDK* (2003), *Apartment 1303* (2007), *The Complex* (2013) and, most recently, *The Inerasable* (2016). The spatial imagery of the home as a locus of belonging and everyday (family) life in these films is replaced by an estranged sense of dislocation caused primarily by spectral hauntings. Considering how the domestic sphere is highly gendered in the Japanese context, these narratives reflectively relegate the female protagonists to the home – a space traditionally regarded as a feminine domain – and imprison them among the unsettled spirits of past occupants. The nexus between women and the built environment thematizes the former as sexed subjects that are still governed by the patriarchal family law in contemporary Japan.

This chapter, therefore, maps out the spatial politics of the domestic setting in *Dark Water* (2002) and *Kotoko* (2011) – two maternal horror films that associate spatial disturbance with the (mis)appropriation of Japanese femininity.

Both films are set in timeworn apartments inhabited by single mothers whose plights articulate female displacement within Japan's patriarchal social system. As a spatial motif, the interiority of these apartments further demonizes the characters' performativity of femininity and motherhood. Accordingly, this chapter ruminates on the idea of *ryōsaikenbo*[2] – an expression that translates into 'good wife, wise mother' – as an ideal maternal identity in Japanese culture. The notion positions women only within the boundaries of domesticity; they are primarily responsible for raising children into becoming productive members of society and maintaining family harmony. The female protagonists' negligence of their children in the two films subverts this particular ideology by expressing a form of resistance towards traditional concepts of mothering. By failing to observe this particular gender ideology that upholds Japanese social norms, this chapter maintains that *Dark Water*'s Yoshimi and the title character of *Kotoko* are condemned to punishment in the domestic sphere.[3]

Furthermore, this chapter critically discusses how the apartment in each film acts as a maternal agency that imposes the *ryōsaikenbo* ideology on its occupants through spatial manipulation. The Platonic concept of the *chora* (or 'womb' in Greek) as reflected by feminist theorists Luce Irigaray and Elizabeth Grosz is deployed specifically to address the spatial monstrosity of the apartments and explore how domestic architecture is aligned with the corporeality and consciousness of maternal figures. In addressing the aforementioned, the vernacular architectural features of the apartments and the cultural sensibilities imbuing the design and use of the living space are considered to see how these elements may influence the identity of the occupants.

(En)Gendering the home and body

In his *Bodily Structures*, Japanese philosopher Hiroshi Ichikawa puts forward the notion of '*mi*' – the body, or more specifically, an absolute consolidation of the mind, spirit and the corporeal – and connects it with the feeling of being 'at home'.[4] Such culturally specific concept of the body/consciousness relating to domestic spatiality mirrors Grosz's view on how subjectivity is constructed based on the physical body that is located in space.[5] Grosz has argued that a subject experiences the world from his or her visual-spatial perspective of the body, thereby 'anchoring' the subjectivity and identity solely to sites.[6] It is necessary to bear in mind that subjectivity, according to Irigaray, is an imprint of one's gender, sex and sexuality with different bodily needs and desires.[7] She views the masculine as an alignment of the external as the male sex organ is situated in exteriority while the feminine threads on the complex duality of the internal and external based on the body's

ability to contain (pregnancy) and expel (labour).[8] Due to this perceptible sexual difference, Irigaray suggests the importance of constructing an appropriate 'architecture of place' that espouses the differing needs of the sexed bodies to experience and dwell accordingly.[9]

Spatial segregation of the sexes, however, characterizes Japanese domesticity as the interior space of the home is traditionally partitioned according to gender and rank. The traditional domestic arrangement often situates the minimalist, Japanese-style *zashiki* or principle room as a place to entertain casual guests by the male authority figure of the household.[10] The study room or *shoin*, decorated either according to traditional style or Western style, is another performative space for the males to receive more formal visitants.[11] The home's more private, inner spaces are ultimately regarded as feminine areas that notarize the domestic chores and household duties. A wife is known as '*oku-san*' – a term that implies a woman who 'inhabits a house's depths'; this image is deeply ingrained in Japanese consciousness as a norm of femininity.[12] As an exclusively female domain, the kitchen (*daidokoro*) is customarily positioned to the rear of the house, standing isolated from the other living quarters.[13] In Edward Morse's classic architectural study of the Japanese house, the traditional kitchen layout is described as a dark and narrow space that is 'the least defined of Japanese rooms' and 'altogether devoid of comfort' as well as orderliness.[14] This space is presumed to be of the lowest position in the hierarchy of all rooms in the house, thus reflecting the privilege of the patriarch and the devaluation of the feminine.[15]

Contemporary Japanese apartments, however, are heavily influenced by post-war *danchi* architecture that physically resonates with the urban aspirations and modern idealism adopted by the Japanese. Despite the reduction in size, the design of the home is 'democratized' from the 'feudalistic' shackles of the pre-war past with the introduction of the living-dining-kitchen (LDK) arrangement where the open-plan kitchen and dining area are centrally located and adjacent to the living and sleeping areas.[16] The traditional guest room is superseded by the Western-style living room where the male family head is encouraged to spend quality time relaxing with the family.[17] The change in layout is meant to promote a lifestyle change, especially for the housewife to be more visible in the presence of the family while fulfilling household obligations. Regardless of the spatial design changes over time, the *ryōsaikenbo* ideal remains prevalent as women are expected to be home-bound in shouldering domestic duties and care for the family. The gradual gender shift and institutional change in modern Japan have increasingly yielded more single-mother households, thus problematizing traditional thoughts on femininity and motherhood that are deeply intertwined with the domestic sphere.

Working single mothers in present-day Japan face a double-bind dilemma in negotiating their autonomy and maternal identities in a social system that

marginalizes them for not adhering to specific cultural codes. The social and cultural meanings of the space inhabited by women subtly, if not outwardly, affect their subjective well-being and how they perform and carry their (maternal) bodies. In analysing Irigaray's spatial metaphors and understanding of gender, Grosz surmises that women are left in a paradoxical state of 'homelessness within the very home itself' for dwellings are rarely constructed by or for them in mind.[18] The physical space of the home is hence 'built and appropriated by the masculine', while women are enclosed within, becoming complicit to their own 'erasure' by submitting to duty and 'repeatable chores' with no recognition and, at times, domestic violence, abuse as well as isolation.[19] Irigaray asserts that domestic architecture has primarily been conceived and built throughout history 'to either contain women or to obliterate' female presence.[20]

Hence, the concept of the *chora* as deliberated by these feminist thinkers proves to be a redeeming idea of a space made possible for women to exist and holds sacred from male intrusion. Grosz views the concept attributing to the feminine, or more specifically, the maternal as it has been described as a 'receptacle', 'womb' or 'incubator' that 'provides the point of entry, as it were, into material existence' yet without any substantial form of its own.[21] These feminine-coded terms all point to the process of gestation, and indeed the mother's womb is man's earliest, nurturing dwelling.[22] While Irigaray may not approach the *chora* directly, she does, however, allude to the concept by contending that the maternal-feminine should cease to be perceived as a lack in comparison to the symbolic order of masculine power. Women are constructed in language and culture to be passive vessels that contain the male seed during conception and house the child throughout pregnancy. Feminine corporeality is likened to 'pure disposable matter', based solely on the maternal body's relationship to fluids such as blood, milk and the amniotic sac.[23] This image of malleable and formless fluids without proper boundaries debases the reproductive power held by women in their ability to alter the form of their body-vessels by giving 'being and birth' and later nourishing life.[24] Fluid forms an 'archaic' and 'bodily' relationship between a mother and her child.[25] Irigaray maintains that the female body is exceptional and inimitable as it is both 'matter and form insofar as she is woman'.[26]

Dark Water: *Returning to the maternal space*

The narrative of *Dark Water* revolves around Yoshimi Matsubara who has recently stepped out from her marriage to a salaryman. While fighting for the custody rights of her child Ikuko, Yoshimi's status as a divorcee further displaces her from the culture that still clings to the idea of conventional family structure. In maintaining

the custody, she is forced to find a dwelling of her own and a job that will provide security for Ikuko. As a single mother, Yoshimi is in a state of 'homelessness' after being 'expelled' from society for existing outside the periphery of Japanese social norms and experiences. This situation propels her to step into the realm of the *chora* in the form of an aged apartment complex located by a riverside in the outskirts of Tokyo. Despite being in a crippling state of decay, the building appears imposing when framed in long and aerial shots in the scene where Yoshimi and her daughter Ikuko first chance upon it. The deteriorating condition of the austere apartment is a symbolic metaphor for the corrosion of the institution of family, paralleling her ambiguous status as a divorcee.

Emptiness pervades the film, mirroring such displacement that envelops Yoshimi as a single mother in contemporary Japan. The interior of the edifice shows neglect as we see long shots of empty, identical corridors with puddles of water on the floor from the rain outside. The elevator, with water droplets leaking from its fragile ceiling, establishes a profound sense of spatial dread. This constant permeation of water signals porous boundaries which confound the separation between the interior and the exterior. While viewing their apartment 2LDK unit with the realtor, it dawns on Yoshimi that the building seems to be in uninhabited isolation, pointing to the overall decline of familial community relationships. Moreover, the risk of social isolationism remains ubiquitous in Japanese apartment living as the small, structural design of each unit provides privacy from neighbours and encourages even smaller households of 'only two'.[27] Instead of welcoming, the apartment appears on the surface to be spatially aloof in its sacred, maternal role of 'hosting' bodies. As a feminine receptacle, the building is ultimately maternal, personified by its materiality. According to architectural scholar Marjorie Garber, a house may replicate bodily functions in which different parts of its household anatomy perform in an organic manner.[28] The dimly lit, narrow corridors and stairwells are symbolic of the building's main artery that connects to the rooftop where the ominous water tank rests. The Matsubaras' claustrophobic unit indicates the extent to which the space mimics a womb enveloping a foetus. During the viewing, Yoshimi describes the unit's dampness and humidity as 'unreal', thus alluding to the nature of the uterus. The pipes which connect the bathroom and kitchen to the water tank act as an umbilical cord that nurtures the pair with fluids.

Yoshimi is the only character who is phenomenologically affected by the apartment's structural resemblance to maternity. This functions to underline the lack of maternal figure in Yoshimi's life, as foregrounded by the sepia-toned flashback scenes at the kindergarten which shows the emotional abandonment she has endured as a child while waiting for her mother who never arrives. As Grosz postulates, the *chora* is meant to be an opportunity to return women to the place(s) which they have been exiled from. As a symbolic mother figure, the building offers

Yoshimi and Ikuko a space of shelter and protection and even unites the pair as mother and child. The pair, having unpacked their belongings on the night after their move, indulges in a light-hearted game of catch in the tight space of their unit. The apartment is presented as a warm and comfortable womb-like space, sheltering them from a threatening patriarch as represented by Yoshimi's former husband.

Despite the protection that the apartment lends to Yoshimi and her child, its agency seems to be monstrous as it aligns itself culturally with the patriarchal establishment. In its will to safeguard Yoshimi, the apartment also harbours an inclination to coerce her to embrace the concept of the *ryōsaikenbo* by fostering an otherwise motherless ghost-child named Mitsuko. Monstrous maternity is a common archetype in Japanese texts as the acts of mothering – even in the name of the mother's will to protect – are often demonized as evil and destructive. The apartment configures the materialization of Mitsuko who mirrors Yoshimi's past of having been abandoned by her mother. In reasserting the traditional gender ideology, the apartment thus punishes Yoshimi through Mitsuko's haunting for her transgression of not safeguarding the sanctity of the Japanese *ie* ('household') system by undergoing divorce. Thus, the apartment becomes a reversed *chora* and ironically acts as a maternal authority to submit its occupant back to symbolic patriarchy.

Scenes of Yoshimi encountering Mitsuko in her dreams and reality indicate how the apartment has managed to affect the former at an unconscious level.[29] In a grainy dream sequence, the camera trails after a girl in a yellow raincoat as she makes her way back home on a deserted street by the river. Upon reaching the apartment, Mitsuko takes the elevator to the rooftop and climbs onto the desolate water tank. She accidentally drops her red bag into the tank and slips to her death as she reaches out to retrieve it. Meanwhile, Yoshimi wakes up from her slumber, only to find the amoeba-shaped leakage stain on her ceiling has become more pervasive as drops of water profusely hit the hardwood floor. The pool of liquid, or matter in Irigayan term, seems out of place against the rigid, level lines of the structure's ceiling and floor. The imagery of water permeation and the porousness of the apartment's ceiling are a commentary on the boundaries or borders that separate Yoshimi's subjectivity from her physical environment that have now become fluid and formless. The leakage seeps through the crevice of an otherwise solid construction, thus revealing her motional porosity due to a childhood trauma (Figure 2.1).

The intensification of the leakage in their bedroom ceiling, as well as volumes of polluted water flooding the bathtub in later scenes, bring forth Irigaray's notion of female fluidity. Characterized by the forceful water permeation in the Matsubaras' unit, the apartment has now fully taken on the maternal-feminine

FIGURE 2.1: The permeation of water is constant imagery within *Dark Water*. Hideo Nakata (dir.), *Dark Water*, 2002. Japan © Toho.

role in a more ostensible manner. To a certain degree, the apartment and its ghostly materialization of Mitsuko precipitate Yoshimi's mental collapse until she undergoes a 'rebirth'.[30] A process of gestation, however, has to occur prior to the cycle of rebirth, and this is shown in the film through the motif of running water. Akin to Irigaray's point of view, water is considered a maternal symbol in Japan with its primary association with amniotic fluid. Located on the rooftop of the apartment building that overlooks the modern city, the water tank is indeed the most reflective of the primal womb. Its concave shape echoes the maternal womb while its volume of abject, cloudy water points to the amniotic fluid that shelters the developing foetus. The water tank epitomizes the abject in-between as borders between two individuals (the mother and the child) are ruptured as they coexist within the same bodily space. Mitsuko's death in its space is merely a conception (and later gestation) of a haunting that is meant for Yoshimi who will later arrive at the building to stay.

The climax of the film shows the water tank ripened with dark water that trickles down on its rusty wall in excess. As Yoshimi runs her fingers along the surface of the water, the tank suddenly alarms her with pregnant bulges as a sign of labour. The rebirth act takes place in the elevator where the apartment separates Ikuko from Yoshimi as Mitsuko clings onto her in a moment of confusion (Figure 2.2). In this dramatic scene, Yoshimi assumes the role of the *hahamono* ('self-sacrificing

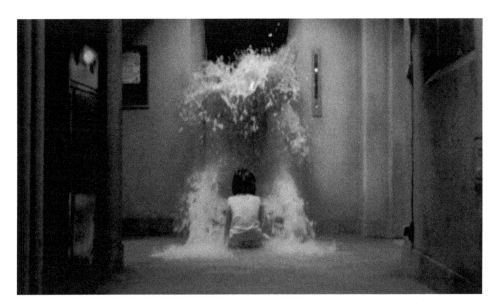

FIGURE 2.2: The 'rebirth' scene taking place at the elevator. Hideo Nakata (dir.), *Dark Water*, 2002. Japan © Toho.

mother') by sparing Ikuko from danger and conceding to Mitsuko's needs for a mother. Despite Ikuko's cries, Yoshimi accepts her fate and allows for her rebirth to occur as water streams from the elevator's pores, cleansing her of her transgressions and 'unmaternal' sins as a divorcee and single mother. Embracing Mitsuko is an act of embracing the ideological ideal of wise motherhood. The apartment has finally served its purpose: to restore Yoshimi according to the traditional Japanese construction of motherhood.

Space and unmothering desires in Kotoko

While *Dark Water*'s apartment possesses a maternal agency that influences Yoshimi to cleanse her modern identity in favour of a traditional one, the living quarters of Kotoko is one that mirrors her subjectivity concerning motherhood. Her situation as a single mother to a child out of wedlock is presented as graphic and disturbing, indicating a form of female ostracization in modern-day Japan. The father of her newborn son Daijiro is unknown, and the film focuses on the disintegration of her fragile mind as she raises him alone. The apartment, however, slowly introjects Kotoko's inner resentment by becoming an unmaternal nest that resists the child in a monstrous yet subtle manner. The apartment space is neither a separate

entity nor agency but instead functions as Kotoko's alter ego. Kotoko's intimate relationship with her apartment and the living choices she is afforded with by the domestic space determine her psyche and shape her unstable maternal identity.

The film opens with Kotoko narrating her predicament of having double vision. Unsteady tracking shots of Kotoko encountering strangers, men and women alike, with their doppelgangers accompany her neurotic narration. Each pair of strangers has one acting indifferent and the other violent towards her. Such depiction signals a sense of prejudice and discrimination of the society towards Kotoko's status as a single mother, leaving her in a state of homelessness similar to Yoshimi. Julia Kristeva, for example, delineates the maternal body as a site of an 'infolding of otherness' (i.e. the foetus in the womb) that is both 'double and foreign', thus questioning the concept of self/other identity in motherhood.[31] Such doubling foregrounds her dwelling – a nondescript *danchi* block in a quiet suburb of Tokyo – as an alter ego. Due to the threats she receives from the outside world, she then decides to confine her son in the apartment in a bid to protect him.

According to Irigaray's viewpoint, women are excluded from the symbolic order, and their role is reduced to the maternal provision of a space through womb for men, or in this case, for Daijiro to exist.[32] In doing so, women have consequently lost their space in this particular masculine universe. The apartment unit indeed has a space specifically for Daijiro to dwell in – a small, Japanese-style tatami-matted room that has been turned into his nursery. The tatami room is a relic of the traditional Japanese past for its culturally significant purpose as a space associated with 'seasonal change, religious celebrations and life-cycle events' such as nuptial ceremonies and funeral rites.[33] The interior design principle for such native, vernacular space is commonly 'refined and light'.[34] In the context of the modern apartment, the tatami room serves as a means to accommodate more space in an otherwise constricted interior. Similarly, Kotoko has chosen this traditionally symbolic space to nurture her newborn son – a room that confines her to a past that honours motherhood and family life. The nursery seems to reflect the *chora* at first – a space that engenders and gives without possessing or receiving. Kotoko is numerously seen responding to the distress cries of the infant in this room where her vulnerable, infantile ego is located. A montage of shots later reveals the apartment's interior as a space that undergoes a significant transformation: the tatami nursery where Daijiro sleeps, once cluttered with toys and baby products, is turned into a whimsical, carnivalesque site with party streamers hanging from the ceiling and cardboard cut-outs of the city scattered on the floor (Figure 2.3). The clutter of mock-ups can be read as a commentary of architecture essentially being 'the production of a (male) world' and the 'construction of an "artificial" or cultural environment'.[35] Such domestic disarray is a thinly disguised metaphor for Kotoko's rejection of the pre-modern past (that is embedded in the minimalist

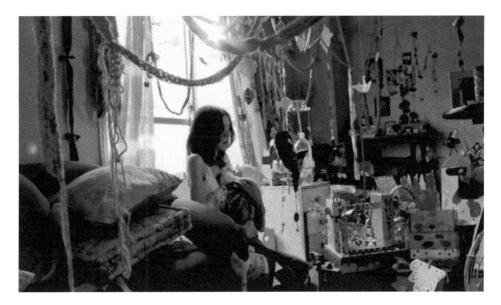

FIGURE 2.3: The chaotic nursery room in Kotoko's apartment. Shinya Tsukamoto (dir.), *Kotoko*, 2011. Japan © Makotoya.

orderliness of the tatami room) in favour of a more Western-influenced individualism and independence. The apartment may appear as a nurturing *chora* with the nursery's set-up, yet it proves to be ambivalent, if not threatening space for Daijiro as Kotoko furtively begrudges his existence.

Implicitly, the apartment has the capacity to reflect the protagonist's unconscious, 'unmothering' desires as evident in the scene when Kotoko's attention on her baby is disrupted by the television that switches on on its own. The screen shows devastating news of male children being kidnapped and reported lost. Perturbed by the news or rather her cruel intention to destroy her son, she switches it off. Since the apartment corresponds to her inner subjectivity, it continues to support Kotoko's intention to orchestrate infanticide by invoking hallucinations of her dropping Daijiro onto the ground from the rooftop. Kotoko also has great difficulty in accepting the burden of traditional domesticity. In one scene, she prepares food out of hunger while cradling her crying baby in one arm. In a dizzying handheld shot, she is shown stir-frying vegetables in the wok frantically, only to drop it onto the floor. The kitchen is thus another confining 'space of duty', and the film positions it as a constrictive and cluttered space that is consistently enfolded in bluish-grey dark tones (Figure 2.4).[36] It is yet another space that is culturally resonant of asymmetric gendering of the home – an isolated area where domestic drudgery that is devoid of social value is carried out by routine of subservience.

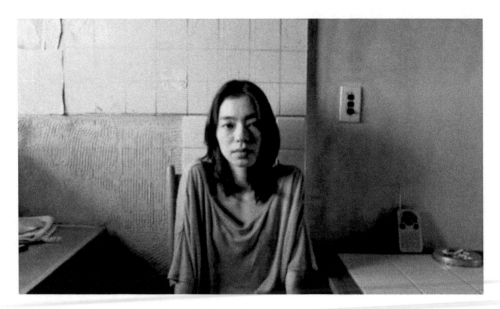

FIGURE 2.4: The kitchen where Kotoko isolates herself. Shinya Tsukamoto (dir.), *Kotoko*, 2011. Japan © Makotoya.

According to social anthropologist Inge Daniels, there is a tendency among many Japanese housewives to critically view the kitchen as 'dirty' (*kitanai*),[37] and this association expresses a form of symbolic pollution that threatens order.[38]

Following this episode, Kotoko is prompted by social services to send Daijiro to live with her sister in an Okinawan countryside. Once her son is no longer in the picture, Kotoko finds herself in an ironic, discomforting state of loneliness. A pervasive atmosphere of disconnection envelops the apartment as Kotoko is seen smoking in the dark kitchen and watching television in the living room at night. In both scenes, the use of chiaroscuro lighting is achieved by a single point of light source – either the small kitchen window or television – as a visual marker of the apartment resembling an empty womb. This scene echoes Irigaray's sentiment on women left as receptacles for the materiality discarded by men. She writes: 'I was your house and when you leave, abandoning this dwelling, I do not know what to do with these walls of mine.'[39] Daijiro's absence, and him exiting the maternal space of their apartment, is symbolic for how 'men have conceived of themselves as self-made, and in disavowing this maternal debt, have left themselves, and women, in dereliction, homelessness'.[40]

Meanwhile, the apartment conjures the ghostly figure of Tanaka to fill the absence of a patriarchal figure to head the household and also restore Kotoko's non-maternal sexual desire. The celebrated novelist saves Kotoko from her suicide

attempts, and their relationship soon develops into a sadomasochistic entanglement while he moves into the apartment. Tanaka's subtle yet forceful entry into Kotoko's life and apartment demonstrates Grosz's description of the female territory that is continuously penetrated, colonized and dominated without permission by the masculine.[41] The once cluttered yet feminine living room with a red couch and shoddily hung curtains are soon replaced by Tanaka's books and writing desk – a symbol of masculine intellectual. Upon moving in, he asks her to remain at home while he works. His presence metaphorically resembles the *daikokubashira* – a large, black pillar that exists in traditional Japanese homes. In this context, the man is lauded as a dominant, architectural pillar that supports the roof to shelter his family. In this light, Kotoko has subconsciously lost control of her property – the apartment – as she becomes a 'property' of Tanaka. The apartment is no longer an 'autonomous space' that she can occupy for herself as Tanaka insists that he stays at home to protect her from her unhinged mind.[42] His presence is, by all means, a form of male domination of her female body and home – a space that has incongruously delimited her movement.

Kotoko's ensuing violent assaults against Tanaka is only emblematic of the anger she has towards her unstable, fluid self as well as the masculine order that binds her through culture. She resists the paternalist idea, and subsequently the apartment, in displaying its allegiance to her internal desire, dematerializes Tanaka into oblivion. As soon as she returns home after receiving news of Daijiro's return, Kotoko discovers that Tanaka has mysteriously disappeared from the apartment. His privileged space – the study desk and books – has vanished from the living room that was once her sole domain. Daijiro soon returns to her custody while Kotoko assumes her maternal identity once more. This identity only serves to authenticate her final submission to the idea of wise motherhood. The *chora* is also a site of conflicting desires, and soon, the apartment begins to manifest hallucinations, which further disorients Kotoko. Visions of Daijiro's deaths repeatedly occur before her outside of their unit, particularly in liminal spaces such as the building's entrance and rooftop. The climactic hallucination sequence takes place in their unit in which the television is turned into a conduit again. On screen, a man fires an M-16 in her direction before emerging out of the television set to shoot Daijiro point blank. The film then cuts to her son who is only asleep in the nursery, prompting her to recognize her own delirium.

Convinced that Daijiro is in danger from external sources (rather than the apartment, which is an unconscious re-signification of her alter ego), she proceeds to take his life as a safeguarding effort. Once the deed is done, the apartment 'celebrates' Daijiro's passing by filling up the nursery with surrealistic decor of flying origami and soft string lights. The space of the room appears narrower via a tight shot to capture the illusion of a stillborn descending a birth canal.[43]

The camera then turns to a cardboard door that opens on its own, revealing a female doll sprawled limply on a red couch. Next to Kotoko lies another doll – one that appears to be a lifeless Daijiro. The apartment has succeeded in 'evicting' Daijiro, thereby demolishing the masculine from the interior of the womb. The apartment's nature as a *chora* is now everted – the space leaves no place for the males to occupy and allows for mothers, like Kotoko, to assume agency instead.

Conclusion

The instability and contradictions of the apartment in both films mostly derive from the ambiguous relationship that Japanese women have with space in modern times. *Dark Water* concludes with the apartment's victory in submitting Yoshimi to a lifelong sentence as a mother to the ghostly Mitsuko, separating her from Ikuko, the biological daughter. She remains entombed in the derelict architecture that has long been abandoned by the living as punishment for defying the sanctity of marriage and neglecting motherhood. After Daijiro's death, Kotoko is placed in a psychiatric facility – a heterotopic place that further isolates her from patriarchal familial society. In both texts, the child of each protagonist returns to reunite with their mother, albeit only briefly. A teenage Ikuko reappears at her former apartment only to learn that her mother is home-bound in a spirited dimension. *Kotoko*'s conclusion invokes ambiguity as an older, well-mannered Daijiro pays a visit to his mother at the institution, causing her to succumb to greater grief. His ghostly presence can be read as Kotoko's desire for masculine imaginary – a young man that finally sees her being a comforting, former 'home' instead of an empty, forsaken vessel. Drawing upon Grosz's and Irigaray's discussion on the maternal-feminine, this chapter has argued that Yoshimi and Kotoko do not possess their own bodies or even appropriate the (domestic) space that they are in. In other words, they have 'neither being nor the possibilities of becoming' in a man-made universe.[44] The women in these films are indeed subjugated to exclusion and denied access to a site of *chora* in the actual built environment that can provide refuge from the dominion of males.

NOTES
1. *Danchi* refers to the post-war public housing built between 1950s and 1980s across Japan by the Urban Renaissance Agency owned by the government. The *danchi* collectives were built in response to the demand for low-cost housing after the Second World War ended.
2. For more information on the concept of the *ryōsaikenbo*, see Vera Mackie, *Creating Socialist Women in Japan* (Cambridge: Cambridge University Press, 1997). The ideology

is a combination of Western and Confucian idea of domesticity and was practiced in Japan during the Meiji period by the power elite. The ideology later formed the basis of the Japanese government's social policy (39). See also Chizuko Ueno, *Patriarchy and Capitalism: Horizon of Marxist Feminism* (Tokyo: Iwanami Shoten, 1990). Governmental slogans promoting the ideology include 'the wise woman builds her house' and 'the woman is the key of the home' (514–15).
3. See Colette Balmain, *Introduction to Japanese Horror Film* (Edinburgh: Edinburgh University Press, 2008). In general, characters who do not comply with the obligatory Japanese social system tend to undergo unfortunate circumstances as punishment (based on Shintō beliefs).
4. Hiroshi Ichikawa (1993), quoted in Inge Daniels, 'Feeling at Home in Contemporary Japan: Space, Atmosphere and Intimacy', *Emotion, Space and Society* 15 (2015): 47–55.
5. Elizabeth Grosz, *Space, Time and Perversion: Essays on the Politics of Bodies* (London: Routledge, 1995), 89.
6. Grosz, *Space, Time and Perversion*, 89–90.
7. Luce Irigaray, *An Ethics of Sexual Difference* (New York: Cornell University Press, 1993).
8. Irigaray, *An Ethics of Sexual Difference*, 63.
9. Irigaray, *An Ethics of Sexual Difference*, 39.
10. Tatsuo and Kiyoko Ishimoto, *The Japanese House: Its Exterior and Interior* (New York: Bonanza, 1963), 26.
11. Jordan Sand, *House and Home in Modern Japan: Architecture, Domestic Space, and Bourgeois Culture, 1880–1930* (Cambridge, MA: Harvard University Press, 2005), 104.
12. Kimie Tada and Geeta Mehta, *Japan Style: Architecture + Interiors + Design* (Tokyo: Tuttle, 2005), 13.
13. Ritsuko Ozaki, 'Housing as a Reflection of Culture: Privatised Living and Privacy in England and Japan', *Housing Studies* 17, no. 2 (2002): 209–27.
14. Edward S. Morse, *Japanese Homes and Their Surroundings* (New York: Routledge, 2005), 175.
15. Laura Nietzel, 'Living Modern: *Danchi* Housing and Postwar Japan' (Ph.D. diss., Columbia University, 2003), 46.
16. Nietzel, 'Living Modern', 46–47.
17. Inge Daniels, *The Japanese House: Material Culture in the Modern Home* (New York: Berg, 2010), 30.
18. Grosz, *Space, Time and Perversion*, 122.
19. Grosz, *Space, Time and Perversion*, 121–22.
20. Grosz, *Space, Time and Perversion*, 120.
21. Grosz, *Space, Time and Perversion*, 115.
22. Grosz, however, does not equate the *chora* specifically to the uterus but acknowledges its pregnancy and maternity attributes (*Space, Time and Perversion*, 117).
23. Irigaray, *An Ethics of Sexual Difference*, 90.

24. Irigaray, *An Ethics of Sexual Difference*, 60.
25. Irigaray, *An Ethics of Sexual Difference*, 156.
26. Irigaray, *An Ethics of Sexual Difference*, 43.
27. Nietzel, '*Danchi* Housing and Postwar Japan', 71.
28. Marjorie Garber, 'The Body as House', in *The Domestic Space Reader*, ed. Chiara Briganti and Kathy Mezei (Toronto: University of Toronto Press, 2012), 123–26.
29. Yoshimi also encounters the red bag belonging to Mitsuko as it surfaces in various parts of the apartment complex.
30. See Balmain, *Introduction to Japanese Horror Film*. The *kawara* ('riverbed') is seen as a sacred site for rebirth to occur. Based on the works produced by theatre director Juro Kara, the kawara is usually symbolic of the 'violated maternal body' as the architectural make-up of modern Japan obscures the running water underneath (140). Midori Matsui (2002), as quoted in Balmain, argues that water remains a 'regressive image symbolizing suicide and amniotic fluid, related to the memory of pre-modern Japanese existence' (140).
31. See Julia Kristeva, *Revolution in Poetic Language* (New York: Columbia University Press, 1984). A sense of 'otherness' occurs during motherhood, especially in the earlier stages, as the mother tries to negotiate self, identity and boundaries between her and the child.
32. Grosz, *Space, Time and Perversion*, 121.
33. Daniels, *The Japanese House*, 42.
34. Sand, *House and Home in Modern Japan*, 103.
35. Grosz, *Space, Time and Perversion*, 121.
36. Grosz, *Space, Time and Perversion*, 122.
37. Daniels, *The Japanese House*, 35.
38. See Mary Douglas, *Purity and Danger: An Analysis of Concepts of Pollution and Taboo* (New York: Routledge, 2013).
39. Irigaray (1992), quoted in Grosz, *Space, Time and Perversion*, 122.
40. Grosz, *Space, Time and Perversion*, 121.
41. Grosz, *Space, Time and Perversion*, 123.
42. Grosz, *Space, Time and Perversion*, 122.
43. See Luce Irigaray, *Speculum of the Other Women* (New York: Cornell University Press, 1985). This reproductive passageway, according to Irigaray, is 'forgotten' by men as it lies dormant within the cave of the uterus (247).
44. Grosz, *Space, Time and Perversion*, 116.

BIBLIOGRAPHY

Balmain, Colette. *Introduction to Japanese Horror Film*. Edinburgh: Edinburgh University Press, 2008.

Daniels, Inge. 'Feeling at Home in Contemporary Japan: Space, Atmosphere and Intimacy'. *Emotion, Space and Society* 15 (2015): 47–55.

———. *The Japanese House: Material Culture in the Modern Home*. New York: Berg, 2010.

Douglas, Mary. *Purity and Danger: An Analysis of Concepts of Pollution and Taboo*. New York: Routledge, 2013.

Garber, Marjorie. 'The Body as House'. In *The Domestic Space Reader*, edited by Chiara Briganti and Kathy Mezei. Toronto: University of Toronto Press, 2012.

Grosz, Elizabeth. *Space, Time and Perversion: Essays on the Politics of Bodies*. London: Routledge, 1995.

Irigaray, Luce. *An Ethics of Sexual Difference*. New York: Cornell University Press, 1993.

———. *Speculum of the Other Women*. New York: Cornell University Press, 1985.

Ishimoto, Tatsuo, and Kiyoko Ishimoto. *The Japanese House: Its Exterior and Interior*. New York: Bonanza, 1963.

Kovar, Zuzana. *Architecture in Abjection: Bodies, Spaces and Their Relations*. London: I.B. Tauris, 2017.

Kristeva, Julia. *Revolution in Poetic Language*. New York: Columbia University Press, 1984.

Mackie, Vera. *Creating Socialist Women in Japan*. Cambridge: Cambridge University Press, 1997.

Morse, Edward S. *Japanese Homes and Their Surroundings*. New York: Routledge, 2005.

Nakamura, Yoshihiro, dir. *The Inerasable/Zan'e: Sunde wa ikenai heya*. Japan: Shochiku, 2016.

Nakata, Hideo, dir. *The Complex/Kuroyuri danchi*. Japan: Shochiku, 2013.

———, dir. *Dark Water/Honogurai Mizu no soko kara*. Japan: Toho, 2002.

Nietzel, Laura. 'Living Modern: *Danchi* Housing and Postwar Japan'. PhD diss., Columbia University, 2003.

Oikawa, Ataru, dir. *Apartment 1303/Apartamento 1303*. Japan: 3G Communications, 2007.

Sand, Jordan. *House and Home in Modern Japan: Architecture, Domestic Space, and Bourgeois Culture, 1880–1930*. Cambridge, MA: Harvard University Press, 2005.

Tada, Kimie, and Geeta Mehta. *Japan Style: Architecture + Interiors + Design*. Tokyo: Tuttle, 2005.

Tsukamoto, Shinya, dir. *Kotoko*. Japan: Makotoya, 2011.

Tsutsumi, Yukihiko, dir. *2LDK*. Japan: DUEL Film Partners, 2003.

Ueno, Chizuko. *Patriarchy and Capitalism: Horizon of Marxist Feminism*. Tokyo: Iwanami Shoten, 1990.

Yoshida, Akio, dir. *Tales of Terror: Haunted Apartment/Kaidan Shin Mimibukuro: Yūr Mansion*. Japan: Tokyo Broadcasting System (TBS), 2005.

Film List

2LDK. Directed by Yukihiko Tsutsumi, Japan: DUEL Film Partners, 2003.

Apartment 1303 (*Apartamento 1303*). Directed by Ataru Oikawa, Japan: 3G Communications, 2007.

The Complex (*Kuroyuri danchi*). Directed by Hideo Nakata, Japan: Shochiku, 2013.

Dark Water (Honogurai Mizu no soko kara). Directed by Hideo Nakata, Japan: Toho, 2002.
The Inerasable (Zan'e: Sunde wa ikenai heya). Directed by Yoshihiro Nakamura, Japan: Shochiku, 2016.
Kotoko. Directed by Shinya Tsukamoto, Japan: Makotoya, 2011.

3

Tehran Has No Soul!

Tania Ahmadi

Tehran is a beautiful city, but its citizens are bad.
– Tehran Has No More Pomegranates (2006)

Introduction

The city is a rich and diverse cinematic setting that has often been referred to as an exploration of social classes, transformation, modernity, violence and so on. Film theorist Siegfried Kracauer has called the city an exemplary and essential cinematic space 'attuned to the experience of contingency, flow, and indeterminacy linked to modernity'.[1] Other scholars, theorists and philosophers have noted the correlation between mobility and the visual and aural sensations of the city and of cinema.[2] Cinema is able to portray and shape the way we view cities, and, likewise, the unique cinema space helps to express the most vital details of the film. As Barbara Mennel wisely writes, 'The city has always been particularly important in understanding how social change manifests itself. And urban studies has begun to address films as cultural visions of what cities represent.'[3] Therefore, cities are reflections of society and films are a useful medium by which to study and express the relationship between the city and cinema.

In discussions of Iranian cinema, Tehran is viewed as an archetypal city environment. It is a thrumming beehive of middle-class lives, all buzzing with secrets and lies. Due to its history and reputation, film-makers portray this city as the core of Iran's modernization and the centre of political power. Just as Tehran's past has influenced how it is portrayed in film, so too has the medium of cinema shaped its identity. This reciprocal relationship is portrayed in *Fireworks Wednesday* (2006), directed by Asghar Farhadi, and *Tranquility in the Presence of Others* (1973), directed by Naser Taghvai. The first film is a product of Iran's reformist period, a time when

the country enjoyed a greater amount of freedom and democracy. The latter, which was banned in Iran for almost four years, was made before the Revolution of 1979.[4]

After his first two films – *Dancing in the Dust* (2003) and *The Beautiful City* (2004), both romantic dramas infused with social criticism – Asghar Farhadi released *Fireworks Wednesday*. This film set in motion a new type of filmic narrative not only in his own oeuvre, but also in the genre of the Iranian post-reform subversive melodrama. This new narrative focused heavily on themes of inner (mental) violence and conflict, which were incorporated into the film's plot and formal layers, and addressed the huge number of people who moved from the country to metropolitan Tehran during that time.

Naser Taghvai's directorial debut, which was based on Gholam-Hossein Saedi's story *Tranquility in the Presence of Others* (1972), was initially filmed in 1969. However, the film was boycotted by the Shah's regime due to its harsh critique of Iranian political and cultural affairs during the 1960s and onwards. After realizing the value of the film and its director, the regime accepted Taghvai's cinema, and *Tranquility in the Presence of Others* was eventually released in 1973. The film is filled with a wide range of narrative designs, thematic patterns, visual and rhythmic compositions and visual tropes that are built around the modern city. Film scholar Farbod Honarpisheh writes of the film: 'It portrays a world that is new and urban, and that is leading its characters into fearful lives and mental disintegration.'[5]

The cinematic manifestation of Tehran in both Farhadi's and Taghvai's films has an 'external' and an 'internal' relationship with its inhabitants. In the former, cinema's portrayal of the city's exterior, that is, the appearance of the buildings, streets and the distribution of the population, reflects the turbulence in the lives of its inhabitants. This relationship is seen in *Fireworks Wednesday*. The second, 'internal' relationship is psychological and is seen in *Tranquility in the Presence of Others*. Life in metropolitan Tehran imparts sadness and depression onto the mentalities of its inhabitants, people who, for the most part, have moved to the city from villages and smaller cities. Incidentally, in both films these exterior and interior relationships go hand in hand, as one reflects the other. The 'exterior' chaos of the city reflects the 'interior' turmoil of the people. The contrast between old houses in working-class areas, which are emblems of Iranian tradition, and buildings with modern façades in metropolitan Tehran complicates our vision of characters who grapple with this incongruity, eventually leading them to mental instability.

Fireworks Wednesday

The events of *Fireworks Wednesday* take place on the last Wednesday before the start of spring. On this day, called Chahar-Shanbeh-Soori (Fireworks Wednesday),

people set off fireworks, jump over fire, and sing and dance in the streets, following an ancient Zoroastrian tradition. Rouhi, a working-class woman, spends the day cleaning the house of a middle-class couple. There, she witnesses an ongoing dispute between the couple about the man's faithfulness. Mojdeh, the wife, suspects that her husband, Morteza, is having an affair with a divorced woman, Simin, who lives in the apartment across from them. The drama becomes even more intense after Rouhi is required to stay longer at work, observing a deeper layer of the couple's marital strife.

At the beginning of the film, Rouhi walks down an alley trying to find the apartment for which she is assigned to do the cleaning while curiously observing her surroundings. The shot, filled with modern buildings and inhabitants who possess expensive cars, clearly suggests that this area belongs to an upper-middle-class milieu. Scholars Mohsen Habibi, Hamideh Farahmandian and Reza Basiri Mojdehi describe this atmosphere thus: 'There are chess-like pavements, very high buildings, and modern spirit of architecture representing conditions of the economically rich classes.'[6] Rouhi suddenly stops, and her puzzled gaze fixes on something of which the audience is not yet aware. A reverse shot shows that the broken window of a building is what caught her attention. Later, she finds out that this very apartment is the one that she is supposed to clean. The fracture in the window, which caused her to pause, is the film's signal of welcoming her and the audience into an environment full of strife and rupture. Here, Farhadi uses the signs and signals of mise en scène to reflect the turbulent atmosphere of the city.

When entering the home of Morteza and Mojdeh, the epitome of an upper-middle-class couple, Rouhi is taken aback, as their home is extremely disorderly. All the furniture is wrapped in plastic, and plates and other fragile items are strewn all over the place. Traces of broken glass and ashtrays cover the floor. The home is full of unrelated things: there are books and picture frames on the stairs, dirty dishes everywhere and clothes on the chairs and tables. Nothing is in its proper place. Adding to the physical chaos, the couple continuously argues about the husband's alleged affair without realizing that Rouhi is there working. Through this example of class hierarchy, viewers note the upper-middle-class tendency to ignore members of the working class. Yet, by creating such a situation, Farhadi gives authority to Rouhi. At some point, she gets involved in the scene and embraces the dual roles of observer and participant, wondering about the entire scenario: Is Morteza in fact cheating on Mojdeh with Simin? Or is Mojdeh suffering from paranoia? Thus, not only does Farhadi portray domestic troubles and violence between characters through their arguments, but the turmoil fittingly manifests itself in the midst of a chaotic and messy apartment. Here, the themes of violence and conflict speak the loudest in the formal layer of the apartment, which is in complete disarray.

Chaos is not only depicted inside the troubled couple's apartment, it also permeates the social fabric of Tehran itself. The apartment is, in fact, a microcosm of the city. Towards the end of the film, Morteza decides to take his son to celebrate Chahar-Shanbeh-Soori in the park. Rouhi accompanies them, since Morteza has promised to drop her off at her home, which is far away from the middle-class sector of the city. While driving through the city, the film showcases numerous shots of metropolitan life, clearly showing it in a state of joyful chaos. The youth use firecrackers and other explosive elements to celebrate, and families gather in public places such as parks to sing, dance and eat.

All the interweaving nodes of the plot masterfully construct meaning even within the more private spaces in the city. Earlier in the film, Morteza asks Rouhi to keep an eye on his son while he is out shopping. We come to see that he is lying about his plans as the next shot captures the clandestine meeting between Morteza and Simin in his car, exposing their romantic relationship. This is the moment of the film that justifies Mojdeh's suspicion about her husband's affair.

Later that night, before Rouhi is dropped off at home, Morteza, his son and Rouhi are wandering through the city while the celebrations go on around them. The camera constantly pans to the right and left, showcasing the city's madness and people's excitement as they jump over fire and exploding firecrackers. In the midst of this clamour – amid imagery of cracked walls, modern buildings, fireworks and turmoil – Morteza lights his cigarette using the lighter that Simin gave him in the previous scene. Since the lighter is a unique one that plays music when lit, Rouhi suddenly recognizes it as earlier in the film, when Rouhi met Simin, Simin used it to turn on a gas stove. At this moment, Rouhi confirms the secret affair and decides what she will do with the information. When they return home for a moment to drop off Morteza's sleeping son, Rouhi decides to join the circle of lies, deception and immorality by choosing not to tell the truth to Mojdeh. In this scene, Rouhi enters the couple's apartment. The truth is on the tip of her tongue, but when she sees Mojdeh, she decides to remain silent and keep Morteza's secret. In her eyes, concealing the truth would save Morteza and Mojdeh's marriage. Morteza's immoral behaviour and lack of integrity, coupled with the chaos of the city, lead Rouhi down a different, darker path.

Farhadi depicts explosive domestic strife as coinciding with the mayhem in the city, and the film becomes a battleground of undeclared war between the sexes and the classes. The result of this conflict is the impossibility of achieving any form of reconciliation. Tehran is a city at war with itself and its citizens, all of whom have turned against each other. Indeed, Tehran has become the ground for a different kind of battle, as its inhabitants ruthlessly cheat, manipulate and abuse one another. It is a mad place, and in all of this deception and loss of values no one stays true to her or his principles.

Tranquility in the Presence of Others

In *Tranquility in the Presence of Others*, viewers witness how the city negatively affects the character and mental state of its inhabitants. Known as one of the most controversial films made before the Revolution of 1979, *Tranquility in the Presence of Others* is a critique of modernization and the social changes that have occurred in Tehran. The film tells the story of a former army colonel who visits Tehran with his wife and finds it very difficult to adapt to city life. The colonel lived in Tehran many years ago, and at some point he decided to move to a village in the country. Now, after many years, he comes back to metropolitan Tehran and finds it very different from the city he once knew. The hustle and bustle of the city, with its tall monochromatic buildings, its overpopulated streets filled with chaos and clamour and its feeling of soullessness cause the colonel extreme grief. What is more, the colonel is bewildered by the change in his two daughters, who he sent to live in Tehran many years ago. City life, he finds, has completely changed their behaviour as well as their lifestyles. The confrontation between the colonel and his much-transformed daughters leads him to become isolated in his feelings of solitude. Here, Naser Taghvai draws our attention to the theme of alienation as a result of the outward changes within the city.

The most significant, shocking detail for the colonel is how much his daughters' lives have changed. They have both become nurses and have relationships with doctors. While one of the daughters is engaged to a doctor, the other is continuously betrayed by another, which eventually leads her to commit suicide. The colonel cannot understand his daughters' dilemmas and frustrations, and as a result he feels very isolated. Nacim Pak-Shiraz describes this gap between the generations by saying that the film 'looks at the changing values, the fears and threats within the city and the impact these have on its inhabitants, particularly women and their movement within the city'.[7] It seems as though the process of modernization has affected the colonel's daughters, and the scale of Tehran's transformation makes him unable to relate to what he sees around him. Furthermore, the film comments on the fact that the modernized Tehran makes all its inhabitants identical, creating people who lack any individuality, like the daughters who are both nurses dating doctors. The loss of individual relationships and bonds in the city increasingly turns people into faceless inhabitants who cannot be defined or identified.

With respect to physical environment, the film also indicates that there is a significant contrast between the old and the modern. The film centres on the confrontations and interactions between two different spaces: the modern Tehran and the old Tehran where the colonel used to live before moving to the country. Years ago, when he lived in Tehran, he served in an official position in the army. But now, after many years, no one sees him, respects him or treats him as a decent man.

Even the face of the city has changed: the huge towers of steel and concrete have wiped out much of the city's history. Hence, neither the people nor the city itself is inviting: the steel is not warm or welcoming. In one scene, he goes to see a group of soldiers marching while the Iranian military song plays in the background. He finds the combination of the marching and the song agonizingly discordant. In the colonel's eyes, Tehran's inhabitants have become cruel and untrustworthy, and values such as honour, integrity, culture and knowledge have lost their meaning in favour of greed and materialism. Due to the severity of this change and his opposition to it, the colonel's internal well-being begins to destabilize.

In his confused state, it becomes increasingly difficult for the colonel to distinguish the real from the unreal, the present from the past. Later in the film, he runs into a bar to drown his sorrows in alcohol. This behaviour is his response to his own nostalgia for a forgotten Tehran as well as because of the change in his beloved daughters. Tehran's transformation and its forgotten history can, in fact, be thought of as personified by the colonel. Both have swiftly faded and lost their glamour. Now, he can only yearn for the city that he remembers because the shock, disgust, temptation and violence of the new Tehran beat him ruthlessly. He finds himself not only violated but also forced to continue plunging into the unknown as he proceeds to explore the city.

In the final scene, the colonel's feelings of alienation by Tehran bring him to a state of madness, and his family insensitively decides to take him to a madhouse. This scene acts as a vehement critique of the fact that in Tehran there is no longer a place for people who long for tradition and nostalgia, because it has embraced modernization. His own daughters put him in the car, and he observes the chaotic city from the window. The shot is taken in a paradoxical way: the image of trees and nature, symbols of freedom and beauty, are captured in the window, but the window's frame appears as that of a prison, asserting that Tehran itself is a prison and a madhouse.

Taghvai's *Tranquility in the Presence of Others* therefore highlights the theme of madness, but through the use of more recognizably modernist, controversial tropes, such as the dangers of women's liberation, hollow relationships and Western popular music, among others. Rapid urbanization has caused unemployment, residential space scarcity, high rural-urban influx, the separation of social classes and sexes and an imbalance in city services, but since the city is moving towards modernity, the negative aspects lose their significance. The rise of the bourgeois, alcoholism, Western fashion, suicide and insanity are manifested in Tehran, a city in which the theme of modernization is stronger than the sense of humanization. Consequently, modernization appears to be about constructing a façade or, as one interpreter of the film describes it, 'a renewal of space, with no real concern for its occupants. In this process, the vulnerable suffer the most'.[8]

The city and the representation of memory

The modernization of Tehran in the past decade came with the destruction of many old structures. The decision to destroy the city's historic buildings was made in order to expand and finally modernize the city. During 1941–79, countless efforts were made by Mohammad Reza Shah Pahlavi to modernize Iran, in the hope that it would become equal to the West. However, at the same time, he sought to uphold traces of Iran's ancient and rich history. Iran is in fact a country obsessed with memory. Memories of the glory days of Iran's history still resonate in people's imagination. The urge for modernization and the nostalgia for the past simultaneously battle for attention. After the Islamic Revolution (1979) and the eight-year war between Iran and Iraq (1980–88), the government decided to honour the memories of its martyrs by adorning the walls of the city with paintings of their faces. In this way, Iran retained evidence of both modernity and tradition: on the one hand, the city was filled with modernized structures, but, on the other hand, the billboards and paintings found throughout the city kept the memories of the vicious war and heroic martyrs alive.

In 'Symbols, Signs, Signals: Walls of the City', Jean-Jacques Guibbert indicates that 'the city has its language, and one can discover it all along its wall'.[9] In Iran, the walls of the cities thereby became spaces of expression. Images of martyrdom, soldiers bidding their families farewell and others depicting religious authority and war could be seen as disciplinary forces. These reminders of the past became strikingly pronounced in a city barrelling towards the future. Tehran has been in the process of modernization, but it does not forget its history.

Fireworks Wednesday and *Tranquility in the Presence of Others* reflect how the city and memory are intertwined. However, each film reveals a different perspective. *Tranquility in the Presence of Others* was made before the Revolution and war, and its protagonist attempts to treasure the old city and his precious time in it. The many shots of the city in *Tranquility in the Presence of Others* suggest that the theme of nostalgia is still breathing, but only just under the skin of the city. The colonel's vision of the city is full of passion and memories, but in his eyes, modern Tehran failed to preserve its sacred past. These memories are left drifting while modernity hastily moves beyond remembrance.

Farhadi's *Fireworks Wednesday* offers a fresh perspective on how the city is constructed within our minds. While the city and its billboards are reminders of its history, of war and revolution, it is also a site of happiness and celebration. On the night of Chahar-Shanbeh-Soori, the Iranian people joyously and blissfully celebrate the last Tuesday of the year in the streets of Tehran, which used to display war and revolutionary billboards. Farhadi goes beyond the idea of martyrdom, a sacred topic in Iran, and shows how modern foundations transcend traditional and

cultural memory of the past. The space – the city – is not a death zone anymore; it is a place of lively celebration and dancing. Ingeniously, in his well-textured drama, Farhadi never shows any billboards or signs that highlight memories of the past, but all the shots of the city clearly display the clamour of bonfires, firecrackers and dancing in the street, which move the atmosphere towards the future. If the billboards are the reminders of the past, then the bonfires and firecrackers suggest a celebration of present.

A city ruled by class

Both directors pay a great deal of attention to the conflicts and tensions surrounding class differences. The lower-class characters of *Fireworks Wednesday*, such as Rouhi and the colonel's wife, are defined to us through their low-class social milieus. Rouhi is introduced in the first sequence of the film while sitting on the backseat of a motorcycle, enjoying a ride with her fiancé through the rural fringes of Tehran. The cheap cars, old and fractured buildings and lower quality attire all call attention to their class, especially when soon enough the drama unfolds on the busy streets and in the train stations, the buses, a modern apartment and between Morteza and Mojdeh, who are the epitome of an upper-middle-class couple. Likewise, in *Tranquility in the Presence of Others*, the colonel, his wife and their house-worker are first shown in an alley with their suitcases, desperately looking for the colonel's daughters' house. While nervously inquiring about the address, the wife in her modest dress and headscarf and their house-worker wearing rustic clothes become symbols of rural spaces and low-class social status. The sense of alienation and frustration in their behaviour are in contrast with the locals', who are confident enough in their social classes.

Taghvai's and Farhadi's protagonists of lower-class status never adapt to the modern city and their behaviour never falls in line with that of the middle class. For them, only one solution remains: to go back to what they know. The colonel is unhappy, constantly reminiscing about his past life of dignity and greatness in the military. However, in the end, mental disintegration is his awaited destiny, and he never again finds a sense of tranquility. Similarly, Rouhi in Farhadi's film never truly comprehends the ethics and morals of the middle class. She is baffled by the lies and covert realities of their lives. By portraying her character as a naïve and modest girl, Farhadi clearly demonstrates that Rouhi is unable to belong to the middle class. In a scene towards the end of the film, Morteza drives her back to the rural part of the city, where her fiancé curiously awaits her. Upon their reunion and in her comfort zone, Rouhi smiles and takes refuge in the presence of her fiancé, no longer troubled by what she went through that day.

Conclusion

Films provide a unique sense of place unable to be experienced through other media. The space where a film is shot and the location and landscape of a narrative setting play crucial roles in untangling the knots of the plot. The aforementioned films show that the biggest rift in Iranian codes of conduct is between the people's interior and the city's exterior. The cinematic manifestation of Tehran in *Fireworks Wednesday* and *Tranquility in Presence of Others* has an 'external' and 'internal' relationship with its inhabitants. Both films invite viewers to reflect on Tehran's identity, allowing us to delve into the social and political changes this metropolis has undergone over the past four decades (1973–2006). Through the depiction of streets, modern buildings, frustrated drivers, restricted pedestrian movement and traffic jams, these films display the endless chaos at the heart of the city. The city becomes an emblem of threats and fears. The internal effect of the city's mayhem, brought about in conjunction with the harsh reality of class and the clash between the modern and the traditional, is the annihilation of morality (for Rouhi) and a descent into madness (for the colonel). The fear and threats experienced by Tehran's inhabitants, particularly the vulnerable, lead to a stifling image of the city. Both directors powerfully depict how the city has ceased to protect its helpless inhabitants.

Over time, Tehran in *Fireworks Wednesday* and *Tranquility in the Presence of Others* sinks to a level at which its inhabitants become cruel and untrustworthy, with values such as honour, integrity and honesty superseded by greed and hypocrisy. Amidst the disorder, clamour and chaos of the city, it has become increasingly challenging to decipher the real from the unreal, truth from falsehood – so much so that the city itself and the very existence of its citizens come into question.

NOTES

1. Siegfried Kracauer, *Theory of Film: The Redemption of Physical Reality* (Princeton, NJ: Princeton University Press, 1997), 39. Kracauer's book is not primarily about the city but offers crucial insights into the relationship between the city, especially the street, and cinema.
2. See, for instance, Pamela Robertson Wojcik, 'The City in Film', in *Cinema and Media Studies* (Oxford, UK: Oxford Bibliographies Online Datasets, 29 September 2014); and Cláudia Lima, 'Filmic Narratives of the City', City in Film Conference Liverpool [UK]: 26–28 March 2008, https://www.liverpool.ac.uk/media/livacuk/architecture/images-research/cityinfilm/downloads/Cities_in_Film_2008_Proceedings.pdf.
3. Barbara Mennel, *Cities and Cinema* (New York: Routledge, 2008), 15.

4. The Revolution of 1979, also known as the Islamic Revolution or Enqelāb-e Iran, refers to events involving the overthrow of the Pahlavi Dynasty under Mohammad Reza Shah Pahlavi, who was supported by the United States.
5. Farbod Honarpisheh, 'Fragmented Allegories of National Authenticity: Art and Politics of the Iranian New Wave Cinema' (Ph.D. diss., Columbia University, 2016), 212.
6. Mohsen Habibi, Hamideh Farahmandian and Reza Basiri Mojdehi, 'Reflection of Urban Space in Iranian Cinema', *Cities* 50 (2016): 232.
7. Nacim Pak-Shiraz, 'Exploring the City in the Cinema of Bahram Beyzaie', *Iranian Studies* 46, no. 5 (2013): 812. In this essay, Pak-Shiraz draws attention to the generation gaps in Bahram Beyzaie's cinema. Yet, her provocative analysis can still be used in the context explored here.
8. Pak-Shiraz, 'Exploring the City in the Cinema of Bahram Beyzaie', 823.
9. Jean-Jacques Guibbert, 'Symbols, Signs, Signals: Walls of the City', in *Reading the Contemporary African City*, ed. Brian Brace Taylor (Singapore: ArchNet, 1983), 75.

BIBLIOGRAPHY

Baharloo, A. 'Aya Tehran Shahr-e Zibaee ast?' [Is Tehran a Nice Place?]. *Film* 14 (2007): 80–81.

Fanni, Z. 'Cities and Urbanization in Iran after the Islamic Revolution'. *Cities* 23 (2006): 407–11.

Guibbert, Jean-Jacques. 'Symbols, Signs, Signals: Walls of the City'. In *Reading the Contemporary African City*, edited by Brian Brace Taylor. Singapore: ArchNet, 1983, 75.

Habibi, M. 'Barnamerizi-e-Shahri dar Iran ba'ad az Enqelāb' [Urban Planning in Iran after Revolution]. *Goftegu* 13 (1997): 7–18.

Habibi , Mohsen, Hamideh Farahmandian and Reza Basiri Mojdehi. 'Reflection of Urban Space in Iranian Cinema'. *Cities* 50 (2016): 228–38.

Hasani-Nasab, N. 'Khodahafez Tehran' [Goodbye Tehran]. *Film* 14 (2007): 78–79.

Honarpisheh, Farbod. 'Fragmented Allegories of National Authenticity: Art and Politics of the Iranian New Wave Cinema'. Ph.D. diss., Columbia University, 2016, 212–13.

Kracauer, Siegfried. *Theory of Film: The Redemption of Physical Reality*. Princeton, NJ: Princeton University Press, 1997.

Mennel, Barbara. *Cities and Cinema*. New York: Routledge, 2008.

Mottahedeh, Negar. *Displaced Allegories: Post-revolutionary Iranian Cinema*. Durham, NC: Duke University Press, 2009.

Pak-Shiraz, Nacim. 'Exploring the City in the Cinema of Bahram Beyzaie'. *Iranian Studies* 46, no. 5 (2013): 811–28.

Film List

Aramesh dar Hozor-e Digaran/Tranquility in the Presence of Others. Directed by Naser Taghvai, Iran: National Iranian Radio and Television, 1973.
Charshanbeh-Soori/Fireworks Wednesday. Directed by Asghar Farhadi, Iran: Boshra Film, 2006.
Raghs dar Ghobar/Dancing in the Wind. Directed by Asghar Farhadi, Iran: Neshane, 2003.
Shahr-e Ziba/The Beautiful City. Directed by Asghar Farhadi, Iran: Neshane, 2004.
Tehran Anar Nadarad/Tehran Has No More Pomegranates. Directed by Masoud Bakhshi, Iran: Documentary and Experimental Film Center, 2006.

4

The Unconscious and the City: A Neuropsychoanalytic Exploration of Cinematic Space

Susannah Gent

Introduction

The three essay films by the author referenced in this chapter use different strategies to present inner and outer perspectives in accordance with essay film conventions. The dominant tradition of mainstream film-making employs the camera as though it were a third-person observer at a performed scene; however, the cinematic image offers potential to represent the subjective viewpoint. Laura Rascaroli defines the essay film as 'an audiovisual discourse that asks to be experienced by the viewer as eminently personal'.[1] She suggests that the presentation of a subjective meditation 'mobilises the subjectivity of the spectator'.[2] The film-making employs an intuitive method in which the film-maker allows affective responses to the environment to guide choices when shooting. Artistic interventions in post-production generate sequences designed to produce specific affective responses.

The film-making is underpinned by interdisciplinary research, including neuroscience, psychoanalysis and philosophy. The new field of neuropsychoanalysis that aims to explore the neurological origins of Freudian psychoanalysis proposes hypothetical models for the architecture of the brain and the psyche. These ideas provide starting points for the three essay films mentioned earlier.

This chapter presents some of the outcomes of the research, focusing on cinematic space as a novel environment built at the border of real and imaginary spaces. The research recognizes a rich two-way process between the environment and the individual's experience; the instinctual behaviour of the human being is written onto the landscape that is, in turn, mapped onto the mind. Beside

the author's films, her personal experiences are one of the main materials of this research, narrating the intuitive acts of the mind of an individual.

Deleuze writes of 'Intuition as Method' following Henri Bergson's 1896 text *Matter and Memory*, which states that perception and recollection 'interpenetrate' by 'a process of osmosis'.[3] He clarifies: 'The Bergsonian revolution is clear: We do not move from the present to the past, from perception to recollection, but from the past to the present, from recollection to perception.'[4] Perception is selective and informed by experience. Bergson describes a method by which 'we detach ourselves from the present in order to replace ourselves, first in the past in general, then in a certain region of the past [...] like the focusing of a camera'.[5] Film-making involves a process where choices are made based on aesthetic and affective response that is grounded in previous experience. In this manner the film-maker and the performer may introduce aspects of their past personal history that can be unconscious.

The films have been produced by the author in the past five years. *Influence of Mars* (2017) is a four-minute film in which the author's son, aged ten, talks enthusiastically about toy weapons. Here the child's fantasy is shown to be less sharply delineated than the adult's, as the use of green-screen technology emphasizes his imaginary world. *Unhomely Street* (2016) is a twenty-minute film made while the film-maker was recovering from post-concussive syndrome. *Psychotel* (2020), a sixty-minute film, investigates the uncanny using the hotel as a metaphor for the mind. Ordinary perception employs a dual mechanism of observation and experience. The film explores this doubling of the psyche as a spatial metaphor. Through the research, comparisons drawn between Damasian neuroscience, Merleau-Ponty's *Phenomenology of Perception* and Merlin Coverley's *Psychogeography* focus on the interplay of experiencing a place and its transformation by the film-making process into a filmic space.

Influence of Mars: *The neuroscientific unconscious and the cinematic space*

Influence of Mars takes as its starting point a ten-year-old boy's enthusiastic description of his arsenal of toy weapons. Many of these weapons have other functions; the handle of a back-brush, juggling batons, a golf club, all become deadly instruments in his hands. He describes the bizarre manner in which some of these items cause death: an arrow that causes the victim's organs to explode, an axe that kills not only those it comes into contact with but also others in the surrounding area. We experience a window on his world at an age where fantasy and reality are not sharply delineated. The film is comical but also sinister. Revealed

in this account of how a boy would deal with his enemies, in an imaginary world informed by Lego and *Minecraft*, is the instinctual tendency to create enemies and delineate territory without ethical comprehension. Deleuze and Guattari, in *A Thousand Plateaus: Capitalism and Schizophrenia*, state: 'The territory is first of all the critical distance between two beings of the same species.'[6] Their concept of territorialism and deterritorialism offers a framework through which to view human encounters from a handshake to acts of conflict. It is crucially bound up with identity and informs unconscious responses.

The film begins with what appears to be a straightforward image of the boy's bedroom (Figure 4.1). The audience soon understands that the bedroom is a re-projected image of the room, and the boy stands in front of a green screen. The ambiguous nature of filmic space is revealed. In an age where digital manipulations are commonplace, the authenticity of factual images and news reports are questionable. The film draws inevitable parallels between different classes of digital images: the innocuous and blocky world of *Minecraft* and the gritty world of the war zone. The first perhaps a training ground for the latter, normalizing territorialism, or perhaps, simply responding to consumer psychology.

Dilek Altuntaş describes cinematic space as a 'threshold between reality and fantasy, the real and the unreal, the organic and the inorganic, as well as the visible

FIGURE 4.1: *Influence of Mars*, still from film, by author.

and the invisible'.[7] This echoes the conscious and unconscious divisions of the psyche represented in *Influence of Mars* that reveal the boy's conviction of his fantasy world and the unconscious behaviour that underpins it. The use of obvious digital manipulations shows the artifice of the cinematic image and complicates the relation between the mind's-eye view and the real world. The two-way process on which the child's fantasy is constructed is emphasized.

Although awareness of the unconscious mind is well documented prior to the birth of psychoanalysis, Sigmund Freud's topologies propose models for how the divisions of the psyche operate together.[8] Freud was among the first to recognize that much of our mental processing occurs nonconsciously, a fact now firmly upheld in the neurosciences. Despite this, sectors of the scientific community have rejected Freud whereas his work has contributed to the humanities. Psychoanalytic readings are widely applied to art and film.[9] The artwork reveals not only unconscious aspects of the artistic process, but also broader societal trends and the instinctual drives of the human animal. Such a reading can be applied to *Influence of Mars*, in which the child's unconscious territorial instinct is revealed through the film-making process.

The Freudian unconscious is a flexible concept often viewed as a receptacle for repressed desires and unruly instincts. It does not correlate entirely with the neuroscientific term 'nonconscious'. The unconscious is known through dreams, and the 'return of the repressed', mental material that is always experienced as anxiety.[10] Everyday experience demonstrates the division of the psyche, as evidenced by the phrase, 'I am sick of myself'. Barry Opatow understands the notion of psychoanalytic repression in terms of one brain region being suppressed by another.[11] He suggests the cortex functions as memory space that allows ideas to be simultaneously held to enable predictive strategy. It is a process of restraining immediate action in consideration of the future outcome.

Freud's second topography proposes the ego, the superego and the id, three hypothetical regions of the psyche that span the conscious and the unconscious mind. It is noteworthy that the Freudian topography employs a spatial metaphor. The ego is mostly equated with consciousness; the id and the superego are thought to be unconscious. In the light of neuroscientific accounts that understand consciousness and emotion to be related structures, Mark Solms, founder of the journal *Neuropsychoanalysis*, suggests that it is the id that is conscious and not the ego. His research demonstrates that brainstem damage results in loss of consciousness whereas cortical damage or obliteration does not. The example Solms gives is the case of hydranencephaly, the in utero destruction of the cortex, which is reabsorbed and replaced with cerebrospinal fluid. Hydranencephalic people have no functioning cortex, yet they have distinct levels of consciousness, including sleep and waking cycles, seizures and recovery, and can be observed to show emotional

responses. The presence of their primary (affective) self 'proves that affective consciousness is both generated and felt subcortically'.[12] The conscious id implies that emotional states that guide behaviour are located in primitive neural structures. Rather than human behaviour being guided by rational thought, as previously assumed, responses are initially primitive and affective.

With the advent of brain imaging technology alongside the study of patients with neurological damage, Damasio was one of a number of neuroscientists who brought emotion to the forefront of neuroscientific study in the late twentieth century.[13] He uses the word 'image' to describe the conscious experience of an object. By object, Damasio means a diverse range of entities, such as a place, a person, an emotional state, an occurrence of pain and so on. An 'image' is described as 'a mental pattern in any of the sensory modalities, e.g., a sound image, a tactile image, the image of a state of well being'.[14] Thinking in images predates thinking in language by millennia.[15] These associations support the relation of artistic practice to psychoanalysis, in which metaphor and lateral thinking result in novel associations.

The brain did not come about by design; instead it has evolved. The outcome of this is that the connection and communication across regions are imperfect. Freud showed that unconscious expression frequently erupts through language. This is revealed in *Influence of Mars* by the boy's territorial expression.

Unhomely Street: *The unconscious and the city*

Unhomely Street follows a female protagonist in a state of fugue as she wanders an alienating city underbelly of clubs and free parties. Through recollections of anti-capitalist conversations, historical information about wartime atrocity, and human brutality, the narrative presents a disturbing, subjective landscape. By featuring the sites of 'free' parties and past raves, the film inquires whether dancing and graffiti stand for human resistance to mainstream culture. In psychoanalytic terms, these regions could be said to constitute the city's unconscious.

The film aims to explore connections between mental health and capitalism. It represents post-concussive syndrome, a condition characterized by a pervasive feeling of anxiety, punctuated by episodes of despair. Emotional tone dictated how the material was shot and edited. By not using a plan or a script, spontaneity and intuition are employed. This method reveals that the creative process is not always transparent to the artist.

Patricia Townsend draws a comparison between the artist's engagement with their medium and the analyst/analysand relationship as a way of understanding the artistic practice.[16] She interviewed 30 artists about their experience of making

new work and found frequent reports of a discontinuity between the conscious mind of the artist and the idea of the work; inspiration seemed to come from elsewhere. Other artists describe allowing ideas to 'jostle', 'resonate' and 'crystallise'. Townsend observes: 'There is a sense of "recognition" as if there is a precise fit between the shape of the idea and the inner "something" that the artist wants to put into the work.'[17] Among her participants, artist John Aitkin describes an 'otherness' at work, in which the idea has its own energy that the artist enters into a dialogue with.[18] This 'otherness' can be likened to a reactive intuition described by Dryden Goodwin, who notes an oscillation between making practical decisions and this unconscious force.[19] Other artists describe being absorbed in the making to an extent they do not stop at night and fear that they may 'tip over the edge'.[20]

These observations correlate with the experience of producing *Unhomely Street*. Townsend suggests, 'The artist has gone through a training in intuition so that her perceptions are increasingly refined and increasingly attuned to responding to elements which will carry her work forward.'[21] The subjective landscape constructed in *Unhomely Street* was produced through, and represents, post-concussive syndrome. The affect associated with the condition becomes a cinematic space. It is difficult to measure the extent to which the production of this film aided recovery or was merely coincidental with it. In the latter stages of post-production, infrequent episodes were used to record voice-over with the appropriate tone. There was a shift in attitude towards the illness, from one of dread, to a positive association with progressing the film. By making a fictional landscape in which anxiety was controlled, and by entering into a dialogue with the artistic idea, the filmmaking contributed to a return to health.

Unhomely Street was shot in Derbyshire and Berlin (Figure 4.2). The Berlin locations include Ostkreuz and areas of former East Berlin close to the wall. Graffiti, which is prevalent in these regions and features in the film, is a territorial activity. 'Tagging' is perhaps the human equivalent of peeing up a lamppost. It can be seen as the ugly daubing of the unruly or the creative outpourings of the repressed. As a region where repression is expressed in creative terms, these areas of the city could constitute the city's unconscious. The graffiti-covered houses of Ostkreuz are clearly the sites of dance parties. The free party environment exists outside of society, due to the illegality of the events. Here one can encounter solidarity, acceptance, permissiveness and human expression.

Deleuze and Guattari describe the *refrain* as a territorializing assemblage, referencing the child in the dark whispering a tune as comfort, birdsong as a claim to territory, the drinking song and the choir as acts of unity.[22] Similarities can be drawn between dance and the refrain in terms of intersubjectivity. Lara Maister at the *New Scientist* Consciousness conference noted pro-social effects in activities with synchronized group movement, including song, dance and tai chi.[23] Dance

FIGURE 4.2: *Unhomely Street*, still from film, by author.

can be a war dance, intended to rouse the spirits before a battle, or a territorial statement that marks personal space and regional boundaries. It can also be a uniting gesture, an invitation and a creative expression. Dance is a primitive, non-linguistic form of communication that one can only assume is dangerous, given the number of cultures across history that have sought to control and suppress it. The dance that concludes *Unhomely Street* recognizes these modes. As the post-concussive syndrome diminished, the narrative of *Unhomely Street* moved from inner city club to an outdoor party (Figure 4.3). In line with popular wisdom, a move from town to country appeared good for the health.

The Derbyshire locations featured in *Unhomely Street* shows moorland, assumed to be wild and natural. However, if left alone, the Peak District would have forests. As is true of much of England and Scotland, the so-called wild landscape is a particular type of farmland where grouse are reared for shooting. Sheep are grazed on grouse moors to keep down the trees and other vegetation and serve as 'tic mops', the host to parasites that would otherwise affect the grouse, convenient as the sheep can be seasonally dipped. As such the wild landscape of the Peak District is managed for the purpose of blood sport. Psychoanalysis accounts for the development of the psyche by the resolution of childhood phases, including the Oedipal and castration complexes. In broader terms, these relate to the mammalian traits of breeding, killing and building territory. The resolution of these complexes, in the individual, brings about the formation of the unconscious.

FIGURE 4.3: *Unhomely Street*, still from film, by author.

In neuroscientific terms, the human operates according to largely nonconscious processes. Language and predictive strategy are relatively new in terms of the evolution of the brain.[24] The individual's behaviour tattoos the environmental surface. The graffiti-covered borderland of Ostkreuz may show the territorial marks of the oppressed, but the Peak District's barren expanse is a symbol of the power of the land-owning elite.

The human tendency to consume and expand was a cause for anxiety during the time of the production of *Unhomely Street*. Since finishing the film and recovering from the post-concussive syndrome, the work of Donna J. Haraway has provided an alternative perspective. Haraway suggests it matters 'what thoughts think thoughts'.[25] She is critical of the narrative of the Anthropocene, which she considers to be a poor story on which to build a future. She promotes new 'big enough' tales of interspecies collaboration. In cross-referencing psychoanalysis and neuroscience, the conclusion could suggest we are at the mercy of our instincts. Yet we have the capacity to act strategically in favour of a positive future outcome, built on deterritorialization and creativity.

Unhomely Street concludes with reference to Jacques Derrida's critical framework of hauntology, which uses the contradiction of the ghost, whose first visit is also a return, to reference the atemporality of thought and the continuous presence of the trace of the past.[26] Both the character in the film and the experience of post-concussive syndrome coalesce around anxiety that history will repeat itself.

The constant availability of archive material, especially details of past atrocity as referenced in the film, contributes to Mark Fisher's understanding of hauntology, which states that we live in an age of mental illness, unable to envisage an alternative future.[27] *Specters of Marx*, in which Derrida outlines hauntology, was first presented at the 'Wither Marxism' conference, managed by the Center for Ideas and Society at the University of California, in 1993.[28] This was the same year as the release of the first version of Microsoft's Outlook. Derrida's text was written in response to the fall of the Berlin Wall in 1989 and the changing economic and political face of Europe. In *Specters of Marx*, Derrida repeats the mantra 'the time is out of joint'.[29] The impact of the Internet with increased connectivity, work intensification, compacted archives and condensed history could signal another sense in which time is out of joint. Following Marx's theory of the 'annihilation of time and space' that refers to the requirement of cheap transport and communication for capital-based production, geographer David Harvey proposed 'space-time compression' in 1989, to reflect the contemporary shrinkage of distance that brings about the 'global village'. Harvey's 'space-time compression' describes an 'imperative to reduce the circulation time of capital'.[30] Email reduces the time of information travel so drastically that the contemporary workforce is unable to keep up. Fisher describes the twentieth century as seized by 'recombinatorial delirium', whereas thetwenty-first century is an inert, anachronistic, 'desolation of hauntological melancholia'.[31]

Psychotel: *Psychogeography in Istanbul*

Whereas *Unhomely Street* could be seen to focus on time, anxiety in the knowledge of historical events in the face of an uncertain future, *Psychotel* is concerned with space, exterior space and interior psychological space. The narrative, which explores the uncanny, focuses on the dual aspect of the psyche and the notion that the oddity of mental life arises from the play of conscious and unconscious thoughts. Like the other films, *Psychotel* was not scripted; instead it was shot with a responsive attitude to the environment, in hotels in towns and cities, including Istanbul, Helsinki, Oberhausen, Brussels, Shrewsbury, Liverpool and Bridlington (Figure 4.4). The journey, specifically the train journey, becomes an allegory of narrative and a metaphor for life in general. Getting lost in a city as a tourist turns into a tool to get to know the city better. While mobile phones become the major tool for navigation, unfolding the spatial experience through the movement, paper maps give a more overall exploration of both the place and the city. However, in a city like Istanbul, where people are not concerned about street names, using phone navigation becomes a necessity. The phone navigation system creates

FIGURE 4.4: *Psychotel*, still from film, by author.

a fragmentary approach in which the sense of an overall direction and the relation of the moves to the geography of the city as a whole are lost.

Regarding that, the perception of space and place changes as the exploration tool changes, and this affects the mind and space relationship accordingly. 'Psychogeography', as the name implies, concerns the relation of mind and space. Merlin Coverley suggests the concept resists definition but can be viewed as a series of interwoven themes combining political strategy, literary movement and avant-garde practices.[32] He draws together physical wandering and mental travelling. Psychogeography attempts to overcome what he describes as the process of 'banalisation', in which every day appears mundane and drab. For Coverley, the ordinary contains an undercurrent of the mysterious. He describes the city as 'a place of dark imaginings'.[33]

Genius loci, in classical Roman religion, refers to a protective spirit of a place. Coverley uses the term to describe an 'eternal landscape' that underpins our sense of place.[34] He considers genius loci as 'deeply embedded in our national consciousness', through the histories of previous inhabitants.[35] Here the genius loci gains a hauntological attitude as the dead retain influence over the living.

Online maps allow for preview visits; a city can be virtually explored and then revisited like a return to the real, no longer distorted by technology. Without technological assistance, landmarks such as large buildings and directional indicators such as tramlines become key. It may be that relying on phone technology for orientation reduces the capacity to navigate by a sense of direction and the sun.

It is thought that to migrate, birds use a physiological magnetic compass, possibly a quantum-based mechanism.[36]

For Merleau-Ponty, 'the body is our anchorage in the world'.[37] He writes: 'Experience discloses beneath objective space, in which the body eventually finds its place, a primitive spatiality of which experience is merely the outer covering and which merges with the body's very being.'[38] He sees our connection with the space around us as an extension of the body itself, that 'our own body is in the world as the heart is in the organism'.[39] He expands:

> The thing, and the world, are given to me along with the parts of my body, not by any 'natural geometry', but in a living connection comparable, or rather identical, with that existing between the parts of my body itself.[40]

Merleau-Ponty's phenomenological position could imply that we evolve alongside our environment. Speculation of our future form in the light of our relation to technology is a post-human concern.

Audio material for the film was gathered in Istanbul; buskers, trams, gulls, the Adhan and other ambient sounds of the city. In post-production when reviewing recorded material, the sound files recreate the experience of the place in the mind. The film footage already occupies another realm; the direction of the camera and the framing of the shot transform the real space into an image that is mixed with fantasy, a state of becoming filmic space. In listening to the audio recordings the experience of the city returns.

With reference to Stevenson's novel *The Strange Case of Dr Jekyll and Hyde* (1886), Coverley describes 'a psychological doubling of the protagonist on to the topography of the city itself'.[41] David Lynch's *Blue Velvet* (1986) is an example of this common filmic and literary overlap of psychology and environment in which the topography of the cinematic or fictional landscape follows the contours of the character's psychical story arch.[42] In *Psychotel*, the film-maker's doubling as protagonist produces an overlap between the lived experience, the act of filming, memory and the filmic narrative. The film becomes a recorded fantasy of itself.

Automatism, a strategy employed in psychogeographical research, was employed by the Surrealists as a means to access the unconscious mind and is a deliberate version of everyday autopilot in which one finds oneself at a familiar location that one did not intend to visit. Here the uncanny arises in this reminder that our conscious mind is not the chief operator, and much of our action is presided over by automatic and instinctual mechanisms. In adopting an open attitude to exploring the city, and more widely, an intuitive, artistic approach in making *Psychotel* though a response to the environment, the film bears the hallmarks of a psychogeographical project. The aim of uncovering the strange in the everyday,

revealing the automatism in the urban wanderer, the doubling of the psyche and the environment, makes the psychogeographical intention an uncanny approach.

The Istanbul material enriches the filmic landscape of *Psychotel*. That the film-maker was an outsider contributes to the uncanny quality of these sequences. While visiting the city, the paper map used for navigation became redundant as its contents transformed into a lived experience that built a neural map. Through the film-making process, the mental map of the city is transformed into a new place, a cinematic space.

Psychotel: Metaphor and mind

Psychotel employs the hotel as a metaphor for the mind to explore the Freudian 'unheimlich'. The hotel caters for your needs but is never a home. The slick front of the house contrasts with the concealed service regions that invite association with the implied architecture of the Freudian topology of the psyche. The place itself is unhomely in its constant reminder that you are a guest. In the word 'guest', there is the suggestion of the 'ghost', a transient entity that shows up and disappears, sometimes in the night. The word 'ghost' contains the word 'host', an ambiguous term that at once offers to accommodate and threatens to take over.

The labyrinthine space of the hotel can be reminiscent of the dream; corridors, rooms, staircases, service regions. During sleep the seeking function of the mind is still active, accounting for the tendency in dreams to be searching. Nicholas Royle, in 'Hotel Psychoanalysis', reminds us that Freud considered the dream of the hotel to be a concealment of a dream about a brothel. As Royle points out: 'If it is possible to have a brothel or harem dream, why not a hotel dream?'[43]

The hotel as a metaphor for the psyche explores the notion of the ego as a guest and the idea of unhomeliness. The working title of *Psychotel* was *The Guest in the Hotel*, prompted by Freud's analogy that 'the ego is not master in its own house'.[44] In her account of the uncanny in the work of Heidegger, Katherine Withy describes the human essence: 'The human being remains inside, or in relation to, its essence, but in such a way that it is off-center or out-of-joint in its essence – like a guest in someone else's home.'[45] Merleau-Ponty employs spatial metaphors in his descriptions of the phenomenology of perception. He writes: 'Perception is built up with states of consciousness as a house is built of bricks',[46] and 'the phenomenological world is not pure being, but the sense which is revealed where the paths of my various experiences intersect.'[47]

In their study of the human conceptual system cognitive scientists George Lakoff and Mark Johnson identify nonmetaphorical structure as stemming directly from

experience giving examples of spatial orientations such as UP–DOWN, NEAR–FAR, IN–OUT. They propose that metaphorical concepts are understood and structured both on their own terms and in terms of other concepts.[48] Examples of orientational metaphors such as UP–DOWN include 'Good is UP': 'Things are looking up', 'Things are at an all-time low'. Ontological metaphors include 'Ideas are Entities and Words are Containers' – 'It's hard to get that idea across', 'Try to pack more ideas into fewer words' – and 'The Mind is a Container' – 'I can't get the tune out of my mind', 'He's empty-headed'.

They contest classical language theory that understands metaphor as 'novel or poetic linguistic expression',[49] stating: 'The generalisations governing poetic metaphorical expressions are not in language, but in thought: They are general mappings across conceptual domains.'[50] They stress that metaphor is an ordinary way of conceptualizing the world. Lakoff describes everyday language, not ordinarily considered to be metaphorical speech, an example being 'our relationship has hit a dead end'. He points to this as an example of LOVE IS A JOURNEY metaphor. Other examples include 'We're at a crossroads' and 'We may have to go our separate ways'.[51]

Irving Massey, in *The Neural Imagination*, suggests metaphors are 'incubators of ideas'.[52] For him art seeks essences and metaphor provides access to the essence. In this way the work of art provides a view that is different from ordinary perception.[53] He considers a function of creative thought to be advantageous in evolutionary terms, as natural selection shows adaptability to have survival advantage. Massey acknowledges that dreams are pre-linguistic in evolutionary terms and notes that during sleep, the linguistic centres of the brain are inactive.[54] He proposes that dream language 'represents an undertow in all our expression'.[55] In this way, artistic practice promotes novel association.[56]

In the research and practice surrounding *Psychotel*, a two-way process is apparent. The starting point of the film is academic research, the medium of which is language. Whereas the main intention is to convey emotion by audiovisual means, the main strategy is to use film to make manifest the spatial metaphors found in language. This does not return the audience to a previous means of understanding; instead it takes the viewer to a new environment, a cinematic space in which these ideas intersect.

Conclusion: Minds and maps

In the films, artistic interventions in post-production shift the representational status of everyday footage, images of cities and bodies, for example, to new sequences that represent interiority. Here the boundaries between the interior

FIGURE 4.5: *Unhomely Street*, still from film, by author.

and exterior, the organic and the inorganic, break down. The body becomes architectural, the city like a dream (Figure 4.5).

Damasio views selfhood in evolutionary terms. He proposes that self is a three-tiered construct: the proto-, core- and autobiographical self, with the proto-self being the nonconscious forerunner to consciousness and being present in all organisms with brains.[57] For Damasio, the proto-self can be viewed as a map of the organism's body as represented by the brain. Merleau-Ponty, writing in 1961, uses the term 'map' to describe the individual's relationship between sight and movement. He writes: 'Everything I see is [...] marked upon the map of the "I can". Each of the maps is complete. The visible world and the world of my motor projects are both total parts of the same Being.'[58] Damasio tells us,

> Complex brains such as ours naturally make explicit maps of the structures that compose the body proper, [...] brain maps are the substrate of mental images, map-making brains have the power of literally introducing the body as content into the mind process.[59]

The brain maps both the body and the environment in a rich two-way process. Each shapes the other, perhaps in ways not dissimilar from how the termite holds the map of the termite mound.

Antony Vidler, in his book *The Architectural Uncanny*, describes 'the frightening double existence of man himself, an existence divided between the

ego and the ego that observes itself'.[60] Here he references Freud, who notes a mental facility that allows for self-observation, able to 'treat the rest of the ego like an object'.[61] This ability to project ourselves as players in the content of our thoughts connects psychogeography and cinematic spectatorship. The viewer's relation to the on-screen character shifts between identification, alignment and fantasy – a sense of recognition of the character's situation, an understanding that the character leads the narrative and personal imaginings that place the spectator in a similar situation to the on-screen scenario. Vidler suggests that art is uncanny as it is a double that 'veils reality'.[62]

The three films represent the interior viewpoints of the characters and the film-maker as unconscious presence. *Influence of Mars* reveals the boy's fantasy and points to a relation between toys, the media, war and human territorialism. *Unhomely Street* offers an interior image of post-concussive anxiety, references historical events and presents these past atrocities as forming a dark aspect of a collective unconscious. *Psychotel* follows a character's journey while showing an uncanny doubling of the conscious and unconscious mind. As the topography of cinematic space maps these ideas, a bridge is built between the interiority of the film-maker and that of the spectator.

Attempts to show the mind's-eye view will always fail. Despite associations made between the filmic image and thought, between cinema and the dream, the mental image and the cinematic image are very different. Yet each can represent the other. By using an intuitive and responsive approach to film-making, the border between real and imaginary space grows complex. The environment shapes the psyche as the psyche represents the environment. The film-maker presents a cinematic landscape and the spectator expands that space to situate themselves in the topography of the film-makers' fantasy.

NOTES

1. Laura Rascaroli, *The Personal Camera: Subjective Cinema and the Essay Film* (New York: Wallflower, 2014), 12–13.
2. Rascaroli, *The Personal Camera*, 36.
3. Gilles Deleuze, *Bergsonism*, trans. Hugh Tomlinson and Barbara Habberjam (New York: Zone Books, 1997), 26.
4. Deleuze, *Bergsonism*, 63.
5. Deleuze, *Bergsonism*, 56.
6. Gilles Deleuze and Felix Guattari, *A Thousand Plateaus: Capitalism and Schizophrenia*, trans. Brain Massumi, Mark Seem and Helen R. Lane (Minneapolis: University of Minnesota Press, 1987), 319.

7. Dilek Altuntaş, 'Hotel as a Double Metaphor: Space, Representation, Reality and Beyond', in *Design and Cinema: Form Follows Film*, ed. Belkis Uluoğlu et al. (Newcastle: Cambridge Scholars, 2006), 99–109, 99.
8. See Guy Claxton, *The Wayward Mind: An Intimate History of the Unconscious* (Lancashire: Abacus, 2005); and Lancelot Law Whyte, *The Unconsciousness before Freud* (London: Tavistock, 1962).
9. André Breton, founder of the surrealist movement and associated with the Dadaist movement, was influential in introducing Freud's work as an instrument in the theory and criticism of art. Christian Metz later applied Freudian and Lacanian theory to film. See Christian Metz, *The Imaginary Signifier: Psychoanalysis and the Cinema*, trans. Celia Britton (London: Palgrave Macmillan, 1984).
10. See Sigmund Freud, 'On Metapsychology, on Repression and the Unconscious', in *The Theory of Psychoanalysis*, vol. 11, trans. and ed. James Strachey et al. (London: Penguin, 1984), 139–216.
11. See Barry Opatow, 'The Real Unconscious: Psychoanalysis as a Theory of Consciousness', *Journal of the American Psychoanalytic Association* (1997): 45, 865–90.
12. Mark Solms, 'The Conscious Id', *Neuropsychoanalysis* 15, no. 1 (2013): 5–19, 11.
13. Other neuroscientists include Jaak Panskepp, Louis LeDoux and V. S. Ramachandran. See Antonio Damasio, *Descartes Error: Emotion, Reason, and the Human Brain* (New York: Harper Collins, 1995), and *The Feeling of What Happens* (London: Vintage, 1999); Louis LeDoux, *The Emotional Brain* (London: Weidenfield and Nicholson, 1998); Jaak Panskepp, *Affective Neuroscience: The Foundations of Human and Animal Emotions* (New York: Oxford University Press, 1997); V. S. Ramachandran and S. Blakeslee, *Phantoms in the Brain: Human Nature and the Architecture of the of the Mind* (London: Fourth Estate, 1999).
14. Damasio, *The Feeling of What Happens*, 9.
15. See Peter Wyeth, *The Matter of Vision: Affective Neurobiology and Cinema* (Hertfordshire: John Libby, 2015), 80–81.
16. Patricia Townsend, 'A Life of Its Own: The Relationship between Artist, Idea and Artwork', *Free Associations: Psychoanalysis and Culture, Media, Groups, Politic*, no. 65 (2014): 99–119, 101–2. Townsend contributed to the 'Making Space' conference, UCL, 2012, from which this special edition of *Free Associations* arose. Her interviews with artists were prior to the conference in support of the conference contribution and subsequent publication.
17. Townsend, 'A Life of Its Own', 104.
18. Townsend, 'A Life of Its Own', 106.
19. Townsend, 'A Life of Its Own', 108.
20. Townsend, 'A Life of Its Own', 110.
21. Townsend, 'A Life of Its Own', 105.
22. Deleuze and Guattari, *A Thousand Plateaus*, 319.

23. Patrick Haggard et al., 'Consciousness Conference', *The New Scientist Live* (London: British Library, 2015).
24. Peter Wyeth notes that in evolutionary terms vision predates language by over two million years, suggesting that emotional response to image, and the construction of narratives by predictive cause-and-effect association, forms the most basic neural structures on which language is built. See Peter Wyeth, *The Matter of Vision: Affective Neurobiology and Cinema* (Hertfordshire: John Libby, 2015), 13.
25. Donna J. Haraway, *Staying with the Trouble: Making Kin in the Chthulucene* (London: Duke University Press, 2016), 12.
26. Jacques Derrida, *Spectres of Marx, the State of the Debt, the Work of Mourning, & the New International*, trans. Peggy Kamuf (New York: Routledge, 1994), 10–11.
27. Mark Fisher, 'Lost Futures', in *Ghosts of My Life: Writings on Depression, Hauntology and Lost Futures* (Winchester: Zero Books, 2014), 6–8.
28. Bernd Magnus and Stephen Cullenberg, 'Editor's Introduction', in Derrida, *Spectres of Marx*, x.
29. This phrase, originally from Hamlet, repeats throughout the book.
30. Aejaz Ahmad Wani and Mohd. Rafiq Wani, 'Time, Space and Capitalism', *International Journal of Multidisciplinary Research and Development* 2, no. 9 (2015): 306–9.
31. Fisher, *Ghosts of My Life*, 28.
32. Merlin Coverley, *Psychogeography* (Harpenden: Pocket Essentials, 2010), 10.
33. Coverley, *Psychogeography*, 14.
34. Coverley, *Psychogeography*, 16.
35. Coverley, *Psychogeography*, 33.
36. Thorsten Ritz, 'Quantum Effects in Biology: Bird Navigation', *Chemistry Procedia* 3(2011): 262–75.
37. Maurice Merleau-Ponty, *Phenomenology of Perception* (London: Routledge and Kegan Paul, 1962), 167.
38. Merleau-Ponty, *Phenomenology of Perception*, 171.
39. Merleau-Ponty, *Phenomenology of Perception*, 235.
40. Merleau-Ponty, *Phenomenology of Perception*, 237.
41. Coverley, *Psychogeography*, 18.
42. For further reading, see Laura Mulvey, 'The Netherworlds and the Unconscious: Oedipus and Blue Velvet', in *Fetishism and Curiosity: Cinema and the Mind's Eye* (London: British Film Institute, 2013), 187–209.
43. Nicholas Royle, 'Hotel Psychoanalysis: Some Remarks on Twain and Sigmund Freud', *Angelaki: Journal of the Theoretical Humanities* 9, no. 1 (2004): 3–14, 4.
44. Sigmund Freud, 'A Difficulty in the Path of Psycho-analysis', in *The Standard Edition of the Complete Works of Sigmund Freud*, vol. 17 (London: Vintage, 2001), 143.
45. Katherine Withy, *Heidegger: On Being Uncanny* (Cambridge, MA: Harvard University Press, 2015),138.

46. Merleau-Ponty, *Phenomenology of Perception*, 25.
47. Merleau-Ponty, *Phenomenology of Perception*, xxii.
48. George Lakoff and Mark Johnson, 'The Metaphorical Structure of the Human Conceptual System', *Cognitive Science* 4 (1980): 195–208, 195–96.
49. George Lakoff, 'The Contemporary Theory of Metaphor', in *Metaphor and Thought*, ed. Andrew Ortony (Cambridge: Cambridge University Press, 1993): 202–251.
50. Lakoff, 'The Contemporary Theory of Metaphor', 1.
51. Lakoff, 'The Contemporary Theory of Metaphor', 3.
52. Irving Massey, *The Neural Imagination: Aesthetic and Neuroaesthetic Approaches to the Arts* (Texas: University of Texas Press, 2009), 93.
53. Massey, *The Neural Imagination*, 43.
54. Massey, *The Neural Imagination*, 59.
55. Massey, *The Neural Imagination*, 59.
56. Massey, *The Neural Imagination*, 96.
57. See Damasio, *The Feeling of What Happens*, and *Self Comes to Mind* (London: Vintage, 2010).
58. Maurice Merleau-Ponty, 'Eye and Mind', in *The Merleau-Ponty Aesthetics Reader: Philosophy and Painting,* trans. Michael B. Smith (Evanston, IL: Northern University Press, 1993), 121–50, 124.
59. Damasio, *Self Comes to Mind*, 89.
60. Anthony Vidler, *The Architectural Uncanny: Essays in the Modern Unhomely* (Cambridge, MA: MIT Press,1994), 34.
61. Sigmund Freud, 'The "Uncanny"' (1919), in *The Standard Edition of the Complete Psychological Works of Sigmund Freud*, vol. 17, trans. and ed. James Strachey et al. (London: Hogarth, 1955), 217–56, 10.
62. Vidler, *The Architectural Uncanny*, 35.

BIBLIOGRAPHY

Altuntaş, Dilek. 'Hotel as a Double Metaphor: Space, Representation, Reality and Beyond'. In *Design and Cinema: Form Follows Film*, edited by Belkis Uluoğlu et al., 99–109. Newcastle: Cambridge Scholars, 2006.

Claxton, Guy. *The Wayward Mind: An Intimate History of the Unconscious*. Preston, Lancashire: Abacus, 2005.

Coverley, Merlin. *Psychogeography*. Harpenden: Pocket Essentials, 2010.

Damasio, Antonio. *Descartes Error: Emotion, Reason, and the Human Brain*. New York: HarperCollins, 1995.

———. *The Feeling of What Happens*. London: Vintage, 1999.

———. *Self Comes to Mind*. London: Vintage, 2010.

Deleuze, Gilles and Felix Guattari. *A Thousand Plateaus: Capitalism and Schizophrenia*. Translated by Brain Massumi, Mark Seem and Helen R. Lane. Minneapolis: University of Minnesota Press, 1987 [*L'Anti-Oedipe*, Paris: Les Editions de Minuit, 1972].

Derrida, Jacques. *Spectres of Marx, the State of the Debt, the Work of Mourning, & the New International*. Translated by Peggy Kamuf. New York: Routledge, 1994 [*Spectres de Marx: L'État de la Dette, le Travail du Deuil et la Nouvelle Internationale*, Paris: Éditions Galileé, 1993].

Fisher, Mark. *Ghosts of My Life: Writings on Depression, Hauntology and Lost Futures*. Winchester: Zero Books, 2014.

Freud, Sigmund. 'A Difficulty in the Path of Psycho-analysis'. In *The Standard Edition of the Complete Works of Sigmund Freud* 17. Translated and edited by James Strachey et al., 135–44. London: Vintage, 2001.

———. *On Metapsychology: The Theory of Psychoanalysis* 11. Translated and edited by James Strachey et al. London: Penguin, 1984.

———. 'The "Uncanny"'(1919). In *The Standard Edition of the Complete Psychological Works of Sigmund Freud* 17. Translated and edited by James Strachey et al., 217–56. London: Hogarth, [1919] 1955.

Haggard, Patrick and Lara Maister. 'Consciousness Conference'. Paper presented at *The New Scientist Live*. London: British Library, 2015.

Haraway, Donna J. *Staying with the Trouble: Making Kin in the Chthulucene*. London: Duke University Press, 2016.

Lakoff, George. 'The Contemporary Theory of Metaphor'. In *Metaphor and Thought*, edited by Andrew Ortony, 202–51. Cambridge: Cambridge University Press, 1993.

Lakoff, George and Mark Johnson. 'The Metaphorical Structure of the Human Conceptual System'. *Cognitive Science* 4 (1980): 195–208.

LeDoux, Joseph. *The Emotional Brain*. London: Weidenfield and Nicholson, 1998.

Massey, Irving. *The Neural Imagination: Aesthetic and Neuroaesthetic Approaches to the Arts*. Texas: University of Texas Press, 2009.

Merleau-Ponty, Maurice. 'Eye and Mind'. In *The Merleau-Ponty Aesthetics Reader: Philosophy and Painting*. Translated by Michael B. Smith, 121–50. Evanston, IL: Northern University Press, 1993 [*L'Oeil et L'Esprit*, Paris: Gallimard, 1960].

———. *Phenomenology of Perception*. Translated by Colin Smith. London: Routledge and Kegan Paul, 1962 [*Phénoménologie de la Perception*, Paris: Gallimard, 1945].

Metz, Christian. *Psychoanalysis and Cinema: The Imaginary Signifier*. Translated by Celia Britton. London: Palgrave Macmillan, 1984 [*Le Significant Imaginaire: Psychanalyse et Cinéma*,Paris: Union Générale d'Editions, 1977].

Mulvey, Laura. 'The Netherworlds and the Unconscious: Oedipus and Blue Velvet'. In *Fetishism and Curiosity: Cinema and the Mind's Eye*, 187–209. London: British Film Institute, 2013.

Opatow, Barry. 'The Real Unconscious: Psychoanalysis as a Theory of Consciousness'. *Journal of the American Psychoanalytic Association*, 45 (1997): 865–90.

Panskepp, Jaak. *Affective Neuroscience: The Foundations of Human and Animal Emotions*. New York: Oxford University Press, 1997.

Ramachandran, V. S., and S. Blakeslee. *Phantoms in the Brain: Human Nature and the Architecture of the Mind*. London: Fourth Estate, 1999.

Rascaroli, Laura. *The Personal Camera: Subjective Cinema and the Essay Film*. New York: Wallflower, 2014.

Ritz, Thorsten. 'Quantum Effects in Biology: Bird Navigation'. *Chemistry Procedia* 3 (2011): 262–75.

Royle, Nicholas. 'Hotel Psychoanalysis: Some Remarks on Twain and Sigmund Freud'. *Angelaki: Journal of the Theoretical Humanities* 9, no. 1 (2004): 3–14.

Solms, Mark. 'The Conscious Id'. *Neuropsychoanalysis* 15, no. 1 (2013): 5–19.

Townsend, Patricia. 'A Life of Its Own: The Relationship between Artist, Idea and Artwork'. *Free Associations: Psychoanalysis and Culture, Media, Groups, Politic* 65 (2014): 99–119.

Vidler, Anthony. *The Architectural Uncanny: Essays in the Modern Unhomely*. Cambridge, MA: MITPress, 1994.

Wani, Aejaz Ahmad, and Mohd. Rafiq Wani. 'Time, Space and Capitalism'. *International Journal of Multidisciplinary Research and Development* 2, no. 9 (2015): 306–9.

Withy, Katherine. *Heidegger: On Being Uncanny*. Cambridge, MA: Harvard University Press, 2015.

Whyte, Lancelot Law. *The Unconsciousness before Freud*. London: Tavistock, 1962.

Wyeth, Peter. *The Matter of Vision: Affective Neurobiology and Cinema*. Hertfordshire: John Libby, 2015.

Film List

Blue Velvet. Directed by David Lynch, USA: De Lauretis Entertainment, 1986.
Influence of Mars. Directed by Susannah Gent, 2016.
Psychotel. Directed by Susannah Gent, 2019.
Unhomely Street. Directed by Susannah Gent, 2017.

5

A Vision of Complexity: From Meaning and Form to Pattern and Code

Loukia Tsafoulia and Severino Alfonso

Information, ubiquity, form and space

Humans interact in simultaneously static and changing environments. Today, processes based on data technologies redefine the built environment as to its 'perceptual system', claiming its capacity for interactivity. Increasingly, studies explore psychological, social and cultural methods for designing. How do we connect to a larger, data-driven world, and how does design respond to these invisible forces where traditional structures have become global and decentralized?

Sentient City, Smart Architecture, Living City, Spatial Intelligence, Datascapes are just a few of the terms that refer to an environmental condition where space is understood through interaction. As early as 1984, William Gibson defined 'cyberspace' as an 'infinite datascape', focusing on the realm of data as the medium to understand the world. The concept of *datascapes*[1] in architecture – as introduced in 1998 by the Rotterdam-based architecture firm MVRDV in their project *Metacity/Datatown*[2] – refers to the creation of a '-scape' or topography by means of manipulating data. At a conceptual level, by affixing the term '-scape' to the stem word 'data', the latter would take actual form, thus raising possibilities of intersecting with and conforming to other objects.

This design manifesto relied on earlier ideas set outside the design discipline. Mark Weiser's coined term 'ubiquitous computing', for example, defined a series of principles linked to the possibilities of the computer regarding its capacity to extend human unconscious.[3] His concept would not have been possible either without earlier writings by technology and media theorists such as Buckminster Fuller or Marshall McLuhan through their seminal texts of the 1950s and 1960s

expanding on the idea of a globally networked planet.[4] These thoughts also overlapped and concurred with early information theories published in the aftermath of the Second World War by mathematicians, scientists and philosophers such as Norbert Wiener, Alan Turing and Claude Shannon who anticipated the logic behind storing, retrieving, transmitting and manipulating data.

With the increase of computational power at exponential rates, and the palpable ubiquity of the current technologies, new modes of experiencing space have emerged. Forces such as personal technology and social media exceedingly affect human experience. Spatial design, in turn, follows suit in looking beyond defined spaces to understand the effects of these forces on the way we perceive space. How could we then narrate a history of visual perception? Moreover, how could we construct revealing connections between the technologies that defined perception during the twentieth century and keep evolving today? Tracing the evolution of visual communication technologies and the visual environment – from montage theories in early experimental films to the backstage of a TV studio that brings to our home TV a synthesized version of multiple cameras – is key to the design of a new form of perception.[5]

Techniques in cinematic vision: From flânerie *to cinéma-vérité*

The nineteenth-century *Flaneur*, as narrated by Charles Baudelaire[6] and later analysed by Walter Benjamin,[7] was an impersonation of the urban explorer – the connoisseur of the street – wondering cinematically around the metropolis and longing for urban distractions. *Flânerie*[8] was a way of understanding the rich variety of the city landscape, a moving photograph of the urban experience.[9] It was also a term with political charge, being closely related to the bourgeois class and the effects of capitalism as described in Benjamin's concept of 'homogenous empty time'.

If *flânerie* entailed a 'real-time' and physically present experience of a cityscape using the city of Paris as its spatial laboratory, documentary films of the early twentieth century would present a different experience of the urban environment. With the advent of abstraction and the avant-garde manifestos of the time, montage theories epitomized by Sergei Eisenstein's writings and film scripts would influx into the film industry, thus becoming a universal reference ever since, not only in film direction but also in design. In *Film Form: Essays in Film Theory* (1963), Eisenstein argues that 'montage is an idea that arises from the collision of independent shots' wherein 'each sequential element is perceived not next to the other, but on top of the other'.[10] He goes on to write that 'montage as a means of description by placing single shots one after the other like building blocks, and the consequent length of the component pieces was then considered as rhythm'.[11]

The compositional logic therein – layering, overlapping or superposing – has had a similar groundbreaking influence on the design realm ever since.[12]

Documentary films known as *City Symphonies* (1920–30) were mutually influenced by Eisenstein's montage theories and put into practice film operations that exploited similar technical and compositional principles. In the 1921 *Manhatta* – a pioneer film of the movement – Charles Sheeler and the photographer Paul Strand accumulated a palette of New York City film segments and thereafter alternated them in a specific sequential order. The most influential *City Symphonies* to be highlighted are *Berlin, Symphony of a Great City* (Walter Ruttman, 1927) and *The Man with a Movie Camera* (Dziga Vertov, 1929). In his poetic, futuristic and often expressionist film, Ruttman edited the shots of the city of Berlin as if a 'symphony', by adding transparencies, translations and overlapping effects, all emphasizing the dynamics of people and machines in contemporary industrial environments. On the other hand, with the Soviet cities of Kiev, Kharkov, Moscow and Odessa as backdrop, Vertov's *The Man with a Movie Camera* exemplifies quick-cut editing, self-reflexivity and emphasis on form over content. Both authors find in the city the material to create an experimental film with saturated poetic imagery and a thoroughly montage-driven post-production. It will not be until the 1960s and 1970s with movements such as cinéma-vérité[13] in France or *Direct Cinema* in North America that urban documentary filmmakers would consider reducing the visual sophistication of their work – lessening the intentional search for effectual collisions between various shots – the laboratory production time and the degree of involvement with their subjects. In that sense, cinéma-vérité's conceptual intent aimed to transmit a direct and truthful encounter with the reality being shot. On the technical side, these films would gain from the advances in lighting, reliable cameras and portable sync sound systems to film events on location and as they unfolded.

Aside from the poetic and highly 'plastic' films of the avant-garde, and the more sincere and untouched documentaries of the Cold War, another experimental film style that equally dealt with the urban context – but from a communication perspective – came to exist. The multimedia presentations of Charles and Ray Eames stand in between the two countering movements. Timewise, since most of their films correspond with the second half of the 1950s and early 1960s, and conceptually, as they borrowed from each movement the necessary conditions to achieve a type of film that represented the new technologies of the time. Even though the film work of Charles and Ray Eames looks specifically through the lenses of fragmentation as in the early twentieth-century films, they also relied on less dominant montage operations, like in cinéma-vérité. Regardless of their seemingly simple organization of parts, the films of the Eames employ a divergent studio-based post-production process. Basing their montage on patterns, repetitions and

alternating sequences, they serve as an example of how computation could trigger a design rationale.

What is our relationship today with our constantly moving, dynamic environments? From the constructed rhythmic environments actualized as montage outputs and experienced through the camera lenses to today's actual environments, we are always surrounded everywhere by juxtaposed moving images, more than we can or care to possibly synthesize to a comprehensive impression. Even further, referencing Walter Benjamin's 'dialectics at a standstill'[14] (*jetztzeit*), nowadays, informational environments offer a ruptured experience of particular moments. We are continuously experiencing fragments of a timeless complexity; our surroundings are emptied by Benjamin's 'empty time' even further and contradict the biological time of historical evolution.[15]

Space-time inflection point

Designers and artists contributed from early on to the evolution of the multiscreen and multimedia techniques. As analysed by Reinhold Martin in his article 'The Organizational Complex: Cybernetics, Space, Discourse', László Moholy-Nagy 'had long advocated for technological advances in the form of a new vision'. For him, 'the ubiquity of rapid movement in all aspects of modern life necessitated a biological adaptation of the human visual apparatus aided by experimental photography, in order to process visual information moving along at greater speed than ever before'.[16] Indeed, Moholy-Nagy, in his 1947 *Vision in Motion*, wrote with a post-war uneasiness regarding the missed opportunity for an optimal and bidirectional influence between the human biological standards and the machines of industrial production. He stated in his first chapter,

> To be specific: The biological evolutionary progress of man was possible only through the development and constructive use of all his senses, hands, and brains, through his creative ability and intuition to master his surroundings; through his perceptive power, conceptual thought, and articulated emotional life.[17]

For Moholy-Nagy, these senses should have been empowered through the industrial advancement, but instead, the 'biological functions were suffocated under the tinsel of an easy-going life full of appliances and amenities, much too overestimated in their value'.[18] He predicted the direction that the post-war sociopolitical agenda would follow.

Even though Moholy-Nagy was very much interested in addressing the relationships between the sciences, social studies, technology and the arts, the book did

not consciously address the important advancements in information theory and computation. In a matter of ten years from the publication of *Vision in Motion*, the computer would be the machine to be looked at in understanding some of the philosophical and social questions of the time – a world order based on information.

A year after Moholy-Nagy's influential text was published, Claude Elwood Shannon's 1948 landmark paper *A Mathematical Theory of Communication* would see the light of day. In the article, 'the father of information theory' ignited the foundations of information theory. The same year, Norbert Wiener published his *Cybernetics: Or Control and Communication in the Animal and the Machine* coining the term 'cybernetics', which formalized the notion of feedback and was influential in many disciplines. Moholy-Nagy could not have adjudicated on the information age's new conceptual framing, neither could he have critiqued its further distancing from the biological evolutionary progress of man, as he put it. Hence, during the post-war era, it became apparent that the legacy of the modern movement had to be revised, among other reasons, because of the surprising speed and impact of the scientific advances at the time. A new terminology based on receptors and emitters, a planet understood as a controlled environment, a broader consideration of non-human agents and most importantly, the idea that all agents are connected through information flows in feedback loops would prove to be profoundly altering to the society. Consequently, human perception would evolve hand in hand with this new conceptual enclave. Again, in *Vision in Motion*, in the chapter 'Space-time Problems', Moholy-Nagy writes, 'Experiencing speed that can be arrested, rendered, stretched and compressed, in short, articulated, we can state that we have possession of it, that we are approaching a new vocabulary of space-time.'[19] Even though he writes about photography, the language that he uses forecasts the computationally ubiquitous world of our current time. The computer would indeed increase the space-time perception of our biological entity, exponentially increasing both the immediacy of time and simultaneity of space as Moholy-Nagy describes.

Design, space and the moving image: The film work of the Eames

An artistic and educational work that with great clarity addressed Moholy-Nagy's 'space-time problem' from the understanding of perception and the moving image is the series of experimental films by Charles and Ray Eames done in collaboration with IBM during the 1950s and 1960s. Besides IBM, the Eameses worked for clients such as Boeing, Polaroid, Westinghouse, ABC and Herman Miller Inc. embodying a forward-looking perspective that fit well within the nation's

expanding capitalist economy.[20] By 1978, the Eameses had made more than 80 short films, including award-winning multimedia films such as *Parade or Here They Are Coming Down Our Street* (1952) and *Blacktop* (1952), or science-driven films such as *A Communications Primer* (1953), *The Information Machine* (1958) or the well-received *Powers of Ten* (1968). While the Eameses did not consider themselves as film-makers, a clear deviation from their bohemian and avant-garde film-making contemporaries is worth noting.[21]

For the Eameses, their film work was important primarily as a means of communicating ideas rather for creative expression, and the medium offered them an outlet for exploring relationships between scripts and visual material. Their interest in computers, information and communication theory (particularly in the case of Charles) started in a period when various emergent notions of communication were appearing. Most importantly, the newly minted term 'cybernetics' in the late 1940s, the emergent disciplines of information and communication theory, as well as the promise of the computer as a potential design tool marked the Eameses' interest in science and influenced their commitment to interdisciplinary exchange. Hence, the publication of Shannon's *The Mathematical Theory of Communication* in 1948 triggered their 1953 film *A Communications Primer* that presented the theory of information, based on Shannon's famous information diagram (Figure 5.1). Parts of this work were also used for the 55-minute educational multimedia component that the Eameses did the same year in collaboration with George Nelson and Alexander Girard.[22] The use of multiple screens and the idea of multimedia presentations became the precursor for *Glimpses of the USA*.

FIGURE 5.1: Claude Shannon, diagram of a general communications system (1948). From *A Mathematical Theory of Communication*.

Glimpses of the USA *and* Think

The main design components for the American National Exhibition at the Moscow World's Fair in 1959 included the dome by Buckminster Fuller, a pavilion by Welton Becket and the film *Glimpses of the USA* by the Eameses. *Glimpses of the USA* was projected onto seven, 20-by-30-feet screens suspended from the 250-feet-in-diameter geodesic dome designed by Buckminster Fuller (Figure 5.2). More than 2,200 rapidly changing still and moving images presented 'a typical work day' in the life of the United States in nine minutes and 'a typical weekend day' in three minutes.[23] The images were combined into seven separate film reels and projected simultaneously through seven interlocked projectors. The amount and size of images employed as well as the variations and rhythms in changing the images was the primary consideration of the Eameses:

> We wanted to have a credible number of images, but not so many that they couldn't be scanned in the time allotted. At the same time, the number of images had to be large enough so that people wouldn't be exactly sure how many things they had seen.[24]

FIGURE 5.2: Charles Eames and Ray Eames (dir.), *Glimpses of the USA*, 1959. USA © Eames Office.

A VISION OF COMPLEXITY

The strategy during the overall film conception demonstrated the flexibility of the image's pattern organization in regard to Elmer Bernstein's music composition, altogether emphasizing the production's interdisciplinary liberty.[25]

The carefully curated use of images and music was meant to be sentimental. Interesting references are the use of a clip from the movie *Some Like It Hot* with Marilyn Monroe, and the ending of the presentation with people saying goodnight and the image of a bowl of flowers. These were genius communicative tools to create a warm and attractive message while they engraved a friendly face of America in the heart of the Soviet audience.[26] As Beatriz Colomina argues, the mission of *Glimpses* to reveal a well-curated domestic life with all its intimacies yet excluding the real life of ghettos, poverty and depression while presenting 'a day in the life of the U.S.A' intensified an existing mode of perception.[27] As argued in the following section on computer vision, similarly to how artificial intelligence's image recognition is coded with political datums, *Glimpses* used the power of the image to convey a 'universal' message loaded with preconceptions and constructed realities.[28]

The 1961 IBM exhibition *Mathematica: A World of Numbers and Beyond* was the prelude to the pavilion and exhibition for the 1964 New York World's Fair that hosted the multimedia presentation *Think* (Figure 5.3). The success of

FIGURE 5.3: Charles Eames and Ray Eames (dir.), *Think*, 1964. USA © Eames Office.

Mathematica encouraged the Eameses to continue to use exhibitions exploring complex themes and led IBM to trust them with the commission of the pavilion and exhibition for the 1964 New York World's Fair. The exhibition included a one-and-a-quarter-acre site divided into distinct exhibition areas, each covered with a large-scale canopy. On top of the canopy was an ovoid theatre of 500-person capacity, housing fourteen screens of different sizes at various angles and heights on which the Eameses projected *Think*. Its content dealt with modern technologies, data processing and problem-solving in everyday life. The Eameses' installation with its twenty-two screens drew inspiration from Herbert Bayer's techniques as illustrated at his 1930 *Diagram of Field of Vision* (Figure 5.4). The audience was fully immersed within a digital environment where the human eye could not grasp each one of the images and their diverse content.

Technique-wise, both films *Glimpses* and *Think* focused on rapid cutting of still images transferred to motion-picture footage. Their content was organized around the logic of information transmission, following the idea of 'compression',

FIGURE 5.4: Herbert Bayer, *Diagram of Field of Vision*, 1930. Herbert Bayer, Section Allemande catalogue. Section-perspective of photo installation. Source: © 2019 Artists Rights Society (ARS), New York/VG Bild-Kunst, Bonn.

to convey the tremendous quantity of information that would be impossible to physically fit within the exhibition space. Fragments were presented to be momentarily linked together as a group of images; the time between each group was such that the audience drifted through a multimedia screen that clearly exceeded their capacity to absorb it.[29] Together with the system of compression, according to Charles Eames, the function of 'simultaneity' which entails the use of multiple images to relate simultaneous happenings to the same theme is a valuable device as the subject discovers critical relationships unexplored beforehand. He also argues that these techniques correspond with the way the brain registers the images it collects.[30] Interestingly, the concept of compression has a spatial connotation, that is, the space of the screen similar to the space of the computer has higher capacity than the physical space. Physical space can, therefore, be compressed within the multiscreen space or the digital space.[31]

Together with the notion of 'compression' and 'simultaneity', the film work of the Eameses can also be a process of sampling. In their work, overload is not a concern[32]; if their sample is vast in number, their preoccupation is rather to reach as large a number of people as possible in the hopes that a single unrevealed pattern of images becomes appropriated by each viewer – a hidden pattern to be sought by the subject.[33]

The rapid succession of images results in a mesh of shapes and an interwoven impression in which recognizing the context and identity of individual images is beyond the point. Image as meaning is stripped away and reduced into basic patterns which in themselves evoke renewed meanings; The films were therefore designed in a way that the various messages were simplified, thus promoting new forms of communicating with a mass audience not only through the curation of meanings but also by promoting alternative ways of seeing. This interconnectedness between moving images and patterns sparked representation processes, methods and environments that redefined the notion of meaning: 'You could take apart everything that had meaning and form and could show it as a simple combination of yes-no binary choices.'[34]

Computer vision: On meaning in pattern and code

Through his art and technology laboratory known as the Center for Advanced Visual Studies (CAVS), Gyorgy Kepes explored theories of visual communication and perception, organizational and recurring natural patterns and universal dynamic scales which became recurrent throughout all of his work. Indicative are the names of the Center as well as his 1965–66 *Vision + Value* anthology series. His fascination with scalable, abstract, modular formations such as the crystalline

lattices[35] is evident in his 1956 book *The New Landscape in Art and Science*, where he compares the systematic patterns from images of natural structures to the products of modern art and architecture. As Reinhold Martin argues in his essay *Historicism Other*, 'We are speaking, during the atomic age and the space race, of the scaleless reinscription of the human into a technoscientific milieu that described the universe as a "system of systems".'[36]

Concurrently to the technologically mediated human vision, an important transition from the organizational patterns and systems also occurred in the realm of computer vision in regard to the construction of new meanings through perception in the design and art. Tracing its evolution and impact,[37] scientific experiments conducted on cats[38] by neurophysiologists David Hubel, Torsten Wiesel (1959) and later Colin Blakemore (1970) among others contributed to a history of vision. In trying to demystify perception, these early laboratory experiments argued that all representations are built up by primitive shapes. The analysis of objects, subjects and environments into basic geometries and the reading of patterns deriving from those shapes implied that we perceive information in isolation from the cultural associations and complex experiences we carry as individuals. These findings set the epistemological background in which generations of computer scientists were trained to think about perception.

Today's computer vision systems ranging from those used daily, such as face recognition embedded in our mobile devices, to visual intelligence operating in larger scales of governance, such as drones used as war machines, are the aftermath of these early experiments. They manifest the critical relationship between vision, perception and meaning in machine learning. Human neurons and brain development relate to our experiences during youth and based on these experiences, visual inputs are transformed into conceptual representations.[39] Artificial neural networks, through example training, learn how to analyse an object into shapes through computing numerical patterns and eventually they achieve a degree of image recognition. Questioning whether a computer sees the way a human does invokes thoughts on the language of vision as a whole. If the term 'visualization' in a human involves the formation of mental images of 'things not present in sight',[40] how does visualization based on algorithmic processes construct these mental images?

Algorithmic vision assumes an 'accurate' relationship between the image and the things represented, that is, meanings are derived by an objective correspondence to the world. In this regard, accuracy is discerned through images, like the early cat experiments. For example, systems of image recognition claim automatic inference of criminality using images of faces, or they assess a person's gender based on a pattern analysis of their facial characteristics. However, who is 100 per cent female? There is a political datum coded into the algorithm infrastructure;

meanings are fixed, non-contextual and universal in accepting social constructs and preconceptions. Visual recognition today is decontextualized from identity and meaning and has evolved to a new paradigm of experience based on data and information assimilation alone, and via the reduction of vision into a series of technical operations.

There is a twofold relationship between these scientific experiments and the film work of the Eameses: first, the technical and technological associations employed during the post-war years – that even though analogue in nature, were heavily information-based – firmly contributed to algorithmic processes embedded in human perception; second, their shared political implications anticipated today's mediated environments.

Conclusion

The history of computer vision and the history of visual perception in design and art clarify the roles of information, communication and the moving image in the shaping of the collective environment. During the awakening of the information age, new junctions between sociopolitical implications, philosophical considerations and technological manifestations of an expanding visual culture have emerged. Understanding these nuances has opened possibilities for critiquing human-machine-image interactivity and offered opportunities for both historical reflection and prospective thinking. A new visual language has developed a capacity to discuss, collect, measure and quantify behaviours and patterns with emphasis on the role of the machine and the algorithm in the construction of new meanings.

The multiscreen and multimedia films of Charles and Ray Eames played an important role during the advent of the moving image and promulgated the evolution in the conceptualization of vision, perception and cognition, thus resulting in renewed ways of seeing and sensing information based on organizational patterns and algorithmic processes. The films, first, mutated the relationship between space and the moving image and, second, redefined perception and cognition as an interaction between spaces, subjects and moving patterns. Both Moholy-Nagy prior to the information age and Gyorgy Kepes during, concurred with the Eameses in advocating for technological advances in the form of a new vision and a shift from 'thing-seeing' to 'pattern-seeing'.[41] Yet, for Charles and Ray Eames, the source of the image was not just to ease with its aesthetic value, but most importantly, to entangle the means of its elusive power. Understanding the subtle powers behind these moving images requires digging into the patterns within the broader field of images. These patterns operate with seemingly trivial effects but are charged with the capacity to convey a hidden message.

Attempting to decipher the structural logic hidden within image and pattern recognition, post-war scientific experiments suggested that human perception breaks down representations into basic shapes and eventually into flows of patterns. Knowledge, under this umbrella, can, therefore, be acquired through a fast and fragmented pool of information and manifests new deliberate meanings to the viewer. For Norbert Wiener 'a pattern is a message and may be transported as a message'.[42] It should, therefore, be considered together with the new forms of visual perception associated with the current use of interactive algorithm-controlled machines. The transition from a physical space determined by symbolic and formal aspects to an informational environment that operates through real-time data processing yields a meaningful alteration in human perception. Vision, though, cannot be taken as an isolated form of perception as it holds multiple functions: a physical sense, a medium and a discourse.

As argued by Moholy-Nagy, the industrial revolution of the machines of production distanced our biological beings from our creative ones. Similarly, the visually saturated and flickering complexity that currently dominates our mediated environments seems to be expanding in the same direction. The two not only have fused in the present, but they have also reached the point where our biological beings have been delegated to the non-biological ones.

The aforementioned inter-discursive ideological permutations have redefined human inherent structures in the form of patterns, digits, messages and feedback. The aesthetics and politics of algorithms, information and the digital technologies impact our capacities to assign meanings to objects, subjects and our environments. It is therefore critical to define our agency as mediators between the instrumentality of algorithmic protocols and human perception.

NOTES

1. See also Nadia Amoroso, *The Exposed City: Mapping the Urban Invisibles* (New York: Routledge, 2010), 69.
2. See also 'Metacity/Datatown 1999', Vimeo, https://vimeo.com/106793190 (accessed 29 July 2018); MVRDV, https://www.mvrdv.nl/projects/147/metacity-% 2F-datatown- (accessed 02 May 2020).
3. Mark Weiser, 'The Computer for the 21st Century', Donald Bren School of Information and Computer Sciences (ICS), https://www.ics.uci.edu/~corps/phaseii/Weiser-Computer21stCentury-SciAm.pdf (accessed 13 February 2019).
4. For example, Buckminster R. Fuller, *Nine Chains to the Moon* (New York: Anchor, 1971); Marshall McLuhan, *Gutenberg Galaxy* (S.l.: University of Toronto Press, 2017); Marshall McLuhan, *Understanding Media: The Extensions of Man* (New York: McGraw-Hill, 1964);

Buckminster R. Fuller, *Operating Manual for Spaceship Earth* (Richmond Hill, ON: Pocket Books, 1970); 'The Delos Symposium', *Ekistics* 16 (October 1963): 257.

5. See Beatriz Colomina, 'Enclosed by Images: The Eameses' Multimedia Architecture', *Grey Room* no. 2 (2001): 6–29.
6. Charles Baudelaire, *The Painter of Modern Life and Other Essays* (London: Phaidon, 1995).
7. Walter Benjamin, *The Arcades Project*, trans. Howard Eiland (Cambridge, MA: Belknap of Harvard University, 1999).
8. 'Flâneur', Wikipedia, 12 November 2018. https://en.wikipedia.org/wiki/Flâneur (accessed 12 November 2018).
9. 'un daguerréotype mobile et passioné'. See Victor Fournel, *Ce qu'on voit dans les rues de Paris* (collection XIX, 2016), 268.
10. Sergei Eisenstein and Jay Leyda, *Film Form: Essays in Film Theory* (New York: Meridian Books, 1963), 48.
11. Eisenstein and Leyda, *Film Form: Essays in Film Theory*.
12. For example, MoMA's *Deconstructivist Architecture*. Philip Johnson and Mark Wigley, *Deconstructivist Architecture*, 1st ed. (Boston: Greenwich, Conn. Museum of Modern Art/ Little Brown and Company, 1988).
13. Cinéma vérité is a style of documentary film-making that combines improvisation with the use of the camera to unveil truth or highlight subjects hidden behind crude reality. See James Thomas, John Techwriter, Don Guy and Fabien L'Amour, 'The Camera That Changed the World', Top Documentary Films, 5 November 2014, https://topdocumentaryfilms.com/camera-changed-world/ (accessed 14 February 2019).
14. See Peter Osborne and Matthew Charles, 'Walter Benjamin', in *The Stanford Encyclopedia of Philosophy*, ed. Edward N. Zalta, Fall 2015 (Metaphysics Research Lab, Stanford University, 2015), https://plato.stanford.edu/archives/fall2015/entries/benjamin/.
15. Reinhold Martin, 'Organicism's Other', *Grey Room*, no. 4 (2001): 36.
16. Reinhold Martin, 'The Organizational Complex: Cybernetics, Space, Discourse', *Assemblage*, no. 37 (1998): 110, doi:10.2307/3171358.
17. László Moholy-Nagy, *Vision in Motion* (Chicago: P. Theobald, 1947), 20.
18. Moholy-Nagy, *Vision in Motion*, 20.
19. Moholy-Nagy, *Vision in Motion*, 247.
20. Donald Albrecht and James H. Billington, *The Work of Charles and Ray Eames: A Legacy of Invention* (New York: Harry N. Abrams, 2005).
21. For example, Maya Deren and Kenneth Anger – also from Southern California – were concerned with surrealism, psychoanalysis or eroticism, criticized Hollywood, spent little on their films and made little to nothing from them. Sarah Cowan, 'The Best for the Most for the Least', *The Paris Review* (blog), 14 June 2017, https://www.theparisreview.org/blog/2017/06/14/the-best-for-the-most-for-the-least/.

22. Nelson referred to it as *Art X* while the Eameses called it *A Rough Sketch for a Sample Lesson for a Hypothetical Course*. They believed such extensive titles could further express the notion that the work was an idea still in progress. 'Sample Lesson for a Hypothetical Course', Eames Office, 19 December 2017, http://www.eamesoffice.com/the-work/sample-lesson-for-a-hypothetical-course/ (accessed 15 February 2019).
23. See John Neuhart, Marilyn Neuhart and Ray Eames, *Eames Design: The Work of the Office of Charles and Ray Eames* (New York: Harry N. Abrams, 1989), 238–41.
24. Charles Eames, Ray Eames and Daniel Ostroff, *An Eames Anthology: Articles, Film Scripts, Interviews, Letters, Notes, and Speeches* (New Haven: Yale University Press, 2015), 362–63.
25. Elmer Bernstein said that the Eameses 'married the music to their films'. The music was usually composed before the film was finalized. It was a common procedure for the film to be edited so that it fit the music. 'Vitra | How Charles and Ray Eames "Married" Music to Films', Vitra, https://www.vitra.com/en-us/magazine/details/how-charles-and-ray-eames-married-music-to-films (accessed 17 February 2019).
26. Pat Kirkham, *Charles and Ray Eames. Designers of the 20th Century* (Cambridge, MA: MIT Press, 1995), 323.
27. Colomina, 'Enclosed by Images', 13.
28. See Severino Alfonso and Loukia Tsafoulia, 'Perceiving AI: The Eye of the Algorithm', *Clog x Artificial Intelligence* (2018): 58–59.
29. Ralph Caplan argues that its message was not comprehended,

> the pace of the show is so fast that a person doesn't have enough time to weed out what he wants to see [...] a succession of images and sounds move so rapidly in time and space that they cannot be isolated, recognized or remembered as individual events but they are interwoven to form a total impression [...] too fragmented.

See Kirkham, *Charles and Ray Eames*, 325–28.
30. Eames, Eames and Ostroff, *An Eames Anthology*, 363.
31. Colomina, 'Enclosed by Images', 18.
32. In a 1970 interview of Charles Eames, American film critic Paul Schrader asked about information-overload as the most consistent technique in their films; he answered that it was 'to give more data than the mind can assimilate and the method to expand the ability to perceive'. Paul Schrader, 'Poetry of Ideas: The Films of Charles Eames', *Film Quarterly* 23, no. 3 (Spring 1970): 14.
33. Schrader, 'Poetry of Ideas', 14.
34. Philip Morrison, 'Eames Celebration', in Kirkham, *Charles and Ray Eames*, 347.
35. 'The crystal was for Kepes a module, an abstract integer, a cipher that encrypted order at all scales.' See Martin, 'Organicism's Other', 43.
36. Martin, 'Organicism's Other', 42–43.
37. See Alfonso and Tsafoulia, 'Perceiving AI', 58–59.

38. See 'Cats and Vision: Is Vision Acquired or Innate?', *Computer Vision Neural Science*, https://computervisionblog.wordpress.com/2013/06/01/cats-and-vision-is-vision-acquired-or-innate/ (accessed 29 July 2018).
39. 'Our conceptual knowledge reflects what we know about the world, such as learned facts, and the meanings of both abstract (e.g., freedom) and concrete (e.g., tiger) concepts.' See 'Understanding What We See: How We Derive Meaning from Vision', *Trends in Cognitive Sciences*, https://www.sciencedirect.com/science/article/pii/S1364661315001989 (accessed 21 April 2018).
40. *Oxford English Dictionary* (Oxford: Clarendon, 2013).
41. Gyorgy Kepes, *Language of Vision: With Introductory Essays by S. Giedion and S.I. Hayakawa* (Chicago: P. Theobald, 1951).
42. Norbert Wiener, *The Human Use of Human Beings: Cybernetics and Society*, 2nd ed. (Garden City, NY: Doubleday, 1954), 130–31.

BIBLIOGRAPHY

Abercrombie, Stanley. *George Nelson: The Design of Modern Design*. Cambridge, MA: MIT Press, 1995.

Amoroso, Nadia. *The Exposed City: Mapping the Urban Invisibles*. New York: Routledge, 2010.

Baudelaire, Charles. *The Painter of Modern Life and Other Essays*, 2nd revised ed. London: Phaidon, 1995.

Benjamin, Walter. *Charles Baudelaire: A Lyric Poet in the Era of High Capitalism*. London: Verso, 1999.

———. *On the Concept of History*. Createspace Independent Publishing Platform, 2016.

Blakemore, Colin, and Grahame F. Cooper. 'Development of the Brain Depends on the Visual Environment'. *Nature* 228, no. 5270 (1970): 477–78. doi:10.1038/228477a0.

Colomina, Beatriz. 'Enclosed by Images: The Eameses' Multimedia Architecture'. *Grey Room* 2 (2001): 6–29.

Corner, James, and Alison Bick Hirsch. *The Landscape Imagination: Collected Essays of James Corner, 1990–2010*. New York: Princeton Architectural, 2014.

Eames, Charles. 'Language of Vision: The Nuts and Bolts'. *Bulletin: The American Academy of Arts and Sciences* 28 (October 1974): 13–25.

Eames, Charles, Ray Eames and Daniel Ostroff. *An Eames Anthology: Articles, Film Scripts, Interviews, Letters, Notes, and Speeches*. New Haven: Yale University Press, 2015.

Eames, Charles, and Owen Gingerich. 'A Conversation with Charles Eames'. *American Scholar* 46, no. 3 (1977): 313–26.

Eisenstein, Sergei M., and Jay Leyda. *Film Form: Essays in Film Theory*. Cleveland, OH: World, 1964.

———. *The Film Sense*. London: Faber and Faber, 1986.

'Films'. Eames Office. Accessed 29 July 2018. http://www.eamesoffice.com/catalog-category/films/.

'George Nelson'. George Nelson Foundation. Accessed 29 July 2018. http://www.georgenelsonfoundation.org/george-nelson/index.html#exhibitions/american-national-exhibition-moscow-124.

Halpern, Orit. *Beautiful Data: A History of Vision and Reason since 1945*. Durham, NC: Duke University Press, 2015.

Haraway, Donna Jeanne. *Crystals, Fabrics, and Fields: Metaphors of Organicism in Twentieth-century Developmental Biology*. London: Yale University Press, 1976.

Hubel, D. H., and T. N. Wiesel. 'Receptive Fields of Single Neurones in the Cats Striate Cortex'. *Journal of Physiology* 148, no. 3 (1959): 574–91. doi:10.1113/jphysiol.1959.sp006308.

Jacob, François. *The Logic of Life*. Translated by Betty E. Spillmann, 1st ed. Princeton, NJ: Princeton University Press, 1993.

Kay, Lily E. 'Cybernetics, Information, Life: The Emergence of Scriptural Representations of Heredity', vol. 5. 1997. doi:10.1353/con.1997.0004.

Kepes, Gyorgy. *Language of Vision*, 1st ed. Chicago: P. Theobald, 1944.

———. *The New Landscape in Art and Science*, 1st ed. Chicago: P. Theobald, 1956.

Kirkham, Pat. *Charles and Ray Eames: Designers of the Twentieth Century*. Cambridge, MA: MIT Press, 1995.

Martin, Reinhold. 'Organicism's Other'. *Grey Room* no. 4 (2001): 35–51.

———. 'The Organizational Complex: Cybernetics, Space, Discourse'. *Assemblage* no. 37 (1998): 103–27. doi:10.2307/3171358.

McLuhan, Marshall. *Understanding Media: The Extensions of Man*. New York: McGraw-Hill, 1964.

Moholy-Nagy, László. *The New Vision: Fundamentals of Bauhaus Design, Painting, Sculpture, and Architecture*. Translated by Daphne M. Hoffmann. Mineola, NY: Dover, 2005.

———. *Vision in Motion*, 1st ed. Chicago: P. Theobald, 1947.

Neuhart, John, Marilyn Neuhart, Ray Eames and Charles Eames. *Eames Design: The Work of the Office of Charles and Ray Eames*. New York: Abrams, 2012.

Picon, Antoine, and Alessandra Ponte. *Architecture and the Sciences: Exchanging Metaphors*. New York: Princeton Architectural Press, 2003.

Schrader, Paul. 'Poetry of Ideas: The Films of Charles Eames'. *Film Quarterly* 23, no. 3 (1970): 2–19. doi:10.1525/fq.1970.23.3.04a00030.

Shannon, Claude, and Warren Weaver. *The Mathematical Theory of Communication*. Urbana-Champagne: University of Illinois Press, 1963. Originally published 1949; reprinted 1998.

Underwood, Max. 'Inside the Office of Charles and Ray Eames'. *Ptah* (2006): 46–63.

Weiser, Mark. 'The Computer for the 21st Century'. *Scientific American* 265, no. 3 (1991): 94–104.

Wiener, Norbert. *Cybernetics: Or Control and Communication in the Animal and the Machine*. New York: MIT Press, 1961.

———. *The Human Use of Human Beings: Cybernetics and Society*. New York: Avon Books, 1988.

Film List

Berlin: Symphony of a Great City. Directed by Walter Ruttman, USA: 20th Century Fox, 1927.
Blacktop. Directed by Charles Eames and Ray Eames, USA: Eames Office, 1952.
The Camera That Changed the World. Directed by Mandy Chang, UK: Lambent Productions, 2011.
A Communications Primer. Directed by Charles Eames and Ray Eames, USA: Eames Office, 1953.
Glimpses of the USA. Directed by Charles Eames and Ray Eames, USA: Eames Office, 1959.
Here They Are Coming Down Our Street. Directed by Charles Eames and Ray Eames, USA: Eames Office, 1952.
The Information Machine. Directed by Charles Eames and Ray Eames, USA: Eames Office, 1958.
The Man with a Movie Camera. Directed by Dziga Vertov, Soviet Union: All-Ukrainian Photo Cinema Administration, 1929.
Manhatta. Directed by Charles Sheeler and Paul Strand, USA: Paul Strand Archive, 1921.
Metacity/Datatown. Directed by MVRDV, Netherlands: MVRDV, 1999.
Powers of Ten. Directed by Charles Eames and Ray Eames, USA: Eames Office, 1977.
Some Like It Hot. Directed by Billy Wilder, USA: Mirisch Company, 1959.
Think. Directed by Charles Eames and Ray Eames, USA: Eames Office, 1964.

PART II

NARRATED DIVERSITY OF FILMIC URBAN CULTURE

6

Architecture of Constructed Situation: Understanding the Perception of Urban Space through Media

Katarina Andjelkovic

Introduction

Despite the fact that technology and media are designed to support our everyday lives, their omnipresence has started to steer our reality. As a consequence, space is no longer a neutral container in which media can simply take place or come to pass; it responds to the presence of media.[1] Over the past decades, architects and urbanists have been trying to understand and guide these new conditions. They are finding that media is reconfiguring the expression of what is real. Moreover, these media-saturated environments significantly change the way we perceive space and consequently destabilize one's connection with reality. The implications are visible as urbanists of the new digital age are primarily focused on the new regimes of multiple screens and images in urban settings, which are radically redefining qualities of real space through the qualities of virtual worlds. Walter Benjamin's method of dissecting urbanity towards producing readings of real worlds[2] and Paul Virilio's strategy of producing virtual worlds[3] can be understood as samples which probe and problematize the perceptual construction of urban space. This chapter's hypothesis is that understanding specific economies of perception in the context of media-saturated urban conditions is only possible by dissecting their historical trans-media framework, as initiated by Benjamin and Virilio. For that purpose, this chapter reads the conditions of our changed perception of space through the eyes of film-makers Jacques Tati, David Lynch, Ronald D. Moore and Michael Dinner, specifically by adopting their cinematic concepts of 'distracted perception' and 'dialectic montage'. The argument is that early twentieth-century interest in new technologies and their perceptual effects helped produce a groundbreaking

redefinition of art, one that literalized the Greek *aesthesis* by turning aesthetics into a training ground for sensory capacities.

In her essay 'Stimulating the Second Space', Julian Petrin asserts, 'The perceptual space overlays the physical space to make the latter visible.'[4] This claim addresses the construction of urban space based on the value of the mental images. As our daily experience of urban space has gradually become mediated through digital images via web applications, technologies of urban display and personal devices, all our existence has begun migrating beyond the limits of physical space. Rather than relying solely on the reassertion of physical conditions in regulating visual parameters of the urban environment, could urban display be legitimized as including meditated windows to other realities? In fact, the past decades testify that urban space has become a progressively mediatized and mobilized category, trapped in a high degree of instability. This is reflected in some of its most radical versions constructed by media, such as film or photography, which aspire to alienation from our reality. Consequently, our perception of the urban environment has been flattened to a fragmentary re-collection of impressions trapped in a play with the alienated reality, contending over an uncertain future only to negotiate with reality. This change has propelled new intellectual grounds for thinking through images.

In *The Work of Art in the Age of Mechanical Reproduction* (1936), Walter Benjamin asserts that architecture is a prototype for film, since both are received 'by a collectivity in a mode of distraction'.[5] What Benjamin suggested in the early twentieth century as the potential of architecture to estrange the perception of the real by exposing the ordinary spectator to the shocking newness of the modern city was later elaborated in Paul Virilio's writing. As screens are being mounted in urban spaces and installed in buildings, new forms of communication grow into the daily consumption of moving images and finally reach a frame of reference for spatial phenomena, or, in Virilio's words, 'since the beginning of the twentieth century [...] the screen [...] became the city square'.[6] In identifying that both cinema and urbanity are the technologies for capturing and managing spatial and temporal matters, such weakening of urban space can be turned into potential. Indeed, cinema and urbanity share common ground, as both are technological expressions for the emergent culture of screens, fictions, simulacra, motion, spectatorship and flow. In such a context, it becomes certain that the urban instability of the real world today can be problematized by analysing the film-makers' methods employed for managing similar problems in the fictional worlds of the films. Whether the film-maker seeks to keep spectators' attention, trap them in the alternating *simulacrum*, as described by Jean Baudrillard, or walk them through space in the Benjaminian 'distracted' mode, the film-maker would respond by establishing anew the continuity of tension through the protagonist of

the film action. As it became increasingly mediated by film, urban space inevitably replaced monumentality as an urban constant of the eternity for an intensified and empowering dialogue of the moment. In this way, urban space finally discovered means to maintain the dynamic continuity of its temporal manifestations. Therefore, film-makers' procedures have challenged an immediate spatial scenario of real space in mirroring alternate realities – one that represents things in the world as they are, and the other that examines its potentially illusory character.

To deal with this issue, this author proposes to replace the static narrative of architecture with a more dynamic architecture of constructed situation, whereby the word 'situation' is interpreted in ambivalent conditions: in realms of human emotional amplification, and beyond the realms of human in instability raised from recolonization of the urban environment.

The first situation: Dialectic montage

Dialectic montage is a way of combining and productively juxtaposing film frames from which new ideas arise. It deals with examining how the rhythm of editing film induces emotions. In Jacques Tati's *Playtime* (1967; Figure 6.1), this was achieved by taking the dialectic montage to directly address the viewer. For example, Tati juxtaposed historical scenes of the city with nascent high-tech modern ambiance, to reveal how the montage affects their respective reality and interpretation. By emulating the choreography of city movements (people, vehicles, lights) and technology (lifts, machines, glass facades), the film-maker transformed the city into an audiovisual event. This way, conventional architectural space in *Playtime* disappears in favour of a moving city in time and space. In other words, the dialectic is contained in the presentation of architecture on the screen, whereby Jacques Tati replicates it through the experience of its presence – signals, shapes and lights – and not the object itself. He demonstrates an impossible representation, that of a city that has no existence in itself, but which is only an incident in time and space.

Another example of triggering emotional amplification through dialectic montage is video stills from Pharrell Williams's *Happy* (2013). These images keep the emotional logic of expression by choosing the one-point perspective and changing the background of each shot. Progressing in a sequenced order, architecture gravitates to the boundary of the spectacle. Even closer to the spectacle is the programmed light signals game of two towers in Bull.Miletic's video *Par Hasard* (2009; Figure 6.2). The spatial progression is described significantly by non-visual means: from impossible encounters to even less certain perspectives while physical movement and virtual communication are juxtaposed in an encoded dialogue. Instead of the protagonists, the two towers now enter into communication.

FIGURE 6.1: Jacques Tati, *Playtime*, 1967. © Film stills.

In a strange encrypted dialogue, the first tower says, 'No, the past is fantastic', while the second one replies, 'No, the future is fantastic.' The mute building is communicating with us in a dead language of modernity, the Morse code, which was used as an international standard for communication.[7] The dialogue is mediated by constant displacement from its space and time, removing all constraints between them. This way, the artists use the visual language as a mode of 'encoding' our contemporary spatial experience, resisting persistently the time and place it seemingly belongs to. Superimposing the present with scenes from the past, they create a tension in this dialogue, and by manipulating the material from diverse time sources they open the dialectic reading of the imaginary spatial progression through the tower.

On the other hand, the dialectic reading of David Lynch's TV series *Twin Peaks* (1990) challenges the status of the image that is neither media nor medium specific. In the postmodern reading, we have an opportunity to examine how his films affect our perception of space decoded in its emotional and temporal progression. As Lynch uses conventional language to convey ideas, his film images operate beyond merely material or intellectual practice, and thus refer specifically to the ideas of American architect Mark Linder. As elaborated by Linder in his essay 'Images and Other Stuff', the mode of image operation is through association, affect and processing.[8] These functions are typified in postmodern film production. David Lynch's red room scene from *Twin Peaks* (Figure 6.3) is what Lynch calls a 'site of vision' to be experienced in a location specifically demarcated for affect. This method of operative image through affect is generated as a postmodern reaction against idealism and simplicity of modernism. As intended to work through complexity and often to impose multiple layers of meaning and truth, the postmodern principle is reflected in confusing the spectator. By fully embodying the potentialities of postmodern hyper-reality, intertextuality, distrust and distortion, Lynch establishes a space in which time proceeds in a different way. Thus, he directs a series of truth-provoking sequences implying their spatial expression.

David Lynch articulates a 'real-time cinematic process that blends images together through time',[9] generating immersive drama for the spectator. This is

FIGURE 6.2: Bull.Miletic, *Par Hasard*, 2009, SD video (colour, sound), 5:23 min. © Video still. Courtesy of the artists.

detected within the red room scene with a dwarf in a red suit, and a woman whom the FBI agent meets on his way to solve the mystery regarding the death of Laura Palmer. One layer of the mystery for the spectator is contained in the dialectic image of the woman in the scene, questioning whether she looks exactly like Laura Palmer. In the final episode of *Twin Peaks*, we meet another layer of mystery contained in the remarkable complexity of the threshold. With the idea of linking different spaces in the same scene by navigating the spectator through an endless series of corridors, cinematic spaces start to work as temporal passages. To mark the impossibility of reaching the final destination, Lynch suddenly starts to blur spaces in the film scene, and this is achieved by overlaying images. This narrative works precisely to convey the idea of the red room as a space of permanent transition. As such, the narrative of the scene implies the disturbances of space, time and identity, and their final distrust in an exclusively postmodern manner.

Similar disturbances of space and time with an ability to transform urban space are recognized in Edward Soja's writings. It is precisely his explication of the *postmetropolis*[10] that can link this discussion to the dialectical reading of the space in film. This was possible due to the tradition of these spaces functioning as places simultaneously real and imagined. The application of Soja's experience of the postmetropolis within the contemporary media climate is in understanding formal complexity of the city paired with certain instability. More precisely, his recognition of what he calls 'weakening of the sense and idea of place' can

help us unearth the present but not immediately visible strata of the contemporary city, whether we are attempting to deal with increasing electronic media in our daily routines, the layer of perception or environmental and multiplying geopolitical conflicts. In it we can experience a convergence of simultaneous de-territorialization and re-territorialization of the urban environment, which means simultaneous processes of disassembling pre-existing urban realities and re-colonization of the city with new ones.[11] On the other hand, in film, urban space is dissected in its fragments, disturbances and the imaginary – a series of pilgrimages that are focused on frustrations, affect and diversions of the city. Thus, one might conclude that the film-maker's ability to transform space-time relations from real space to the conceptual gives the film image applications for understanding real spaces within the diversity of its perceptions. Such an approach is recognized in Soja's decision to offer space as a dialectic phenomenon: simultaneously actual and conceptual.

This is precisely how static architectural representations have been challenged to give way to the dynamic architecture of constructed situation. We were warned about it much earlier, when Henri Bergson claimed that 'we cannot grasp the unceasing flux of reality with static ready-made concepts'.[12] This way, we are moved towards discerning what Fredric Jameson calls 'emergent mediatic conceptuality'.[13] For this purpose, Bergson offered a clear philosophical strategy of breaking the habit in representing things spatially that should be understood temporally. This is aligned with Jameson's hopes of solving postmodernism's loss of temporal continuity.[14] The strategy was made possible once Bergson separated the mechanistic time of science (clock-time) from time as we actually experience it (lived time) or *durée*. This was achieved in his crucial passage from *Matter and Memory*, where he issued a challenge that 'questions relating to subject and object, to their distinction and their union, should be put in terms of time rather than space'.[15] This philosophical strategy can be applied to direct the observer's attention in the urban space. The aim is to offer a systematic framework for implementing cinematic dialectic montage in future urban procedures. Namely, this method can be compared with the alternate overlapping of the real and virtual spaces of synchronized movements. Whether in the real environment or through mobile phone applications, it is a world in which we ourselves are the directors of our own dialectical realities. Given that architecture is at once emotional and intellectual, humanity's perception is qualified to give place ultimately to events and constructed situations instead of static narratives. As such, this space exists on the threshold between the real and the imagined. It is arguable that urban space in the future should consider not only its intellectual but also its emotional layer, as it is more concerned with associated instable iterations and manifestations.

FIGURE 6.3: David Lynch, the red room scene in *Twin Peaks*, 1990. © Film stills.

The second situation: Distracted perception

Distracted perception deals with ideas beyond the realm of human. By using Walter Benjamin's important view on the history of perception and its correlation with the history of technology, the image of instability will now be contextualized in the urban scale. Although Benjamin uses the word 'technology' in this context, his discussions participate in the formative period of media theory and as such are undeniably closely related to what we call media discourse today. In the context of generating historically specific economies of perception, our interest lies in detecting whether a category of urban display can function as a device for providing a passage to other realities, as the specific mode of distraction. For example, by developing a type of urban display with his installation art, Philippe Parreno demonstrates a specific understanding of film frames inserted into the large-scale installation. He constructed a billboard saying 'Welcome to Twin Peaks' to greet visitors entering the labyrinthine spaces of the seminal group exhibition *No Man's Time* in Nice in 1991. This installation offers an opportunity to contemplate other realities. Involving architectural elements from Lynch's film, the 'distraction' is contained in the very act of display. The spectators get instantly familiar with the other reality – that of the film. As such, the film narrative of inverted set of relations exemplifies the coexistence of spaces belonging to different realities.

Dealing with film in the second case study, we are tempted to illustrate the nature of relationship between the 'perception of urban space' and 'the logic of moving image operations', as reflected on the viewer. Practicing architects use the notion of a display to challenge different ideas about what it means to design for display. Architecture theorists problematize the notion of an urban display as a window to other realities. What started with Benjamin's recognition that 'distraction' occurs in film through the 'shock effect' of its image sequences[16] originates from the urban environment where the collective seeks to be distracted. This can be recognized in some of its most radical versions constructed by film, where it becomes a means to escape everyday reality. That is to say, it is possible to continue the modernistic aspiration for alienation from our reality, trapped in a high degree of insecurity. In a science-fiction ten-episode TV series *Philip K. Dick: Electric Dreams* (Ronald D. Moore and Michael Dinner, 2017), the alienation was achieved by exploring unknown realities of human memory. The film narrative unfolds as the passage between mental states, with an idea to disclose memories of a person (Figure 6.4). The mental state of the protagonist functions as a metaphoric window through which he seeks to uncover reality. Remembering an everyday life situation is presented as follows: each protagonist's presumably primary reality is the other's vacation. What we get at the end is mirroring alternate realities. Consequently, the mental state of the protagonist seems to be the device for challenging reality, asking: which is the real one of the two alternate realities? Yet another dilemma: how do our needs transform that reality in

FIGURE 6.4: Ronald D. Moore and Michael Dinner, *Electric Dreams*, 2017. © Film still.

order to maintain it through the productive tension with illusion? In order to maintain the dynamic continuity of permanently unfolding events (which is in the etymology of the word 'display'), while searching to keep up the spectator's attention or work in the Baudrillardian *simulacrum*,[17] the film-maker would respond by establishing anew the continuity of tension through the protagonist of the film action.

Following the elaborated trend of distracted perception, the image of instability might introduce an apocalyptic scenario on a wider urban scale. Profiled in ephemerality, the dominant trends of the present – unstoppable flows of climate crisis, massive migrations and financial capital – are heavily mediated circulating continually through diverse news channels. As such, they respond to the logic of the media constructions of reality by constantly renewing the present moment. Moreover, this space of real-time flows progressively becomes part of our everyday perception of the urban environment. The world has taken a flexible shape through the juxtaposed interactions, transactions and communications. As such, the world needs no architecture anymore in order to keep the utopian relationship between technology, media and contemporary life. Notwithstanding, willing to re-gain its place in the world, architecture has brought its disciplinary boundaries to their safe asylum and is now circulating exclusively in the hyper-modern simulacrum. As result, this apocalyptic scenario exists beyond normal boundaries of space and time, in Foucault's *heterotopia*.[18]

In this context, it is not rare for architects to provide alternatives to the apocalyptic scenario. They start investigating the idea that our perception in movement can link real and virtual spaces into simultaneous reality. I tested this hypothesis in my research project *Key of the Game – The Conquest of Belgrade Fortress* (2010; Figure 6.5).[19] The research is set in the domain of interactive urban environment. It is essentially connected to the inability of traditional urbanism to support our perception in movement. I test the hypothesis through the scenario of Foucault's *heterotopia*, not only due to its ability to remain outside of all places,[20] but rather due to its capacity to keep the relation with all the other sites. In such a way, it suspects, neutralizes or inverts the set of relations that they happen to designate, mirror or reflect.[21] Implementing Foucault's scenario into my research, *Key of the Game* research project was designed as a space occupying alternately virtual and real environments, during game playing in the Belgrade Fortress area. The players take interactive roles and are guided virtually to move physically through the site. They build together the physical and virtual layers of the city in a continuous fashion by providing the complementary analysis of information in the virtual system. These incessant interactions occur between actors in real physical space, as well as actors with space. Direct participation in the game is based on the selection of a personal

FIGURE 6.5: Katarina Andjelkovic, *Key of the Game – The Conquest of the Belgrade Fortress*. Web Platform: Processing the Game. Research project by author, 2010. © Courtesy of the author.

trajectory of movement, identification with a particular historical figure (avatar, Figure 6.5) and the completion of the survey. All stored data on the web platform would then link the physical spaces, objects in the park and the Fortress with a virtual online resource. Simultaneously, a continuous data circulation is visualized in the trenches of the Fortress, where the collaborative engagement with video installations is finally executed.

Today we are equipped with instruments to record processes faster and transmit them continuously to a network. Thus, structuring data spatially and creating interactive virtual bases can reveal something about the perception in movement in real space. Information is the key to this process. The role of the game is to indicate invisible mutable traces of actions that could never before be traced as such. By experimenting with virtual reality in exchange for the real-world experience, architects aim to understand and guide these new conditions of mediated urban space. Their method is based on gradual shifts from digital environments into real-life situations by identifying each element of the digital world with its equivalent in the real world. Considering that hierarchies do not exist in digital space to link data, by transferring its phrases and syntaxes to real space

the hierarchies of the physical world could be abolished. In that regard, the implications are also visible in the unconventional language of architecture that uses information as cultural product to incessantly fill the system and transform fixed values and subjects. Manuel Gausa highlights the possibility of implementing these ideas in architecture by emphasizing that 'the innovation with which the digital world is constructed needs to be carried over into the physical world'.[22] He states that technological advances effectively make it possible to animate structure, anticipate processes and generate flexible, interactive systems. In fact, Virilio is the one who has retrieved the role of perceptual dimension to this discussion, having identified the determinants that generate specific economies of perception produced by the media. The function of the perception is to impose a new dimension of space that can continually locate us in the virtual network of the city. Deprived of objective boundaries, the architectonic element begins to drift and float, devoid of spatial dimensions (depth, distance, scale, the type of spatial form, openness), but inscribed in the singular temporality of an instantaneous diffusion.[23] The space-time of such representation of the world no longer involves the physical dimensions of geometry, as the notions of time and space became invalidated with Heisenberg's uncertainty principle[24] and Planck's constant.[25] From here on, architecture of real space will have to work with the opening of new technological space-time. This technological degradation of various milieus that, according to Lyotard, has capacity to overwhelm experience,[26] and consequently break the intuitive notion of order, is also

> topological to the extent that – instead of constructing a perceptible and visible chaos, such as the processes of degradation or destruction implied in accident – it inversely and paradoxically builds an imperceptible order, which is invisible but just as practical as masonry or the public highway system.[27]

Accordingly, the abandonment of existing urban conditions triggered by removing the boundaries between architecture, technology and media produces the 'image of instability', following post-Kantian and a post-Heideggerian displacement.

In consequence, the virtual world is ushering in a space rich in perceptual possibilities – a space open to new programs and new spatial definitions, born of operative environments that are capable of 'reacting to' and 'mutating with' reality, and thus capable of 'tuning in' to and 'acting' in it at the same time. Virilio's technological and communicational deregulation heralds a new feature of architecture in relation to its capacity to organize society's time and space[28] – a phase that will in all probability see the introduction of previously unimagined – or at best vaguely intuited – technologies and formal concepts in every aspect of urban thinking.

Conclusion: Implication

Despite the current apocalyptic status of the discipline, architecture will eventually survive the conditions of instability caused by progressive immersion of virtual realities into everyday life. Instead of neglecting the new reality, architecture will choose to practice the impossible, virtual and the imaginary, in order to make the invisible conditions now visible in its Hegelian *dasein*.[29] Moreover, architecture is trying to reinvent itself through a mirage of illusions and delusions, according to the logistics of perception in movement of not only people and goods, but also images, as indicated by Virilio. All the more so because the resulting changes might concern the very idea of designing future urban space as necessity to 'take a realistic attitude to reality',[30] to use François Penz's words. Hiding behind this problematic is the specific condition that we need to undertake to be able to perceive and grasp the complexity of urban phenomena today. As emphasized in the series of Penz's writings, it is exactly our reality that needs to challenge the traditional disciplinary boundaries of urban design by cinematic means.[31] In other words, while keeping the virtual as the contestable condition of a non-welcoming post-space, real space is getting de-territorialized and re-territorialized through the cinematic re-constellation of images imploded perpetually in urban space.

It is now clear that the dominancy of the image in the present culture can be orchestrated by the film-makers and thus re-contextualized and reconnected with our physical reality over again. All the same, with the emergence of such alternative reality as the defining scheme of the emerging digital urbanity, our world is becoming spatially and temporally discontinuous. On the other hand, the emergence of the 'space of flows' (Manuel Castells) referenced back to the dominance of 'image' and 'information' over 'space as location'. This unique condition is seen as the possibility to reconnect places and spaces previously constructed in different environments: virtually from images and information, and physically, from streets, blocks and squares. In that regard, film strategies have the potential to reveal both material and immaterial worlds. It is exactly in this context that film strategies have been shown as a positive example of exploring growing urban trends nowadays.

Finally, today, managing our perceptual engagement with urban space needs to be re-examined in its ambivalent conditions: first, in the realm of human, and second, beyond human as primarily technologically saturated. However, what can defeat this system of urban strategies is not advocating different forms of a positive alternative to reality, offered by the film-maker. In other words, 'specificities' do not contribute to either positive principle or negative connotations. They are not 'alternatives', they belong to the 'other order of things',

according to Baudrillard. There is no other regime of reality to our own. We all perceive the world around us in images and these images are mediations between us and the virtual environment. What we get in the end is perceived reality through moving images transgressing the limits of our imagery, revealing to each and every one of us the potential agency of moving and creating images of our own realities. It would also be one of the most important functions of urban space today: to become the key connector of human experience in order to ensure spontaneous use, frequent interaction, freedom of expression and multifunctionality of space.

NOTES

1. Francesco Casetti, 'Mediascapes: A Decalogue', *Perspecta* 51, Medium (2018): 21.
2. Walter Benjamin, *The Work of Art in the Age of Mechanical Reproduction*, trans. J. A. Underwood (London: Penguin Books, [1936] 2008).
3. Paul Virilio, *The Lost Dimension*, trans. Daniel Moshenberg (New York: Semiotext(e), 1991); and Paul Virilio, *Negative Horizon: An Essay in Dromoscopy*, trans. Michael Degener (London: Continuum, 2008).
4. Julian Petrin, 'Stimulating the Second Space', in *The Image and the Region: Making Mega-City Regions Visible!*, ed. A. Thierstein and A. Foerster (Baden: Lars Muller, 2008), 155–67.
5. In *The Work of Art in the Age of Mechanical Reproduction* (1936), Walter Benjamin defined what he called the viewer's 'reception in distraction': a floating attention, in which sensations were more the fruit of a chance impression than of sustained attention.
6. Virilio, *The Lost Dimension*, 25.
7. Branislav Dimitrijevic, 'Experiencing a City – Between Reflecting and Projecting', in *Cities Re-imagined: Film & Video from Norway*, ed. Bull.Miletic (Novi Sad: Museum of Contemporary Art Vojvodina, 2010), 23–24.
8. Mark Linder, 'Images and Other Stuff', *JAE* 66, no. 1 (2012): 3–8.
9. Gilles Deleuze, *Cinema 1: The Movement-Image*, trans. Hugh Tomlinson and Barbara Habberjam (Minneapolis: University of Minnesota Press, 1986).
10. Edward Soja used the concept of *postmetropolis* as a general term to write about the modern Metropolis changing very dramatically in the last four decades of the twentieth century. Edward W. Soja, *Postmetropolis: Critical Studies of Cities and Regions* (Oxford, UK: Blackwell, 2000).
11. Patrik Sjöberg, 'I Am Here, or, The Art of Getting Lost: Patrick Keiller and the New City Symphony', in *Urban Cinematics: Understanding Urban Phenomena through the Moving Image*, ed. François Penz and Andong Lu (Bristol, UK: Intellect, 2011), 48.
12. Henri Bergson, *Creative Evolution*, trans. Arthur Mitchell (New York: Henry Holt, [1907] 1911).

13. Fredric Jameson, *Postmodernism, or, the Cultural Logic of Late Capitalism* (Durham, NC: Duke University Press, 1992).
14. Daniel Punday, *Narrative after Deconstruction* (Albany: State University of New York Press, 2003), 91.
15. Henri Bergson, *Matter and Memory*, trans. Nancy Margaret Paul and W. Scott Palmer (London: George Allen and Unwin, [1896] 1911), 71, 218.
16. Benjamin, *The Work of Art in the Age of Mechanical Reproduction.*
17. Baudrillard is arguing that the everydayness of the terrestrial habitat hypostatized in space marks the end of metaphysics, and signals the beginning of the era of hyper-reality: that which was previously mentally projected, which was lived as a metaphor in the terrestrial habitat, is from now on projected, entirely without metaphor, into the absolute space of simulation. Especially important in this context is his notion of 'the satellization of the real itself'. Read more in: Jean Baudrillard, *The Ecstasy of Communication*, trans. Bernard Schütze and Caroline Schütze (South Pasadena, CA: Semiotext(e), 2012).
18. Michel Foucault, 'Of Other Spaces, Heterotopias', *Architecture, Movement, Continuite* 5 (1984): 46–49.
19. *Key of the Game – the Conquest of Belgrade Fortress*, originally performed in full authorship at the University of Belgrade, Faculty of Architecture, as part of the doctoral studies program, during 2010. Later published in: Katarina Andjelkovic, 'Spatial Context of the Cinematic Aspect of Architecture' (PhD diss., University of Belgrade, 2015).
20. Even though it may be possible to indicate their location in reality. Read in: Michel Foucault and Jay Miskowiec, 'Of Other Spaces', *Diacritics* vol. 16, no. 1 (Spring 1986): 24.
21. Michael Foucault's elaboration in his piece 'Of Other Spaces', based on a lecture, but first published in English in 1986.
22. Manuel Gausa, 'Theoretical Framework', in *Media House Project: The House Is the Computer. The Structure Is the Network*, ed. V. Guallart (Barcelona: Institut d'arquitectura avançada de Catalunya, 2004), 36.
23. Virilio, *The Lost Dimension*, 13.
24. The 'Uncertainty principle' (also known as Heisenberg's uncertainty principle), https://en.wikipedia.org/wiki/Uncertainty_principle (accessed 2 April 2018).
25. Virilio, *The Lost Dimension*, 21–22.
26. Jean François Lyotard, 'Presenting the Unrepresentable: The Sublime', *Artforum* 20, no. 8 (1982): 64–69.
27. Virilio, *The Lost Dimension*, 21.
28. Virilio, *The Lost Dimension*, 22.
29. The term was used most notably by Georg Wilhelm Friedrich Hegel, with the meaning of human 'existence' or 'presence'. It is derived from *da-sein*, which literally means 'being-there/there-being'.
30. François Penz and Andong Lu (eds), *Urban Cinematics: Understanding Urban Phenomena through the Moving Image* (Bristol, UK: Intellect, 2011), 16.

31. Penz and Lu, *Urban Cinematics*, 219–310.

BIBLIOGRAPHY

Andjelkovic, Katarina. 'Spatial Context of the Cinematic Aspect of Architecture'. PhD diss., University of Belgrade, 2015.

Baudrillard, Jean. *The Ecstasy of Communication*. Translated by Bernard Schütze and Caroline Schütze. South Pasadena, CA: Semiotext(e), 2012.

Benjamin, Walter. *The Work of Art in the Age of Mechanical Reproduction*. Translated by J. A. Underwood. London: Penguin Books, [1936] 2008.

Bergson, Henri. *Creative Evolution*. Translated by Arthur Mitchell. New York: Henry Holt, [1907] 1911.

———. *Matter and Memory*. Translated by Nancy Margaret Paul and W. Scott Palmer. London: George Allen and Unwin, [1896] 1911.

Caldwell, Glenda Amayo, Carl H. Smith and Edward M. Clift, eds. *Digital Futures & the City of Today: New Technologies and Physical Spaces*. Chicago: Intellect, 2016.

Casetti, Francesco. 'Mediascapes: A Decalogue'. *Perspecta* 51, Medium (2018): 21–44.

Colebrook, Claire. *Gilles Deleuze*. London: Routledge, 2002.

Deleuze, Gilles. *Cinema 1: The Movement-Image*. Translated by Hugh Tomlinson and Barbara Habberjam. Minneapolis: University of Minnesota Press, 1986.

Dimitrijevic, Branislav. 'Experiencing a City – Between Reflecting and Projecting'. In *Cities Re-imagined: Film & Video from Norway*, edited by Bull.Miletic. Novi Sad: Museum of Contemporary Art Vojvodina, 2010.

Foucault, Michel, and Jay Miskowiec. 'Of Other Spaces'. *Diacritics* Vol. 16, no. 1 (Spring 1986): 22–27.

Guallart, Vicente, ed. *Media House Project: The House Is the Computer. The Structure is the Network*. Barcelona: Institut d'arquitectura avançada de Catalunya, 2004.

Jameson, Fredric. *Postmodernism, or, the Cultural Logic of Late Capitalism*. Durham, NC: Duke University Press, 1992.

Linder, Mark. 'Images and Other Stuff'. *JAE* 66, no. 1 (2012): 3–8.

Lyotard, Jean François. 'Presenting the Unrepresentable: The Sublime'. *Artforum* 20, no. 8 (1982): 64–69.

Penz, François, and Andong Lu, eds. *Urban Cinematics: Understanding Urban Phenomena through the Moving Image*. Bristol, UK: Intellect, 2011.

Petrin, Julian. 'Stimulating the Second Space'. In *The Image and the Region: Making Mega-City Regions Visible!*, edited by A. Thierstein and A. Foerster, 155–67. Baden: Lars Muller, 2008.

Punday, Daniel. *Narrative after Deconstruction*. Albany: State University of New York Press, 2003.

Soja, Edward W. *Postmetropolis: Critical Studies of Cities and Regions*. Oxford, UK: Blackwell, 2000.

Virilio, Paul. *The Lost Dimension*. Translated by Daniel Moshenberg. New York: Semiotext(e), 1991.

———. *Negative Horizon: An Essay in Dromoscopy*. Translated by Michael Degener. London: Continuum, 2008.

Film/TV Series/Video List

Electric Dreams. Directed by Ronald D. Moore and Michael Dinner, UK, USA, 2017.

Par Hasard. Directed by Bull.Miletic. SD video (colour, sound), 5:23 min, 2009.

Playtime. Directed by Jacques Tati, France, 1967.

Twin Peaks. Directed by David Lynch, USA, 1990.

7

Polyphonic Asia: Contemporary City Symphonies of Singapore and Seoul

Simone Shu-Yeng Chung

Introduction

Discussions on city symphonies continue to revolve around the 1920s avant-garde films that showcased the modern city experience of Paris, Berlin and Moscow. With its rhythmic editing of on-location shots, John Cavalcanti's social commentary on Paris in *Rien que les Heures* (1926) sets the precedent for this genre, but the canonical films of this modernist experiment are undoubtedly *Berlin: Symphony of a Great City* (Walter Ruttmann, 1927) and *Man with the Movie Camera* (Dziga Vertov, 1929). Located in the silent film era, these cinematic masterpieces sought to convey the urban textures and competing rhythms that characterized the modern European metropolis. For this reason, early city films were seen to provide valuable visual documentation. As Helmut Weihsmann has argued, the 'incorruptible camera-eye' was a reliable tool for truthfully recording everyday places and real-life situations.[1]

Made five decades later, the eight-minute film *Sunshine Singapore* (1968–72) by Rajendra Gour fulfils the criteria of a city symphony – with its rhythmic montage, the use of real city locations and a diurnal sequence – even though Gour himself was unaware such a genre existed.[2] Originally from India, Gour relocated to Singapore in 1964 to work as a news editor at Radio and Television Singapore. *Sunshine Singapore*, a labour of love that took four years to complete, was motivated by a desire to record the accelerated urban transformations and socio-economic progress in his adopted country. Employing rhythmic montage and experimental cinematography, the film's dynamic audiovisual content is a testament to Gour's editing skills. Photographs as well as tender close-ups of his wife are

FIGURE 7.1: Singapore River c.1970. *Sunshine Singapore*. Courtesy of Asian Film Archive and Rajendra Gour.

juxtaposed against footage of urban life. Frame speeds are manipulated to match the varying tempo of an instrumental soundtrack, which is punctuated midway by the roar of thunder and rainfall. In the same vein as early city symphonies, this portrait of 1960s Singapore under Prime Minister Lee Kuan Yew's leadership treats the 'big city as a living organism, symbol of industry and progress' envisioned by Weihsmann.[3] More importantly, Gour understood the medium's archival value, having gifted all his films to the Asian Film Archive for safekeeping. *Sunshine Singapore*, in particular, features views of Singapore that no longer exist: from an uncluttered city skyline in its early years of heightened modernization to idyllic shots of the Singapore River prior to its nationwide clean-up campaign in 1977 and subsequent riverine redevelopment (Figure 7.1).

This chapter extends scholarship on city symphonies to include two contemporary city films that play homage to Singapore and Seoul – arguably the leading global cities of Southeast Asia and East Asia, respectively. Unlike the early

twentieth-century city symphony exemplars from Europe, which are distinctively tied to modernity, these millennial Asian features are clearly products of globalization. While the European films constitute documentations of an emerging global condition, the Asian films interrogate what it means to be a global city. Through a comparative study of Tan Pin Pin's *Singapore GaGa* (2005) and PARKing CHANce's *Bitter, Sweet, Seoul* (2014), three lines of investigations are pursued: how facets of each city are translated to film; how modes of production of Asian city symphonies differ from their Western predecessors; and how these different approaches illuminate innovations in the conceptualization and realization of the two films.[4]

In city symphonies, the city is cast to play itself, emphasizing the axiomatic fact that cities have their own distinct flavour. As such, they highlight characteristics unique to each city and its people. The comparative component is important: a single film may present several aspects of a culture but reading across several films can reveal certain underlying features, common themes and emerging trajectories. The provocation for this study is a feature of city symphonies that perturbed pioneering documentary film-maker John Grierson; namely, its depiction. In his essay 'First Principles of Documentary', Grierson's dissatisfaction with Ruttmann's approach for *Berlin* stems from the following:

> The symphonists have found a way of building such matters of common reality into very pleasant sequences [...] But by their concentration on mass and movement, they tend to avoid the larger creative job [...] [with] little to say about the man who tends [the machine] and still less to say about the tin-pan product it spills.[5]

Grierson criticizes the non-fiction aesthetics of *Berlin* for Ruttmann's masterful glossing of underlying tensions and socio-economic inequalities. Through the deft use of montage, an aesthetics-driven image of a coherent modern city is presented whereby featured characters seemingly contribute to its achievements. By contrast, the eponymous films of Singapore and Seoul foreground the diverse views and voices of its citizens. It is the personal stories of individuals in *Singapore GaGa* and contributors of the crowdsourced *Bitter, Sweet, Seoul* that determine the vignettes. Cinematic framing simply enunciates the heterogeneity of spaces, their uses and associated meanings. This more democratic approach to honouring cities reflects how truly polyphonic and rich in content contemporary city films can be.

The complex montage principles applied to city symphonies and the omnipresence of the camera suggest that the narratives of early city symphony films are stories of the city rather than its people. What will be revealed through the Singapore and Seoul documentaries is a purposeful repositioning, with

contemporary projects pursuing stories of the city as told by and through its people. Despite the relatively homogeneous population of Singapore consisting of 74.3 per cent ethnic Chinese, and 97.4 per cent South Korean nationals living in Seoul, these cities, being global cities, are very multicultural. The diversity of languages and Chinese dialects featured in *Singapore GaGa* and the diffusion of foreign influences in Seoul life evidence this trait.[6] In this regard, the audio component becomes as vital, if not more so, than the visual content in these Asian films. The advent of sound film prompted a trio of Vertov's Soviet compatriots led by Sergei Eisenstein, who pioneered the theory of montage, to issue a manifesto imploring film-makers to rise above what they recognized as 'adhesion of sound to a visual montage piece', and instead pursue a contrapuntal function for sound. This, they felt, was essential if film was to thrive as an art form.[7] Decades later, in his bid to recast the importance of sound to film experience and comprehension, Michel Chion probes the subversive potential of sound, stating:

> The consequence for film is that sound, much more than the image, can become an insidious means of affective and semantic manipulation. On one hand, sound works on us directly, psychologically [...] On the other hand, sound has an influence on perception, through the phenomenon of added value, it interprets the meaning of the image, and makes us see in the image what we would not otherwise see, or would see differently.[8]

Furthermore, a close reading of selected scenes from the films reveals how the interplay between the diegetic and non-diegetic can be deftly manipulated to construct a rich audiovisual field of experience constitutive of contemporary films of the city.

Asian global cities on film

On the notion of 'urban worlding', Aihwa Ong explains how Asian cities present a situated experience and variations of global cosmopolitanism quite different from their Euro-American counterparts: 'A view of the city as a site of experimentation allows us to integrate qualities of fluidity, interactivity, and interactivity that crystallize the possibilities within which we reimagine, remake, and re-experience urban conditions and notions of the urban self.'[9] By offering Asian cities as 'fertile sites' for exploration, Ong's positioning advances discourse away from the hegemonic themes and tired tropes associated with globalization. Hypotheses on the effects of globalization often overlook how external forces and influences are more likely to undergo grassroots heterogenization at the local level. For this reason, moving image forms the medium best placed to illustrate inherent differences and

underlying features. Films shot in real locations offer subtle commentaries on the particularity of a place: they disclose via documented observation how global flows shape local conditions through the spatial practices of everyday folks. By the same logic, an evaluation on the performativity of space in Asian films reveals how cinematic space interprets the material space it references and cinematic practices adopted in their production.[10] Such considerations are crucial to obtain a nuanced reading of real spaces in the city shaped by the people who inhabit them.

Globalization as a concept carries complex undertones. In the context of South Korea, the Korean equivalent, *segyehwa*, is directly associated with the period of economic growth during the country's developmental phase beginning in the 1960s until the 1997 Asian Financial Crisis struck. Following IMF bailout, globalization in the millennium resumed importance under the contemporized rubric *global-hwa* to demarcate a new era and clean break from the previous one tainted by negative connotations and the shadow of humiliation from having to accept financial aid.[11] This next phase crucially acknowledges the presence and contributions of numerous stakeholders that now include civil society, NGOs and the media whose interests intersect with the Seoul government's global city agenda. In Singapore, on the other hand, the state's global city blueprint combined three decades of strategic development of its arts and culture scene alongside an ambitious plan to comprehensively transform the Marina Bay area into a new downtown for the twenty-first century.[12]

In the presence of dominating macro-level forces, Mikhail Bakhtin's concept of heteroglossia becomes essential to understanding the premise of the two films. Heteroglossia allows the totality of the world and associative ideas to be represented using multiple viewpoints but expressed through one artistic genre.[13] In *Singapore GaGa* and *Bitter, Sweet, Seoul*, voices of individuals that might otherwise be subsumed under the master narrative are given a space to be heard. This takes place on a narrational level where context is prioritized over the text itself. Rejecting a monologic approach, heteroglossia seeks to construct a semantic layer that conveys a polyphony of people's voices. The various strands of thoughts, characterized by meanings and values, enunciate plural ways of conceiving the world. For this reason, discussions on city films must also address the extra-cinematic aspects.

Singapore GaGa

According to documentarian Tan Pin Pin, her film *Singapore GaGa* pays tribute to 'the quirkiness of the Singaporean aural landscape'.[14] Aimed at an international audience, the film's unwavering obsession with mundane everyday spaces offers a counterpoint to the gleaming waterfront's iconic skyline many have come to identify as the meticulously state-crafted image of Singapore, a well-governed

and future-forward global city. Instead, transitory spaces – public squares, MRT stations and void decks in the residential 'heartland' – are foregrounded. Lilian Chee goes further to suggest that subtext is a constant in Tan's oeuvre: while this innate layer fulfils the film's affective qualities – narrative potential, materiality of space and emotional impact – the experience of space in Tan's films is derived from viewers' identification with a counter-narrative.[15] For example, several scenes depict buskers and street performers in concourses or at the entrances of underground stations. One such talent is the self-styled 'skater waltzer' Gn Kok Ling operating at Raffles Place, the main interchange hub in Singapore's CBD. Despite viewers warming up to the affable Gn on-screen, the reality is that the majority of commuters arriving at this station during rush hour remain oblivious to his performance (Figure 7.2). Undeterred, he continues to entertain impassive passers-by until evicted by a security guard. In this sequence, the light-hearted tune he plays on the harmonica, accompanied by his rhythmic shuffling across the floor on wooden clogs, transitions from on-screen performance into a non-diegetic soundtrack for the monotonous stream of office workers ascending the station's escalators (Figure 7.3). Throughout the film, the rhythm of life is implicit in the

FIGURE 7.2: Street performer on a station concourse. *Singapore GaGa*. Courtesy of Tan Pin Pin.

FIGURE 7.3: Morning rush hour. *Singapore GaGa*. Courtesy of Tan Pin Pin.

editing while disparate shots are juxtaposed against an audio source for contrapuntal effect to reinforce the counter-narrative.

With the documentary vignettes organized into aural episodes, one appreciates the film-maker's heuristic attempt to confront the visual regime governing moving images, particularly the inexorable emphasis on sights over sounds where on-location shoots are concerned. Vernacular sounds of the city, contextualized in space and dialogue, are painstakingly compiled by Tan to challenge assumptions of mono-culturalism. Singapore's multi-ethnic composition is evidenced in the diversity of languages featured in the film, including English, Singlish, Tamil, Arabic and various Chinese dialects such as Hokkien, Cantonese, Teochew, Hainanese, Hakka and Hockchew. Traces of this port city's transnational past persist in the narratives of the subjects interviewed, as does the linguistic hybridization following cultural assimilation. These vignettes convey the cumulative experience of being Singaporean.

While the ascription of 'city symphony' appears in the DVD's synopsis, Tan prefers the term 'polyphony'. She says:

[My films] are constructed like mosaics. The process is very organic, like a patchwork. And some tunes just stay within me. Therefore, the films are an expression of these tunes. What I wanted to achieve was to decouple the image from the sound. In *Singapore GaGa*, the visuals only have meaning when they are coupled with sound.[16]

An instructive scene from the film takes place on a busy night in Little India, frequented by South Indian migrant workers. An establishing aerial view of the neighbourhood descends into a series of static shots at street level, where the sights and sounds of this lively ethnic enclave are foregrounded. An abrupt change in pace ensues when the camera becomes mobile, beginning with a travelling shot maintaining diegetic sound and action, then an interior view of a taxi with its driver's profile in medium close-up. In the latter shot, the viewer is subjected to reduced listening to an acousmatic radio broadcasting in successive Chinese dialects. Masking the exterior din, the fidelity of the announcer's voice is akin to an 'on-the-air' sound close-up, as if the viewer is listening to the transmission directly sans filmic mediation. The contrasting shots heighten the discrepancy between the image and the sound. On-the-air sounds, located in a scene's real time but directionally ambiguous, blur the boundaries of on-screen, off-screen and the nondiegetic.[17] This is used effectively when the location abruptly switches to a radio station, transitioning acoustically from electronic audio to diegetic speech as the camera frames each announcer. Through continuity editing, seemingly unrelated on-screen activities are revealed to be connected temporally.

Cinema's contribution to image production lies in its ability to imprint a length of time: as textures of space are mapped on film, real time is simultaneously stored, allowing viewers to immerse themselves in the temporality of the diegesis. The passing of time is acutely felt in Margaret Leng Tan's performance of John Cage's 4'33" on her signature toy piano. In this long take, a second layer of sonic information, comprising diegetic sounds from the housing estate, enters the viewers' consciousness. Construed as high-brow culture meets mass-living conditions (since 82 per cent of Singapore residents live in homes built by the Housing & Development Board [HDB], Singapore's public housing authority), the withholding of foreground action, Leng Tan explains on film, creates an 'artificial parameter [for the] music of the environment [which] never ceases [and] is continually varied' to emerge. In other words, the on-screen silence heightens the acuity of passive, off-screen sounds which in turn establishes the auditory setting and atmosphere of the location. The choice of a nondescript void deck in Ang Mo Kio as the backdrop exposes a general underutilization of communal areas and perceptible absence of communality in Singapore's housing estates.[18] Such spaces were originally meant to host community gatherings and encourage social interactions between estate

residents. Although the current insular lifestyles and nucleated family structures may explain why people seldom lingered or ventured into shared spaces outside their apartments, challenges to building social cohesion is related to how HDB communities were formed in the early years, when displaced residents from various dismantled settlements were 'grafted' into new residential estates.[19]

From the examples cited, what is engaging about *Singapore GaGa* is the multitude of ways in which itinerant performers resourcefully defend a diffused presence by exercising agency, transitory inhabitation and offering entertainment in public spaces across a city regulated by omnipresent authority.

Bitter, Sweet, Seoul

In 2011, Park Won-soon, a well-regarded South Korean human rights lawyer and social activist, ran as an independent candidate in the Seoul mayoral by-election. His landslide victory over his rival from the republic's then ruling Grand National Party was widely construed as the population's discontent with paternalistic governance in favour of a popular leader who prized people-centred policies, and effectively marked the start of a new progressive era for the metropolis. Furthermore, Park's steadfast disavowal of any party allegiance following his reappointment affirms his commitment to serve as a mayor chosen by and for the people of Seoul. Throughout his term, Park has been forefront in harnessing technology, especially ICT, to introduce creative approaches aimed at social improvement and liveability across the capital; this objective is crystallized in the 2030 Seoul Master Plan launched in 2013.[20] A crucial agenda of the Seoul Metropolitan Government (SMG) is to foster civil inclusion through civic engagement and empowerment.[21] This not only facilitates collaboration between various stakeholders on key public projects but by encouraging sustained, tangible involvement, it also ensures the inhabitants of Seoul remain invested in the future of their city.

Mayor Park's sharing city ethos, devised to streamline infrastructural resources, promote venture opportunities and a sense of community city-wide,[22] undergirds the campaign launched virtually in August 2013 by PARKing CHANce called 'Our Movie, Seoul/Seoul, Our Movie'. Spearheaded by the production unit run by Korea's foremost film-making brothers, Korean New Wave director Park Chan-wook and the media artist Park Chan-kyong, the project utilized social media to crowdsource for video clips from members of the public in Korea and overseas. Various footage were used to construct a digital film that represented an authentic image of Seoul.[23] Its novel approach aligns with SMG's vision of Seoul as a digitally connected global city that champions participatory initiatives in its city-building and management. This stems from how mobile devices with recording capabilities have become an indispensable part of our lives, as

testified by the high volume of submissions received. Of the near 12,000 clips totalling 159.5 hours of footage received worldwide over a three-month period, 141 videos were chosen to construct a textural audiovisual mosaic that encapsulates the assemblage of experiences, impressions and stories in *Bitter, Sweet, Seoul*.[24] Mayor Park personally endorsed the documentary at the Seoul Cinema screening concurrent with its YouTube premiere in February 2014. Although *Bitter, Sweet, Seoul* is not the first film project to adopt crowdsourcing, its success affirms the technological agility of industry professionals to incorporate new media platforms and online resources in their repertoire, consequently expanding the parameters of film as an art form.

Optimizing YouTube's video-sharing capabilities, the content sought for the Seoul project was specific. Contributors' submissions had to address one of three themes: 'Working in Seoul', 'Made in Seoul' or 'Seoul', a broader category to cover contemporary lifestyles, landmarks and places and visitors' perception of Seoul. Each theme is skilfully edited into rhythmic montage sequences that bookmark the documentary. The 'Working in Seoul' segment's distinctive tempo is driven by an upbeat percussion soundtrack, overlaid with diegetic sounds of machinery and background noises. A range of shot scales, from the extreme long shot of a wholesale fish market's landscape to close-ups of a watchmaker's hands (Figure 7.4), captures a wealth of information on different trades and types of workplaces to complement a rich soundscape.

FIGURE 7.4: A watchmaker at work. *Bitter, Sweet, Seoul*. Courtesy of MOHO Film.

The film's title, *Bitter, Sweet, Seoul*, implies the compounded adversities experienced by South Koreans when the Korean peninsula was devastated by the 1950–53 civil war. This was followed by two successive authoritarian regimes throughout its period of industrial growth. The continued hardships faced by the marginalized, disenfranchised and those living in poverty are made audible in interview clips, as are references to the capital's geographical proximity to the demilitarized zone, which stands as a physical reminder of the irreconcilable ideologies that sparked the Korean War. Memories may dwell in people's collective consciousness as truths, but the incorporation of archival footage, such as views of the city during the war and the mass exodus of survivors, are strategically inserted as match-on-action in between digital clips. This anachronistic juxtaposition generates what Astrid Erll identifies as a filmic *effet de réel* (effect of reality).[25] From an experiential perspective, the grainy monochrome images, coupled with the indexicality associated with their portrayal of past events, imbues archival footage with an air of authenticity. For Park Chan-kyong, these historical records create a mental connection with the past in the absence of surviving landmarks.[26]

Globalization and tolerance have since transformed Seoul into a multicultural and multifaceted city – a feature that has been actively promoted by local government. Administrative division of Seoul's urban spaces by function during the city's accelerated growth in the 1980s indirectly allowed neighbourhoods across Seoul to develop their own identities.[27] Itaewon, featured several times in the film, evolved into a cultural enclave through an organic historical process.[28] The accumulated cultural currency that multi-ethnic neighbourhoods such as Itaewon possess is key to fostering cosmopolitanism in Seoul, as testified by the influx of foreigners who have settled to raise their families there. In a poignant clip, with the shaky quality and portrait orientation distinguishing it as a mobile phone footage, an expatriate father introduces his newborn son to their neighbourhood and proudly presents the baby to the camera as he whispers, 'Made in Seoul'.

By his own admission, Park Chan-kyong's excitement upon encountering 'a video that had an image we had been looking for' implied that his team methodically worked towards a predetermined visual structure and narrative for *Bitter, Sweet, Seoul*, akin to completing a jigsaw puzzle.[29] For this reason, the crowdsourcing exercise is no different than working with found footage, notwithstanding the mode for soliciting textual material. Regardless of the indispensability of digital affordance to the project, the technology is of secondary importance. What is paramount is whether the ubiquity of recording devices has changed the way people engage with images (which can be gauged from the submissions), and whether global connectivity has truly democratized the landscape of sharing. The finished product would suggest that there are limitations to the latter. To complete

the vision, PARKing CHANce resorted to shooting a scene of the fusion ensemble Be Being performing the folk song *Shincheongga* about filial sacrifice at the Han River on board a boat cruising along the waterway.[30] This pivotal scene highlights the significance of the river to Korean identity and as the cradle of Han civilization. The performance itself symbolically reconciles the traditional with the modern. More crucially, it underscores a necessity for strategic creative decisions even though the premise of the project hinges on a participatory approach to sourcing content.

Empowered by film

The urban spaces depicted in contemporary city films constitute representations of space in the Lefebvrian sense.[31] As products of the mediascape – one of the five dimensions conceived by Arjun Appadurai to frame an understanding of global cultural flows – concerned with the circulation and consumption of images, these cinematic translations are what Appadurai calls 'image-centred, narrative-based accounts of strips of reality'.[32] The complicit role of the subjects and content contributors is therefore integral to the image-making process. In *Singapore GaGa* and *Bitter, Sweet, Seoul*, the subjects are clearly talking to and even performing for the camera – a significant departure from the genre's early days when Vertov agonized over methods to capture 'life unawares'.[33] We are nowadays so accustomed to the presence of image-recording devices that what is captured on camera is in fact our natural reactions. Joshua Meyrowitz believes the proliferation of media has affected social behaviour, saying, 'How you choose to act *for the camera* is also how you *really* behave in the situation, and how you behave in the situation is how the camera captures you.'[34] As relayed by an interviewee in *Bitter, Sweet, Seoul*, even public perception of CCTV surveillance has shifted, and is in fact generally welcomed, having demonstrated a positive contribution to solving crimes across the capital.

Closely linked to mediascape is ideoscape, which addresses the political aspect.[35] It crucially discloses the films' intent. Sponsored by SMG, the documentary portrays Seoul as first and foremost a place to live. Ultimately, *Bitter, Sweet, Seoul* is a promotional film to market Seoul as a liveable and inclusive global city. For *Singapore GaGa*, its film-maker's motivation is more personal. Even though Tan Pin Pin is widely regarded as a patriot, her putative search for a holistic understanding of her country does not always align with official narrative.[36] Tan's more recent documentary entitled *To Singapore, with Love* (2013), an homage to their home country by Singaporean political exiles abroad, was controversially denied a domestic screening permit despite achieving critical success overseas.[37] Like Tan,

Mayor Park expressed a similar view on the importance of presenting an array of perspectives, admitting that 'Seoul has a sad history. If we try to project only the good side, it is not the real thing.'[38] His statement adjures us to celebrate the complexity and heterogeneity of the city, accepting that many aspects are irreconcilable, but their irreconcilability is precisely what gives depth and variety to urban life. This enlightened position fulfils what Grierson considered the most important aspect of a realist documentary: to not disregard a sense of social responsibility or aesthetic vision but to 'express dialectics', for cities are made richer due to their inherent contradictions.[39]

The two Asian city films discussed here are symphonies for their film-makers' demonstration of skilful editing and balance to achieve dynamic coherence on two levels – image and sound – in the constitution of their cinematic essence. A rigid montage structure is eschewed for montage rhythm whereby precise calculation of each shot is vital to create a unified work, much like a musical composition. Following Alexander Graf, the label 'symphony' recognizes the compositional value of these non-fiction city films: tempo and structural arrangement guide the interweaving webs of vignettes that reflect the entanglements of life conveyed through shared thoughts, points of views and personal values.[40] The distinction of cinema is that discrete geographies and cultural sites are intelligibly linked together to achieve narrative coherence on-screen.

Conclusion

If contemporary symphonies of the city appear to confront certain polemics, this is because space in itself is political and the act of translating real spaces into film is inevitably shaped by the film-maker's motivations and intentions. The inclusion of films about Asian global cities not only updates discourse on city films but also reasserts that indispensable feature of city living: cosmopolitanism. Considered the humanist counterpart of globalism, cosmopolitanism crucially acknowledges multiculturalism and tolerance. It is actively shaped by transnational processes and connections that enrich contemporary life. Premised on awareness and recognition of differences as well as empathy towards others, a cosmopolitan outlook ironically perpetuates a respectful separation between 'us' and 'them', prompting the analogy of a 'glass world' by Ulrich Beck to describe this persisting ontological divide.[41] The film-maker's subconscious distance from the migrant workers in Little India and the insulated lifestyles of the expatriate community in Itaewon suggests the existence of different subjectivities. Nevertheless, in the context of urban space, a cosmopolitan worldview remains vital for it emphasizes the importance of place to help its proponents navigate a heterogeneous landscape.[42]

The revelatory potential of film lies in its capacity to articulate locally cultivated cultural diversity. In reality, both Singapore and Seoul exhibit this feature but it is downplayed on the global stage in favour of the technocratic excellence and progressive vigour they respectively exemplify.

Stylistic differences and production agendas aside, *Singapore GaGa* and *Bitter, Sweet, Seoul* deliver a sobering dose of reality on-screen without compromising their aesthetic integrity. Voices of under-heard factions of society are not only represented but become the audiovisual focus. The privileging of the everyday ordinary is a historical nod to the slice-of-life moments proffered by actuality film reels at the turn of the twentieth century which preceded the documentary genre. Sometimes banal activities or routines can yield unexpected discoveries, such as the visually arresting aerial shot of a thriving rooftop garden in Hannam-dong (Figure 7.5). Engaging the sensorial and haptic properties of cinema enables us to apprehend the complexity and heterogeneity of contemporary urban space and life vicariously. This parallel discussion of *Singapore GaGa* and *Bitter, Sweet, Seoul* promotes a cinematic mode of thinking about different urban experiences through textual analysis and contextual understanding of two filmic odes to the city. In foregrounding their spatial qualities and urban textures, what emerges from the exploration are the processes and conditions actualizing the production of urban life.

FIGURE 7.5: Roof garden in Hannam-dong. *Bitter, Sweet, Seoul*. Courtesy of MOHO Film.

ACKNOWLEDGEMENT

The research was supported by an ARI Research Fieldwork Grant and attendance at the *Moving Image – Static Spaces?* conference by the author's Start-Up Grant at the National University of Singapore.

NOTES

1. Helmut Weihsmann, 'The City in Twilight: Charting the Genre of "City Films" 1900–1930', in *Cinema and Architecture: Méliès, Mallet-Stevens, Multimedia*, ed. Maureen Thomas and François Penz (London: British Film Institute, 1997), 8.
2. Interview with Rajendra Gour, 6 February 2015.
3. The common theme for city symphonies according to Weihsmann, 'The City in Twilight', 19.
4. These queries relate to the extra-filmic dimension, termed by Christian Metz as the 'cinematic fact', which focuses on how larger issues such as technology, sociological, economic and even political factors affect film production and the end product. Metz, *Language and Cinema* (The Hague: Mouton, 1974), 12.
5. John Grierson, *Grierson on Documentary*, ed. Forsyth Hardy (London: Collins, 1946), 84–85.
6. Singstat, *Population Trends 2017* (Singapore: Department of Statistics, 2017), 5. SMG, 'City Overview: Population (2017)', *Seoul Metropolitan Government*, http://english.seoul.go.kr/get-to-know-us/seoul-views/meaning-of-seoul/4-population/ (accessed 20 March 2018).
7. The English translation of 'A Statement' is published as Appendix A in Sergei Eisenstein, *Film Form: Essays in Film Theory* (New York: Harcourt Brace Jovanovich, 1977), 258.
8. Michel Chion, *Audio-Vision: Sound on Screen* (New York: Columbia University Press, 1990), 34.
9. Aihwa Ong, 'Worlding Cities, or the Art of Being Global', in *Worlding Cities: Asian Experiments and the Art of Being Global*, ed. Ananya Roy and Aihwa Ong (Malden: Wiley-Blackwell, 2011), 10.
10. Lilian Chee and Edna Lim, 'Asian Films and the Potential of Cinematic Space', in *Asian Cinema and the Use of Space: Interdisciplinary Perspectives*, ed. Lilian Chee and Edna Lim (New York: Routledge, 2015), 2.
11. Jieheerah Yun, *Globalizing Seoul: The City's Cultural and Urban Change* (Abingdon: Routledge, 2017), 9.
12. An overview of the bay's millennium transformation is provided by Justin Zhuang, 'Marina Bay', *National Library Board Singapore*, 21 June 2016, http://eresources.nlb.gov.sg/infopedia/articles/SIP_2016-06-21_160714.html.
13. This analogy was first applied to literature by Mikhail Bakhtin, *The Dialogic Imagination: Four Essays* (Austin: University of Texas Press, 1981), 263.

14. 'Singapore GaGa: A Documentary by Tan Pin Pin', Tan Pin Pin, http://www.tanpinpin.com/sgg/story.html (accessed 13 March 2018).
15. Lilian Chee, 'Chasing Inuka: Rambling around Singapore through Tan Pin Pin's Films', in *Asian Cinema*, 60.
16. Tan credits Ivan Polunin's collection of colour film footage and audio recordings, the subject of the documentary *Lost Images* (2010), as the inspiration for *Singapore GaGa*. Interview with Tan Pin Pin, 6 May 2011.
17. Chion, *Audio-Vision*, 76–77.
18. Chee, 'Chasing Inuka', 68.
19. The rupturing of established neighbourhood networks and the transition of villagers into an unfamiliar housing typology had profound impact on the first generation of HDB dwellers. Tan Ern Ser, 'Public Housing and Community Development: Planning for Urban Diversity in a City-State', in *50 Years of Urban Planning in Singapore*, ed. Heng Chye Kiang (Singapore: World Scientific, 2017), 258–59.
20. SMG, '2030 Seoul Master Plan', *Seoul Metropolitan Government* (2017), http://english.seoul.go.kr/policy-information/urban-planning/urban-planning/1-2030-seoul-basic-urban-plan/.
21. Myungrae Cho and Mike Douglass, 'Making the Progressive City – the Seoul Experience', *Korean Institute Center for Sustainable Development* (2014), 10–11, http://kicsd.re.kr/bbs/view.php?id=eng_data11&no=1.
22. SMG, ' "The Sharing City Seoul" Project', *Seoul Metropolitan Government* (2014), http://english.seoul.go.kr/policy-information/key-policies/city-initiatives/1-sharing-city/.
23. SMG, 'Our Movie, Seoul/Seoul, Our Movie', *Seoul Metropolitan Government*, 20 August 2013, http://sculture.seoul.go.kr/archives/25038.
24. From the film's opening credits.
25. Astrid Erll, *Memory in Culture* (New York: Palgrave Macmillan, 2011), 140–41.
26. Darcy Paquet, 'Park Chan-kyong: In Search of Odd Traces in Modern History', *Koreana* (Autumn 2014): 30.
27. Lee Dong Yeun, 'Consuming Spaces in the Global Era: Distinctions between Consumer Spaces in Seoul', *Korea Journal* 44, no. 3 (2004): 113.
28. Yun, *Globalizing Seoul*, 124. Itaewon began life as a military command post for the Japanese imperial army and housing for their dependents after annexation in 1910. After the Korean War ended, it became a foreign settlement for the Americans. The neighbourhood has since expanded to host a thriving Muslim community following an influx of African and Southeast Asian migrants, cementing Itaewon's reputation as a multicultural district.
29. 'Bitter, Sweet, Seoul', Park Chan-kyong, http://www.parkchankyong.com/bitter-sweet-seoul_film (accessed 13 March 2018).
30. Philip Gowman, 'Film Festival Review: *Bitter, Sweet, Seoul*', *London Korean Links*, 16 November 2014, https://londonkoreanlinks.net/2014/11/16/festival-film-review-bitter-sweet-seoul/.

31. 'Representational space', one of the three spatial spheres in Marxist philosopher Henri Lefebvre's framework, pertains to 'space directly *lived* through its associated images and symbols, and hence the space of "inhabitants" and "users", but also of some artists and perhaps a few of those, such as writers and philosophers'. Lefebvre, *The Production of Space* (Oxford: Basil Blackwell, 1991), 39.
32. In brief, the focus is on the capabilities of the media industry, its organizational structure, networks and influencing power on its consumers. Arjun Appadurai, 'Disjuncture and Difference in the Global Cultural Economy', *Public Culture* 2, no. 2 (1990): 9.
33. Keith Beattie remarks on the use of hidden cameras during on-location filming for *Berlin* and *Man with A Movie Camera* to preserve their subjects' natural behaviour. Beattie, *Documentary Display: Re-viewing Nonfiction Film and Video* (London: Wallflower, 2008), 41–43.
34. Joshua Meyrowitz, *No Sense of Place: The Impact of Electronic Media on Social Behavior* (New York: Oxford University Press, 1985), 114.
35. Appadurai, 'Disjuncture and Difference', 9.
36. Tan's short film *9th August* (2006), commissioned by the Singapore National Museum, was a laborious undertaking which entailed editing four decades worth of footage of the National Day Parade.
37. See Olivia Khoo, 'On the Banning of a Film: Tan Pin Pin's *To Singapore, with Love*', *Senses of Cinema* 76 (September 2015), http://sensesofcinema.com/2015/documentary-in-asia/to-singapore-with-love-documentary/.
38. Park, 'Bitter, Sweet, Seoul'.
39. Grierson, *Grierson on Documentary*, 89.
40. Alexander Graf, 'Paris-Berlin-Moscow: On the Montage Aesthetics in the City Symphony Films of the 1920s', in *Avant-Garde Film*, ed. Alexander Graf and Dietrich Scheunemann (Amsterdam: Rodopi, 2007), 80.
41. Ulrich Beck, *The Cosmopolitan Vision* (Cambridge: Polity, 2006), 8.
42. Brenda Yeoh, 'Cosmopolitanism and Its Exclusions in Singapore', *Urban Studies* 41, no. 12 (2004): 2432.

BIBLIOGRAPHY

Appadurai, Arjun. 'Disjuncture and Difference in the Global Cultural Economy'. *Public Culture* 2, no. 2 (1990): 1–24.

Bakhtin, Mikhail M. *The Dialogic Imagination: Four Essays*. Translated by Caryl Emerson and Michael Holquist. Austin: University of Texas Press, 1981.

Beattie, Keith. *Documentary Display: Re-viewing Nonfiction Film and Video*. London: Wallflower, 2008.

Beck, Ulrich. *The Cosmopolitan Vision*. Translated by Ciaran Cronin. Cambridge: Polity, 2006.

Chee, Lilian. 'Chasing Inuka: Rambling around Singapore through Tan Pin Pin's Films'. In *Asian Cinema and the Use of Space: Interdisciplinary Perspectives*, edited by Lilian Chee and Edna Lim, 59–76. New York: Routledge, 2015.

Chee, Lilian, and Edna Lim. 'Asian Films and the Potential of Cinematic Space'. In *Asian Cinema and the Use of Space: Interdisciplinary Perspectives*, edited by Lilian Chee and Edna Lim, 1–18. New York: Routledge, 2015.

Chion, Michel. *Audio-Vision: Sound on Screen*. Translated by Claudia Gorbman. New York: Columbia University Press, 1994.

Cho, Myungrae, and Mike Douglass. 'Making the Progressive City – the Seoul Experience'. *Korean Institute Center for Sustainable Development*, 2014. http://kicsd.re.kr/bbs/view.php?id=eng_data11&no=1.

Eisenstein, Sergei. *Film Form: Essays in Film Theory*. Translated by Jay Leda. New York: Harcourt Brace Jovanovich, 1977.

Erll, Astrid. *Memory in Culture*. New York: Palgrave Macmillan, 2011.

Gowman, Philip. 'Film Festival Review: *Bitter, Sweet, Seoul*'. *London Korean Links*, 16 November 2014. https://londonkoreanlinks.net/2014/11/16/festival-film-review-bitter-sweet-seoul/.

Graf, Alexander. 'Paris-Berlin-Moscow: On the Montage Aesthetics in the City Symphony Films of the 1920s'. In *Avant-Garde Film*, edited by Alexander Graf and Dietrich Scheunemann. Amsterdam: Rodopi, 2007.

Grierson, John. *Grierson on Documentary*. Edited by Forsyth Hardy. London: Collins, 1946.

Khoo, Olivia. 'On the Banning of a Film: Tan Pin Pin's *To Singapore, with Love*'. *Senses of Cinema* 76 (September 2015). http://sensesofcinema.com/2015/documentary-in-asia/to-singapore-with-love-documentary/.

Lee, Dong Yeun. 'Consuming Spaces in the Global Era: Distinctions between Consumer Spaces in Seoul'. *Korea Journal* 44, no. 3 (2004): 108–37.

Lefebvre, Henri. *The Production of Space*. Translated by Donald Nicholson-Smith. Oxford: Basil Blackwell, 1991.

Metz, Christian. *Language and Cinema*. The Hague: Mouton, 1974.

Meyrowitz, Joshua. *No Sense of Place: The Impact of Electronic Media on Social Behavior*. New York: Oxford University Press, 1985.

Ong, Aihwa. 'Worlding Cities, or the Art of Being Global'. In *Worlding Cities: Asian Experiments and the Art of Being Global*, edited by Ananya Roy and Aihwa Ong, 1–26. Malden: Wiley-Blackwell, 2011.

Paquet, Darcy. 'Park Chan-kyong: In Search of Odd Traces in Modern History'. *Koreana* (Autumn 2014): 30–35.

Park, Chan-kyong. 'Bitter, Sweet, Seoul'. Accessed 13 March 2018. http://www.parkchankyong.com/bitter-sweet-seoul_film.

Singstat. *Population Trends 2017*. Singapore: Department of Statistics, 2017.

SMG. '2030 Seoul Master Plan'. *Seoul Metropolitan Government*, 2017. http://english.seoul.go.kr/policy-information/urban-planning/urban-planning/1-2030-seoul-basic-urban-plan/.
———. 'Our Movie, Seoul/Seoul, Our Movie'. *Seoul Metropolitan Government*, 20 August 2013. http://sculture.seoul.go.kr/archives/25038.
———. '"The Sharing City Seoul" Project'. *Seoul Metropolitan Government*, 2014. http://english.seoul.go.kr/policy-information/key-policies/city-initiatives/1-sharing-city/.
Tan, Ern Ser. 'Public Housing and Community Development: Planning for Urban Diversity in a City-State'. In *50 Years of Urban Planning in Singapore*, edited by Heng Chye Kiang, 257–72. Singapore: World Scientific, 2017.
Tan, Pin Pin. 'Singapore GaGa: A Documentary by Tan Pin Pin', n.d. http://www.tanpinpin.com/sgg/story.html.
Weihsmann, Helmut. 'The City in Twilight: Charting the Genre of "City Films" 1900–1930'. In *Cinema and Architecture: Méliès, Mallet-Stevens, Multimedia*, edited by Maureen Thomas and François Penz, 8–27. London: British Film Institute, 1997.
Yeoh, Brenda. 'Cosmopolitanism and Its Exclusions in Singapore'. *Urban Studies* 41, no. 12 (2004): 2431–45.
Yun, Jieheerah. *Globalizing Seoul: The City's Cultural and Urban Change*. Abingdon: Routledge, 2017.
Zhuang, Justin. 'Marina Bay'. *National Library Board Singapore*, 21 June 2016. http://eresources.nlb.gov.sg/infopedia/articles/SIP_2016-06-21_160714.html.

Film List

9th August. Directed by Tan Pin Pin, Singapore: National Museum of Singapore, 2006.
Berlin: Symphony of a Great City. Directed by Walter Ruttmann, Germany: Fox-Europa Film, 1927.
Bitter, Sweet, Seoul. Directed by PARKing CHANce, South Korea: MOHO Film, 2014.
Lost Images. Directed by Ivan Polunin, Singapore: Moving Visuals Company, 2009.
Man with the Movie Camera. Directed by Dziga Vertov, Soviet Union: VUFKU, 1929.
Rien que les Heures. Directed by John Cavalcanti, France: Néo Film, 1926.
Singapore Gaga. Directed by Tan Pin Pin, Singapore: Point Pictures, 2005.
Sunshine Singapore. Directed by Rajendra Gour, Singapore: Asian Film Archive, 1968–72.
To Singapore, with Love. Directed by Tan Pin Pin, Singapore: MBG Media, 2013.

8

Cinema and the Walled City

Gül Kaçmaz Erk

A wall is a very big weapon.
It's one of the nastiest things you can hit someone with.

– Banksy[1]

The walls were not built overnight. They will not come down quickly.
Some walls last a century, a few for millennia.

– John Paul Lederach[2]

2013. A young Palestinian walks towards the West Bank wall and looks up. His audience think he will walk along this overwhelmingly high concrete barrier. He starts climbing. 1971. A British soldier in the back alleys of Belfast terrace houses stops running, leaning on a brick wall to catch his breath. If only he knew where a Catholic neighbourhood finished and a Protestant one started, he would be okay. 1987. Two male angels, yes angels, stroll towards the Berlin Wall chatting quietly. They walk and walk and suddenly disappear through the wall (Figure 8.1).

Filmic depictions of urban walls are beneficial to understand the complex relationships between cinema and architecture in the city. They are strong physical representations of conflict and contested spaces in divided societies. Studying such 'polarized and unsettled cities'[3] via film in different parts of the world may highlight commonalities and possible clues towards a more tolerant and even shared future. Bollens states these

> cities are distinct in their histories, cultures, and traditions, but they share a common sorrow – exposure to periods of intense and sometimes violent conflict. It is within this context that every day the people who live in these areas have had to struggle for co-existence.[4]

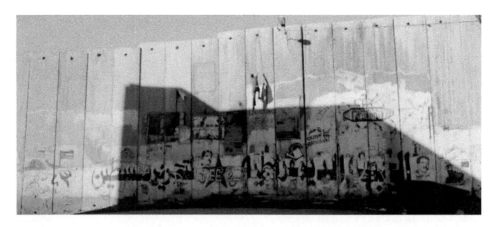

FIGURE 8.1: West Bank Wall. Hany Abu-Assad (dir.), *Omar*, 2013. Palestine © ZBROS. Film still captured by the author.

An audiovisual and temporal art form such as cinema has the potential to represent 'lived spaces'[5] of everyday practices in the fragmented landscape of walled cities by showing ordinary people who would like to get on with their lives. Cinema makes use of techniques and tools, such as framing, movement, lighting, sound, point-of-view shot, black-and-white/colour, flashback/flashforward and cut/montage, to capture a more subjective and humane perspective of walled cities.

Accordingly, this study, and the event series that led to it, ask: How can academics, architects, urbanists and film-makers contribute to the inclusion and integration of divided societies in the scale of the built environment for a shared future? In 2014, a research group entitled CACity, which stands for Cinema and Architecture in the City, funded by the Institute for Collaborative Research in the Humanities, was founded in Queen's University Belfast. The group gathers academic (mostly in the humanities) and non-academic specialists such as architects, artists and film-makers interested in the built environment and in looking at it through the lens of cinema.[6]

In 2017, CACity organized a film season, Walled Cities,[7] in collaboration with Queen's Film Theatre (QFT)[8] in Belfast. Walled Cities questioned our contribution to urban inclusion/integration in divided societies. Syrian and other refugee crises and the post-conflict setting in Belfast aroused the theme. Three films were chosen: Hany Abu-Assad's[9] *Omar* (2013) with the West Bank wall in Palestine/Israel, Yann Demange's[10] *'71* (2014) based in Northern Ireland during the Troubles and Wim Wenders's[11] *Wings of Desire* (1987), a milestone movie in German cinema portraying walled Berlin (Table 8.1).[12]

Omar, *'71* and *Wings of Desire*, films exhibited at QFT in Walled Cities I,[13] will be analysed in this chapter through a non-hierarchical discussion of diverse perspectives. The intention is to approach urban walls without prejudice. Unconventionally, an architectural and cinematic approach will be followed to unfold social issues such as divided communities, steps towards conflict transformation and inclusive urbanism. The study also reverses the research process. Commonly, researchers study a subject matter, write/present/publish on the topic and then do a public engagement event like Walled Cities for non-academic audiences. Contrarily, this research follows the film season and interprets urban walls via distinct perspectives of film directors to benefit from cinema to understand their role in contested spaces.

From Belfast to West Bank via Berlin

Omar is the story of a young Palestinian baker trying to find his way and purpose in a highly divided city under military surveillance. He risks his life to see the girl he loves by regularly climbing up the West Bank wall built by Israel to protect the Israelis but also to split Palestinian neighbourhoods. *'71* portrays the survival story of a British soldier who lost his unit and his way in the split streets of a grim Belfast during the early days of the Troubles. This is a long period of conflict (1968–98) in Northern Ireland marked with segregation and violence between Catholic and Protestant communities. The film is actually shot in England.[14] *Wings of Desire* is the story of West Berliners who have been physically cut off by the wall from East Berlin and the rest of the world for 25 years, at the time, as well as angels that can easily pass through it. Angels are not bound to physical space and linear time so they can experience Berlin, West and East, in any historical period. The feeling of division fills the onscreen space through the representation of a walled European city.

Why have the Walled Cities film season and this study brought *these* geographies together? The main reason is the theme; West Bank, Belfast and Berlin are/were walled cities, and the films portray their divided communities. These are internal walls parting a city from within rather than external/peripheral ones, that is, borders. The wall situation alters for each city. *Omar* is shot and set during the 'wall period' (2013) and the walls the Israelis built still exist. *'71* is also shot during the wall period (2014) but intentionally set at a time before the walls (1971). Having said that, the invisible divisions between Catholic Nationalist and Protestant Unionist streets are already explicit in the film (Figure 8.2). *Wings of Desire* on the other hand is shot and set during the wall period (1987), but the Berlin Wall fell shortly after (1989). The aftereffect of separation walls lasts for

several decades. Commonalities of the films also include an inclusive and hopeful attitude towards these traumatized cities that aims not to take sides by picturing one side as the victim and blaming the other. They serve the healing process that is crucial for conflict transformation.

City walls are terrifying and fascinating at the same time. Historically, a walled city would be an (ancient, medieval, etc.) urban settlement with thick and tall stonewalls that are built at the periphery of the city to protect the inhabitants from potential attacks of enemies and possible invaders. Fontana-Giusti defines this function of protection stating:

> It was only with the formation of fortified walled cities that humans found themselves in a situation of feeling terror and under threat by a presumed enemy – a human enemy. This is unlike the feeling that prevailed before, when humans were unarmed, exposed to the elements and fearing animals.[15]

Being the setting for much larger populations, urban walls in contemporary cities do not create a loop and seal off a territory. Instead, they are internal; they stand between two parts of the city. This situation does not however change the fact that their presence has a significant influence on the existence and architecture of the city. Having said that, a city wall is never solely a protector or divider; it could be a symbol, landmark or space, or even an object of fetishism. It has multiple faces and can be read via many distinct ways through an approach based on the multiplicity of non-hierarchical perspectives. Atun and Doratli emphasize that

> the concept of wall in the urban context has more than one meaning. Walls may be multi-functional, multi-dimensional and physically define social and physical territories within the urban context. Acting as a type of border, a wall in essence separates the 'self' from the 'other' and it is associated with protecting 'we – insiders' from 'those – outsiders'.[16]

Walls in the city

City wall as a protector

Some city walls or fortification enclose and seal a city to protect it. It surrounds the whole city, while fully controlled military gates and checkpoints provide the transition between inside and outside.[17] Its nature is defensive; it is a shield. Most historical examples, be it Mycenae, Babylon, Hattusa, York or Prague, are in this category. Borders around present-day countries serve the same purpose.

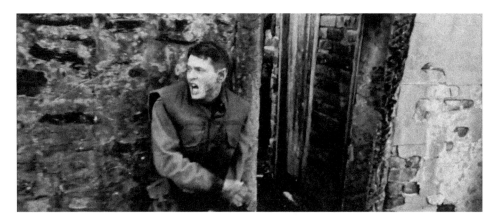

FIGURE 8.2: Belfast's alleyways. Yann Demange (dir.), '71, 2014. UK © Warp Films. Film still captured by the author.

Belfast is a 'fortress city';[18] the peace walls have a similar character to fortification. Though they vary in physical nature (not continuous, intercity, various materials/heights/lengths), they are built between Nationalist and Unionist communities to protect either side from physical violence.[19] The first wall was constructed 50 years ago.[20] Therefore, by the time the film was set, there were not many physical protectors in the city. Gaffikin et al. state 'Belfast has mental "walls" as well as the obvious physical ones.'[21] Locals were able to see the invisible dividers between the Catholic and Protestant streets in West and North Belfast, but the British soldier was not. Bollens says, 'Life in polarized cities constitutes a different normal, where urban separations overlap cultural fault-lines and where long memories fit into tight spaces.'[22] The peace lines, if existed, could have protected the young soldier.

Walls in *Omar* and *Wings* do not show the characteristics of protection for different reasons. The wall that cuts through the West Bank in *Omar* strategically separates Palestinian neighbourhoods from each other. Though the long concrete structure is built between Palestinian and Israeli territories to protect the latter, that is not what the Arab director of the film portrays in *Omar*, as that is not how Palestinians experience and perceive the wall.

The German Democratic Republic government, on the other hand, built the wall around West Berlin not for the protection of their East German citizens but, interestingly, to prevent them from fleeing into the west. Referring to the Berlin Wall, Grech writes:

> This empty zone of nothingness was where the East attempted to cordon off the West and secure the survival of the communist regime [...] The German Democratic Republic's solution to the seductive lure of the West was to try to shut it out of the minds of the people. Empty, silent space.[23]

Understanding the reasons behind the lack of a purpose (in this case, protection) of a wall has proven to be as significant as studying its presence.

City wall as a divider

'The walls scar the cityscape', in Cosstick's words.[24] When the purpose of a wall, or a set of walls, is to divide a city into two or multiple pieces for political reasons, the streets or neighbourhoods on opposite sides of this boundary stop interacting with each other. This lack of exchange leads to the fragmentation of the city, and in time to its possible destruction. The walls that once separated ancient and medieval cities from the outside world and marked their territorial boundaries are not impenetrable any longer; they have opened up. Accordingly, they do not act as a barrier or control point today unlike the walls portrayed in the films.

In the Palestinian film, the West Bank wall exists to 'divide and conquer'. Omar's success in crossing over to the other side on a daily basis, climbing the wall using a rope – an act only a few can achieve – merely strengthens the depiction of the political power of Israel in the film. The rest of the Palestinians need to accept the presence of the wall as a divider of their lost homeland. Later in the film, 'Omar is not able to climb the wall, and this weakness brings tears to his eyes. He can no longer reconcile the two fragmented worlds.'[25]

Similarly, the continuous horizontal concrete structure in Germany divides Berliners from Berliners. The transparency of the wall for angels in *Wings* emphasizes its solidity for humans. The director says, 'With angels you could do anything, there were connections all over the place, you can go anywhere. You could cross the Wall, pass through windows into people's houses';[26] the wall 'has never previously been a barrier to' them.[27] The humans, on the other hand, cannot cross it or see the other side. It is an embodiment of division and separation. Under different political regimes, one socialist republic, the other parliamentary democracy, the city starts to evolve separately on two sides of the double-skin wall. The colourful graffiti on one side and clean, whitewashed surfaces on the other highlight this separation.[28] Grech mentions, 'This white-board of concrete, kept forcibly at bay from the hands of the East German people, allowed the West to invisibly write messages of freedom and democracy in indelible ink.'[29] Today the Berlin Wall does not exist, but its essence lies within the reunified and yet deeply fragmented city.

Belfast peace walls have not been built as of 1971; however, the division is visible mainly via the reactions of people to the soldier in different parts of the city. 'There are two Belfasts, two parallel worlds.'[30] This division is different though. While there are more than a hundred peace walls in Belfast today, they do not necessarily prevent people from experiencing either side of the walls.

City wall as a symbol

Symbols are meanings attached to objects, though the two are not directly related. Historically, a city wall has typically been a symbol of power and authority. The more recent intercity examples may or may not have the same symbolic character. The West Bank wall in *Omar* is an embodiment and symbol of the power of Israel in the area. Fontana-Giusti claims, 'The wall and the checkpoint materially and symbolically separate Omar from his lover Nadia.'[31] The long-lasting conflict between the two communities is yet to be resolved, and the wall symbolizes the domination of Israel for the time being. Nashef believes, 'The wall symbolically fragments the already divided country into mini enclaves, aborting any possibility of a state.'[32]

The symbolism of the peace lines is different. Particularly in West and North Belfast, separation walls and murals on gable walls that are related to the Troubles[33] are almost everywhere. They are an indicator of the continuous separation between the Catholic and Protestant communities of the city. (This is a more ideological separation rather than religious.) Each wall symbolizes the differences of the people on its opposite side and their tendency to refuse to keep the dialogue open. Cosstick asks, 'How much longer these physical signs and symbols of sectarianism and the Troubles will disfigure the cityscape [...] The walls are relics of and memorials to the conflict and a reminder of the unfinished nature of the peace process.'[34]

As Bakshi clarifies, 'In divided cities, the past can intrude more forcefully into the present.'[35] The wall in *Wings* is part of the memory of the 1940s, and a symbol and reminder of the Second World War.[36] The flashbacks to Berlin in rubble right after the war support the wall's symbolic meaning. It is also the three-dimensional representation of the cosmopolitan city in pieces; Wenders uses the Berlin Wall as a symbol of the fragmented city. Harvey reconciles some of these meanings:

> The distinctive organization of space and time is, moreover, seen as the framework within which individual identities are forged. The image of divided spaces is particularly powerful, and they are superimposed upon each other in the fashion of montage and collage. The Berlin wall is one such divide, and it is again and again evoked as a symbol of overarching division.[37]

FIGURE 8.3: Berlin Wall and the west side of Potsdamer Platz. Wim Wenders (dir.), *Wings of Desire*, 1987. West Germany © Road Movies. Film still captured by the author.

The symbolic presence of the wall does not come to an end with its demolition; as Bach claims, 'The fall of the Berlin Wall provides testimony to the restored "normalcy" of a "Europe, whole and free" and therefore has a universal symbolic function far beyond the local or national level'[38] (Figure 8.3).

City wall as a landmark

Similar to historic walled cities, the walls in *Omar* and *Wings* are landmarks that people can use to orient themselves. A landmark noticeably marks a territory. When someone gets lost, they can find the wall and go on. It is an architectonic element within the city that is always with the urban dweller, always in the foreground. It is a daily routine for Omar to walk straight to the wall and cross it. Scott defines the setting:

> Abu-Assad uses the narrow alleyways and densely packed houses of the urban West Bank as the setting for a handful of breathless foot chases. The embattled topography of the area – desolate hillsides shadowed by barbed wire and high concrete security barriers – is both a backdrop and a living presence, a constant reminder that every aspect of local existence is intensely politicized.[39]

Potsdamer Platz in the heart of Berlin has lost the life and character it once had. Bordo agrees:

> In 1987 there were no street signs; there wasn't even a convergence of streets because there were no streets. If 'Platz' means place, public space, commons, even square where people gather [...] Potsdamerplatz wasn't such a place. It wasn't a place, at all. Potsdamerplatz circa 1987 was a wasteland, a 'zone of exception' extricated from the everyday circulation of life and the 'no-man's land' between east and west Berlin in the partition of the city by the Four Powers after World War II.[40]

The 'square' has gained a new face with the long horizontal wall that sits in the landscape like the horizon, or a never-ending canvas filled with vivid graffiti. 'It is impossible to get lost in Berlin', someone says, 'because you can always find the wall'.[41] Being an interruption to the natural growth of a city, walls stand out from the urban fabric marking the spaces close to them and cutting out prohibited parts of the city.

Landmarks, Tuan writes, 'serve to enhance a people's sense of identity; they encourage awareness of and loyalty to place'.[42] In the context of divided cities, however, this is seldom a shared identity; a wall as a landmark relatively emphasizes the contestedness of space and loyalty to 'one side'. The presence of such indicators could have solved some of the problems of the young private in '71 as he would be aware of who is loyal to what.

City wall as a space

Some walls are more three dimensional, or spatial, than others. As walls of historical cities are constructed for defence purposes, they most of the time have thickness and depth. They have enclosed spaces within and external spaces on top for surveillance and attack. The West Bank wall and Belfast's peace walls do not have such characteristics, because their height affects their functionality more than their depth. Having said that, their verticality adds to the three dimensionality of the area. In *Omar*, the protagonist 'crosses' the wall vertically, an act of illegal passage that is not intended without a checkpoint.

In *Wings*, angels do the same and 'cross' the solid concrete wall instead of using Checkpoint Charlie. The Berlin Wall, originally built overnight[43] using concrete posts and barbed wire, has a 'no-man's land', an in-between space within two layers of the precast reinforced concrete wall, a space favoured by angels for tranquillity. The no-man's land can be considered as a heterotopia (of crisis) in Foucault's terms. In 'Of Other Spaces', the philosopher talks about heterotopias

as places dissimilar to ordinary cultural spaces stating: 'Heterotopias always presuppose a system of opening and closing that both isolates them and makes them penetrable. In general, the heterotopic site is not freely accessible like a public place.'[44] Neither is Berlin's no-man's land.

City wall as a fetish

Anthropologist Charles de Brosses who published *Cult of the Fetish Gods* in 1760 coined the term 'fetish', which is a derivation of a Portuguese word *feitiço*, meaning amulet or charm. Portuguese appropriated the word to refer to the various objects believed to be sacred, impregnated with imaginary powers and used in religious ceremonies by West African natives. For various reasons (emotional, personal, nostalgic, social, cultural, traditional) urban separation walls may turn into desirable entities or fetish, or at least 'dark tourism' attractions. Apparently, 'conflict tourism sells'.[45] Pieri explains,

> Berlin has dealt (and continues to deal) with the unpleasant memories of war and division, but has also instituted ways to protect and preserve those unpleasant memories, either through contemporary memorials or by incorporating existing 'dark' heritage sites into the current fabric of the city.[46]

An extreme example was keeping or buying/selling small pieces of the Berlin Wall after its demolition by the people 30 years ago: 'The Wall was made accessible to all who wanted to physically experience its vulnerability by hammering off pieces as souvenirs.'[47] The motivation behind the desire to attain a piece of the wall that once encircled West Berlin could be emotional or nostalgic. The power of this ordinary piece of concrete comes from the 'worshipper' rather than the object itself. Whatever has triggered 'consumerist object fetishism' in this context value has been exaggerated because of the rarity of original pieces.[48] According to Benjamin, its uniqueness is the core value for a (fetish) object.[49]

Ancient and medieval walls, such as the Great Wall of China, Hadrian's Wall in England, Aurelian walls of Rome and Constantinople's sea walls, are all commercialized as tourist attractions to impress millions. Local and international tourists take a stroll on the 1.5-kilometre-long city walls of Derry built in the seventeenth century. Though contemporary in comparison, peace lines of Belfast are also a primary destination of black cab tours and city sightseeing bus tours.

The West Bank wall is not the most popular tourist attraction. 'Touristification' of a separation wall usually follows the resolution of the conflict or at least the beginning of the healing of the wounds. Maybe what we need is 'Disneyfication' of West Bank: such an experience would be safer: 'One imagines an American

entrepreneur like Disney building a simulated "divided city" complete with "authentic" portrayals of human suffering and physical destruction.'[50] In one sense, *Omar* provides that genuine depiction of West Bank; cinema provides genuine depictions of walled cities.

Following Walled Cities I, CACity organized a second film season in 2018 to exhibit fiction films based in East Berlin (*The Legend of Paul and Paula*) and Cyprus (*Akamas*) as well as a Spanish documentary (*Walls*) portraying several segregation walls between different countries (Table 8.1).[51] Towards the end of *Walls*, Iraburu and Molina write on the big screen: 'This film was shot at the borders between USA-Mexico, Morocco-Spain, and Zimbabwe-South Africa. It could have also been shot at the borders between …', and they list 22 new borders.[52]

Against the wall

Tuan states, 'Spaciousness is closely associated with the sense of being free. Freedom implies space; it means having the power and enough room in which to act.'[53] To be free in an un-walled city, society needs to deal with the reasons behind the building of separation walls as a wall is a symptom rather than the cause of the problem. Walls start to be built in minds, and they are the outcome of unresolved social (/political/religious/ideological/economic) oppositions in urban areas.[54] 'The walls in the city, built to offer a short-term solution, had become part of a long-term problem';[55] Gaffikin et al. add that they 'did not create "safe spaces"'.[56] Bach emphasizes the Berlin Wall's 'terrible power' and how walled cities create their identity out of the negative.[57] Belfast 'brands' itself with its separation walls, Troubles murals and sunken ship while Berlin brands its share of divisions and loss.

'I have touched the walls. / They touched me back.'[58] It is hard not to be touched by the peace walls while living in Belfast. The author's perspective is that of an outsider, similar to Costtick who writes,

> The closer you get to the walls, the less you see them: a privilege of my position has been that I have been able to gain a 'helicopter view' of the world around the walls – and I continue to be shocked by them.[59]

Not taking the walls for granted is key for 'seeing' them as they hinder the peace process, delay a possible shared future and contribute to division and polarization. Alternatively, walls can be seen as a vehicle for peacebuilding. In Atun and Doratli's words:

Film	Director	Country	Year	Guest Speakers
'71 (I)	Yann Demange	United Kingdom	2014	Frank Gaffikin, QUB Planning
				Ken Sterrett, QUB Planning
Akamas (II)	Panikos Chrissanthou	Turkey, Hungary, Greece, Cyprus	2006	Satish Kumar, QUB Geography
				Evropi Chatzipanagiotidou, QUB Anthropology
The Legend of Paul and Paula (II)	Heiner Carow	East Germany	1973	Tanja Poppelreuter, University of Salford Architectural History
				Gul Kacmaz Erk, QUB Architecture
Omar (I)	Hany Abu-Assad	Palestine	2013	Merav Amir, QUB Geography
				Mazen Iwaisi, QUB School of History, Anthropology, Philosophy and Politics
Walls (II)	Pablo Iraburu and Migueltxo Molina	Spain	2015	Murat Akser, University of Ulster Cinematic Arts
				Ulrike Vieten, QUB Mitchell Institute
Wings of Desire/Der Himmel uber Berlin (I)	Wim Wenders	West Germany, France	1987	Liat Savin Ben-Shoshan, Bezalel Academy of Arts and Design
				Gül Kaçmaz Erk, QUB Architecture

TABLE 8.1: Filmography: Walled Cities I + II

> Instead of emphasising the notions of difference, mutual fear and threat, the border itself can be accepted as an entity with elements of socialisation, constituting the mechanisms through which difference is accepted and instead of prolonging the conflictual aspects, a co-existence is achieved as an assurance towards future sustainable resolution.[60]

Building new highways does not solve traffic problems in big cities. Similarly, building new walls are not the solution to the conflict between communities. As a protagonist in *Walls* says, 'Walls are useless.' So how do we move from walled

public spaces to shared spaces? A platform of communication can be a beginning to touch on mental walls, and film and other forms of art can provide this platform. That is the main outcome of the Walled Cities film seasons. This does not change the fact that countries are divided with internal and external borders that are stronger than ever, and tall walls and fences fragment cities, with more on the way. Understanding the dynamics of a walled city and the reasons behind its contested spaces could be a starting point. Humanity has a long way to go, and cinema can help as its filmic representations portray walled cities and walled minds in unexpected ways.

NOTES

1. Banksy, *Banging Your Head against a Brick Wall* (Weapons of Mass Distraction, 2001).
2. John Paul Lederach, 'Foreword', in Vicky Cosstick, *Belfast: Towards a City without Walls* (Belfast: Colourpoint Books, 2015), 12. See also *Wall Street Journal* short film: https://www.youtube.com/watch?v=4W7yP8JJP38.
3. Scott Bollens, *City and Soul in Divided Societies* (London: Routledge, 2012), 6.
4. Bollens, *City and Soul in Divided Societies*, 23. The prison-like feeling of the place is explained, for instance, in relation to *Omar*: 'When the Israeli security guards chase Omar, we are exposed to the West Bank's landscape of narrow alleys and densely populated houses, which adds to the claustrophobic existence of people living under occupation.' Hania Nashef, 'Demythologizing the Palestinian in Hany Abu-Assad's *Omar* and *Paradise Now*', *Transnational Cinemas* 7, no. 1 (2016): 91. This is not different from the claustrophobic feeling in *'71*'s chase scenes. *Wings* seems like the only film out of the three that has accepted the divided nature of its city.
5. The term was coined by Karlfried Graf von Dürckheim (1932) and popularized by Juhani Pallasmaa; see, for instance: *The Architecture of the Image: Existential Space in Cinema* (2001).
6. CACity provides networking, education and research opportunities via film exhibits, talks, round table discussions, funding applications and conference presentations to more than three hundred members and the general public, especially cinemagoers and university students.
7. The *Culture and Society* Research Cluster in the School of Natural and Built Environment provided the funding.
8. QFT works closely with the British Film Institute in London.
9. The Palestinian-Dutch director was born in 1961 in Nazareth. He moved to Holland when he was 20.
10. The British director, with a French mother and Algerian father, was born in 1977 in Paris. He moved to London when he was two.
11. The German director was born in 1945 in Dusseldorf. He lives in Berlin.

12. Walled Cities film season incorporates public discussion into film exhibition. The event starts with an introduction, continues with the screening and a discussion follows. Two invited scholars working in the humanities discuss the film around the theme of walled cities. The audience contributes with questions, comments and oral histories. The conversation continues in the foyer of the cinema in smaller groups over refreshments. An email list is put together during the three-hour event.
13. Walled Cities II and III followed in 2018 and 2019, respectively.
14. '71 is filmed on location in Sheffield, where its production company Warp Films is based (Park Hill Flats), Leeds (period terrace housing in Hyde Park and Beeston), Blackburn/Lancashire and Liverpool (http://www.screenyorkshire.co.uk/showcase/71).
15. Gordana Fontana-Giusti, 'Walling and the City: The Effects of Walls and Walling within the City Space', *Journal of Architecture* 16, no. 3 (2011): 316.
16. Resmiye Alpar Atun and Naciye Doratli, 'Walls in Cities: A Conceptual Approach to the Walls of Nicosia', *Geopolitics* 14, no. 1 (2009): 111.
17. Architects design walls to enclose a space, and they open it up with windows and doors. Similarly, windows, gates, checkpoints and tunnels are punched on city walls. Watchtowers are built. Walls are never mere barriers. They have many faces and different meanings for the people on opposite sides.
18. Frank Gaffikin et al., *Public Space for a Shared Belfast* (Belfast: City Council, 2008), 33.
19. Gunfire, throwing stones/Molotov cocktail and so on.
20. Cupar Way in West Belfast between the Catholic Falls Road and Protestant Shankill Road is considered as the first wall. What started in September 1969 as a barbed-wire barricade is now a concrete wall, elevated to the height of a three-storey building using fencing and mesh.
21. Gaffikin et al., *Public Space for a Shared Belfast*, 7. The authors continue: 'Both need to be systematically dismantled, along with other paraphernalia of surveillance and enclosure.'
22. Bollens, *City and Soul in Divided Societies*, 13.
23. John Grech, 'Empty Space and the City: The Reoccupation of Berlin', *Radical History Review* 83 (2002): 120.
24. Vicky Cosstick, *Belfast: Towards a City without Walls* (Belfast: Colourpoint Books, 2015), 32.
25. Nashef, 'Demythologizing the Palestinian in Hany Abu-Assad's *Omar* and *Paradise Now*', 93.
26. Wim Wenders, *The Logic of Images: Essays and Conversations* (London: Faber and Faber, 1991), 109.
27. Wenders, *The Logic of Images*, 82.
28. The inner faces of the wall are grey in colour, while the face on the west side has colourful graffiti (for instance, of human faces in big scales). The eastern face is never onscreen. The wall is not too high, but it is impossible to see the other side.
29. Grech, 'Empty Space and the City', 131.

30. Cosstick, *Belfast*, 30.
31. Fontana-Giusti, 'Walling and the City', 128.
32. Nashef, 'Demythologizing the Palestinian in Hany Abu-Assad's *Omar* and *Paradise Now*', 90.
33. 'There are the murals, used for sectarian and paramilitary propaganda, to campaign for war, peace or justice, as history lessons, as memorials to the dead in the conflict, to define territory or alert outsiders.' Cosstick, *Belfast*, 135.
34. Cosstick, *Belfast*, 21–22.
35. Anita Bakshi, 'A Shell of Memory: The Cyprus Conflict and Nicosia's Walled City', *Memory Studies* 5, no. 4 (2012): 483.
36. The construction began much later during the Cold War in the early 1960s.
37. David Harvey, *The Condition of Postmodernity* (Massachusetts: Basil Blackwell, 1990), 316. Harvey continues: 'Is this where space now ends?'
38. Jonathan Bach, 'Memory Landscapes and the Labor of the Negative in Berlin', *International Journal of Politics, Culture, and Society* 26, no. 1 (2013): 33.
39. A. O. Scott, 'Treachery Thrives Where Trust Withers: In "Omar" the West Bank Is a Backdrop for Betrayal', *New York Times*, 14 February 2014.
40. Jonathan Bordo, 'The Homer of Potsdamerplatz – Walter Benjamin in Wim Wenders's Sky over Berlin/Wings of Desire', *Critical Topography* (2009): 91. Bordo adds: 'This site became one of the world's biggest real estate bonanzas with the fall of the Berlin Wall in 1989.'
41. Harvey, *Condition of Postmodernity*, 316.
42. Yi-Fu Tuan, *Space and Place: The Perspective of Experience* (Minnesota: University of Minnesota Press, [1977] 2001), 159.
43. 12–13 August 1961.
44. Michel Foucault, 'Of Other Spaces', *Diacritics* 16, no. 1 (1986): 25–26.
45. Cosstick, *Belfast*, 143.
46. Christina Pieri, 'Selective Heritage Management in Divided Cities: Focusing on Nicosia's Walled City Centre' (PhD, Nottingham Trent University, 2017), 55.
47. Bach, 'Memory Landscapes and the Labor of the Negative in Berlin', 34.
48. In the 1990s, I was gifted a piece of the Berlin Wall with a miniature East German car on the top by a friend visiting from East Berlin. (I choose to believe it is an original piece.) I have moved to five countries since then and I still have this souvenir.
49. Walter Benjamin, 'The Work of Art in the Age of Mechanical Reproduction', in *Illuminations* (Glasgow: Fontana/Collins, 1977), 224.
50. Bollens, *City and Soul in Divided Societies*, 9.
51. Similar to *'71*, the audience does not see the wall in *Paul and Paula*, though made in the 'wall period' just like *Wings*. However, the film depicts the construction and transformation in East Berlin during the separation.
52. The *Wall Street Journal* video mentioned earlier starts with American President Donald Trump's words about building a 'great wall' along their southern border between Mexico

and the United States as well as the discussions around a hard/soft border between Northern Ireland and the Republic of Ireland threatening the 'Free State' and 'Good Friday Agreement' (1998) because of the United Kingdom's European Union Membership Referendum (2016), known as the Brexit.
53. Tuan, *Space and Place*, 52.
54. The title of this section, 'Against the Wall', is the translation of the original title (*Gegen die Wand*) of Fatih Akin's *Head-on* (2004) portraying divided communities in Hamburg.
55. Gaffikin et al., *Public Space for a Shared Belfast*, 33.
56. Gaffikin et al., *Public Space for a Shared Belfast*, 25.
57. Bach, 'Memory Landscapes and the Labor of the Negative in Berlin', 35–39.
58. John Paul Lederach in Cosstick, *Belfast*, 11.
59. Cosstick, *Belfast*, 26.
60. Atun and Doratli, 'Walls in Cities', 131.

BIBLIOGRAPHY

Atun, Resmiye Alpar, and Naciye Doratli. 'Walls in Cities: A Conceptual Approach to the Walls of Nicosia'. *Geopolitics* 14, no. 1 (2009): 108–34.

Bach, Jonathan. 'Memory Landscapes and the Labor of the Negative in Berlin'. *International Journal of Politics, Culture, and Society* 26, no. 1 (2013): 31–40.

Bakshi, Anita. 'A Shell of Memory: The Cyprus Conflict and Nicosia's Walled City'. *Memory Studies* 5, no. 4 (2012): 479–96.

Banksy. *Banging Your Head against a Brick Wall*. Weapons of Mass Distraction, 2001.

Benjamin, Walter. 'The Work of Art in the Age of Mechanical Reproduction'. In *Illuminations*. Glasgow: Fontana/Collins, [1936] 1977.

Bollens, Scott A. *City and Soul in Divided Societies*. London: Routledge, 2012.

Bordo, Jonathan. 'The Homer of Potsdamerplatz – Walter Benjamin in Wim Wenders's Sky over Berlin/Wings of Desire, a Critical Topography'. *Images* 2, no. 1 (2008): 86–109.

de Brosses, Charles. *Du Culte des Dieux Fétiches (Cult of the Fetish Gods)*. Ghent: Ghent University, 1760.

Cosstick, Vicky. *Belfast: Towards a City without Walls*. Belfast: Colourpoint Books, 2015.

Fontana-Giusti, Gordana. 'Walling and the City: The Effects of Walls and Walling within the City Space'. *Journal of Architecture* 16, no. 3 (2011): 309–45.

Foucault, Michel. 'Of Other Spaces'. *Diacritics* 16, no. 1 ([1967] 1986): 22–27.

Gaffikin, Frank, et al. *Public Space for a Shared Belfast*. Belfast: Belfast City Council, 2008.

Grech, John. 'Empty Space and the City: The Reoccupation of Berlin'. *Radical History Review* 83 (Spring 2002): 115–42.

Harvey, David. *The Condition of Postmodernity – An Inquiry into the Origins of Cultural Change*. Massachusetts: Basil Blackwell, 1990.

Mendes, Ana Cristina. 'Walled In/Walled Out in the West Bank: Performing Separation Walls in Hany Abu-Assad's *Omar*'. *Transnational Cinema* 6, no. 2 (2015): 123–35.

Nashef, Hania A. M. 'Demythologizing the Palestinian in Hany Abu-Assad's *Omar* and *Paradise Now*'. *Transnational Cinemas* 7, no. 1 (2016): 82–95.

Pieri, Christina. *Selective Heritage Management in Divided Cities: Focusing on Nicosia's Walled City Centre*. PhD diss., Nottingham Trent University, 2017.

Scott, A. O. 'Treachery Thrives Where Trust Withers: In 'Omar' the West Bank Is a Backdrop for Betrayal'. *New York Times*, 14 February 2014.

Tuan, Yi-Fu. *Space and Place: The Perspective of Experience*. Minnesota: University of Minnesota Press, [1977] 2001.

Wenders, Wim. *The Logic of Images: Essays and Conversations*. London: Faber and Faber, 1991.

'The World's Biggest and Most Famous Walls'. *Wall Street Journal*, 26 January 2017. http://www.youtube.com/watch?v=4W7yP8JJP38.

Film List

'71. Directed by Yann Demange, UK: Warp Films, 2014.

Omar. Directed by Hany Abu-Assad, Palestine: ZBROS, 2013.

Wings of Desire (Der Himmel uber Berlin). Directed by Wim Wenders, West Germany: Road Movies, 1987.

9

Architectures of the Suspended Moment

Jean Boyd

For a moment the football game is forgotten. The camera pulls in, shallow depth, the boy looks up as the seagull dips for the offered food. The image dissolves into another. The focus is close, a different view, a child's smiling face. Dissolve and up, we are aloft now, among the gulls, wide angle. Below us the Casbah and the city of Algiers stretches to the sea.

It is strangely quiet, but for the noise of the helicopter below us. East London is set out beneath like a map. Some streets are empty of traffic and we can see people running, others are gathering, waiting. Fires have been started. We are high above, the people are tiny, but from here we can see everything, every detail.

However from where, when, and how can the viewer see?

To image or imagine the city is to address not only the production and representation of space but also the mediation of its heterogeneous temporalities, in these examples, it would seem by photography and film. What demands and affordances do still and moving images make; when is the time and where is the space of the digital image? To ask this is also to address what is perceptible, and what may be occluded, in both the image and the lived city.

In their mediation of cityscapes, David Claerbout (*The Algiers Sections of a Happy Moment*, 2008) and Stan Douglas ('Mare Street' and 'Pembury Estate', 2017) position the viewer as one whose gaze can roam and pause, shift scale, linger, encounter the city as an object of thought as much as vision. While acknowledging the diverse concerns of these artists' practices, both utilize sophisticated post-production in works that simultaneously offer and withdraw familiarly situated readings. Indeed it is recognizing this familiarity, this 'realism' and its disturbance, that allows access in both these works to the potentiality of lived urban space.

At a time when many sense that in our cities there is, in Henri Lefebvre's words, 'the impossibility of the existing social relations being adhered to indefinitely', it has become an urgent task to find out 'what this impossibility makes possible and, conversely, what the "real" obscures and blocks at present'.[1] Lefebvre deployed

the utopian as a critical tool: embedded in the everyday, intercalated in its space and time, it rendered the 'otherwise' sensible, visible and legible.[2] It is not therefore consonant with the ideal, the abstract nor necessarily the good; rather it is available as an experience and as an aesthetic to those observant enough to discern its traces. Expressed in metaphors of light, space and time, the utopian is present as 'an illuminating virtuality'.[3]

This study considers how Claerbout's and Douglas's works operate within these metaphoric territories of light, space and time, and using Lefebvre's configuration of the urban and the virtual, how the mediated city reveals itself in these images.

Art as civic imaginary

Making the contemporary legible to itself is a task of art practice: it is a means of grasping what makes this time our own. As aesthetic forms, the digital techniques used by Claerbout and Douglas cannot be understood simply as vehicles for visual information: rather they are environments for meaning-making as an interaction between technical media and viewer subjectivity. Spaces and temporalities can be compressed, expanded or overlapped; the proximate coincides with the distant, the remembered, and each are productive of contemporary sensibility and hence political possibility.

As a prefiguring of the possible, art gives form to what can now be imagined, experienced, distributed and collectively understood. This composition of a shared civic sphere is both of concern in the oldest texts of political philosophy and a topic of current urgency, as reflected in the work of Jacques Rancière,[4] Giorgio Agamben[5] and Ariella Azoulay,[6] among others.

Recent art practices have encouraged public discourse on the relation of the individual to the group, interrogated distinctions between public and private spheres and critiqued coercive and disciplinary manifestations of power. Rancière suggests the political force of art lies in its reordering of the visible and thinkable: a redistribution of the sensible.[7] Azoulay brings a new critical imperative to the analysis of photography itself as political ontology: imaging/imagining as acts that can bring forth the civic, for 'civil imagination is a tool for reading the possible within the concrete'.[8]

Lefebvre argued for similarly interpretive, critical urban practices to which art was a crucial contributor, defined as the capacity to transform reality, transfigure time-spaces, create structures of enchantment, even to suggest praxis and poiesis on a social scale.[9] Where can such strategies be found in the artworks under discussion?

To consider how the city reveals itself to the camera and the gaze is also to consider how this might constitute a form of civil knowledge. In their temporal and spatial 'flows of life', the modern city and the films that captured these flows seemed to share affinities. The life of the street was marked by encounters structured and contingent, shaped by rhythms of work and leisure, but also improvised, ephemeral, spontaneous.

These affinities have been thoroughly explored; the city's 'optical unconscious' has long been in analysis.[10] The observations of Benjamin's companion Franz Hessel, in his 'Architectures of the Instant' (1927; cited in Friese[11]), seemed to apply equally to the ever-shifting visual cityscape and film's capacity for its capture as 'indexical trace', conjuring its own temporal and spatial architectures of experience. Siegfried Kracauer, who originally studied architecture, would later echo such structural equivalences in his consideration of the cinematic object, now available through previously unimagined spatial and temporal perspectives through the close-up, the long shot, the slowing of time.[12] Equally, the city might be considered, via filmic devices of slowed time or the long shot, as a redistribution of the politically sensible. A projection of the civil imaginary revealing the yet-unrealized city, making visible where state power becomes inoperable on bodies in spaces, for Agamben 'art is political in itself, because it is an operation which contemplates and renders non–operational man's senses and usual actions, thus opening them to new possible uses'.[13]

In his 'Right to the City' of 1967 Henri Lefebvre defines the city as a 'projection' of society on the ground, not only onto the actual site, but also as a projection onto thought: on how the city is perceived and conceived, as a set of temporal modes and rhythms.[14]

The projection in and onto space, perception, modes and rhythms of time: the language is intrinsically cinematic. However, what does this cinematic framing foreground, or reveal, of the city as a set of social relations? Can the art of our time show us the city as a projection of our own socio-technical and civil imaginaries?

Digital image construction belies the indexicality of there/then, here/now or even distinctions between photography and film: we might, therefore, ask what temporal compressions, expansions or suspensions become available between or beyond the still and moving image. Cinematic architectures of the extended 'instant', as in these artworks, demand that the viewer treats the dynamic manipulation of viewpoint, framing and time as critical vantage points from which to address the city as a social projection.

What space then becomes available for that which previously had no place, the utopic? Lefebvre suggests,

Utopia is to be considered experimentally by studying its implications and consequences on the ground. These can surprise. What are and would be the most successful places? [...] What are the times and rhythms of daily life which are inscribed and prescribed in these 'successful places' favourable to happiness?[15]

It is to happiness, in an ordinary moment of city life, that the 2008 work by Belgian artist David Claerbout refers.

A Happy Moment

A 37-minute projection, run as an ongoing continuous loop, *The Algiers Sections of a Happy Moment* transports the viewer to a Casbah rooftop. A group of boys and their football game, a space appropriated from the steep rise of the old city, a sun-filled day and seagulls wheeling overhead.

At first, the unhurried passage of frames is likely to be read as slowed film, but as each stilled image fades into the next, the viewer gradually becomes aware this is a single moment in time. More baffling still, the lexicon and syntax of frame and edit, focal depth, close-up, aerial view and long shot explore the space so thoroughly, so widely and so intimately that it becomes apparent this cannot possibly be a single moment captured from multiple vantage points (Figure 9.1).

The privileged, decisive moment of photography is at once denied and spun out like a thread through cinematic space and suspended time. Crucially, this mobilized view is an exquisitely crafted digital construction that voids any distinction between still and moving: thousands of photographs from which hundreds were chosen and sequenced to create the form, or experience of a film.

The moment, fleeting and almost ungraspable, has a particular relation to time and representation. It is both a privileged exception to the flow of time, its interruption and something that has always already moved away. The dual inference of stillness and momentum leaves it perfectly poised as stasis and as change, as presence and as becoming.

The viewer too must shift their gaze, and their own pace of looking, to adjust to this mobile accumulation of immobilized images. Observing, discovering anew, is soon matched with recollection and recognition. As the scene unfolds again, afresh with each new view, so the viewer builds on memories of the previous images. To stay with the work and to submit to its temporality is to be held in a synchronous state of remembering, observing and anticipating. The looped sequence is experienced as almost infinite, and so too is the sense that this single moment of city life and happiness could never be exhausted or adequately captured in all its potential.

FIGURE 9.1: Still frame from *The Algiers Sections of a Happy Moment*, 2008. Courtesy of David Claerbout and galleries: Sean Kelly, New York; Esther Schipper, Berlin; Rüdiger Schöttle, Munich.

We seem to be both in time, in space and outside any common understanding of these; either as everyday experience or as representation (Figure 9.2).

Into this temporal space, the contemplative gaze has time to roam and inhabit the privileged, kairotic instance of happiness. Lying dormant in the everyday, for Lefebvre, such moments can detonate into fully lived presence and intensity – as such they cannot endure but should be grasped in all their utopic potential.[16] Claerbout states that an intention for *The Algiers Sections of a Happy Moment* was to disarm and relax the 'suspicious gaze'.[17] The line of sight made available in this happy moment might not just be spatial, but an attentive awareness of the fully present and inhabited now-place, to be in-time with others. Thus a city space, adapted and improvised by its residents, becomes accessible as a projection of civic imagination. Importantly, this 'moment' never was an event but instead a cinematic image as temporal and spatial excess, an impossible-possible granted to the gaze. The viewer joins those imaged in a paused fragment of happiness, now manifest as a field of relations that might define a liveable, civic space.[18]

FIGURE 9.2: Still frame from *The Algiers Sections of a Happy Moment*, 2008. Courtesy of David Claerbout and galleries: Sean Kelly, New York; Esther Schipper, Berlin; Rüdiger Schöttle, Munich.

The work allows the city to accumulate topographically, accessible from multiple viewpoints and across multiple scales. Near-space and far-space are always anchored by the men and boys on their makeshift football ground; the city expands away from and towards their playful habiting of place. Sometimes the texture of a garment or brush of a seagull's wing feels close enough to touch; sometimes the rooftop can only be glimpsed, distant, almost indistinguishable among many. The viewer starts to learn something of the city's steep and labyrinthine structures, to feel the density of its vertiginous buildings, sense the freedom that this rooftop space affords. Six hundred individual frames, even purporting to be of a single instant, cannot begin to capture this city space as it is lived. The multiplication and expansion of the viewpoint evade any totalizing gaze, offering always yet another way of looking at the city, inexhaustible in its potential.

For the eye to move so freely through the suspended instant allows time for other images and memories to rise up and dissolve: most notably the luminous monochrome frames of Gillo Pontecorvo's 1966 *The Battle of Algiers*, in which

the everyday lived spaces of the old city are both the physical and conceptual spaces of resistance to those of the colonizer. It is worth noting how urban planning of Algiers in the 1830s helped establish colonial spatial and cultural dominance. A spectacle of sovereign power, its ability to destroy and construct was an exemplar of political-aesthetic reordering.[19] The victorious French commander Marshal Bugeaud's subsequent treatise on urban warfare, *The War of Streets and Houses* (1849), ushers in not only urban spatial organization for military advantage, but also an emphasis on habited, everyday civilian space and social fabric as the definition of the city itself and thus a legitimate target of warfare. Against this production of dominant and dominating space, in the Algerian uprising of the mid-twentieth century, the Casbah came to represent both a physical and representational obstruction to the logic of the colonizer. The rhizomatic and contiguous structures of the buildings, linked on many levels by steps, winding passageways and connecting rooftops, expressed the resistance of historic social formations and cultural memory, the lived spaces of representation as complexities against which military tactics would always struggle.

Claerbout's images may also recall more recent scenes from the so-called Collateral Murder Baghdad airstrike of July 2007, with footage from the Target Acquisition and Designation System of the Apache helicopter, leaked controversially into the public domain. The gunsight camera, from its circling aerial vantage (long-shot) and precision targeting (close-up), scans rooftops and courtyards of the city suburb, rendering in hazy monochrome the people gathered below. The suspicious gaze of the apparatus identifies its mirror image – a camera telephoto lens as a weapon – with lethal effect.[20]

These examples are a reminder of other contexts and narratives that filmic images make available: how images construct and are constructed, how the image is a surface, a ground onto which society is projected, but also a means by which its concepts are reproduced, circulated and distributed. How important it is to understand the vantage point from which an image is captured, and to engage as a viewer-actant in the civil discourse of the image.

Mare Street and Pembury Estate

It is exactly this awareness that Canadian artist Stan Douglas seeks to provoke in the diptych of large photographs 'Mare Street' and 'Pembury Estate' (2017) (Figures 9.3 and 9.4). Images of Hackney, east London, at the moment of impending riots, they form part of a current project examining the global upheavals and emancipatory demands of 2011, from Zuccotti Park to Tahrir Square, the 'year of dreaming dangerously'.[21] That political claims could still be expressed so forcefully

FIGURE 9.3: Stan Douglas, Mare Street, 2017. Courtesy of Victoria Miro Gallery.

by the gathering of bodies together in city streets was striking. These events have revitalized debates on the interaction of space, collective politics, utopianism and the city, and have brought renewed interest in Lefebvre's extensive work on these topics. In the span of two months London would see two very different forms of protest against the government's response to the economic crisis, both expressed through the occupation of public space. Whereas Occupy London was an active form of collective, visible citizenship that made demands for just governance and profound political change, the riots were a reactive form of violence that made visible an absence of citizenship while making no demand for alternatives. The latter pointed to a deeper crisis in civil imagination and has proved significantly more resistant to explanation.[22]

The London riots of August 2011 were triggered by the police killing, in unclear circumstances, of an alleged minor criminal. Local anger rapidly escalated into rioting and looting across London, then spreading nationally to other cities in explosive outbreaks of unrest. Three years into austerity, in the wake of the financial crisis, it was the nearby City and Canary Wharf financial districts that appeared to have been bolstered at everyone's expense, and there was a particular intensity legible in London's proximity of privilege to its absence.

Douglas has always been interested in moments when normative forces can no longer maintain consensus; in Rancière's terms, these moments are political. They

flare up and illuminate the possibilities and constraints on individual subjectivity and collective civic imaginations; times of unpredictability when history might go one way or another and potential is found, or perhaps squandered. The outcome may be regretted, but the coordinates of the possible have shifted; what remains is the utopic trace of what had no place but searched for its place. For Douglas, 2011 saw the city become a locally specific and globally distributed stage for this search.

For the rioters, the potential – as power and as a future inscribed in the present – lay in occupying those streets in a moment of apparent subjective freedom, enabled by the coming together of bodies in space, in a carnival of destruction. This was the full terror, and the full revelation, of the city and the crowd. As an articulation of the people, for whom and from whom democratic political representation should arise, the crowd had no coherent agenda from which to contest power: rather as a destructive mob (still incipient in the moment of the Mare Street and Pembury Estate images) they turned their rage on their neighbourhoods. This ruination and looting expressed a perverse power for 'defective and disqualified' consumers; those who could neither inhabit the streets legitimately as consumers nor feel represented as citizens of a city in transition.[23] Žižek suggests the lack of any political agenda signals that this was not a conflict between different parts of society or different views of society: instead, society saw its opposite, non-society, and those who felt neither agency nor stake in their community.[24]

Douglas always attends carefully to how access to these moments is given representation and mediated into documents of history: by photo-journalism, broadcast television, film and documentary. He is alert to the often-overlooked space of power *behind* the lens and the temporal implications of the medium; how transient moments might be captured, held, extended. Combining meticulously researched documentation, from news footage to Google Street View, with newly shot aerial film, Douglas assembled a (re)construction of the gathering disturbances on that August evening in Hackney. Great care was taken to replicate the details of the shopfronts and signage, exactly the ephemeral architectures of the instant that fascinated Hessel. Asynchronous, temporally distributed images build a spatial, visual field that is at once past, and tangibly present before us. Focus, clarity and narrative truth are desired from visual documentation and historical perspectives alike: Douglas problematizes simple access to either. We are made aware that these images are simultaneously actual, virtual and historiographical.

Douglas utilizes the grammatical structure of panoptic surveillance then displaces their agent. There is an unmooring, a rupture in the closed system whereby structures of representation and power implicate each other. The apparatuses of these are in the optical structures – viewpoint, perspective – but it is not possible to locate, and identify with, any single vantage point among the dense composited layers.

Most images of riots place us, dramatically, at street level. Instead, it is the viewer that has to choose where to place and move their gaze, a mobile and focused attentiveness. What might narratively unfold as a sequence in film is available, all-at-once, scattered across the surfaces of the two photographs. The viewer's gaze overrides the cuts and edits. Moving between the two images, awareness grows of the margins and what must fall between fields of vision, both spatially and temporally. The locations lay barely three hundred metres apart, almost contiguous. Time may be synchronous or time may slip between them: searching for clarity in the pin-sharp images renders less certain the master narrative of what 'is happening'.

Significantly, what might seem contingent to the unfolding violence are the tangible traces of lives lived, improvised and routine. The washing drying on balconies of the Pembury flats, the worn-out summer grass around the playground, the plastic chair in the yard, plants in a window box: the compressed spaces of the city. All are rendered in same focus, an uncanny hyper-clarity that telescopes proximity and distance.

Central and periphery are always in play in Douglas's work, a consideration of social and ethical frameworks, of race, for instance, hidden in the everyday. Who decides what stays local, or becomes significant? Histories still residual, or marked as absences; in making present these failed past utopias, his works operate as virtual images of what might still shape futures yet to come.

The Pembury Estate is emblematic of the utopic ideals of pre- and post-war social housing programmes for London's East End: a production of the social through architectural and spatial planning. As such it is equally a physical structure,

FIGURE 9.4: Stan Douglas, Pembury Estate, 2017. Courtesy of Victoria Miro Gallery.

and an ideologically contested zone of public and private space. Estates were a significant focus in the search for blame, or cause, in the wake of rioting: framed as either private or public responsibility, individual or collective failings, whose emblems were the malfunctioning consumer-citizens who disrupted codes of spatial practice, looting rather than shopping, rioting rather than organizing politically.[25] Lefebvre reminds us

> The *urban* cannot be defined either as attached to material morphology [...] or as being able to detach itself from it [...] It is a mental and social form, that of simultaneity, of gathering, of convergence [...] It is a *field* of relations including notably the relation of time (or of times; cyclical rhythms and linear durations) with space (or spaces: isotopias and heterotopias).[26]

Hackney is a heterotopic space of multiplicity and difference, historic neglect and local resilience. In August 2011 construction continued at the nearby Olympic Park, with less than a year remaining before the Games, the promises of prosperity and legacy still abstract. Prosperity remains elusive for many Hackney residents. The Park, however, is an isotopic space, a space of post-industrial leisure and lifestyle that smooths difference, aligning itself not with its near neighbourhoods but with similar locations across London, and globally.[27]

Douglas's images are located right on the cusp of event, at the moment when conflict becomes inevitable. He places the gaze at a distance, high above, from where it roams among streets and rooftops, fascinated, distracted, until the unfolding conflict becomes almost incidental. It is the city itself as the stage for the everyday and the extraordinary, the planned and the unforeseen, that spreads out below.

Representations of space, spaces of representation

Here can be glimpsed the overlap between a critique of spatial practice and critical art practice. Lefebvre suggested the colonization of everyday life was underwritten by visual regimes of signification: single point perspective, space measurable and geometrically distributed. Facades, monuments, lines of sight and vistas of architecture treat space as a predominately visual medium: something common to urban planning and film alike.[28] The panoptic 'view from above' that flattens and abstracts space while also mapping and surveilling it: the gesture of the colonizer, the flight of the drone and more than ever the visual regime of our time.

These 'representations of space' are abstract, conceptual; they delimit the boundaries of public and private. This is space looked at from the outside, the first (arche) differentiation. It can be quantified and expressed as economic value,

likewise, its temporality can be measured as rational economic units, linear and directional.

In contrast to these prescriptions and proscriptions of the city there is space as it is lived in, inventively, unpredictably, often precariously. For Lefebvre these are 'spaces of representation' whose meanings or patterns emerge from their inhabiting and use: lived space, creating cycles of return or divergence. They have participatory rather than economic value: civic spaces for being-with-others, in consensus and dissensus. Spaces of representation express bodies politic. Not space from the inside but space understood without the need for such differentiation; porous and adaptable. Its temporality is dilatory, uneven, time as it is felt: time that pauses in 'moments' of play, wonder or absorption.

These artworks open up architectures of the instant as modes of analysis: spaces where thought can move around. Digital assemblage, not indexicality; multiple and suspended time, not linear flow. These features acknowledge the conditions of contemporary image production and the experience of the contemporary city. The layering of conflicting temporalities, proximities and vantage points act as aesthetic and critical strategies.

Douglas's photographs collapse panoptic mastery and the intimacy of lived detail into the same space. A vivid moment when the street is occupied differently, but the possibility of the crowd or agonistic polemic cannot find legitimate expression: what is right there yet is occluded.

The Happy Moment dilates and pauses time: it constructs a temporal space of representation, freedom to survey and inhabit this present moment of happiness. It points towards successful spaces on the ground of lived experience, to the times and rhythms of the city 'favourable to happiness'. A virtual possible-impossible, right there, but now no longer occluded. Lefebvre asserts that the 'urban remains in a state of dispersed and alienated actuality, as kernel and virtuality. What eyes and analysis perceive…can at best pass for the shadow of a future object in the light of a rising sun'.[29]

Claerbout and Douglas return the city to us as such a future object, and its shadow, in images made of light and darkness. This is the city available to 'eyes and analysis': real and imagined, constructed and contingent, quotidian and now utopian.

The utopic gaze

To make the utopian city available requires re-imaging and reimagining what already surrounds its present citizens. Can art practice enact a similar gesture? Transforming, however briefly, what, how and from where the viewer sees,

activating and redirecting the gaze. Against the familiar routines and experiences of daily lives, art might produce or explore other temporalities and durations: these are experienced in our encounter with the work, in our present and its presence.

Appearing in the semblance of photography and film, these works invite the viewer to position themselves as viewing subject of represented objects, in ways familiar to these media, their histories and uses. Crucially, in neither artwork do the images conform to the spatio-temporal logic of the photographic or the filmic: it is precisely this experience of dislocation, as viewers, that opens the city to eyes and analysis in new ways, among the architectures of the suspended moment, in the contraction and expansion of near and far, of the punctual and the global.[30] Lefebvre asks, 'What about u-topia, the non-place, the place for that which doesn't occur, for that which has no place of its own, that is always elsewhere?'[31] A horizon, a desire, an excess: the gaze of these works looks out from this place, not just towards it.

Claerbout's work immerses the viewer in the plenitude of the happy moment, one that appears to 'take place' but in a time that only takes place for them. The images conjure a place for that which did not occur as a past event or as the decisive moment of photography. Instead, the happy moment continues to occur, in its and the viewer's infinitely unfolding present; not as the durée of the long exposure photograph, the progression of the cinematic sequence, nor the stilled repetition of the freeze-frame. It is a view onto what is always elsewhere, offered from a place – or an infinite number of potential places – suspended between the actual and the virtual, a possible-impossible experienced as wonder.

Douglas's meticulously constructed photographs similarly position the viewer in the non-place of the virtual gaze, both offering and unsettling visual mastery of the scene. They overlook the city from an indeterminate non-place near the border of verticality, the 'dimension of desire, power and thought'.[32] However, the gaze itself is far from indeterminate in its precision; it imagines, it makes images, constructs narratives; it projects from a place of consciousness. Gaze, understood thus, becomes a theory and a practice for observing the virtual city as a territory of agency and desire, in which the viewer is already implicated.

In the experience of The Happy Moment, of Mare Street and Pembury Estate, the artists offer moments of the lived city as enduring, but urgent questions about the ability of the citizen to shape their own spaces of representation, to form publics, participate in and appropriate their time-spaces, create and renew their civic imaginary. If descriptions of these artworks as film or photography are set aside, they might instead be understood as techniques to be mastered: for seeing otherwise, for accessing perspectives and prospects of the urban, in all its complexity, with a gaze infused with utopic potential. Techniques using light, space and time to render the city as (im)possible object, they are illuminated virtualities.

NOTES

1. Henri Lefebvre, *The Survival of Capitalism*, trans. F. Bryant (New York: St. Martin's, 1973), 36. Lefebvre's concept of 'rights to the city' has entered current political language, albeit with new shades of meaning. 'Right to the City: Bridging the Urban Divide' was used to title a 2010 United Nations World Urban Forum and continued in use in the UN Habitat 111 Conference in Ecuador 2016.
2. Henri Lefebvre, *The Urban Revolution*, trans. R. Bononno (Minneapolis: University of Minnesota Press, 2003), 131.
3. Lefebvre, *The Urban Revolution*, 131.
4. Jacques Rancière, *Dissensus: On Politics and Aesthetics* (London: Bloomsbury, 2010).
5. Giorgio Agamben, 'Art, Inactivity, Politics', in *Criticism of Contemporary Issues: Serralves International Conferences*, idem et al. (Porto: Fundação Serralves, 2007).
6. Ariella Azoulay, *Civil Imagination: A Political Ontology of Photography* (London: Verso, 2015).
7. Jacques Rancière, 'Art of the Possible', *Artforum* 45, no. 7 (March 2007): 256–67.
8. Azoulay, *Civil Imagination*, 234.
9. Henri Lefebvre, *Writings on Cities*, trans. E. Kofman and E. Lebas (Oxford: Blackwell, 1996), 164.
10. Walter Benjamin, 'Little History of Photography', in *Walter Benjamin: Selected Writings, Vol. 2, Part 2, 1931–1934*, trans. Rodney Livingstone et al., ed. Michael W. Jennings, Howard Eiland and Gary Smith (Cambridge, MA: Belknap, [1931] 1999), 510.
11. Franz Hessel's 1927 'Architekturen Des Augenblicks', in *Sämtliche Werke Band III* (Oldenburg: Igel Verlag, 1999), cited in H. Friese, *The Moment: Time and Rupture in Modern Thought* (Liverpool: Liverpool University Press, 2001), n11, 87.
12. Siegfried Kracauer, *Theory of Film: The Redemption of Physical Reality* (Princeton: Princeton University Press, 1960), 96.
13. Agamben, 'Art, Inactivity, Politics', 140–41.
14. Henri Lefebvre, 'Right to the City', in *Writings on Cities*, trans. E. Kofman and E. Lebas (Oxford: Blackwell, [1967] 1996), 109.
15. Lefebvre, 'Right to the City', 151. More (1516) would also have been aware that Eutopos – happy place – was a near homophone of Utopia.
16. Henri Lefebvre, *Critique of Everyday Life, Vol. II* (London: Verso, 2002), 345.
17. David Claerbout website, https://davidclaerbout.com/The-Algiers-Sections-of-a-Happy-Moment-2008 (accessed 25 February 2018).
18. This also recalls Bloch's definition of the lived moment as Utopian:

 The final will is that to be truly present. So that the lived moment belongs to us and we to it and 'Stay awhile' could be said to it. Man wants at last to enter into the Here and Now as himself, wants to enter his full life without postponement and distance. The genuine utopian will is definitely not endless striving, rather: it wants to see the merely immediate

and thus so unpossessed nature of self-location and being-here finally mediated, illuminated and fulfilled, fulfilled happily and adequately.

See Ernst Bloch, *The Principle of Hope*, *Vol. 1* (Cambridge, MA: MIT Press, 1995), 16.
19. UNESCO conferred World Heritage status on the Casbah acknowledging it as 'the remains of a traditional urban structure associated with a deep-rooted sense of community'. http://whc.unesco.org/en/list/565 (accessed 17 February 2018).
20. Made available to Wikileaks in 2010, the attack killed twelve civilians, including a Reuters journalist and cameraman. https://wikileaks.org/wiki/Collateral_Murder,_5_Apr_2010 (accessed 16 February 2018).
21. Slavoj Žižek, *The Year of Dreaming Dangerously* (London: Verso, 2012).
22. The LSE Public Policy Group gathered a collection of analyses of the London riots, reflecting a range of interpretations: http://blogs.lse.ac.uk/politicsandpolicy/files/2012/08/London-Riots-20111.pdf. Contrastingly, Žižek argues that in trying to draw the riots into familiar frameworks of critique, what characterized them remains unthought.
23. Zygmunt Bauman, 'The London Riots – on Consumerism Coming Home to Roost', *Social Europe* (9 August 2011), https://www.socialeurope.eu/the-london-riots-on-consumerism-coming-home-to-roost (accessed 12 February 2018).
24. Žižek, *The Year of Dreaming Dangerously*, 60.
25. Polly Curtis, 'Were Estates to Blame for the London Riots?' *Guardian Newspaper*, 15 September 2011, https://www.theguardian.com/politics/reality-check-with-polly-curtis/2011/sep/15/reality-check-estates-riots (accessed 11 February 2018).
26. Lefebvre, 'Right to the City', 131.
27.

It was never clear how an Olympic Games could or would address inequalities which derive from relative poverty [...] market led physical development of the kind now underway cannot address core areas of need, and runs the risk of excluding or even displacing those with little market power.

See Ralph Ward, 'Regeneration Games', in *Olympic Games Impact Study: Post-Games Report 2015*, 154–5, https://library.olympic.org/Default/doc/SYRACUSE/161895/olympic-games-impact-study-london-2012-university-of-east-london?_lg=en-GB (accessed 11 February 2018). An apparently public project has delivered significant private gain.
28. Henri Lefebvre, *The Production of Space*, trans. D. Nicholson-Smith (Oxford: Blackwell, 1991), 49.
29. Lefebvre, 'Right to the City', 148.
30. Lefebvre, *The Production of Space*, 332.
31. Lefebvre, *The Urban Revolution*, 131.
32. Lefebvre, *The Urban Revolution*, 130. Lefebvre is referring to Bretez's immense map of Paris. In the 1730s Michel-Etienne Turgot was Prévôt des Marchands and appointed Louis

Bretez, an academician, to draw the map. Measured meticulously on the ground over two years, the map is presented as an aerial view, isometric and without perspective or horizon line, with every element across its surface equally rendered in detail. Not strictly diagrammatic although almost devoid of human presence, it does make suggestion of a stilled moment in time, with a slight fall of light and shadow, and tiny figures steering boats on the Seine. The map is available at the Kyoto University Library, https://edb.kulib.kyoto-u.ac.jp/exhibit-e/f28/f28cont.html.

BIBLIOGRAPHY

Agamben, Giorgio. 'Art, Inactivity, Politics'. In *Criticism of Contemporary Issues: Serralves International Conferences*. Translated by Caroline Beamish, edited by António Amorim, Rui Mota Cardoso, Manuel Costa, António Guerriero, 131–41. Porto: Fundação Serralves, 2007.

Azoulay, Ariella. *Civil Imagination: A Political Ontology of Photography*. London: Verso, 2015.

Bauman, Zygmunt. 'The London Riots – on Consumerism Coming Home to Roost'. *Social Europe* (2011). Accessed 12 February 2018. https://www.socialeurope.eu/the-london-riots-on-consumerism-coming-home-to-roost.

Benjamin, Walter. 'Little History of Photography' [1931]. In *Walter Benjamin: Selected Writings, Vol. 2, Part 2, 1931–1934*. Translated by Rodney Livingstone and Kingsley Shorter, edited by Michael W. Jennings, Howard Eiland and Gary Smith, 507–30. Cambridge, MA: Belknap, 1999.

Bloch, Ernst. *The Principle of Hope, Vol. 1*. Cambridge, MA: MIT Press, 1995.

Bugeaud, Maréchal. *La Guerre Des Rues Et Des Maisons*. Paris: Rocher, 1997.

Claerbout, David. Studio website. Accessed 25 February 2018. https://davidclaerbout.com/The-Algiers-Sections-of-a-Happy-Moment-2008.

Curtis, Polly. 'Were Estates to Blame for the London Riots?' *Guardian Newspaper*, 15 September 2011. Accessed 11 February 2018. https://www.theguardian.com/politics/reality-check-with-polly-curtis/2011/sep/15/reality-check-estates-riots.

Friese, Heidrun. *The Moment: Time and Rupture in Modern Thought*. Liverpool: Liverpool University Press, 2001.

Groys, Boris. *Going Public*. Berlin: Sternberg, 2010.

Kracauer, Siegfried. *Theory of Film: The Redemption of Physical Reality*. Princeton: Princeton University Press, 1960.

Lefebvre, Henri. *Critique of Everyday Life, Vol. II*. London: Verso, 2002.

———. *The Production of Space*. Translated by D. Nicholson-Smith. Oxford: Blackwell, 1991.

———. 'Right to the City'. In *Writings on Cities*. Translated by E. Kofman and E. Lebas. Oxford: Blackwell, [1967] 1996.

———. *The Survival of Capitalism*. Translated by F. Bryant. New York: St. Martin's, 1973.

———. *The Urban Revolution*. Minneapolis: University of Minnesota Press, 2003.

Mouffe, Chantal. *Agonistics: Thinking the World Politically*. London: Verso, 2013.

Rancière, Jacques. *Aesthetics and Its Discontents*. Translated by S. Corcoran. Cambridge: Polity, 2009.
———. 'Art of the Possible'. *Artforum* 45, no. 7 (March 2007): 256–69.
———. *Dissensus: On Politics and Aesthetics*. London: Bloomsbury, 2010.
UNESCO. *Kasbah of Algiers*. Accessed 17 February 2018. http://whc.unesco.org/en/list/565.
Ward, Ralph. 'Regeneration Games'. In *Olympic Games Impact Study: Post-Games Report 2015*. Accessed 11 February 2018. https://library.olympic.org/Default/doc/SYRACUSE/161895/olympic-games-impact-study-london-2012-university-of-east-london?_lg=en-GB.
Wikileaks. Collateral Murder, 2010. Accessed 16 February 2018. https://wikileaks.org/wiki/Collateral_Murder,_5_Apr_2010.
Žižek, Slavoj. *The Year of Dreaming Dangerously*. London: Verso, 2012.

Art Works

The Algiers Sections of a Happy Moment. David Claerbout, 2008. Single channel video projection, 37-min loop, stereo audio, black and white. Courtesy of David Claerbout and galleries. Sean Kelly, New York; Esther Schipper, Berlin; Rüdiger Schöttle, Munich.
Mare Street. Stan Douglas, 2017. C-print on dibond, 1800 x 3000 mm.
Pembury Estate. Stan Douglas, 2017. C-print on dibond, 1500 x 3000 mm. Courtesy of Stan Douglas and Victoria Miro Gallery, London.

PART III

NARRATED MEMORIES OF MEDIATED URBAN LIFE

10

The City Is a Changing Medium: Imagining New York and Los Angeles in Doug Aitken's Work

Gracia Ramírez

Doug Aitken is a multimedia artist who often works at the intersection between film and the built environment, enfolding buildings like the Hirshhorn Museum with a circular screen for projections in *Song 1* (2012) or using buildings to create kinetic experiences, as in the mirror-covered ranch-style house of *Mirage* (2017) in the Coachella Valley. Aitken is interested in exploring linearity and fragmentation in contemporary life and the role of popular culture in mediating everyday experiences. His practice elicits ambivalent emotions ranging from the mundane to the extraordinary, from the pessimistic to the celebratory, and it often blurs the boundaries between the real and the imagined in typical post-modern fashion. This chapter concentrates on two of Aitken's projects that engage with the cities of New York and Los Angeles: *Sleepwalkers* (2007) and *The Idea of the West* (2010), respectively. These two examples represent two points in Aitken's career which provide insight into our encounters with media art and how popular culture images mediate our experiences of contemporary cities. Ultimately, this chapter illuminates Aitken's take on the city as a medium of transmission of emotions and ideas that strive to adapt to fluctuating contexts.

Embodying the city: Sleepwalkers

Recurrent concerns in Aitken's work are the high speeds of city life and information flows that characterize our times. He uses moving images to recreate fast-paced urban environments and emulate information exchanges that radiate in multiple directions. These concerns are formally evoked in Aitken's editing process,

in the use of multiple channel installations and in the frequent motif of the kaleidoscopic image, which harmonizes disparate elements through the interplay of reflections. Such compositional arrangements and motifs allow Aitken to produce reiterations and disjunctives which result in dynamic fields of vision. His intent is to fracture linear narratives and expand their possibilities for simultaneously representing different characters and stories, thus opening spaces for various combinations and interpretations of meaning. It is indeed the consideration of different but connected stories and the incommensurability of urban experiences that animates *Sleepwalkers* – a major public artwork that brought Aitken to wider attention.

Sleepwalkers was made in collaboration with New York's Museum of Modern Art (MoMA) and the public art commissioners Creative Time. It was designed as a multichannel video to be projected on the outer walls of MoMA, including three exterior facades and four walls surrounding the museum's sculpture garden. The exhibition took place in January 2007 after the museum's renovation by Yoshio Taniguchi, whose design considered the sculpture garden as the core from which to integrate the different modernist buildings of the museum complex. Aitken's video had no soundtrack; it was accompanied only by the background noise of the city during the projection schedule.

City life is, in fact, the key element shaping the themes of *Sleepwalkers* as it follows five different New Yorkers whose lives start when others normally go to sleep. These characters are isolated figures performing quotidian gestures, framed by the built environment which they transit through. Sometimes they seem inflicted by boredom, other times they seem involuntarily pushed by the force and speed of the city's flows of movement. Their actions are often related to the city's networks of transport and energy, both natural and artificial. These are given the same importance as other systems of communication – clocks, blackboards, street signage and so on – which direct and monitor behaviour. These references recall the urban networks of energy and information infrastructures described by Friedrich Kittler in 'The City Is a Medium'.[1] For Kittler, both energy and information have the same ontological status; his radical vision underlines that nothing exists or has ever existed beyond these networks. Taking this further, the city-dwellers are also part of the city's networked medium and, as such, they embody its lights and shadows, its different rhythms and energies.

Close-up shots of spinning wheels, flashing electrical lights and abstracted figures remind us of the tactics of avant-garde artists of the early twentieth century that used speed, electricity and abstraction to delve into the defining aspects of modern life.[2] *Sleepwalkers* places itself in this tradition of modernist languages and, more specifically, along the lines of city symphony films, highlighting the enduring relevance of these approaches to represent contemporary urban experiences.

While still in the tradition of the city symphony, Aitken's piece would be a character-led version. The editing of *Sleepwalkers* makes the different characters' locations and their individual narratives collide into a single moment, wherein the rhythms of their lives are temporarily syncopated. The artist acknowledges that urban rhythms can be 'rough and violent', but his editing tends towards abstraction, which risks collapsing the class and material distinctions that affect the lives of the characters, these being as distinct as a businessman, an office worker,

FIGURE 10.1: *Sleepwalkers* poster, 2007. Courtesy of Doug Aitken Workshop.

a bicycle messenger, an electrician and a busker. Being stripped of their distinctive social and economic characteristics, we are brought closer to their embodiments, as their common humanity is simultaneously exhausted and animated by the incessant flows of energy and information around them.

Sleepwalking the installation

Sleepwalkers was publicized as an unusual museum 'event', where the artwork would be outside the museum walls instead of inside (Figure 10.1). The installation's art status, however, contrasted with the use of commercial cinema marketing tactics. Posters in the streets announced the event using theatrical film advertising conventions such as close-up shots of its famous actors with expressive gestures. At the same time, the star cast lent dramatic credibility to the art project while engaging with popular types. Actors included the veteran charisma of Donald Sutherland; the versatile coolness of Tilda Swinton; the indie ethos of musicians Chan Marshall (Cat Power) and Seu Jorge; and the mythical youth status of actor Ryan Donowho, who had been discovered by a model agent while busking in New York.

Since *Sleepwalking* was commissioned as a public artwork, we can enquire into the type of subjective experiences and sociality that the installation enabled and how these related to the theme of the city as a medium. During the projection of *Sleepwalkers*, spectators could often see the grid of the background building windows within the projected image, making visible the people inhabiting those spaces while engaging in actions that frequently go unnoticed by others, as also happens with the actions of common sleepwalkers. Depending on weather conditions, spectators could see rain across images and shadows of trees or branches being moved by the wind. These elements broke the illusion of the fourth wall, integrating the projection with the built and natural environment where it took place. Architecture scholar Sylvia Lavin praises this type of project because it tries to bring affect, awe and whimsicality to the more rationalist aspects of modernist architecture.[3] The glass curtain wall became a site for projecting emotions, and serendipity was brought to the fore. This way of reimagining the high-rise building and expanding the perception of life within the built environment, nevertheless, can be further questioned in view of how *Sleepwalkers* had some form of continuity with rest of the urban texture of Manhattan and the economic and cultural imperatives of the area.

Large electronic screens are emblems of economic power and cultural modernity in New York City. Erika Balsom notes that, like the advertisements in Times Square, *Sleepwalkers* works as a video billboard for MoMA, attracting people to

the museum with its broad appeal and promises of grand spectacle and sensuality.[4] Along these lines, Alison Butler argues that, with its arty outlook, sleek photography and simple plot, *Sleepwalkers* reinforces the advertised image of the city as a cultural destination, attracting tourists and non-tourists to the area, which was a key strategy after the 9/11 attacks when New York City was rebranded as a safe, humane city, proud of its multicultural and cosmopolitan status.[5]

In the book that commemorates the installation, Aitken discussed lighting in Times Square with Marxist critic Marshall Berman.[6] Berman recalled going there as a child and his mother saying, 'Now we are going to take a bath of light,' and then thinking they became something else by being under those lights. Berman also remembered when many advertisements went dark during the recession that followed the 1972 oil embargo, and how that sight alarmed him. This conversation considered the ritualistic and spectacular aspects of lighting in New York City in both its transcendental and material possibilities. Aitken's installation seems to be treading an ambivalent path between commercialized space, which feeds on mediated images of New York as a modern city to be consumed, and a space for temporary transcendence of material conditions and enjoyment of something extraordinary. This prompts further questions about how this public media art project produces emotions and sense of community for those coming across the installation.

Film and art theorist Giuliana Bruno delves into the subjective states of memory and performance that are activated through installations. She notes that it is through the action of entering and exiting the installation that, as in the movie house, 'forms of emotional displacement, cultural habitation and liminality are experienced'.[7] People passing by could see some projections of *Sleepwalkers* from the street, but the street signage invited them to enter the sculpture garden, to take a moment to watch the projections from there and continue to move around. It is by walking around and being entranced by the moving images that a unique aesthetic experience emerges. The ritualized transcendence that normally takes place within the walls of the museum is brought outside. The actions of moving, stopping, paying and switching attention to the characters' sensations, gestures and actions, amplified to a large scale by the projection, activates personal perceptions and feelings in a public space. Spectators' intimate process of subjective identification and pleasure in looking, which normally occurs in the dark room of cinemas, is exposed and somehow made visible as part of the larger installation. The audience, a mixture of people purposefully attending the event and those just passing by, was thus made aware of their coexistence. They negotiated their own personal space acting upon an understanding of the restriction that others posed to their own mobility and visible engagement with the experience of the installation. As Bruno has noted, such emerging personal space becomes an extension of the safety and intimacy experienced at home.

Nevertheless, Butler goes on to argue that the characters in *Sleepwalkers* 'are connected to the city but isolated within it, and like them, the spectators are connected through an experience in shared space, but also isolated by the emphasis it places on individualized sensory responses'.[8] This can be better understood through Scott McQuire's notion of 'relational space', or frame for experiencing contemporary urban life, which he defines as 'the ambivalent spatial configuration which emerges as the taken-for-granted nature of social space is withdrawn in favour of the active constitution of heterogeneous spatial connections linking the intimate to the global'.[9]

Since the installation activates an intimate relationship with the images and makes this engagement observable, the spectator can become an observer of others and their manifest ways of relating to those images, which can be an opportunity for empathetic engagement with others. For this to happen one must be able to transit between the positions of observer and participant with compassion; from inhabiting one's own feelings to empathize with others without considering them mere objects. Sociality can also be supported by interactions that facilitate sharing and integrating emotional insights into a framework of common understanding or communality; yet, this was not enabled by the installation itself. Therefore, transcendence remains mainly a fantasy. *Sleepwalkers* appears as an all-round instance of what Fredric Jameson calls the narrative of synchronous monadic simultaneity, one where the awareness of separation of characters and spectators is both expression and compensation for such an isolation (Figure 10.2).[10]

In 2012 a limited-edition DVD box of *Sleepwalkers* was released. It contained a transfer of the seven-channel video into a single-channel, more apt to watch on a domestic screen, plus a set of stills, fragments of the scripts, images and recordings of the music performances that took place in the opening night. This materialization of the artwork evidences a withdrawal from the extraordinariness and ephemerality of the public art installation and acquiesces to corporate and institutional strategies which seek to maximize revenue opportunities by turning the project into an exclusive collector-oriented commodity that is to be enjoyed privately.

Concomitant to the increasing presence of different types of screens in public and private spaces over the following years, Aitken has continued producing large-scale video, architecture and performance installations across different countries, supported by major museums and galleries. While these projects often have the more transient character of an event, they are also accompanied by the publication of a book or DVD which documents the project but inevitably misses some of the important aspects of the original work because of being translated across media. In contrast, one of Aitken's projects during this time, *The Idea of the West* (2010), which drew heavily from media images of Los Angeles, was first devised

FIGURE 10.2: *Sleepwalkers* installation view. Courtesy of Doug Aitken's Workshop.

as a book. This book offers the opportunity to examine the artist's approach to not just what it is to live within media but to think cities through media.

Los Angeles's Idea of the West

In 2010 Aitken was asked to envision 'The Artist's Museum Happening', for a gala dinner at Los Angeles Museum of Contemporary Art (MOCA). The event was part of the museum's attempt to rebrand itself after the 2008 economic meltdown had thrown the institution (which was largely dependent on stock investment) into a period of fiscal difficulties and uncertainty. The gala night included art installations, music and sound performances, as well as celebrity guests posing for photos in front of sponsored boards and giftbags. Planted on each of the guest's seats was Aitken's book *The Idea of the West*, produced to accompany the event and made commercially available after it.

For the project, Aitken and his assistants asked 1,000 Angelenos: 'What is your idea of the West?' The book claims to act as a collective response, including more than one hundred original and archival photographs, plus texts and interviews.

To understand this project it is necessary to consider some of Aitken's productions of the 1990s. He had explored the role of media in constructing often fragmented and delusional identities in works such as *I'd Die for You* (1993), *Bad Animal* (1996) and *Into the Sun* (1999), sometimes using existing Hollywood, Bollywood films and ads, and other times producing his own melodramas.[11] But in *The Idea of the West* the city of Los Angeles takes centre stage, invoking its representations in art and popular culture and bringing them to dialogue with twenty-first-century concerns. Jon Alain Guzik notes that Aitken's work 'is an exploration of the long twilight of both technology and America's manifest Destiny'.[12] *The Idea of the West* exemplifies this, taking the myth of the westward expansion into America and testifying to Western civilization having arrived at its last destination, an encounter with the edge of the world.

The West is indeed a problematic and changing idea to try to come to terms with: it invokes European origins, Judeo-Christian foundations and contested geographical, historical and political demarcations. The book refers to the Western region of the United States, but this does not include the Southwest and Northwest states. Far from that, the West of Aitken's project pertains mainly to California. Even with references to San Francisco, as in a picture of the much-photographed Golden Gate Bridge, *The Idea of the West* is circumscribed by Los Angeles, given the choice of respondents. Los Angeles then appears as a regional metropolis that commands the geographical area and a global city that asserts its influence over other cities in the world.

Inevitably, Aitken followed the lead of Reyner Banham's seminal cultural history of Los Angeles's architecture, which distinguished four 'ecologies' of the city: beaches, flatlands, foothills and freeways.[13] Banham's celebration of the informality of Los Angeles pioneered an unorthodox understanding of the city, drawing attention to its 'edges, linkages, closed territories and open field conditions'.[14] Aitken used these notions to connect with his interests on contemporary experiences of the city in the information age, aiming to read Los Angeles as cyberspace. This can be seen again to work under Kittler's assumption that the city is a medium of transmission of information. Such a premise gives us a fresh perspective on the richness of this book which might pass unnoticed in a first glance at its sleek pages. The American West is cyberspace, whose entry points are recognizable images and keywords. Purportedly, cyberspace is non-hierarchical, a utopia of equality, a place of opportunity, very much like America was first envisioned. *The Idea of the West* invokes this utopian vision of California and the many potentials of media technologies, not just for transmitting information but also for connecting isolated individuals and renewing social bonds into more egalitarian societies.

Los Angeles's privileged position comes from its history as a city that, as Norman Klein points out, was designed to look like no other, an arcadia 'where

the raucous American West ended'.[15] As the city started to be shaped by the expanding streetcar system and animated by the boosterism of real estate speculation and the film industry, Klein argues that Los Angeles's design positioned its citizens in a lonely consumer mode, privately consuming images like tourists from the distance of their cars and isolated lives. In the early 1990s, when Mike Davies wrote the critical *City of Quartz*, Los Angeles was at its highest point of suburban expansion, led by a centrifugal sprawl movement.[16] Today, Los Angeles has a population of 22 million, its international ports delivering the fruits of neoliberal trade to its largest market in the world. Densification has revived much of the inner city and, as Klein notes, 'instead of a borderless LA region, we find an imperialist city state, very arterial, not borderless'.[17] From this perspective, the utopian hopes of cyberspace coexisting with the new city state need to be assessed in the light of the current scenario: a globalized economy and increasing unequal distribution of wealth, privatization of public services and reactionary politics, pragmatic allegiances to private power and corporations, a growing distrust in centralized, overarching governments and further suspicion on democratic institutions like news and public opinion. The question of how this project envisions the social imaginarium of the new city state seems now more relevant than ever.

Despite evoking a psychogeographic drift through places, images and icons, Aiken's book *The Idea of the West* has less of the detailed phenomenological experience that typically informs psychogeography and more of the open character of some texts seen through the light of semiotic and post-structuralist analysis. The book's format reflects this clearly: edited in landscape orientation, its pacing and selection of images echo Aitken's moving image work, with an assortment of full bleed pages and cropped images, snapshots alongside carefully taken photographs and archival images. In this way, order and juxtaposition, divergence and parallelism appear, very much like a music video where motifs and tones are repeated and carried through disparate images.

The drift starts with a double spread quotation in big black bold letters that says, 'Wild, wild west', and the numerous names and professions of those who gave that sentence as an answer. The frequency of this response points to the enduring image of the untamed region encountered by Europeans as they advanced towards the Pacific Coast. The fact that the adjective 'wild' is iterated, as in the title of the 1960s television series and the later Hollywood movie and soundtrack song, emphasizes the dominance of film and television representations of the period. Several pages later, nested among other random responses such as 'hot girls', 'John Wayne', 'McDonalds' and 'a huge landmass in the United States that was stolen from my people', another quotation states 'the Will Smith song'. There appears a linkage which connects various meanings and contexts. Even if historical representations and the popular culture images of the West are not the same, they are

presented as having the same status: images of the past and popular culture inform the present vision and they are interchangeable.

One turns the page to see a picture of a Latino boy with a red T-shirt looking at the camera while taking something out of his pocket. Next to him, another kid, with his back facing us and hands above the head pressing on the wall as if in the middle of a police search. There is no clear indication of the presence of police, however, ideas about marginality and racial profiling are quickly invoked. On the left side, a young David Hasselhoff with a calculated look in his eyes sits at the wheel of a fancy red car, the same red as the boy's T-shirt. Notions of authority, visible status and desire are echoed and loosely connected to make these apparently dissimilar images readable together.

Another contrast appears on the following spread, this time creating a tension between the banal every day and the cruelty of Los Angeles's mediated dreams. The gaze is directed first to the right page: a cat lying on the floor looks straight at the camera while a salamander crawls next to it. To the left of this seemingly trivial image appears a more dramatic one. A black-and-white picture of a man lying on the ground on top of Ed Wood's star at Hollywood's Walk of Fame. The angle of the camera is tilted down, as if it was the perspective of a passer-by. The man's cheek rests cushioned by a cloth, as if protecting it from the cold floor tile. A few steps away from him there is a dropped old sports bag. The picture conveys the delusions of the fan subjectively feeling as if floating or being one with the stars, but his imagination is the only support for the misery of his material existence. This star-fan image aptly exemplifies what Klein describes as the central theme of LA noir: 'how consumer hype erases the sense of place and invades the self'.[18] Being in the West is being nowhere and everywhere; the self is multiple, malleable and always available to dreams and desires. One feels compelled to be part of the myth, to believe it and contribute to it by any means.

Sunshine and noir

As evidenced in the previous analysis, in *The Idea of the West* meaning emerges by juxtaposition and repetition. The book features numerous shots of freeways against purple skies, which evoke Bayman's *autopia*. These are accompanied by quotations such as 'opposite to east', 'up', 'next level' and 'not the east, north, south', which represent the trope of movement, search and escape underpinning the myth of the West. There are also images of empty spaces, peripheries and margins. The repetition of these, alongside images of hotels, petrol stations, freeways and nightclubs, seems an attempt at wayfinding through the spaces of modernity.[19] Some images appear spontaneous and banal, capturing moments and gestures that

bring spectators to everyday details. Other times, shots of nature or panoramic views give us the sense of vast and astonishing nature that feeds the myth of the West as the Last Frontier. There are also the obligatory dark silhouettes of palm trees cut against purple and mustard skies. Blonde surfers and flat-tummied girls in bikinis – inhabitants of Banham's *surftopia*. Quotations like 'finding treasures' reaffirm the lure of the fantasy and individual search that sustain the myth of the modern Arcadia.

An interesting association is created in a spread where a black-and-white photograph of Steve McQueen in cowboy hat and smoking a cigarette appears on the right, his eyes as clear as California's sky. The iconic shot, taken by *Life*'s photographer John Dominis in the 1960s in Sierra Madre, epitomizes the legend of the rugged yet cool individuality of the Western hero. On the left, an aerial shot of a massive parking lot, devoid of human presence and at an angle and with lighting and colour values that emphasize the clear, forceful lines of its structure. The contrast yet similarity between these two photographs subtly conjures the myth of the inherent loneliness and uncompromised form of the West.

It is worth noting that Aitken's project uses the 1960s as the most recent reference in utopian thought, often incorporating materials that summon the aesthetics and practices of the counterculture of the time: fanzines, agitprop and assorted pictures and records of the Summer of Love. Those hopes look now faded, naïve, their images are postcards tainted by first nostalgia and then irony when seen in the context of more current documents and images of the West.

Jean Baudrillard's ideas can also shed light on Aitken's approach.[20] In *The Idea of the West*, reality and simulation are often juxtaposed creating both continuity and shock, like in the pages where we see an advertisement for a golf course, with its soft and fresh lawn, cool pond and smoothly contoured hills standing in front of the dry land and rugged hills that is the actual site of the course. Despite this contrast, which calls attention to water issues in California and the illusions used by real estate speculators, there is continuity between the ad and the actual site in the darker tonal values and in the shapes of the mountains. In Los Angeles reality and simulation exist side by side. There is also an image of a wildfire seen from the interior of a house, the blazing flames framed by the clean lines of the modernist structure. It portrays the presence and proximity of the apocalyptic event and spectacle, which are the same and are lived with the detachment of a film spectator or car driver. This image certainly draws from and feeds into the myth of nature taking its revenge upon the city and bringing it to its end.[21]

Returning to the notion of the open text and the utopian possibilities of the information age, one needs to address what 'edges, linkages, closed territories or open field conditions' emerge from the juxtaposition of images and texts where history comes knocking. Two captions from the video footage of LA police

officers lynching Rodney King appear next to a photograph of rolling clouds, with the words 'The American Revolution' at the top of this latter page. One must remember that extracts from the video, which was first used as evidence of racialized police brutality, were also the basis of the defence presented by the police. As Frank Tomasulo explains, such defence argued for the other readings of the images: King's resistance, provocation, his body's uncontrollability – thus legitimizing the police actions under the discriminatory narrative of the primitive and inherent bestiality of black men.[22] The focus on the still frames separated from their context led to the policemen being acquitted, which provoked protests and riots across the city in spring 1992. Tomasulo reminds us that we cannot ignore the subjectivity of the interpreters when purporting meaning from images, such as those of King's lynching. The rolling clouds with the words 'The American Revolution' next to the video captions suggest that both are Rorschach tests of sorts. Perhaps the clouds signify hope for a future revolution that achieves more than the ones past, but first there is a need to acknowledge a failed democracy and a living dystopia, which can only be grasped if one has not forgotten the past.

The Idea of the West emphasizes simultaneity, contradiction and interconnection between multiple ideas of the West. But without a deeper awareness and analysis of the issues, these images run the risk of homogenizing their specificity and reducing history and ideology to pastiche and whimsicality. Many comments and images project fantasies, stories of individual ambition and resilience. These declare the currency of the myth of the land of opportunities for the intrepid individual, entering the city state and enjoying its privileges as something to be done at any costs, a narrative that suits the neoliberal scenario of increased competition and allow for further exploitation and unfairness.

The book reaches its end with photographs of the sun running across seven pages gradually zooming in into the star's centre. Such an exercise in centring, a grand cinematic finale, renders time under the conditions of the book format. This is the same sun that appears on the cover, enfolding the trajectory of the book with its shinning, mighty and mystifying presence. This ending could be taken as a statement on the West's wondrous nature, pointing to where its power of attraction and source of its myths reside.

The book evidences a strong awareness on the role that mediated images of the California region play in the life of the Angelenos. It acknowledges the polarities and dramas of the West, but instead of getting deep into them, leaves it to the reader to bring emotional insight and critical perspective. The book can be read superficially, resembling a well-edited lifestyle magazine which takes in subcultures and social issues in glossy pages, or a mirror which offers a safe reflection of oneself, neither too discomforting, nor too challenging. The idea of the West that emerges from this project is an imaginarium, slowly shifting yet resistant to

change, as it feeds on widespread myths, pop culture and icons. It points to the conditions of a new era where the abstraction of information still rests on physical factors, where there is tension between openness and foreclosure of meaning, between levelling and prioritizing value, between vast, open spaces and borders, edges and enclosures. This idea of the West is both elusive and tangible, a contradictory notion whose strongest point as testimony of its moment rests in its resistance to have its meaning closed, perhaps because of being too near to ascertain it. As time has distanced us from 2010, we can see better now how technological mediations and neoliberal politics are shaping the new city states. In this context, the rebranding of cities like New York and Los Angeles as culturally relevant is key to keep them current. Artworks in the city and about the city embraced by large cultural institutions like MoMA and MOCA contribute to this function, as they contend with the image and the life of the city, with often conciliatory results. What is left to spectators, readers and citizens is to bring to them a critical edge.

NOTES

1. Friedrich A. Kittler, 'The City Is a Medium', *New Literary History* 27, no. 4 (Autumn 1996): 717–29.
2. Glenn D. Lowry, 'From Sleepwalkers to Station to Station: Inverting the Museum', in *Doug Aitken: Electric Earth* (Los Angeles: Museum of Contemporary Art/Prestel, 2016), 197–206.
3. Sylvia Lavin, *Kissing Architecture* (Princeton, NJ: Princeton University Press, 2011).
4. Erika Balsom, *Film Culture in Transition: Exhibiting Cinema in Contemporary Art* (Amsterdam: Amsterdam University Press, 2014).
5. Alison Butler, 'Sleepwalking from New York to Miami', in *Urban Cinematics: Understanding Urban Phenomena through the Moving Image*, ed. François Penz and Andong Lu (Bristol: Intellect, 2011), 183–95.
6. Doug Aitken, *Sleepwalkers* (New York: Museum of Modern Art, 2007).
7. Giuliana Bruno, *Public Intimacy: Architecture and the Visual Arts* (Cambridge, MA: MIT Press, 2007), 17.
8. Butler, 'Sleepwalking from New York to Miami', 188.
9. Scott McQuire, *The Media City: Media, Architecture and Urban Space* (Los Angeles: Sage, 2008), ix.
10. Fredric Jameson, *The Geopolitical Aesthetic: Cinema and Space in the World System* (Indianapolis: Indiana University Press, 1995), 132.
11. Daniel Birnbaum, 'That's the Only Now I Get: Time, Space and Experience in the Work of Doug Aitken', in *Doug Aitken*, ed. Daniel Birnbaum, Amanda Sharp and Jörg Heiser (London: Phaidon, 2001), 38–106.

12. Jon Alain Guzik, 'Paradise Lost: Doug Aitken's *Blow Debris*', in *Doug Aitken: We Are Safe as Long as Everything Is Moving*, ed. Marta Gili (Barcelona: Fundació La Caixa, 2004), 121.
13. Bettina Korek, 'Foreword to the Idea of the West-Dialogues/Fragments', in *The Idea of the West*, ed. Doug Aitken (Zurich: JRPI Rangier, 2010), 113–14. Reyner Banham, *Los Angeles: The Architecture of Four Ecologies* (Berkeley: University of California Press, 2001).
14. Joe Day, 'After Ecologies: Forward to 2009 Edition', in *Los Angeles: The Architecture of the Four Ecologies*, ed. Reyner Bayman (Berkeley: University of California Press, 2009), xviii.
15. Norman M. Klein, 'Inside the Consumer-Built City: Sixty Years of Apocalyptic Imagery', in *Helter Skelter: L.A. Art in the 1990s*, ed. Catherine Gudis (Los Angeles: MOCA, 1991), 24.
16. Mike Davis, *City of Quartz: Excavating the Future in Los Angeles* (London: Verso, 2006).
17. Norman M. Klein, 'A Granular History of Space', in *Doug Aitken: Electric Earth*, ed. Joseph Grima, Anna Katz, Norman Klein, Glenn Lowry and Philippe Vergne (Los Angeles: Museum of Contemporary Art/Prestel, 2016), 214–23.
18. Klein, 'Inside the Consumer-Built City', 25.
19. Kevin Lynch, *The Image of the City* (Cambridge, MA: MIT Press, 1960).
20. Jean Baudrillard, *America* (London: Verso, 1986), 56.
21. Klein, 'Inside the Consumer-Built City'.
22. Frank P. Tomasulo, 'I'll See It When I Believe It: Rodney King and the Prison-House of Video', in *The Persistence of History: Cinema, Television and the Modern Event*, ed. Vivian Sobchack (New York: AFI Film Readers, 1996), 68–88.

BIBLIOGRAPHY

Aitken, Doug. *The Idea of the West*. Zurich: JRP|Rangier, 2010.

———. *Sleepwalkers*. New York: Museum of Modern Art, 2007.

Balsom, Erika. *Film Culture in Transition: Exhibiting Cinema in Contemporary Art*. Amsterdam: Amsterdam University Press, 2014.

Banham, Reyner. *Los Angeles: The Architecture of Four Ecologies*. Berkeley: University of California Press, 2001.

Birnbaum, Daniel. 'That's the Only Now I Get: Time, Space and Experience in the Work of Doug Aitken'. In *Doug Aitken*, edited by Daniel Birnbaum, Amanda Sharp and Jörg Heiser, 38–106. London: Phaidon, 2001.

Baudrillard, Jean. *America*. London: Verso, 1986.

Bruno, Giuliana. *Public Intimacy: Architecture and the Visual Arts*. Cambridge, MA: MIT Press, 2007.

Butler, Alison. 'Sleepwalking from New York to Miami'. In *Urban Cinematics: Understanding Urban Phenomena through the Moving Image*, edited by François Penz and Andong Lu, 183–95. Bristol: Intellect, 2011.

Davis, Mike. *City of Quartz: Excavating the Future in Los Angeles*. London: Verso, 2006.

Day, Joe. 'After Ecologies: Forward to 2009 Edition'. In *Los Angeles: The Architecture of the Four Ecologies*, edited by Reyner Bayman, xv–xxxi. Berkeley: University of California Press, 2009.

Guzik, Jon Alain. 'Paradise Lost: Doug Aitken's *Blow Debris*'. In *Doug Aitken: We're Safe as Long as Everything Is Moving*, edited by Marta Gili, 121. Barcelona: Fundació La Caixa, 2004.

Jameson, Fredric. *The Geopolitical Aesthetic: Cinema and Space in the World System*. Indianapolis: Indiana University Press, 1995.

Kittler, Friedrich A. 'The City Is a Medium'. *New Literary History* 27, no. 4 (Autumn 1996): 717–29.

Klein, Norman M. 'A Granular History of Space'. In *Doug Aitken: Electric Earth*, edited by Grima Joseph, Anna Katz, Norman Klein, Glenn Lowry and Philippe Vergney, 214–23. Los Angeles: Museum of Contemporary Art/Prestel, 2016.

———. 'Inside the Consumer-Built City: Sixty Years of Apocalyptic Imagery'. In *Helter Skelter: L.A. Art in the 1990s*, edited by Catherine Gudis, 23–32. Los Angeles: MOCA, 1991.

Korek, Bettina. 'Foreword to the Idea of the West-Dialogues/Fragments'. In *The Idea of the West*, edited by Doug Aitken, 113–14. Zurich: JRP|Rangier, 2010.

Lavin, Sylvia. *Kissing Architecture*. Princeton, NJ: Princeton University Press, 2011.

Lowry, Glenn D. 'From Sleepwalkers to Station to Station: Inverting the Museum'. In *Doug Aitken: Electric Earth*, edited by Grima Joseph, Anna Katz, Norman Klein, Glenn Lowry and Philippe Vergney, 197–206. Los Angeles: Museum of Contemporary Art/Prestel, 2016.

Lynch, Kevin. *The Image of the City*. Cambridge, MA: MIT Press, 1960.

McQuire, Scott. *The Media City: Media, Architecture and Urban Space*. Los Angeles: Sage, 2008.

Tomasulo, Frank P. 'I'll See It When I Believe It: Rodney King and the Prison-House of Video'. In *The Persistence of History: Cinema, Television and the Modern Event*, edited by Vivian Sobchack, 68–88. New York: AFI Film Readers, 1996.

11

Loss in Space:
Deconstructing Urban Rephotography

Michael Schofield

Introduction

Cities are in a state of constant flux.[1] The seemingly static spaces of the built environment are only experienced as immobile until they are modified or demolished to make way for something new. While this change is happening continually, it is common to perceive the city as a series of inert spaces, the extent of the transformation taking place going largely unnoticed. It is only when that upheaval directly affects personal space, sense of place or memory of somewhere crucial to the individual or community that people usually take notice. Recorded images of the city – whether still or moving – allow observation and contemplation of the scale of urban change over time. Looking at archival images or footage of places well known to the observer can be truly revelatory. However, these spatio-temporal mediations of the city – intrinsically a series of static spaces themselves (or photographic frames of some sort) – embody some surprising limitations and distortions. Acknowledgement of this is essential in understanding how the modern city is viewed, as contemporary media and the digital archive have led to the past becoming 'part of the present in ways simply unimaginable in earlier centuries'.[2] These temporal mediations also undoubtedly play a role in 'how real and imaginary spaces commingle in the mind to shape our notions of specific cities',[3] our view always 'mediated by other people's representations [...] necessary for "cover[ing] the gaps in our remembrances"'.[4]

The photographic practice and moving image work examined in this chapter attempt to document and visually represent changing urban space over time. It is part of a doctoral research project entitled 'Aura and Trace',[5] which sought to forge connections between these lens-based investigations of the city and various theories of media and the imaginary; between issues of representation of the 'man-altered

landscape'[6] and the changing ontology of the photographic image itself. Close examination of the practice of rephotography[7] (or repeat photography), and of how photographic traces of the past can potentially 'haunt' the contemporary city with echoes of prior change, lead the theoretical work to Jacques Derrida's notion of 'hauntology',[8] and a thorough consideration of the photograph as a strange form of material ghost. This Derridean view of medium[9] sees images as disembodied traces of reality, fragments of the past which perpetually haunt and affect the present, but which can never be fully reconciled with it. Through this 'lens' it becomes possible to see how such partial traces might profoundly mediate the perception of the city, and how photographs function as crucial prosthetics to cultural memory, even as they distort the view of both past and present.

A belief in the supernatural is certainly not required to reconnoitre with such 'technological' phantoms.[10] Since the 'spectral turn'[11] in many subjects and disciplines, including literary criticism and cultural geography, the spectre has been rehabilitated as a legitimate academic consideration. The spectre can function as an aspect of memory, as a metaphor, as a material and technological phenomenon (such as the photograph) and also as a tool: a catalyst for the deconstruction of previously established 'truths', or the deconstruction of a simple linear view of progress. Cultural geographer Tim Edensor has written extensively on such reconsidered ghosts and the 'haunting' of derelict buildings: specifically those in the post-industrial ruins and voids of northern England. For Edensor, these sites are an important link to a rapidly disappearing past, an endangered cultural memory, but these remaining traces are, by their very nature, partial objects, elusive and often illusory. 'By virtue of their partiality – they are not whole bodies or coherent, solid entities – ghosts are echoes which refuse reconstruction.'[12] The archival photograph certainly possesses some of these same spectral qualities: a presence that marks an absence, a fragment of time from another time, which is also a fragmentary view of a very narrow spatial configuration.[13] Old photographs are fading echoes of past space, which often constitute the last 'reliable' view of it, however limited that may be.

Static images of moving spaces

Architecture is usually seen as stationary – fixed, motionless and even permanent – but while certain buildings and spaces may survive unchanged for many centuries, the vast majority do not. The notion of static space, or even a static landscape,[14] is just an illusion of (time) scale. Sometimes the built environment can be placed into an accelerated state of flux, such as during rapid urbanization (as seen to a vast extent in China in recent decades[15]), deindustrialization and re-wilding (as in

late twentieth-century northern England), regeneration projects and mass demolition such as slum clearance.

This chapter primarily tries to reveal how these static images (archival photographs) represent and misrepresent *moving* spaces (or the changing cityscape), or how static representations of place give rise to a false temporality, a deceptive sense of movement or its absence. The iterative photography discussed here attempts to represent change; echoes of the city's past and echoes of its future, charting the disintegration of social space, of former structures, the obsolescence of space and its by-product: the voids and derelict 'non-places'[16] that are left behind in every contemporary city. There are places where there are visible traces of an earlier structure, like material ghosts themselves, poignant reminders of that site's former social utility – and sometimes there are spaces which have been effaced, the photographic archive then becoming the only surviving source of visual evidence of its former state.

Nothing disappears completely ...

In his seminal definition of social space, Henri Lefebvre describes its uncanny ability to persist, to outlive such changes, in a way that is problematized when we contrast it with mass urban effacement, and the evident displacement of entire communities that has taken place.

> Nothing disappears completely, however; nor can what subsists be defined solely in terms of traces, memories or relics. In space, what came earlier continues to underpin what follows. The preconditions of social space have their own particular way of enduring and remaining actual within that space.[17]

Spaces change over time and can certainly be haunted by what came before – however, there is an allusion to permanence in Lefebvre's portrayal of space, 'enduring and remaining', which conflicts with photography of urban spaces that have changed beyond all recognition. Sometimes all that is left are those very 'traces, memories or relics' to which Lefebvre refers, the very last of which may well be photographic. While space can be socially produced, it must also be possible that it can be socially destroyed, with that destruction being driven by capital and class in the ways Lefebvre[18] himself identified.

In Figure 11.1, just such a trace is used rephotographically – a prosthetic 'memory' of a space which now only exists on paper (and its spectral copy flickering across screens). The original image used in this montage represents a space which did not endure, a street which no longer exists, in a district which has all but disappeared – from the city's social space and increasingly from lived-memory too.

FIGURE 11.1: Michael C. Coldwell, Cross Templar Street, 1901–2017. Courtesy of the author.

This haunting archival photograph is from Quarry Hill,[19] an inner-city borough of Leeds in the United Kingdom. Otherwise known as Leeds' East End, this area has seen multiple waves of slum clearance since the late nineteenth century. Each major demolition event has constituted a comprehensive erasure of what came before – Quarry Hill no longer fulfils its historical social function as a residential area for extremely low-income families, and no traces of these buildings or even the original road layout remain today. While a small number of historic buildings do survive in this corner of the city, which is approximately one hundred acres in size, the space has been radically transformed over the past century. The Victorian slum was cleared in its entirety and a whole new housing estate constructed in the late 1930s, the largest social housing complex in the United Kingdom: the infamous Quarry Hill flats.[20]

Representing disappearance

This later 'slum' was demolished too, in 1978. The disappearance of Quarry Hill flats was documented beautifully in a book entitled *Memento Mori* by photographer Peter Mitchell.[21] Mitchell's images of the 1978 clearance were interspersed

with archival photographs of the complex, as a new and celebrated architectural work, with blueprints and advertisements, and with vernacular photographs and accounts by the residents themselves, interviewed just before eviction. Quarry Hill's intriguing photographic documentation does not end with Mitchell. A body of photographs of the previous slum has survived and has been used to great critical effect in a canonical book on representation by John Tagg.[22] In a chapter entitled 'God's Sanitary Law', Tagg examined these archival photographs of Quarry Hill, taken before the wave of slum clearance which began at the turn of the past century. These photographic artefacts, held by Special Collections[23] at the University of Leeds, were of particular interest to Tagg, because Leeds Corporation commissioned them for the sole purpose of making the political case for demolition. The entire district had been branded 'unhealthy' by the authorities, and these images were taken to evidence that position, effectively demonizing the area prior to its wholesale destruction.

For Tagg, the photographs were evidence of something else: the lack of a truly objective evidential power to the photograph, but equally, the power the photograph does wield in the hands of authority, its 'contentious legal realism',[24] and its potent political and rhetorical uses, which are often far from forensic. The photographs themselves are often hauntingly empty, with the slum-dwellers unrepresented in this photographic 'evidence' of the residential space – barring the occasional blurred face at a window, the only fleeting indication that these streets weren't already abandoned at the time that they were taken.

This research follows in Mitchell's footsteps and returns to Quarry Hill in 2017, but this time armed with Tagg's archival views of the long-lost slum, intending to reveal the vast changes that had taken place to this ostensibly 'static' space. This became a rephotography project in which rephotography in the usual mode was practically impossible. The artefacts were taken back to the area as it stands today, an unrecognizable space, haunting it with views of its prior self – views that seem to be from a different world entirely (see Figure 11.2).

The problem with rephotography

As a method of recording change in cities, and of experiencing past spaces, rephotography has some surprising inadequacies. The photographer and author of this chapter has been using the technique to document the changing urban environment in Leeds for some years, with somewhat inconsistent results. Rephotography initially seemed like the obvious medium to use for mapping areas of the city under some form of erasure: the gradual disappearance of the city's industrial and working-class past. Quarry Hill is undergoing rapid modification once again, set for mass redevelopment for the fourth time in a hundred years; the area is now

FIGURE 11.2: Michael C. Coldwell, Cornhill, East End, 1901–2017. Courtesy of the author.

being rebranded SOYO,[25] a new 'cultural' sector in the city. This new wave of regeneration has elicited allegations of gentrification, the adjoining areas being some of the most deprived in the county, and neighbouring Mabgate, a former industrial zone, now being home to many artists and small enterprises, making use of cheap rent and large spaces in the crumbling Victorian warehouses that have survived. Earlier photographic research addressing these spaces entitled 'The Disappearing City'[26] did not involve archival images, but instead used iterative rephotographic methods to reveal changes as they were happening.

In such rephotography one slice of time is shown and then the next. They are presented together as a sort of narrative diptych, but little about these montages informs us of the nature or reasons for the spatial changes depicted. Under closer inspection rephotography can be seen as something of a gimmick, a spatial trick picture and a game of spot the difference, rather than an insightful engagement with urban change and the social issues surrounding it. Focusing on the period of transformation itself (Figure 11.3 – in this case demolition) something temporal and dynamic was indeed captured in the work, but the final results still seemed limited in what they could communicate. They are certainly formally gratifying – the repetition performs a strong aesthetic function – but they are spatially composed and framed around what has stayed the same, rather than concentrating

FIGURE 11.3: Michael C. Coldwell, Deconstruction, Gower Street, Leeds, 2016, from 'The Disappearing City'. Courtesy of the author.

on what has actually changed – or the effects (or indeed social affects) of that change. It is the repetition of persisting spatial features that actually draws the eye. All of the various practices of rephotography share these traits. It is essential for the two photographs used to both contain the same persisting features of the landscape or built environment – crucial spatial reference points[27] which allow recognition that the same scene is presented twice, to establish a continuing sense of place. These enduring features maintain the false sense of permanence or stasis mentioned earlier with regards to Lefebvre, and this form fails to communicate any profound change, formally wedded as it is to its opposite.

In much 'professional' rephotography this diptych form dominates – in the cartographic explorations of Mark Klett,[28] exploring the changing landscapes of the American mid-west or the precise recreation of historically significant photographs seen in Douglas Levere's rephotography of Berenice Abbott's New York[29] and Eugene Atget's Paris.[30] Here there is a determination to keep yet more variables under precise control, all features of the image unerringly the same. In these latter

FIGURE 11.4: Michael C. Coldwell, Unhealthy Area, Quarry Hill, 1905–2017. Courtesy of the author.

examples, even the same historical cameras, lenses and film stocks were used, in a concerted effort to take the same photograph again. Even in what could be termed 'vernacular' rephotography – the contemporary social practice[31] in which old printed photographs are physically held up in front of the camera – the form is still dictated by an ability to register the two views presented, and subsequently, understand them as the same view. This limits the rephotographic form and its various practices to spaces which have remained largely the same. The rephotographic motivation to overcome the temporal limitation of the static photograph, and reveal change through a pairing, or even sequence of stills, is nonetheless encumbered by that same photographic stasis, and its unavoidable fragmentation of space as well as time. In Jason Kalin's words:

> Rephotography is best understood as hauntography to emphasise how any perspective upon the present is haunted by its own past. Hauntography – hauntological montage – retemporalizes memory by inventing memory images and places that mobilize perspectives and bodies to perform acts of personal and public remembering.[32]

Haunting as an intervention

Despite some profound formal weaknesses, there is merit in continuing to push rephotography's limits – using its fragmentation and uncanny stasis to reveal the city as a moving target. By taking 'impossible' rephotographs of urban landscapes that have changed beyond all recognition, the form deconstructs itself and also challenges the photographic impression of the city as a static space. In this revised form of the medium the archival photograph floats unmoored in the landscape (see Figure 11.4), unable to form a synthesis with the contemporary view, revealing itself as a spectral and disembodied trace of what came before – a ghost (or 'hauntograph'[33]) of some prior spatial configuration that no longer makes sense in a wholly transformed, and continually transforming, environment. In this 'deconstructed rephotography', the idea is not to attempt an illusion of continuity between past and present, or to create a sense of place where this is no longer possible, but to highlight that very haunting disjuncture.[34] It renders rephotography a method of approaching the forgotten for what it is, rather than 'inventing memory images'.[35] The deconstructed rephotograph might communicate a sense of loss and absence, where rephotography in the normal mode attempts to construct a disingenuous presence, an illusion of a recreated past or something actually remembered. In deconstructed rephotography the contemporary city is haunted by the unknown and the lost, overwhelmingly affected by the enormity of the change that has taken place. Conventional rephotography papers over the temporal cracks, impressing with its technical accomplishment under the misapprehension of successful time travel.

Using the same archival photographs as John Tagg, this project began the deconstructed rephotography of Quarry Hill, carefully studying maps and methodically rephotographing the streets that no longer exist. For some of the archival images it was possible to get very close to the original locations, although this was certainly not obvious from the final outcomes. In others the positioning was necessarily very approximate. Even so, in each case, the archival image was returned to haunt the right area of Quarry Hill, and as the two views could no longer be registered anyway, great precision in that regard seemed of limited importance. Being in roughly the right location was crucial though, and necessary for these images to work as an intervention in the contemporary space; to work as a comment on what should be valued in cities and their histories; to mean something indexically, even if they could no longer work as functioning icons of place.

Reanimating the dead

In a video installation entitled 'The Remote Viewer',[36] these deconstructed rephotographs of Quarry Hill were then projected over one another to create new media art. In this project movement is reintroduced to the static spaces represented. The two views wander about, tracking, and unable to gain purchase, they slowly float apart, echoing the impossible search for streets which have disappeared and the unfeasible act of rephotography in truly changing spaces. This draws attention to the equally impossible and uncanny stillness of the photographs themselves, unnaturally frozen points in time, the added motion highlighting the implausibility of any real stasis in a relentlessly mutable world. The result is a restless, shifting palimpsest of 'static' images, a haunting metaphor for the changing city itself. As they await new development these voids in Leeds certainly echo the sentiments of Andreas Huyssen, of the city as some 'fast changing palimpsest'[37] in which traces are restored and erasures documented. The role of photography here seems vital – without such lens-based interventions in the space, can there be any assurance that memories of these lost slums will remain part of this rewritten city text? The urban palimpsest 'implies voids, illegibilities and erasures',[38] but must also somehow preserve coherent traces to function as prosthetic memories in its structure, in order to keep these stories alive at all.

In 'The Remote Viewer' the photographs are made to return and literally haunt the spaces from which they came – intervening and problematizing the contemporary urban landscape. This seems in keeping with Derrida's own ideas on the politics of haunting – that haunting can be an intervention[39] and potentially a radical act. The idea that the ghosts of history cannot be fully silenced, that they will somehow return, that we can intervene and wake the dead in the name of justice.[40] Spectropolitics[41] is also congruent with the original problematic use of these images, very selectively taken to make the case for slum clearance (which for some meant dispossession, the break-up of communities and the destruction of working-class space) but which failed to represent, let alone consult, those that would be most affected by it. They are the real ghosts in this work – the conspicuous silence felt – the absent presence of those that once inhabited these now voiceless spaces.

Alongside this haunting narrative of displacement and dispossession, there is also a more universal spectrality at work in these shifting images – what Roland Barthes called 'time as punctum'[42] – the still photograph as the most affective haunting reminder of transience. The punctum of photography is not limited to human mortality. People can be equally haunted by the impermanence of the traces left behind – homes and cities are also mortal. The photograph of urban space becomes a memento mori – a visual reminder of entropy itself. Shelley Hornstein

invokes Derrida in her exploration of these themes in *Losing Site* (2013). The idea that buildings and homes are always in a process of ruin is certainly an evocative one, as is the notion that permanence is an idealization of architectural form. The hidden truth, revealed in both that work and this, is that homes and cities are temporary structures, 'always dissolving before our eyes, transforming'[43] and falling out of memory entirely. The deceptive sense of stillness in both photography and architecture belies and hides this fact.

Conclusion

> Our attempts to reflect the world – to record and mark it orthographically – have built into them our failure to do so.[44]

Notwithstanding its temporal limitations, and the many changes to both the technology and social practices of the medium, photography still provides a vital tool for the detailed study and contemplation of urban change, presenting tantalizing glimpses back in time – views of another world that once stood in place of this one. The very stillness of the photographic image makes careful examination of previous spatial configurations possible, giving access to space in a way prohibited in moving images. The photographic archive allows people to remember the forgotten and keep haunting traces of the dead alive. There are certainly limits to what the photograph can capture and communicate – it isn't as reliable a source of evidence as people would like it be. The common faith in its evidential force is routinely exploited (as seen with Tagg's investigation of slum clearance mentioned here, and in so many other rhetorical uses of the image) and so reminders of this fallibility are vital, as are reminders that the archive preserves only fragmentary traces of what came before. New practices such as deconstructed rephotography have the potential to help illuminate these mediations, limitations and failures, as well as helping to highlight the significant changes happening in all urban space – the disappearance of entire neighbourhoods and the hidden and forgotten trauma of this loss. In deconstructed rephotography these things are seen through their erasure and their invisibility, through an intentional frustration of our usual attempts to orientate ourselves spatially, and apprehend or simplify the vast changes that have taken place.

Projecting ghosts onto sites of redevelopment and regeneration is a gesture towards preserving the urban palimpsest in the face of its potential effacement. Layering times and traces that hauntingly no longer fit – ghosts of the past that struggle 'on the same terrain without prospects for reconciliation'[45] – can be a political act, countering those that would erase uncomfortable narratives and

inconvenient memories. In these urban voids, 'saturated with invisible history',[46] it is their palimpsestic quality that haunts. When this is erased in large-scale demolition and regeneration projects, we lose both a fragile link to the past and any palpable sense that change is occurring at all.

NOTES

1. While this may seem something of an obvious observation, surprisingly little research focuses on the mutability of the city as experienced. 'The constant flux of this urban process is constituted through many superimposed, contested and interconnecting infrastructural 'landscapes' which provide the mediators between 'nature' and the production of the "city".' Stephen Graham, 'Introduction: Cities and Infrastructure', *International Journal of Urban and Regional Research* 24, no. 1 (2000): 114.
2. Andreas Huyssen, *Present Pasts: Urban Palimpsests and the Politics of Memory* (Stanford, CA: Stanford University Press, 2003), 1.
3. Huyssen, *Present Pasts*, 49.
4. Jelena Stankovic, 'Mapping the City as Remembered and the City as Imaged', in *Imaging the City: Art, Creative Practices and Media Speculations*, ed. Steve Hawley, Edward Montgomery Clift and Kevin O'Brien (Bristol: Intellect, 2016), 78.
5. Michael Peter Schofield, 'Aura and Trace: The Hauntology of the Rephotographic Image' (University of Leeds, 2018).
6. William Jenkins, 'New Topographics: Photographs of a Man-Altered Landscape', *Rochester, NY: The International Museum of Photography at George Eastman House* (1975).
7. Mark Klett is one of the leading exponents of the rephotographic genre. He defines it thus: 'A repeat photograph, or "rephotograph" is a photograph made to duplicate selected aspects of another [...] The new image typically repeats the spatial location of the original.' Mark Klett, 'Repeat Photography in Landscape Research', *The Sage Handbook of Visual Research Methods* (2011).
8. 'Hauntology' is a philosophical neologism coined by Jacques Derrida. See Jacques Derrida, *Specters of Marx: The State of the Debt, the Work of Mourning and the New International* (New York: Routledge, 2006).
9. Many theorists have alluded to photography's spectral nature, but none more so than Derrida. 'I like the word "medium" here. It speaks to me of specters, of ghosts and phantoms, like these images themselves. From the first "apparition", it's all about the return of the departed [...] The spectral is the essence of photography.' *Right of Inspection* (New York: Monacelli Press, 1998), 34.
10. 'Hauntology isn't about hoky [sic] atmospherics or "spookiness" but a technological uncanny.' Mark Fisher, 'Phonograph Blues', *K-Punk* (2006), http://k-punk.abstractdynamics.org/archives/008535.html.

11. M. Blanco and Esther Peeren, *The Spectralities Reader: Ghosts and Haunting in Contemporary Cultural Theory* (London: Bloomsbury Academic, 2013), 31.
12. Tim Edensor, 'Haunting in the Ruins: Matter and Immateriality', *Space and Culture* 11, no. 12 (2001): 48.
13. 'A shudder runs through the viewer of old photographs. For they make visible not the knowledge of the original, but the spatial configuration of a moment.' Siegfried Kracauer and Thomas Y. Levin, *The Mass Ornament: Weimar Essays* (Cambridge, MA: Harvard University Press, 1995), 56.
14. 'Landscapes shift and move, "collapse and cohere", as we traverse them. This makes the static representation of place, catching the essence of the landscape, impossible.' Ruth Heholt, 'Unstable Landscapes: Affect, Representation and a Multiplicity of Hauntings', in *Haunted Landscapes*, ed. Ruth Heholt and Niamh Downing (Rowman and Littlefield International, 2016), 4.
15. Yuting Liu et al., 'Urban Villages under China's Rapid Urbanization: Unregulated Assets and Transitional Neighbourhoods', *Habitat International* 34, no. 2 (2010). 135.
16. The term 'non-place' originated in Marc Augé, *Non-places: Introduction to an Anthropology of Supermodernity* (London: Verso, 1995). It takes on new signification in Jim Brogden's photographic exploration of post-industrial dereliction and liminal areas of the city: Jim Brogden, *Photography and the Non-place: The Cultural Erasure of the City* (Cham: Palgrave Macmillan, 2019).
17. Henri Lefebvre and Donald Nicholson-Smith, *The Production of Space* (Oxford: Blackwell, 1991), 229.
18. Lefebvre and Nicholson-Smith, *The Production of Space*, 418.
19. A very potted history of the area can be found here for context: Mavis Simpson, 'The History of Quarry Hill', http://www.bbc.co.uk/leeds/citylife/quarry_hill/history.shtml.
20. 'History of Quarry Hill', Leeds Play House, https://leedsplayhouse.org.uk/about-us/playhouse-redevelopment/history-of-quarry-hill/.
21. Peter Mitchell, *Memento Mori: The Flats at Quarry Hill, Leeds*, 2nd ed. (RRB Photobooks, 2016).
22. John Tagg, *The Burden of Representation: Essays on Photographies and Histories* (Basingstoke: Macmillan Education, 1988), 117.
23. 'Print Item: Photographs of Properties Situated in the Quarry Hill Unhealthy Area. Taken Dec. 1900 & Jan. 1901' (Special Collections: University of Leeds).
24. 'Print Item: Photographs of Properties Situated in the Quarry Hill Unhealthy Area', 144.
25. 'Soyo Leeds', https://soyoleeds.com/.
26. http://www.michaelcoldwell.co.uk/disappearingcity.html.
27. Things that are recognisable in the photograph and surroundings play a crucial role as reference points – landscapes, streets, buildings and certain household fixtures and furnishings tend to remain stationary and may have out-lasted human lives. Their identification is key to the experience of place.

See László Münteán, 'Double Exposure: Rephotography and the Life of Place', in *Spectral Spaces and Hauntings: The Affects of Absence*, ed. Christina Lee (New York: Taylor & Francis, 2017), 133–149.

28. William L Fox, *View Finder: Mark Klett, Photography, and the Reinvention of Landscape* (Albuquerque: UNM Press, 2001).
29. D. Levere, *New York Changing: Revisiting Berenice Abbott's New York* (New York: Princeton Architectural Press, 2005).
30. Christopher Rauschenberg et al., *Paris Changing: Revisiting Eugene Atget's Paris* (New York: Princeton Architectural Press, 2007).
31. Jason Kalin, 'Remembering with Rephotography: A Social Practice for the Inventions of Memories', *Visual Communication Quarterly* 20, no. 3 (2013).
32. Kalin, 'Remembering with Rephotography', 176.
33. Kalin, 'Remembering with Rephotography', 176.
34. See Fisher, 'Phonograph Blues':

It is this sense of temporal disjuncture that is crucial to hauntology. Hauntology isn't about the return of the past, but about the fact that the origin was already spectral. We live in a time when the past is present, and the present is saturated with the past. Hauntology emerges as a crucial – cultural and political – alternative both to linear history and to postmodernism's permanent revival.

35. Kalin, 'Remembering with Rephotography', 176.
36. http://www.michaelcoldwell.co.uk/auratrace.html.
37. Huyssen, *Present Pasts*, 83.
38. Huyssen, *Present Pasts*, 84.
39. 'I suggest that a haunting needs an outside, interpretive presence: a haunting is an intervention, an encounter.' Heholt, 'Unstable Landscapes', 5.
40. See Derrida, *Specters of Marx*, xviii.

If I am getting ready to speak at length about ghosts, inheritance, and generations, generations of ghosts, which is to say about certain others who are not present, nor presently living, either to us, in us, or outside us, it is in the name of justice.

41. Blanco and Peeren, *The Spectralities Reader*, 91.
42. Roland Barthes, *Camera Lucida: Reflections on Photography* (London: Vintage, 1993), 94.
43. Shelley Hornstein, *Losing Site: Architecture, Memory and Place* (Farnham: Ashgate, 2013), 83.
44. Lawrence Bird, 'Territories of Image: Disposition and Disorientation in Google Earth', in *Imaging the City: Art, Creative Practices and Media Speculations*, ed. Steve Hawley, Edward Montgomery Clift and Kevin O'Brien (Bristol: Intellect, 2016), 21.

45. Huyssen, *Present Pasts*, 77.
46. Huyssen, *Present Pasts*, 58.

BIBLIOGRAPHY

Augé, Marc. *Non-Places: Introduction to an Anthropology of Supermodernity*. London: Verso, 1995.

Barthes, Roland. *Camera Lucida: Reflections on Photography*. London: Vintage, 1993.

Bird, Lawrence. 'Territories of Image: Disposition and Disorientation in Google Earth'. In *Imaging the City: Art, Creative Practices and Media Speculations*, edited by Steve Hawley, Edward Montgomery Clift and Kevin O'Brien. Bristol: Intellect, 2016: 11–30.

Blanco, M., and Esther Peeren. *The Spectralities Reader: Ghosts and Haunting in Contemporary Cultural Theory*. London: Bloomsbury Academic, 2013.

Brogden, Jim. *Photography and the Non-place: The Cultural Erasure of the City*. Cham: Palgrave Macmillan, 2019.

Derrida, Jacques. *Right of Inspection*. New York: Monacelli, 1998.

———. *Specters of Marx: The State of the Debt, the Work of Mourning and the New International*. New York: Routledge, 2006.

Edensor, Tim. 'Haunting in the Ruins: Matter and Immateriality'. *Space and Culture* 11, no. 12 (2001): 42–51.

Fisher, Mark. 'Phonograph Blues'. *K-Punk* (2006). http://k-punk.abstractdynamics.org/archives/008535.html.

Fox, William L. *View Finder: Mark Klett, Photography, and the Reinvention of Landscape*. Albuquerque: UNM Press, 2001.

Graham, Stephen. 'Introduction: Cities and Infrastructure'. *International Journal of Urban and Regional Research* 24, no. 1 (2000): 114–19.

Heholt, Ruth. 'Unstable Landscapes: Affect, Representation and a Multiplicity of Hauntings'. In *Haunted Landscapes*, edited by Ruth Heholt and Niamh Downing, 1–20. London: Rowman and Littlefield International, 2016: 1–20.

'History of Quarry Hill'. Leeds Play House. https://leedsplayhouse.org.uk/about-us/playhouse-redevelopment/history-of-quarry-hill/.

Hornstein, Shelley. *Losing Site: Architecture, Memory and Place*. Farnham: Ashgate, 2013.

Huyssen, Andreas. *Present Pasts: Urban Palimpsests and the Politics of Memory*. Stanford, CA: Stanford University Press, 2003.

Jenkins, William. 'New Topographics: Photographs of a Man-Altered Landscape'. Rochester, NY: The International Museum of Photography at George Eastman House, 1975.

Kalin, Jason. 'Remembering with Rephotography: A Social Practice for the Inventions of Memories'. *Visual Communication Quarterly* 20, no. 3 (2013): 168–79.

Klett, Mark. 'Repeat Photography in Landscape Research'. *The Sage Handbook of Visual Research Methods* (2011): 114–30.

Kracauer, Siegfried, and Thomas Y. Levin. *The Mass Ornament: Weimar Essays*. Cambridge, MA: Harvard University Press, 1995.

Lefebvre, Henri, and Donald Nicholson-Smith. *The Production of Space*. Oxford: Blackwell, 1991.

Levere, D. *New York Changing: Revisiting Berenice Abbott's New York*. Princeton Architectural Press, 2005.

Liu, Yuting, Shenjing He, Fulong Wu and Chris Webster. 'Urban Villages under China's Rapid Urbanization: Unregulated Assets and Transitional Neighbourhoods'. *Habitat International* 34, no. 2 (2010): 135–44.

Mitchell, Peter. *Memento Mori: The Flats at Quarry Hill, Leeds*, 2nd ed. RRB Photobooks, 2016.

Munteán, László. 'Double Exposure: Rephotography and the Life of Place'. In *Spectral Spaces and Hauntings: The Affects of Absence*, edited by Christina Lee, 133–49. New York: Taylor & Francis, 2017.

'Print Item: Photographs of Properties Situated in the Quarry Hill Unhealthy Area. Taken Dec. 1900 & Jan. 1901'. Special Collections: University of Leeds.

Rauschenberg, Christopher, Eugène Atget, Clark Worswick, Alison Devine Nordström and Rosamond Bernier. *Paris Changing: Revisiting Eugene Atget's Paris*. New York: Princeton Architectural Press, 2007.

Schofield, Michael Peter. 'Aura and Trace: The Hauntology of the Rephotographic Image'. University of Leeds, 2018.

Simpson, Mavis. 'The History of Quarry Hill'. http://www.bbc.co.uk/leeds/citylife/quarry_hill/history.shtml.

'Soyo Leeds'. https://soyoleeds.com/.

Stankovic, Jelena. 'Mapping the City as Remembered and the City as Imaged'. In *Imaging the City: Art, Creative Practices and Media Speculations*, edited by Steve Hawley, Edward Montgomery Clift and Kevin O'Brien. Bristol: Intellect, 2016.

Tagg, John. *The Burden of Representation: Essays on Photographies and Histories*. Basingstoke: Macmillan Education, 1988.

'Tracks in Time: The Leeds Tithe Map Project'. Leeds City Council. http://tithemaps.leeds.gov.uk/.

12

Filming Chinese Settlement in Malaysia: Cinematic Narrative and Urban Settings

Wang Changsong

Introduction

Malaysia is a multi-ethnic, post-colonial country. The Chinese form the second-largest ethnic group and have well-established cultural representation, and Chinese settlements span five or more generations. Large-scale Chinese migration to Malaya (the successor to the Malayan Union, which gained independence within the Commonwealth of Nations in 1957) took place during the first half of the nineteenth century under the British colonial expansion in Southeast Asia. The largest group were those who came to work as labourers in the tin mines, pepper and tapioca farms, and sugar-cane plantations. Sin Yee Koh concludes that 'the Malaysian-Chinese community is not a homogenous group with reference to their family migration history to the degree of Chinese cultural affiliation'.[1] The very first film produced in Malaya was *New Friend* (1927), directed by Kwok Chiu-man. It was a melodrama about the 1920s, focused on a newly arrived Chinese immigrant to Singapore, which was part of Malaysia until it became a sovereign state in 1965. Malaysian Chinese identity in the country is by far the most transnational, modernized and urbanized. Their identity reflects historical continuity as descendants of migrants from China and local transformation within Malaysian society. The Malaysian Chinese, as a migrant category, has been discussed among scholars in migration studies and migration history. For instance, in *New Chinese Migrations: Mobility, Home, and Inspirations*, Sin Yee Koh argued that existing studies are 'insufficient to explain the diverse migration geographies and variegated migration pathways undertaken by these new Malaysian-Chinese migrants from the 1980s to the present'.[2] In their article 'From Multicultural Ethnic Migrants to the New Players of China's Public Diplomacy,' Wanning Sun, John Fitzgerald and Jia Gao pointed out that Malaysia was one of the destinations in the early

history of Chinese migration 'when Canberra [in Australia] progressively eliminated racial categories of immigration exclusion [in 1970s]'.[3] Film and its interrelations with Chinese immigrants and their settlement have been well discussed in a Western context by some scholars for a long time. It is extremely rare, however, to find any systematic discussion of Malaysian Chinese settlement in the field of film analysis. Zakir Hossain Raju has argued that 'the role of Chinese in the film industry, as well as the award-winning Chinese-language digital films of the 2000s, are never promoted as an important part of Malaysian cinema history'.[4] Publications written on cinema in Malaysia still do not acknowledge the achievements of Malaysian Chinese film-makers.

However, over the past few years, Malaysian Chinese-language films have penetrated the Malaysian market. Malaysian Chinese film-makers strive to showcase their artistry and creative freedom to tell stories representing their own cultural norms, philosophical and religious ideas and societal exceptions. As a discursive methodology, domestic space on screen invokes Malaysian cinema's 'Asian-ness' as a theoretical argument. Malaysian Chinese film-makers frequently experiment with space, time, colour, texture, structure and other aesthetic or philosophical principles. They may pursue questions of epistemology, language and history that shape a cultural space. The history of Malaysian Chinese film testifies to the tremendous significance of the Chinese diaspora to the development of not only ASEAN (Association of Southeast Asian Nations) cinema but also world cinema. At the early stage of the development of Malaysian Chinese film, the animated and well-accepted ethnic Chinese film-makers were people who were born in Western countries but worked in Asia or who were born in Asian countries, educated in Europe or America and established careers in Hong Kong or Taiwan. One of the key factors behind the Malaysian Chinese film-makers' success in popularizing cinema was their ability to integrate popular narratives and styles from local cultural practices. Raju critically argued that 'most survey histories written on and about cinema in Malaysia do not acknowledge the filmic efforts of the Chinese in Malaysia'.[5] This stems from the belief that the Chinese Malaysians in the early twentieth century were only temporary settlers in Malaya. Malaysian cinema at that time focused mainly on mainland China. Kwok Chiu-man's *New Friend* touched on social issues of the local Chinese diaspora in 1920s. The 1990s and 2000s can be seen as the period when Malaysia constructed herself as a nation which was preparing to embrace new technologies and new ideas. In 2010, Malaysian film director Chiu Keng Guan[6] released *Woohoo!*, which 'was touted as the first Chinese New Year film in Malaysia'.[7] Chiu's films have since become the most anticipated local Lunar New Year big-screen productions. Of the top three box-office-earning Malaysian Chinese films, two were directed by Chiu, namely, *The Journey* (2014) and *Ola Bola* (2016). The third, *Ah Beng the*

Movie: Three Wishes (2012), was directed by Silver Chung.[8] These three films were all released during the festive season of Chinese New Year in Malaysia. The films' stories and their promotional teasers 'appeal to a sense of humanism during the Chinese New Year'.[9]

In spite of these successes, unequal power relations in the Malaysia film industry restrain the development of Malaysian Chinese cinema. Some studies locate the Chinese films of Malaysia within contexts ranging from the national to the transnational. In his essay 'Transnational Trajectories in Contemporary East Asian Cinemas', Song Hwee Lim argued that a Chinese Malaysian filmmaker 'may align his or her film-making with the umbrella label of "transnational Chinese cinema" rather than with the national cinema of Malaysia'.[10] Malaysian Chinese film-makers are struggling to find their position within the local film industry. According to Chiu Keng Guan, the local Chinese film industry is growing fast although there are obstacles that can be frustrating.[11] Eight years ago there were no local Chinese films screened in the cinemas, and imported Chinese-language films from Mainland China, Hong Kong and Taiwan continued to occupy the screening schedule during the Chinese New Year season in Malaysia. However, these Malaysian-produced Chinese-language films definitely paved the way for a sense of trans-local Chinese cultural identity, since their cinematic trajectories for Malaysian Chinese audiences are inevitably transitional and intra-Asian rather than merely confined to the national milieu.

Malaysian film critic Hassan Abd Muthalib has argued that Malaysian Chinese film-makers are continuing Michelangelo Antonioni's narrative tradition in Malaysia.[12] Antonioni particularly used space in his film as a way of being historical and critical. Space is ordered and organized around the film's characters. The concept of *space* in this study is encapsulated in the memory of Malaysian cinemagoers in a significant way. This study looks at spatial conception of memory, particularly in terms of urban space depicted in the three aforementioned Chinese-language feature films. The year 2014 witnessed a dramatic increase in the number of Chinese film productions. Only seven local Chinese films were released in 2013 and twenty-one local Chinese-language feature films were released in 2014, including Chiu's *The Journey*. The three films in this study represent local films that were not only exceedingly popular but also critically recognized. The process of narrative turns image representation into a realistic form through the use of narrative techniques. The space constructed and represented through narrative allows viewers to be engrossed with the illusionary memories. It is not unusual to see these two film directors engaged in using their settings in a similar way – as a familiar space in which viewers experience the old memories in Malaysian Chinese communities and the society at large.

Cinematic cities in these three films become a discursive mechanism that foregrounds the multiplicity and heterogeneity of space and compels human intervention by ways of narrativization. The use of space is also indicative of how these two Malaysian Chinese film directors conflate time and narrative. As Stephen Teo stated in his book *The Asian Cinema Experience: Styles, Spaces, Theory*, the 'concept of space can be seen as a continuation of style',[13] which projects persistence of memory among declining populations of Malaysian Chinese cinema audiences. Space is itself cold and impersonal. However, these films display storied space in which the questions of history, memory and identity are meaningfully intertwined. The three films in this study were all screened during the Chinese New Year in Malaysia in 2012, 2014 and 2016, respectively. These film productions are comprised entirely of the signature crowd-pleasing comedies which were timed for release to lure in the Chinese New Year festive crowd.

Analytic approaches

In his book *Film Analysis Handbook: Essential Guide to Understanding, Analysing and Writing on Film*, Thomas Caldwell pointed out that 'to "read" a film is to analyse how that film uses images and sounds to tell a story and to powerfully affect the audience's thoughts and feelings about the story'.[14] Films are visual and auditory texts that enable a holistic understanding of the relationship between collective memories of spaces and physical places depicted in the films, rendering an opportunity to identify how Malaysian Chinese film-makers strike a nerve in the Malaysian Chinese film industry. Representation of urban space depicted in the selected Malaysian Chinese films will be examined. Film analysis is used to examine the manifest or latent content of persistence of memory towards spaces. The presence of visual images on screen and the absence of what the images refer to or convey define the fundamental nature of film communication. The characters, events and plots of the film unfold in a place where viewers can conceive the world of film. This chapter employs two analytic methods: (1) ideology criticism (to describe and analyse the ideological meaning of a film), and (2) semiotics (to describe and analyse the meaning construction of a film, and film as a unique grammar).

Urban space depicted in Malaysian Chinese films

According to the official report *Malaysian Box Office*, provided by the National Film Development Corporation Malaysia (abbreviated FINAS),[15] from 2011 to

2018 Malaysia produced 78 Chinese-language feature films. Of these, 64 (over 80 per cent) have Malaysia's cities and townships as their backdrops. For instance, the 2017 family film *You Mean the World to Me* (directed by Saw Teong Hin) was set against the background of a film director's life in Penang; the 2015 gangster film *Kepong Gangster 2* (directed by Teng Bee) depicted gangster fighting in the urban township of Kepong; the 2014 family-oriented action comedy *Bullets over Petaling Street* (directed by Sampson Yuen and Ho Shih Phin) depicted a female triad leader in Kuala Lumpur's Chinatown; and the 2013 comedy *The Wedding Diary 2* (directed by Adrian Teh) took place in Singapore. Cities provide for transnational flows of films and people in a particular way. The three films in this study evoke a complex space, both rooted and dislocated, out of settings that are resolutely specific and manifestly abstract. Those locations on screen were always familiar to Malaysian audiences. Meanwhile, local space portrayed in these films intersects with *ethnoscape*, which is defined as cross-ethnic scene of identity performance and commodities. These Malaysian-produced Chinese-language films are a direct approach to interact with political decisions and architectural blueprints that 'forge an urban contract and create the material city and its ideological constructs'.[16] Urban issues were addressed through the ideological prism of topics such as ' "second-class" ethnic Chinese' or '*balik Cina*' (go back China).

These Malaysian Chinese films project an almost entirely urban phenomenon in Malaysia's ethnic Chinese community. Urban spaces depicted in the films consist of the lived spaces of the social imaginary and are associated with the symbols and icons that shape subjective understandings as well as experiences of space in the more phenomenological sense. Most of Malaysian Chinese feature films set their ancestors' residences, home altars and Chinese temples as the backdrop of the stories. They represent not only the heritage of Malaysian Chinese community, but also an ideological imaginary of rationalization, abstraction and hegemonic spatial ordering. These films invariably involve the ways film and urban space produce not only something real but also a compelling exchange with Malaysian audiences. Many of them illustrate 'urban archaeology' that 'uncover[s] repressed historical and alternative futures'.[17] The spatialities of film and urban processes are entirely interdependent and far-reaching in their effects. These Malaysian-produced Chinese films unearth evidence of the transformation of the fortified city into a major twentieth-century urban port. There are some typical scenes repeated in these films. For example, residents gather at a crowded semi-open coffee shop in a neighbourhood with people of different races to watch badminton championships; or young people meet up at the temporary carnival built up at the urban vacant space. Film as agent, product and source of history is a formidable carrier of information about the urban fabric, but bears witness to human behaviour and culture belonging to specific ethnic groups. These scenes invited audiences to reflect

on the incidents and events that transpired in the twentieth century and became part of the collective memory of all Malaysians.

Chiu's Chinese New Year film *The Journey* explores different attitudes between generations in a Malaysian Chinese family. It is shot in the urban as well as rural areas of Malaysia, with the scenes in the cities providing plot points which reshape the relationships among the protagonists and spin the actions around in another direction. For example, the Chinese father tries to accept a Caucasian son-in-law when both of them ride around Penang city, hand-delivering wedding invites. Memories of the elderly raise another aspect of the intergenerational conflict and show how complicated intergenerational relations are in the film. *The Journey* focuses on Uncle Chuan (played by Lee Sai Peng) who is a conservative father with a rigid set of rules. When his daughter Bee (played by Joanne Yew) returns home with her fiancé Benji (played by Ben Pfeiffer), after having spent most of her formative years in England, Uncle Chuan refuses to give his blessing to the couple unless they follow the Chinese tradition of preparing their wedding in their hometown. The first day Benji stays at Bee's home, Uncle Chuan does not allow him to sleep in his daughter's room since they are not yet married. Instead, he has to sleep on a tiny and broken foldable bed at the home altar where a number of male ancestors' pictures hung above the temporary bed. The father fiercely forced his daughter and son-in-law-to-be to sleep in two different spaces before their marriage, and the sacred space represents the spatial order in which ancestors and seniors commit patriarchal control. The space in this scene provides the meaning of Chinese traditional values regarding female-male relationships before marriage. In the same film, Penang – the city where most of Uncle Chuan's old classmates live – provides a space for the daughter to re-examine her relationship with her father and for the son-in-law and the father to re-look at and appreciate each other's concerns regarding family values.

The entire film is enriched with local religious rituals and urban rhapsodies. Benji attempts to understand the symbolic meaning of the Chinese knot when a Penangite Chinese gives his blessing for his motorbike. Uncle Chuan stands far away from the mourning hall for his deceased schoolmate as he believes the diametrical opposition of red (signifier of a wedding in Chinese culture) and white (signifier of a funeral in Chinese culture) matters. In *The Journey*, Uncle Chuan determines to make a hot air balloon at the local school, which was his deceased schoolmate's wish. Locations where the hot air balloon passes by are like an anthology of his memories in adolescence. Although he and his classmates are no longer young and energetic, they show determination and loyalty to each other's memory. According to Chiu Keng Guan, this film is predominantly about the father-daughter relationship.[18] George Town in Penang provides ample opportunities to visualize improvement in relations, as many of Uncle Chuan's old friends

living in this city help diffuse the tension. According to Eric Yeong who is the director of cinematography for the film, the locations include Penang, Kedah and Ipoh; however the narrative only focuses on the events that occurred in Penang, neglecting the definition of the other cities.[19] The protagonists eventually embrace harmony, concord and compromise while Uncle Chua is gathering everyone to launch the self-made hot air balloon in Penang.

Simplifying and interpreting reality in Malaysian Chinese films

Film provides spectators with the impression of reality narrating itself. In his book *The Reality of Film: Theories of Filmic Reality*, Richard Rushton brings forward the argument that 'spectators do not mistake what they see on the screen for reality, rather they maintain a dual relation to the screen that is structured in a fetishistic manner'.[20] It is important to understand the ways in which the Chinese community in Malaysia has been represented in these Malaysian-produced Chinese-language films. Images of settlements such as Chinese new villages (*kampong baru*)[21] and Chinatown on film screen give symbolic meaning to spaces by simplifying and interpreting reality for Malaysian spectators. Silver Chung's *Ah Beng the Movie: Three Wishes* is an excellent example of this. It tries to tell a meaningful story and simplify reality in order to make its point intelligible.

Ah Beng the Movie: Three Wishes adopts time travel as a central concept and narrative device. It depicts Malaysian Chinese in a Chinese community preparing to receive the auspicious God of Fortune on the eve of the Chinese Lunar New Year – a typical Chinese tradition in Malaysia. Ah Beng's father is very poor, as exemplified by him only having coins to worship the God. One day, the worst dressed, scruffy God of Fortune receives a tiny token from Ah Beng's father. This God, however, is in fact, the true and almighty God of Fortune. Without realizing, Ah Beng's father sincerely expresses that he should be better dressed and wishes him good luck and good health. The true God of Fortune is surprised but touched by his sincerity and grants him three wishes. His wish allows him to meet his future son who is already an adult. His son is a not-so-bright security guard who is usually bullied by a group of rich brats with luxury cars who refuse to pay parking fees at an open car park. Living with Ah Beng at the Chinese new village, this youthful-looking father realizes his lack of commitment issues. At the end, his wish is granted by the God of Fortune who enables him to be a responsible husband and father.

The Chinese new village portrayed in *Ah Beng the Movie: Three Wishes* provides the principal social organism of protection and also economic participation in the Malaysian city. This space reflects not only the ethnic concentrations in various

parts of the city, but also how the family enclaves function as places of unity and harmony, and as an important micro-society. By providing ethnic products and religious practice, the Chinese new village is defined as a harmonious community. Spatial relations are integral to religious practice. At the beginning of the film, every Chinese family in the Chinese new village is waiting for the right moment to receive the auspicious God of Fortune. In the end, the protagonists' house had been painted in bright yellow, and it is the place where they hold a family reunion dinner on the eve of the Lunar New Year. The last crane shot visualizes the family praying together. Home is associated with pleasant memories, intimate situations, a place of warmth and protective security for family members. In contrast, Kuala Lumpur city in the film is defined as a place full of fraudulent conduct, offence and mistrust.

In *Ah Beng the Movie: Three Wishes*, the family is a pervasive social institution. Family setting highlights the fact that the family is pervasive, simply because Ah Beng's personality is influenced to varying degrees by his family upbringing. This time-travel comedy – *Ah Beng the Movie: Three Wishes* directed by Silver Chung – stresses a parent's responsibility by allowing the main character's father to experience the future that is yet to come with his son after making a wish. While the traditional family system within urban ethnic enclaves in Malaysia served a purpose, they are in some sense undone by the success of their economic and social achievements. Ah Beng's father works together with Ah Beng in Kuala Lumpur city. They experience workplace bullying and witness the superiority of urban people. These urbanites are depicted in a negative light. In the beginning, Ah Beng works at an open car park, and he is bullied by a group of rich brats with luxury cars, over their parking fee. In the middle of the film, Ah Beng and his father unexpectedly fight off armed robbers, simply because of an unscrupulous gold shop owner, who requested low-cost security for normal documents while what was really being delivered was a box of gold bars.

As third or fourth generation of Chinese migrants in Malaysia enjoy the benefits of education and economic growth, they often express their accession by highlighting their 'socio-economic success'.[22] *Ah Beng the Movie: Three Wishes* illustrates a grassroots family living in the Chinese new village on the edge of town. The plain wooden single-storey houses are virtually contiguous with each other. The scene in which the main character greets every neighbour indicates the neighbourliness and friendliness within the unique Chinese community. Such feelings are conveyed only in this particular space, not in the city centre. The location does not only tell their socio-economic status, but also provides a contrast with the urbanites, for instance, retail salespersons and the security guard company owner in the film. The urban landscape in the film is replete with explosiveness and self-alienation while the Chinese new village provides

an ecological space that is full of human kindness, cultural atmosphere, mutual help and vitality.

Space is a sociological fact in the films

Spaces in the cities depicted in these films are generated by human dramas that demonstrate sociological realities expressed in spatial forms. The uniform vacuum of social process is confronted with metaphors of a filled-out, dense, consequently resistant spatiality marked by racial and ethnic differences. French sociologist Patricia Reynaud defined 'a social space as a field of objective relations between positions occupied by social agents'.[23] The social space on film screen implies a hierarchy in the classification of agents. From a visual perspective, each space in these three films not only adds colours on the screen but also implies dominant and submissive relationships. The Chinese father portrayed in Chiu's *The Journey* fiercely asked her daughter's English boyfriend to leave his daughter's bedroom at night as he believed premarital cohabitation should not be allowed. In Chui's film *Ola Bola*, the national football team consists of three major ethnic representatives – Malay, Chinese and Indian. The captain is Chinese, the goalkeeper is Indian and the striker is Malay. These three characters' houses clearly indicate the social groups to which they belong. The Chinese team captain's home is full of different working areas (i.e. sewing and tailoring) where his siblings work for a living. When he gave up football, his sister told him that she had made ample sacrifices to support the whole family and there was no reason why he should simply give up on his football career. The open yard was the backdrop of the scene in which she emotionally encouraged him. The Chinese New Year celebration film *Ah Beng the Movie: Three Wishes* depicts Malaysian Chinese in a big Chinese community preparing to receive the auspicious God of Fortune on the eve of the Lunar New Year – a typical Chinese tradition in Malaysia. All community residents share the same open space for their worship ritual. This film portrays typical local religious activities in the urban context.

The unlikeliness of the characters is not simply a sociological fact about its composition but a central narrative feature that focuses attention on the significance of social difference. Space is not only encumbered by the idea of rigidity, but also reminiscent of ethnic debate in Malaysian society for decades. In her book *The Sociology of Space: Materiality, Social Structures, and Action*, Martina Löw argued that 'space is [...] sporadically listed as a basic sociological concept'.[24] Conceptual spaces have emerged out of the thinking specific to Chinese sociological reasoning. It is universal to see space being considered contextual. These three films illustrated social and symbolic space in Malaysian society among the three

major ethnic groups. Space on film screen is a conceptual construction for understanding the living environment of each race. Space in film is shaped by human relations. Likewise, human relations are also shaped by space. The Chinese football captain and the Indian goalkeeper depicted in the film *Ola Bola* are both from humble family backgrounds. The football captain earns a living by rubber tapping; the Indian goalkeeper's father raises a family with his limited revenue. The visual space (i.e. rubber plantation and coconut forest) in which the struggles of Chinese and Indian citizens become visible is created as a form of perceiving social conditions in late 1970s Malaysia. The football players are provided a shared accommodation when the coach brings them to an intensive military training camp. Their personal space bubble has been changed. This in a way helps to build trust among the team players. The football field eventually becomes the space in which there is fierce competition. The film is based on true events involving the national football team's brazen journey towards qualifying for the 1980 Olympics held in Moscow,[25] and where the players overcome their socio-economic differences for the greater good.

It is impossible to grasp the whole city (even the physical component of the city), because it is so large, complex, diverse and ever changing. An urban space is symbolic of the city as a whole and is a powerfully evocative setting. Chiu's *Ola Bola* presents its climax at the Bukit Jalil National Stadium where it echoes with the cheers of a full audience with a patriotic fervour. This stadium is actually located in the National Sports Complex to the south of the city centre of Malaysia's capital city, Kuala Lumpur. The building's construct converts into latter-day poetic realism, becomes a sort of ideal space-station, with emphasis on colour and form rather than graphic realism, and thus refigures some images of spacecraft interiors which appear in the film *Ola Bola*. The grand stadium, shown fully occupied by cheering fans and the glare of fluorescence, visually represents glory, unity and the effort to achieve success for the Malaysian football team at the end of the film. However, confrontation occurs in another space within the stadium – the locker room, which is clearly much smaller than the football field – where endless quarrels among the team players occur due to their internal conflicts (i.e. football player's numbers and their positions). The shots for the national stadium not only cover the football field and the locker, but also various corners of stadium's periphery, where fans could not enter but where the excitement and cheers are audible. These shots undoubtedly are used to tell the spectators it is the most happening space in the city on that day, which gathers all ethnic groups as they celebrate the same joy and success. This particular space, which is employed to express patriotism and glorify regimes, is considered the ideal urban space where race and ethnic differences become less dominant. One of the most obvious postcolonial issues in Malaysia is race, which takes the form of *bumiputera*[26] status and ethnic Malay

indigeneity. Given this context, it is almost inevitably impossible for other ethnic groups to achieve *bumiputera* status and privileges even if they seek to construct their claims for recognized ethnic identities. In the film, the grand stadium is symbolic of the space which may invite spectators to recall the unity among ethnic groups in the 1980s. The plots and narrative related to the football match illustrate the semiotic logic of the film, which is a form of attachment, and not only a form of simple ethnic unity or ethnic communal bonding.

Conclusion

Film represents urban space as it is representational, while simultaneously being sensory and symbolic. Space predominates over time in film narration. The three highest-grossing Malaysian-produced Chinese-language feature films – *Ah Beng the Movie: Three Wishes*, *The Journey* and *Ola Bola* – are studied in this chapter. These three films give viewers a glimpse of ideology and culture in a Malaysian Chinese context. China Town, Chinese schools, Chinese new village and the former National Stadium depicted in these three films are more than just physical locations but are used in segments of the films that refer to a sociological fact and social relations among Malaysia Chinese population. In Malaysia, the complexity of the Chinese diaspora bears certain distinct features. Trans-spatiality enables Malaysian Chinese film-makers to focus on all kinds of spaces. These spaces are places of attachment and/or identification of Malaysian Chinese and act as modes of communication that facilitate such attachment, identification and connection.

NOTES

1. Sin Yee Koh, *Race, Education, and Citizenship: Mobile Malaysians, British Colonial Legacies, and a Culture of Migration* (Basingstoke: Palgrave Macmillan, 2017), 258.
2. Sin Yee Koh, 'Diverse Migration Geographies of Tertiary-Educated Malaysian-Chinese Migrants: Anything New?', in *New Chinese Migrations: Mobility, Home, and Inspirations* (Abingdon, Oxon: Routledge, 2018), 175.
3. Wanning Sun, John Fitzgerald and Jia Gao, 'From Multicultural Ethnic Migrants to the New Players of China's Public Diplomacy', in *China's Rise and the Chinese Overseas* (Abingdon, Oxon: Routledge, 2018), 56.
4. Zakir Hossain Raju, 'Identity and Sovereignty in Asian Art Cinema: Digital Diaspora Films of South Korea and Malaysia', in *Art and Sovereignty in Global Politics* (New York: Palgrave Macmillan, 2017), 225.
5. Zakir Hossain Raju, 'Filmic Imaginations of the Malaysian Chinese: "Mahua Cinema" as a Transnational Chinese Cinema', *Journal of Chinese Cinemas* 2 (2008): 70.

6. Chiu Keng Guan is a Malaysian film director. Chiu initially studied graphic design and then fine arts, and worked on ceramic and sculpture production. He then attended the Beijing Film Academy, which in recent times produced Zhang Yimou and Chen Kaige. Since then, he produced TV dramas, commercials, corporate videos and also worked as an assistant director and cameraman. He was also part of the pioneering group that helped set up the Malaysian Chinese-language free-to-air television network 8TV, and freelanced for Astro. Chiu emerged in the local movie scene with Astro and its movie production arm, Astro Shaw, in directing his acclaimed family-oriented Lunar New Year Trilogy of *WooHoo!* (2010). From 2010 to 2018, he produced five local Chinese feature films.
7. Changsong Wang, 'The Struggles of Malaysia's National Cinema in Multilingual Discourses', *Movie Review*, no. 22 (2017): 7.
8. Silver Chung is a Malaysian film director. He has directed a number of Chinese New Year films in Malaysia since 2012. His films include *Ah Beng the Movie: Three Wishes* (2012), *Once Upon a Time* (2013), *Ah Beng: Mission Impossible* (2014), *3 Brothers* (2014) and *Love from Kampung* (2017).
9. Changsong Wang and Yiming Chen, 'The Ideological Struggle of Multicultural Nationalism: Cultural Identity in the 2014 Malaysian Top-Grossing Movie The Journey', *SHS Web of Conferences*, no. 33 (2017): 4.
10. Song Hwee Lim, 'Transnational Trajectories in Contemporary East Asian Cinemas', in *East Asian Cinemas: Regional Flows and Global Transformations* (New York: Palgrave Macmillan, 2011), 26.
11. Chiu Keng Guan in discussion with the author, November 2015.
12. Hossain Raju Zakir, 'Identity and Sovereignty in Asian Art Cinema: Digital Disapora Films of South Korea and Malaysia', in *Art and Sovereignty in Global Politics* (Basingstoke: Palgrave Macmillan, 2017), 231.
13. Stephen Teo, *The Asian Cinema Experience: Styles, Spaces, Theory* (Oxon: Routledge, 2013), 133.
14. Thomas Caldwell, *Film Analysis Handbook: Essential Guide to Understanding, Analysing and Writing on Film* (Victoria: Insight, 2010), ix.
15. The National Film Development Corporation Malaysia (Malay: Perbadanan Kemajuan Filem Nasional), abbreviated FINAS, is the central government agency for the film industry of Malaysia. FINAS is involved in the promotion of filming in Malaysia, and with the implementation of the Investors Promotion Act, 1986, also censured local film and video production activities. It provides Malaysian films screening and achievement data and reports.
16. Geraldine Pratt and Rose Marie San Juan, *Film and Urban Space: Critical Possibilities* (Edinburgh: Edinburgh University Press, 2014), 5–6.
17. Pratt and Juan, *Film and Urban Space*, 4.
18. See note 11.
19. Eric Yeong in discussion with the author, June 2018.

20. Richard Rushton, *The Reality of Film: Theories of Filmic Reality* (Manchester: Manchester University Press, 2011), 105.
21. New villages, also known as Chinese new villages, are settlements created during the waning days of British rule over Malaysia in the mid-1950s. The original purpose of the new villages in Malaysia was to segregate the villagers from the early Malayan Races Liberation Army insurgents, which were led by the Malayan Communist Party, during the Malayan Emergency. By isolating this population in the 'new villages', the British were able to stem the critical flow of material, information and recruits from peasant to guerrilla.
22. Lee Hock Guan and Leo Suryadinata, *Malaysian Chinese: Recent Developments and Prospects* (Singapore: Institute of Southeast Asian Studies Publishing, 2012), 166.
23. Patricia Reynaud, 'Simple Minds, Complex Distinctions: Reading Forrest Gump and Pleasantville through the Lens of Bourdieu's Sociological Theory', in *Memory and Representation: Constructed Truths and Competing Realities* (Bowling Green: Bowling Green State University Popular Press, 2001), 127.
24. Martina Löw, *The Sociology of Space: Materiality, Social Structures, and Action* (New York: Palgrave Macmillan, 2016), 3.
25. *Ola Bola* is a fictional retelling of true events involving the national football's team brazen journey towards qualifying for the 1980 Olympics held in Moscow, then of the Soviet Union. The team did not make it to Moscow, as the Malaysian government made the decision to boycott the Games in protest of the Soviet Union's invasion of Afghanistan.
26. The concept of a *bumiputera* ethnic group in Malaysia was coined by the second prime minister of Malaysia, Abdul Razak Hussein. It recognized the 'special position' of the Malays provided in the Constitution of Malaysia, in particular Article 153. In the 1970s the Malaysian government implemented policies which the *Economist* called 'racially discriminatory' and designed to favour *bumiputera*s (including affirmative action in public education) to create opportunities and to defuse interethnic tensions following the extended violence against Malaysian Chinese in the 13 May incident in 1969. These policies have succeeded in creating a significant urban Malay and Native Bornean middle class as well. They have been less effective in eradicating poverty among rural communities.

BIBLIOGRAPHY

Brunette, Peter. *The Films of Michelangelo Antonioni*. Cambridge: Cambridge University Press, 1998.

Caldwell, Thomas. *Film Analysis Handbook: Essential Guide to Understanding, Analysing and Writing on Film*. Victoria: Insight, 2010.

Hock Guan, Lee, and Leo Suryadinata. *Malaysian Chinese: Recent Developments and Prospects*. Singapore: Institute of Southeast Asian Studies Publishing, 2012.

Koh, Sin Yee. 'Diverse Migration Geographies of Tertiary-Educated Malaysian-Chinese Migrants'. In *New Chinese Migrations: Mobility, Home, and Inspirations*, edited by Yuk Wah Chan and Sin Yee Koh, 174–90. New York: Routledge, 2018.

———. *Race, Education, and Citizenship: Mobile Malaysians, British Colonial Legacies, and a Culture of Migration*. Basingstoke: Palgrave Macmillan, 2017.

Lim, Song Hwee. 'Transnational Trajectories in Contemporary East Asian Cinemas'. In *East Asian Cinemas: Regional Flows and Global Transformations*, edited by Vivian Lee, 15–32. New York: Palgrave Macmillan, 2011.

Pratt, Geraldine, and Rose Marie San Juan. *Film and Urban Space: Critical Possibilities*. Edinburgh: Edinburgh University Press, 2014.

Raju, Zakir Hossain. 'Filmic Imaginations of the Malaysian Chinese: 'Mahua Cinema' as a Transnational Chinese Cinema'. *Journal of Chinese Cinemas*, no. 2 (2008): 67–79.

———. 'Identity and Sovereignty in Asian Art Cinema: Digital Diaspora Films of South Korea and Malaysia'. In *Art and Sovereignty in Global Politics*, edited by Douglas Howland, Elizabeth Lillehoj and Maximilian Mayer, 225–26. New York: Palgrave Macmillan, 2017.

Reynaud, Patricia. 'Simple Minds, Complex Distinctions: Reading Forrest Gump and Pleasantville through the Lens of Bourdieu's Sociological Theory'. In *Memory and Representation: Constructed Truths and Competing Realities*, edited by Dena Elisabeth Eber and Arthur G. Neal, 127–38. Bowling Green: Bowling Green State University Popular Press, 2001.

Rushton, Richard. *The Reality of Film: Theories of Filmic Reality*. Manchester: Manchester University Press, 2011.

Sun, Wanning, John Fitzgerald and Jia Gao. 'From Multicultural Ethnic Migrants to the New Players of China's Public Diplomacy'. In *China's Rise and the Chinese Overseas*, edited by Bernard P. Wong and Tan Chee-Beng, 55–74. Abingdon, Oxon: Routledge, 2018.

Teo, Stephen. *The Asian Cinema Experience: Styles, Spaces, Theory*. Oxon: Routledge, 2013.

Wang, Changsong. 'The Struggles of Malaysia's National Cinema in Multilingual Discourses'. *Movie Review*, no. 22 (2017): 6–9.

Wang, Changsong, and Yiming Chen. 'The Ideological Struggle of Multicultural Nationalism: Cultural Identity in the 2014 Malaysian Top-Grossing Movie The Journey'. *SHS Web of Conferences*, no. 33 (2017): 1–6.

Yan, Seto Kit, and Michael Cheang. 'Chiu's *The Journey* a Box-Office Hit'. Last modified 12 February 2014. https://www.thestar.com.my/news/nation/2014/02/12/chius-the-journey-a-boxoffice-hit/.

13

Bringing People Together Now: Wong Kar-Wai and Hong Kong

Kimberly Connerton

Architecture

This chapter focuses on film and power and implications of the use of spaces and architecture in its production. Wong Kar-Wai's films will be discussed because of his focus on the urban domain and how the Self becomes reinserted into the world.[1] Typically, in director Wong Kar-Wai's films stories are not only about where the characters are but also about 'how an urban setting shapes characters and make them who they are'.[2] I will also focus on slowed down time in film and architecture and consider Guy Debord's notion of the *dérive*, developed in the 1960s as Wong's memories of Hong Kong are, to explore a *shared dreaming of space*,[3] which is similar to his focus on romantic love. According to cinematographer Christopher Doyle, who crafted scenes in *Chungking Express* and *In the Mood for Love*, 'The best films I've made are when I fell out of love. They are both informed by different kinds of loss, and I think that loneliness is one of the most beautiful experiences of life.'[4] Doyle's remarks echo Wong's use of romantic love in *In the Mood for Love* and *Chungking Express*. Wong's focus on romantic love guided *how the characters* navigate space and *shape and are shaped by urban settings*,[5] architecture and thresholds in Hong Kong in both films.

In *In the Mood for Love*, intimacy is created by Doyle's cinematographic strategy of framing thresholds, which corresponds with Beatriz Colomina's statement that 'comfort in this space is related to both intimacy and control'.[6] The 'intimacy' and 'control' Colomina speaks of is in regard to the Moller house by Adolph Loos and the interior plan he designed to have a hierarchy of views. Also, Loos used smoked or curtained windows to contain the focus on the interior and eliminate an exterior view. Subsequently, bypassing architecture's use of windows as devices to frame the landscape or exterior views, which in contrast, was

crucial to Wong's narrative in *In the Mood for Love*. Alternatively, Wong utilized architecture's device of framing both interior and exterior views to express a sense of emotional, communal and spatial intimacy. In this way, intimacy was not merely about being contained in an interior space. Instead, the human relationships and narrative Wong scripted were his primary guide to filming architecture and space in his films.

Here, the constraints are expressed through some of the clothing the characters wore, which was formal and tight like Li-Zhen's high-necked dresses. The heat of Hong Kong only intensified these social and bodily constraints.

Yet, intimacy isn't only found in the framing of the interiors in *In the Mood for Love*. Instead, many of the exterior scenes are also filmed through windows, passageways and stairways. Framing thresholds created a world for the characters to be together, as well as a precise model for audiences to view and experience this intimacy. The unseen or what is not needed to understand the characters, narrative or a particular scene is eliminated through the cinematic device of framing many of the scenes in *In the Mood for Love*. Wong's underlying desire and inherent focus is the state of being in love. The act of framing scenes in the filming architecture mimics the singular focus that being in love produces. The framing narrowed the focus like being in love – everything else disappears. So the focus is only on the subtleties and bodily gestures of the characters and smaller areas of interior or exterior spaces they inhabit – to maintain an intimate feeling and a sense of emotional closeness crucial to Wong's narrative.

In Wong's films romantic love can be equated with human desire and memory that guide the characters and the filming of space and architecture in Hong Kong. Wong filmed Hong Kong with a subjective lens. His scripts focus on romantic love and tell stories about impermanence, anxiety and uncertainty. The political and social climate of Hong Kong and Wong's memories are the unsaid realities in his films. Wong moved to Hong Kong in 1964 from Shanghai. *In the Mood for Love* was set in the 1960s and drew from his memories of the Shanghainese immigrant community in exile in Hong Kong. Many Shanghainese people left China after the communists took control in 1949. Prior to the communist takeover, Shanghai was a sophisticated, capitalistic metropolis and by moving to Hong Kong, which was a colony under British rule, there was uncertainty and loss.[7] *Chungking Express*, completed in 1994 and released in the West in 1996, preceded the impending handover from Great Britain to China in 1997. Hong Kong under the colonial and postcolonial rule was an unknown reality that Wong's films presence.

The characters in both films moved physically and geographically and are repeatedly filmed walking or running through thresholds: stairwells, underground corridors and malls, and narrow streets. Impermanent spaces are where the main action takes place. The threshold choreographs movement in architecture.

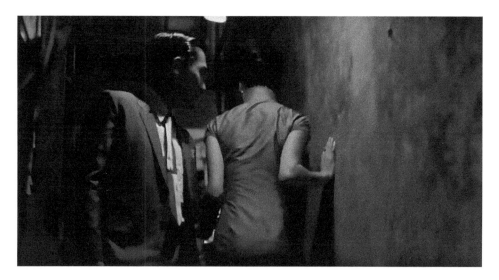

FIGURE 13.1: Wong Kar-Wai (dir.), *In the Mood for Love*, 2000. Hong Kong © Jet Tone Production.

FIGURE 13.2: Wong Kar-Wai (dir.), *In the Mood for Love*, 2000. Hong Kong © Jet Tone Production.

The stairwell that leads to the apartments of the main characters, Li-Zhen and Chow, is repeatedly filmed in *In the Mood for Love* (Figures 13.1 and 13.2). This allowed the audience to focus on intimate bodily gestures of the characters, as they stared at each other in awkward and delightful meetings that conveyed the

beginning of their love. Paul Arthur notes, 'The narrow passages and cloistered chambers in which most of the action takes place are subtle [...] tropes for the labyrinthine quality of the mind, its ceaseless movement along the same unending pathways of remembered experience.'[8] Wong's memories are activated spatially by repeatedly filming 'movement along the unending pathways'[9] – the many thresholds his characters inhabit.

'Deleuze's claim of multiple parallel universes'[10] is relevant in Wong's filmic worlds defined in space by the repeated use of the threshold: 'they exist in a virtual state and become actual [...] pathways "passing through incompossible presents, returning to not necessarily true pasts".'[11] The virtual worlds in *In the Mood for Love* are Wong's memory of Hong Kong in the 1960s, the fictitious space between what actually happened and his memories and the filmic worlds he created. The idea of repetition is 'more a matter of coexistence than succession, which is to say, repetition is virtual more than it is actual'.[12] 'Repetition in Deleuzian understanding', as elucidated by Adrian Parr, 'does not refer to the same thing taking place over and over again but to the power of difference in terms of a productive process that produces variation in and through every repetition.'[13] The spaces and thresholds like the stairwell leading to the lead characters' apartment in Hong Kong produce a circular motion of seeing the evolution of the lead characters and inhabitants of the same apartment building repeatedly walk upwards to go into the home they all share. The loss of the community is revealed towards the end of the film when Chow comes back to visit, and everyone has moved away. The repetition came full circle from the beginning when they met and now to the end where they have separated. The characters have left the building they shared, and now most have left Hong Kong.

The *variations* through repetition produced and filmed in *Chunking Express* are evident in scenes of Cop 663 talking to Faye and her uncle, the owner, at the underground fast food shop. Wong filmed these scenes in the Chungking Mansions mall he remembered as a child in Hong Kong. It was hot, dank, crowded with people and seedy. The character Faye is repeatedly filmed listening to *California Dreamin*, by the Mamas and Papas, so loud that Cop 663 has to yell his order into her ear as they both lean into each other from opposite sides of the counter. The song *California Dreamin*, released in 1966, is a part of the 1960s that Wong remembers. The repetition of this song echoes his dream of the past and the Shanghainese community in Hong Kong that he was a part of and that no longer exists. The dream of the foreign land also brings with it a sense of hope and possibility after the loss of the homeland Wong had in Shanghai. The repeated scenes of Faye serving Cop 663 and listening to *California Dreamin* on many occasions showed the evolution of their relationship and the underground spaces that dominate Hong Kong's urban terrain.

In earlier scenes, Faye begins to notice Cop 663. In one scene, his ex-girlfriend stopped by the fast food shop where Faye worked and left the keys to his apartment shortly after they broke up. Eventually, Cop 663 too begins to notice Faye. She kept his keys, never telling him she had them, and repeatedly went to his apartment. She altered and moved his furnishings around and cleaned his apartment. As their relationship moved to the next level, they moved aboveground and would occasionally walk on the crowded streets of Hong Kong through the markets and open-air lunch tables. Faye defiantly entered his apartment after meeting him on the street because she knew he was not home.

As time passed and their attraction developed, he invited her to meet him for a drink. Faye never showed up. Instead, she moved to the far-off land – the United States – and became a stewardess. The decision not to love and be free rather than commit to staying in Hong Kong with the unknown evidences the aforementioned notion that the political and social climate of Hong Kong and Wong's memories are the unsaid realities in his films.

'Understanding the spatial organization in Wong's films helps to unravel what is hidden under the disguise of the characters' seemingly ambiguous attitudes toward their surroundings.'[14] Wong's memories of the exiled Shanghainese community and the uncertain future of Hong Kong motivated the spatial organizational in his films. This sense of uncertainty, open-endedness and the transient nature of Hong Kong are revealed by the constant movement and use of repetition in Wong's films. Similarly, the characters travel to far-off lands and made the decision not to love and by doing so depicted spatial uncertainty in both *In the Mood for Love* and *Chungking Express* giving life to 'Wong's memories' and 'the political and social climate of Hong Kong'. In turn, this made Hong Kong a place to come and go rather than being a permanent home.

The Deleuzian notion of parallel universes encompassed the shifts when characters changed their lives, the universes included: Wong's filmic universe, his memories of Hong Kong and the Shanghainese community he was a part of, the characters' evolution – Faye's life in a new country which is never seen in the film, and Faye and Cop 663's reuniting scene when they meet in the same underground fast food joint where they had first met. Wong's repeated use of romantic love in *In the Mood for Love* and *Chungking Express* is a metaphor for potential and a signifier that urban spaces are spaces for 'shared dreaming'. Again the choice not to love, in *In the Mood for Love*, for characters Li-Zhen and Chow resulted in parting ways and long-distance travel. Li-Zhen moved to Singapore with her husband and Chow travelled to Angkor Wat to whisper the secret of his unconsummated love for Li-Zhen into a hole in the wall to impress it into the world.

In the Mood for Love, **slow film and slow architecture**

In the last sequence of scenes in *In the Mood for Love*, perhaps the most exquisite, Chow is at the Cambodian Buddhist Temple Angkor Wat. He went there to press his secret of loving Li-Zhen into a wall. Wong's design of the sequence of scenes at Angkor Wat slowed down time and revealed a 'shared dreaming' with architecture. In *In the Mood for Love*, Wong slowed down the film speed in the repeated scenes of Chow and Li-Zhen walking down the stairway to their homes and passing each other. By doing so, he slowed down time to depict slowness in architecture. Wong doesn't slow down the film speed in the sequence of scenes of Chow at Angkor Wat, as he did of the pair in the stairway scenes. Instead, Chow's meditative reflections were revealed as he stood with his body pressed against the edge of the wall whispering his secret of loving Li-Zhen.

Juhani Pallasmaa stated,

> Architecture emancipates us from the embrace of the present and allows us to experience the slow, healing flow of time [...] The time of architecture is a detained time; in the greatest of buildings time stands firmly still [...] Time and space are eternally locked into each other in the silent spaces [...]; matter, space and time fuse into one singular elemental experience, the sense of being.[15]

As soon as Chow began to lean into the wall, even before his head touched the stone wall, the main song repeated throughout *In the Mood for Love*, *Yumeji's Theme*, by Shigeru Umebayashi, is played again. In the aforementioned scenes, where Li-Zhen and Chow passed each other in the stairway at their home, the song slowed down time for their love to bloom and captured moments of intimacy. The slowing down of the film revealed the pleasure between the characters and allowed the audience to see their movements without the excessive element of dialogue. The characters are 'emancipated' even if for a few moments from the heart-breaking fact that their spouses are cheating on them with each other and their neighbours are watching.

Wong's narrative of Chow telling his secret to the wall 'allows the experience to slow' at the temple – the architecture – because Wong's intimate ritual that bared his soul and told his secret slowed time in the film and architecture. The storyline of Chow telling his secret to the wall, the way Wong films this sequence and Angkor Wat speak to Pallasmaa's notion that 'the time of architecture is a detained time; in the greatest of buildings time stands firmly still [...] Time and space are eternally locked into each other in the silent spaces'.[16]

In *In the Mood for Love* Angkor Wat 'stands firmly', the aged, decayed, thick, ornate carved stone pillars and walls transported audiences to another time since the historic evolution of this temple originated in the twelfth century.

Angkor Wat's geographic location outside of the urban context is a shift in the film to a sacred architectural site away from the grit and speed of Hong Kong. The filming of Ankor Wat brings us closer to a past history and also to the purpose of this temple, which is the Buddhist meditative practice. Wong's use of close-up shots and the filmic convention of slowly panning Chow and Angkor Wat for extended periods of time are synonymous with slowing down and stretching time the way a meditative practice would for a practitioner. The program of Angkor Wat was reinforced and architecture is revealed as a space where 'time and space are eternally locked into each other in the silent spaces'.

A closer look – Mr Chow at Angkor Wat

The scenes of Angkor Wat in *In the Mood for Love* are elegant and spacious and produced a feeling of freedom. The filmic style that created an ambience of expansiveness was aided by the full airy, rhythmic string arrangements, and different versions of *Yumeji's Theme* played repeatedly throughout the film. In the initial scene of this sequence, Chow pressed his finger into a hole in the stone wall and stood and reflected for a moment as he stared at this hole. He then pressed his body closer to the wall. The hole is at the level of his forehead, and he pressed closest from that meeting point between his body and Angkor Wat. As he started to move his head closer to the wall the recurring song, *Yumeji's Theme*, began to play and continued throughout the sequence. As well as producing slow time the architecture became a place that could hold secrets and housed human aspirations, similar to the Parthenon's intention of housing the goddess, Athena. In Angkor Wat and the Parthenon architecture is an inhabitable space to slow down, conspire with deities and reconnect with the self.

As the sequence continues, Chow is filmed from behind. We see his full body. The camera moved slowly. Chow's body remained pressed against the wall. The camera zoomed out to a wider view of Angkor Wat's decaying stone wall and carved edges that surrounded Chow. It moved in a circular route – left to right. Chow's body is hidden by a pillar and eventually becomes visible again. His body is next to another threshold, a passageway, several feet larger than he is, and it opened into other buildings that comprise the temple complex. Now the camera zooms in for a close-up of Chow with his head still pressed into the same wall at Angkor Wat. He stood at the edges that led into a passageway that travelled deeper into Angkor Wat's complex of buildings. He tilted his head, as if he were deep in conversation with someone, as he continued to whisper. In the next scene, the edge of his hand is pressed into the wall and covered one side of his mouth to push his whisper into the wall – the way you would into another person's ear. The next scene is an aerial view of Chow. Perched on a building above, a young

male monk stared down at Chow. The scene is composed of three main elements – the young monk's head is in the centre right and on the left side below are piled slabs that form the steps of the temple, the monk's head, and then Chow from a further distance, as he stood in the carved passageway. Chow walked through the corridors of the temple with his jacket over his shoulder. The passageway at the end of the corridor opened to let the sunlight in and offered a view of the temple complex. Yet the open-air corridor Chow walked down was completely dark.

The camera continued to follow Chow as he walked down another beautiful corridor where the carved stone walls and mouldings were flooded with light. At the end of this corridor, a passageway opened into a view with even more sunlight. The camera zoomed in for a close-up shot of the corridor, moved through the passageway and then into another black room with a passageway at the end that was flooded with light. As dusk approached, the camera focused on a rounded edge of the temple. Next scene, Wong returned to the hole in the wall into which Chow had pressed his body and secret, yet in this scene Chow was not visible. Grass and weeds now grew out of the hole. As the saying goes, wherever there is a hole nature will fill it, and along with Chow's secret, which occupies empty space, the weeds have now filled it. Next, the camera zoomed into a view of the high ceilings, shot from below, to reveal the scale and expansiveness of the passageway and corridor. Wong and Doyle's cinematic framing returned, and the camera zoomed in across layers of carved mouldings and along the edges of the ceiling and passageway. Above the passageway we see decaying and faded paintings and a long corridor shot from the ground.

The carvings in the stone walls, pillars and edges of the passageways of repeated patterns of nature and women dancing created a myriad of surfaces that moved and that have depth. Angkor Wat was built in the twelfth century and allowed audiences to view the slow time of this ancient architecture from a different context. The camera moved from the inner chamber of the temple to an aerial view of the exterior of Angkor Wat. The camera zoomed across several buildings before arriving at a mausoleum. In the sequence until this scene, *Yumeji's Theme* had been playing. The music stopped, and again we hear birds chirping as in the beginning scene of this sequence when Chow first pressed his head against the wall. Last, the poetic text below is written on screen:

> He remembered those vanished years
> As though looking through a dusty window pane,
> The past is something he could see but not touch,
> And everything he sees is blurred and indistinct.[17]

The unexpected meeting of Chow and Li-Zhen is the first part of the sequence of Angkor Wat scenes. She is in Cambodia with her husband on a business trip. Li-Zhen and Chow walked through the same corridors, passageway and archways as he did after he embedded his secret into a hole in the wall. As they parted, he asked her if she called him and hung up. She denied it and said she has forgotten about it. Then the camera zoomed in for a close up of Chow's face as Li-Zhen walked away. Chow smiled and looked down. He did not believe she had forgotten, and her denial revealed to him that she did call him and had hung up. The expression on his face is one of delight.

Shared dreaming – the dérive – agency in the city

In contrast to Wong's view of Hong Kong, Anthony Vidler's stated, 'We seldom look at our surroundings. Street and buildings, even those considered major monuments, are in everyday life little more than backgrounds for introverted thought, passages through which our bodies pass "on the way to work".'[18] Vidler captured the disconnection of life in cities today, which is relevant for life in any big city and Hong Kong that Wong filmed. Yet, Wong's film has depicted Hong Kong as an urban scape that brought people together. The spatial signifiers of the intimacy and community that Wong filmed are seen in the repeated thresholds in *Chungking Express* and the many scenes filmed through windows and doorframes in *In the Mood for Love*.

Hamid Naficy points out the diasporic critique relevant in Wong's films, stating:

> The spatial aspects of the closed form in the mise-en-scène consist of interior locations and closed settings, such as prisons and tight living quarters, a dark lighting scheme that creates a mood of a constriction and claustrophobia, and characters who are restricted.[19]

In the Mood for Love relied on interior shots of tight living quarters where the characters are constrained. The couple was cautious knowing they were being watched by the Shanghainese community they lived with. Also, Li-Zhen's dresses are particularly high and tight around her neck and constrained her movement and her freedom walking. These constraints, along with their desire to be unlike their spouses, mean they choose not to love. Naficy's comments are relevant in Wong's films. Nevertheless, Wong presents a positive reality of community and physical closeness within this Shanghainese community. They were not isolated. Instead, they had a shared cultural experience and lived close together, which bonded them in their new home in Hong Kong.

The French theorist Guy Debord's notion of psychogeography was that it was a reverie, a state of mind.[20] Let us remember that psychogeography, invented by Debord in 1955, was based on the dérive or drift, an unintentional act that connects walkers to the city to absorb aspects of the urban domain. The flâneur was heavily influenced by psychogeography, a figure with no purpose to wander around the city, invented by nineteenth-century poet Charles Baudelaire and popularized by twentieth-century philosopher Walter Benjamin.[21] Debord's notion has been extended contemporaneously by Nicolas Whybrow in his book *Art and the City*, in 2011, when he discussed 'psychogeography' as a space of 'shared dreaming of urban space', recognizing on the one hand that 'the self cannot be divorced from the urban environment', but on the other hand that 'it had to pertain to more than just the psyche of the individual if it was to be useful in the collective rethinking of the city'.[22]

In this way *Chungking Express* and *In the Mood for Love* are

> moving with history, cinema begins to define itself as an architectural practice: an art form of the street, an agent in the building of city views. The image of the city ends up closely interacting with filmic representations. The streetscape is as much a filmic 'construction' as it is an architectural one.[23]

Debord designed the dérive for urbanites to construct an authentic experience of the city by walking unplanned paths. Instead of following the grid of the city to walk from one destination to the next, the dérive charted people on unknown paths. Simply walking through the city could facilitate agency and reconnect people to the city and each other. Wong's use of time defined a suspended sense of space and time in the city. Yet, the constant movement, repetition and evolution of the characters depicted filmic worlds where people became who they are through the urban environment in Hong Kong. Wong's use of romantic love is the outward expression, the desire to connect with people and the urban surroundings that is an unknown risk and possibly filled with pleasure – in the same way that Debord, through the dérive, wanted people to find freedom, agency and connection beyond the individual in the urban environment.

The act of walking according to the design of the dérive, begun in 1956 and activated more so in the 1960s, which was also the same time frame in which *In the Mood for Love* was set in Hong Kong, can be seen as an effort to slow down time. The dérive or the unknown journey around the city would mean the person that took this walking journey would have time and not be in a rush. Although it was designed by Debord to be carried out in small groups of like-minded people to explore the urban terrain and psychogeography together, a person could also go alone. Le Corbusier said, 'Walking creates diversity in the spectacle before our

eyes.'[24] This statement supports Debord's notion of discovery in the act of walking and performing the dérive and discovering diverse shared dreaming collective spaces, urban and otherwise.

Conclusion

In conclusion, Wong's films *Chungking Express* and *In the Mood for Love* reveal the implications of power and architecture in their production and provide a poetic and filmic world that provides agency by bringing people together. Wong achieves this by his approach to filming architecture, interior and urban spaces that provided his audience with experiences of intimacy. The uncertainty is the unseen and political reality Wong's films give life to. The intimate and inclusive stories that Wong crafts in his films provide audiences with depictions of humanity in spite of the uncertainty.

Wong and his family fled communist China and moved to Hong Kong which was a colony under British rule in the 1960s. The Shanghai community Wong and his characters lived in in Hong Kong was both a memory and a fleeting reality. This uncertainty connected to immigration and migration that Wong lived through in the 1960s and that his films depict continues today. Millions of Hong Kongese marched in the streets in June 2019 because of the threat of extradition back to China. At the moment extradition has been delayed but not eliminated and protests continue. In the same way that millions of people in Hong Kong have taken to the streets to transform political rule, the power in Wong's films is that he subverts political uncertainty by creating films that take back the streets of Hong Kong in a personal way through his memories and stories of unconventional love. Wong provides audiences intimacy not only with his characters but also with Hong Kong, Angkor Wat, architecture, interior and urban spaces and by doing so, as Leach stated, 're-insert(ed) the self back into the world'. The protestors in Hong Kong today have used the streets to express their collective desire to remain in their homeland. Their continued protests expressed their demand to eliminate extradition and has so far been successful. Although, again, it is uncertain until a final ruling is made.

The act of walking is political in Wong's films. However, it is not only walking, but Wong's framing and repetition of his characters walking through urban thresholds in Hong Kong. In the same way that Debord's urban game – the dérive – gives its participants new possibilities that included collective acts of discovery operating outside the urban plan and Le Corbusier's notion that walking 'creates diversity', Wong's films tell life-affirming stories that move beyond the grit, control, filth and societal, historical, political and personal constraints. Ultimately, they

provide a glimpse into life played by characters who do not simply live by taking the easy way out. Wong tells a love story with a twist. For example, Li-Zhen and Chow could have had an affair but they don't want to merely mimic their spouses. Instead, they re-trace their spouses' steps to understand and discover something together in the urban domain of Hong Kong.

Discovering something new in *In the Mood for Love* is Wong's game of a

> shared dreaming of urban space, recognizing on the one hand that 'the self cannot be divorced from the urban environment', but on the other hand that 'it had to pertain to more than just the psyche of the individual if it was to be useful in the collective rethinking of the city'.[25]

Furthermore, a 'space of urban culture which the boundaries of the individual do not end where the body or walls, end, but intimately extend into the collective environment of the city'.[26] Ultimately, to bring people together to live beyond constraints that are ever present.

The journey beyond the urban domain in *In the Mood for Love* in the Angkor Wat sequence elicit another kind of 'shared dreaming' and allow audiences to understand slow time in film and architecture. This is particularly evident in Wong's tactic to slow down the film speed as well as his approach to represent architecture as 'the art of reconciliation between ourselves and the world, and this mediation takes place through the senses'.[27] The filming of Angkor Wat contrasted the urban realities of Hong Kong and provided the sensorial space for Chow to be on the temple grounds with Li-Zhen, let her go and share his secret within the walls of Angkor Wat – ultimately extending into the collective environment of architecture as a destination and as a filmic representation that audiences absorb and find meaning, pleasure and visceral fulfilment in.

NOTES

1. Neil Leach, 'Camouflage', University of Southern California, YouTube, video file, 6 March 2009: https://www.youtube.com/watch?v=deqv5as9Fsk.html.
2. Li Haihong, 'Cinematic Hong Kong of Wong Kar-Wai' (Ph.D. diss., University of Georgia, 2012).
3. Nicolas Whybrow, *Art and the City* (London: I.B. Taurus, 2011), 13.
4. 'Christopher Doyle, 'Chungking Express', 'In Conversation,' interview by Noah Cowan, *Tiff Originals*, Bell Lightbox, 2 May 2011: https://www.youtube.com/watch?v=03xRxohd-MA&t=96s.
5. Haihong, 'Cinematic Hong Kong of Wong Kar-Wai.'

6. Beatriz Colomina (ed.), *Sexuality and Space* (Princeton: Princeton Architectural Press, 1992), 76.
7. David Clarke, *Hong Kong Art: Culture and Decolonization* (Durham, NC: Duke University Press, 2002), 187.
8. Paul Arthur, 'In the Mood for Love', *Cineaste* 26, no. 3 (Summer 2001): 40–41.
9. Arthur, 'In the Mood for Love', 40–41.
10. Sonia Front, 'Labryrinth of Time in Wong Kar-Wai's *In the Mood for Love* and *2046*', *Asian Journal of Literature, Culture and Society* 5, no. 1 (April 2011): 144–55.
11. David Martin-Jones, *Deleuze, Cinema and National Identity* (Edinburgh: Edinburgh University Press, 2006), 23.
12. Adrian Parr (ed.), *The Deleuze Dictionary* (Edinburgh: Edinburgh University Press, 2005), 224.
13. Parr, *The Deleuze Dictionary*, 223.
14. Haihong, 'Cinematic Hong Kong of Wong Kar-Wai', 22.
15. Juhani Pallasmaa, *The Eyes of the Skin Architecture and the Senses* (West Sussex: John Wiley, 2005), 57.
16. Pallasmaa, *The Eyes of the Skin Architecture and the Senses*, 72.
17. Wong Kar-Wai (dir.), *In the Mood for Love*, Hong Kong: Jet Tone Production, 2001.
18. Anthony Vidler, *Warped Space: Art, Architecture, and Anxiety in Modern Culture* (Cambridge, MA: MIT Press, 2000), 81.
19. Hamid Naficy, *An Accented Cinema: Exilic and Diasporic Filmmaking* (Princeton, NJ: Princeton University Press, 2001), 153.
20. Whybrow, *Art and the City*, 13.
21. Bobby Seal, 'Psychogeographic Review'. *Art of Psychogeography*, 14 November 2013, http://psychogeographicreview.com/baudelaire-benjamin-and-the-birth-of-the-flaneur/html.
22. Whybrow, *Art and the City*, 13.
23. Giuliana Bruno, 'Site-Seeing: Architecture and the Moving Image'. *Wide Angle* 19, no. 4 (1997): 2, https://eurofilmnyu.files.wordpress.com/2014/01/bruno-site-seeing.pdf.
24. Le Corbusier and François De Pierrefeu, *The Home of Man* (Architectural Press, 1977), 72.
25. Whybrow, *Art and the City*, 13.
26. Ralph Rugoff, 'Psycho Buildings', in *Psycho Buildings: Artists Take on Architecture*, ed. Ralph Rugoff (London: Hayward, 2008), 24.
27. Pallasmaa, *The Eyes of the Skin Architecture and the Senses*, 72.

BIBLIOGRAPHY

Arthur, Paul. 'In the Mood for Love'. *Cineaste* 26, no. 3 (Summer 2001): 40–41.
Bruno, Giuliana. 'Site-Seeing: Architecture and the Moving Image'. *Wide Angle* 19, no. 4 (1997): 2. https://eurofilmnyu.files.wordpress.com/2014/01/bruno-site-seeing.pdf.

'Christopher Doyle', 'Chungking Express', "In Conversation". Interviewed by Noah Cowan, *Tiff Originals*, Bell Lightbox. 2 May 2011, video, 2:41. https://www.youtube.com/watch?v=03xRxohd-MA&t=96s.

Clarke, David. *Hong Kong Art: Culture and Decolonization*. Durham, NC: Duke University Press, 2002.

Colomina, Beatriz, ed. *Sexuality and Space*. Princeton: Princeton Architectural Press, 1992.

Corbusier, Le, and François De Pierrefeu. *The Home of Man*. London: Architectural Press, 1977.

Haihong, Li. 'Cinematic Hong Kong of Wong Kar-Wai'. PhD diss., University of Georgia, 2012.

Leach, Neil. 'Camouflage'. University of Southern California. YouTube, video file. 6 March 2009.

Naficy, Hamid. *An Accented Cinema: Exilic and Diasporic Filmmaking*. Princeton: Princeton University Press, 2001.

Pages on Cinema, Chungking Express (1994), 16 July 2014. http://www.pagesoncinema.com/2014/07/chungking-express-1994.html.

Pallasmaa, Juhani. *The Eyes of the Skin Architecture and the Senses*. West Sussex: John Wiley, 2005.

Papastergiadis, Nikos. *Cosmopolitanism and Culture*. Cambridge: Polity, 2012.

Parr, Adrian, ed. *The Deleuze Dictionary*. Edinburgh: Edinburgh University Press, 2005.

Rugoff, Ralph. 'Psycho Buildings'. In *Psycho Buildings: Artists Take on Architecture*, edited by Ralph Rugoff, 17–21. London: Hayward, 2008.

Seal, Bobby. 'Psychogeographic Review'. *Art of Psychogeography*, 14 November 2013. http://psychogeographicreview.com/baudelaire-benjamin-and-the-birth-of-the-flaneur/html.

Vidler, Anthony. *Warped Space: Art, Architecture, and Anxiety in Modern Culture*. Cambridge, MA: MIT Press, 2000.

Whybrow, Nicholas. *Art and the City*. London: I.B. Taurus, 2011.

———. 'In the Mood for Love 2000'. Interview by?, *Eyes on Cinema*, YouTube, 30 September 2014, video, 21:49. https://www.youtube.com/watch?v=ofFalBKSNFw&t=563s.

Film List

Chungking Express. Directed by Wong Kar-Wai, Hong Kong: Jet Tone Production, 1994.

In the Mood for Love. Directed by Wong Kar-Wai, Hong Kong: Jet Tone Production, 2000.

14

Multimedia Architectures: Case Study-Heraklion, a History of a City

Giorgos Papakonstantinou

Introduction

Multimedia phenomenon and multimedia architectures

The spectacular development of digital techniques has brought up a series of mutations affecting the conception and design of space. These changes are situated in a historical perspective of technological, economic and social changes. The starting point of our research on multimedia architecture has been the implication in the creation, between 1998 and 2008, of a number of cultural multimedia projects. On the other hand, teaching, since 1999, representation technologies at the Department of Architecture, University of Thessaly, in Volos, Greece, has led us to investigate the space conception models, from Renaissance to the digital era. Throughout this research, both academic and professional, gradually emerged a particular interest for a type of composite digital space, defined as the 'multimedia space'.[1]

Three fundamental modes of constructing can be defined in digital space: (1) the 3D space produced by CAD software, (2) the parametric space and (3) the multimedia space.[2] The vast majority of architectural practices using digital technologies have explored the first mode of space construction, oriented towards a realistic approach of a seamless, homogeneous environment. This mode uses digital design software but retains the perspective character of traditional design and implies the cinematic image codification for moving through the space. However, parametric design experiments are inspired by mathematical or biological models to produce blobs, folds and other topological singularities. In contrast to the homogeneous, coherent space of the first two modes, multimedia space is characterized by its fragmented, modular structure. It is built through a system of

nodes and links, distributed in local or distant networks and is based on the codifications of fine arts, typography and moving image. These three modes of digital space may coexist, interact with each other and be distributed over networks. In a multimedia work, the term 'multimedia architectures' is implied, in plural form, to describe the structure of the content, the spatial organization of the interfaces and the programmatic structure of the latter. This domain of research is somewhat neglected, with a few exceptions, by both architectural thought and practice.

The CVD-ROM 'Heraklion, the History of a City' will be presented as a case study of multimedia architectures.[3] It belongs to the genre of autonomous offline[4] cultural multimedia that flourished in Europe and the United States, between 1990 and 2005, before the emergence of Web 2.0.[5] The significance of offline multimedia lay in the fact that, compared to the characteristics and speed of Web 1.0, it offered the possibility of non-hierarchical structures and higher speed of response and could support moving image (video, animation, etc.) of a fairly long duration. However, the most important element is the coincidental interest, at the beginning of 1990s, of creators coming from different artistic disciplines (graphic and industrial design, fine art, visual art, architecture, music, etc.) in the interface design – a domain previously exclusively limited to computer scientists. The American scholar Brenda Laurel was the first to study this interdisciplinary nature of the human-computer interface, through the poetics of the human-computer relationship.[6] With the emergence of Web 2.0 and the new possibilities it offered, cultural institutions, as well as independent producers, switched their interest to the design of internet applications.

During that period of interactive multimedia design emerged new spatial modalities and possibilities of navigation in digital environments, which have not yet been surpassed and can enrich both contemporary architectural thought and practice. Despite more than two decades of development, the organization and design of space in interactive multimedia has been of very limited interest. The attention of the theorists was rather oriented towards the status of the electronic and digital image and the modalities of the interaction.

Navigation, a new codification of space communication

The multimedia space is the product of a digital homogenization of the various representation media (iconic, textual and audiovisual) that retain their initial autonomy. It is this coexistence, which the media archaeologist Erkki Huhtamo calls 'multimedia phenomenon'.[7] Moving in multimedia space is based on spatial relationships organized by both an architectural program and software. The approach to the relationship between multimedia architectures and the notion of the program focuses on the following thematic axes: the study of the different

levels of organization of the screen space, the use of the notion of 'program' to analyse at the same time the principles of spatial organization, the organization of data and the development of a new codification of communication based on the modalities of interaction (gesture, index, metaphors).

Analogies could be established between the introduction in architectural thought of notions such as the movement of the human body in physical space and navigation in the digital space, between the design of architectural space by means of events and scenarios and the structuring of interactive storytelling through similar notions in the field of multimedia. The movement of the user in the digital space is an essential feature of computer culture, and consequently digital space is always a navigational space.

Space conception models

Media archaeology provides the necessary analytical and theoretical tools of research on the discourse and material manifestations of culture, highlighting the continuities and ruptures that have gone unnoticed until now.[8] This approach is influenced by Michel Foucault's archaeology of knowledge as well as the media theory. The French philosopher, in his methodological treatise on the 'archaeology of knowledge', argues that systems of thought operate beneath the consciousness of individual subjects in a given period.[9] In the history of ideas one can trace points of discontinuity between broadly defined modes of knowledge. With the 'archaeology of knowledge' is related the philosophical notion of genealogy, which Foucault considers not as the search for origins or for the construction of a linear development. The point of his genealogical analysis is to show that a given system of thought was the result of contingent turns of history, not the outcome of rationally inevitable trends. The American New Media scholars Jay David Bolter and Richard Grusin have suggested the term 'remediation' to describe in particular the phenomenon of continuous retrieval of optical structures from previous optical media in later ones.[10]

The approach to multimedia architectures is based on interdisciplinary thinking, linking studies from distinct fields of research over the past few decades. The study of the evolution of space conception models, from the Renaissance to the present day, is essential to understand the characteristics of the current digital paradigm. Evidently, the primary concern is not the models themselves but the conceptual and ideological implications.

The basic models of space conception could be defined as follows: (1) The frontal contemplation of the Renaissance observer from a privileged point of view, (2) the city perspective view (the veduta), (3) aerial views and maps, (4), the section (5) the panoramic view of the nineteenth-century Panorama buildings,

(6) axonometric representation, (7) collage, as the abolition of the privileged observation point, and (8) walking as a fragmented space experience by a mobile viewer.[11] One can find most of these models in the moving image (television, cinema, animation) codification as well as in the digital space.

The following text comprises two parts: the first part is an overview of the basic space conception models from Renaissance to the present. For each model I try to establish equivalent approaches in digital space conception and track down shifts or changes in meaning. The second part presents the CD-ROM 'Heraklion, the History of a City' as a multimedia architectures case study, and focuses on the application of different space models in the discrete sections of its content.

Models of space conception

From contemplation to immersion

Representation techniques are not simply means of production but also affect the archetypical perception of space, time, movement and matter. Each new medium incorporates aesthetic research and ancient techniques. The conception of space is elaborated by the gaze and movement of the body and represents a certain state of evolution of the human mind. We will attempt a brief genealogy of space conception models in relation to human experience, the social and cultural characteristics of the different periods.[12]

The emergence of the perspective system in the Renaissance has been systematically and widely analysed. Its adoption was the result of the quest for a measurable, isomorphic space that could meet the needs of the new era of commercial networks. At the end of the seventeenth century, the same system was adopted for the representation of urban landscapes (vedutas).[13] City views were more of the art of the painter than that of the engineer or the surveyor.

Urban cartography emerged at the beginning of the sixteenth century, and the creation of a city plan was as much a representation as an interpretation. Vedutas and plans are two forms of geometrization: one in perspective and the other in plane geometry. What is important, in the exploration of the multimedia phenomenon, is that the geometrization can be doubled by a volumetric or elevation representation. We must point out that the aerial view was a mental conception long before the technical possibility of an analogue physical experience.[14] Today, the model of aerial view of urban space is established by Google Maps.

The views of the seventeenth and eighteenth centuries (paintings, maps and plans) used multiple space conception models often accompanied by textual remarks on the history of the city presented. Hence, a multiple space conception

model developed, inhabited by events and movement. Two characteristic examples of the coexistence of different space representation models are John Roque's Garden Plan, Middlesex, 1736, and View and Map of Toledo, by Domenico Theotokopoulos, 1610–14. Cinema director Sergei Eisenstein[15] highlights the exceptional case of Theotokopoulos's painting, which combines different types of understanding space.[16] In John Roque's Garden Plan coexist the park plan and a number of perspective views along a trajectory thus creating a complex narrative space. In this way, architectural observation techniques articulated a relationship between space, movement and narrative, establishing a tradition of storytelling.

Since the seventeenth century, the change of mentalities led gradually to the appreciation of the interior space as a quality apart that can be conceived through the cumulative effect of a series of visual impressions represented by sectionals views. The delay in adopting the cutting plan as a full partner in the designs used to describe a building is due to its mental construction character. The facade has an obvious descriptive character, and the plan has an empirical relationship with the foundations of the building on the ground. The emergence of the cutting plane as a basic tool has often been associated with the parallel development of anatomical research and scientific dissection of the human body in the seventeenth and eighteenth centuries. The sectional plan offered a series of viewpoints inside a building and signalled the transition from the privileged frontal point of view to the different views of a moving body, creating a complex narrative space.

In the nineteenth century, the birth of aviation and the construction of high rise buildings led to the advent of a new perception of an intellectualist mode, that of panoramic vision. A new type of building, Panorama, offered the nineteenth-century citizen immersion and control over natural and urban landscapes.[17] The cylindrical surface of a Panorama recalled the desire of Romanticism to look beyond the horizon.[18] Roland Barthes suggests this new mental activity as deciphering: 'What, in fact, is a panorama? An image we attempt to decipher, in which we try to recognize known sites, to identify landmarks.'[19] A significant number of present-day interactive installations refer to the panoramic conception of space and adopt two essential elements of the panoramic devices of the nineteenth century: the circular iconographic surface and the placement of the viewer in the centre of space.[20] In our digital era, Google Street View offers a sense of place analogous to nineteenth-century cylindrical panoramas. Modern architecture has often applied or commented on the panorama viewing concept. Le Corbusier's 'fourth point' concerns the possibility offered by the new materials to substitute the framed view of Alberti's anthropomorphic vertical window with a window in length offering a panoramic view. In recent times, contemporary architecture continues designing panorama buildings. Jean Nouvel conceived his *Monolith*

building that was the main attraction of the Expo 02 Arteplage in Morat, Suisse, 2002, as a three-level panorama.

The panoramic conception model evolved from the nineteenth-century panoramic view through the attempts for an 'expanded cinema' to the viewer's embedding in digital environments. Today, 360-degree videos are on the agenda for video games and other VR applications.

Changing and mobilized gaze

The economic and social life of the nineteenth century was marked by the impressive growth of communication networks and transport speeds and the gradual emergence of a unique spatio-temporal design status. With the development of train transport in the nineteenth century, a voyager had a totally new spatio-temporal experience while the landscape was reeling out, viewed through the train window frame, while local time kept changing. This cinematic perception has been essential for the emerging society of spectacle of the industrial era. Moving panoramas became the new urban entertainment and transformed the continuous viewing to new multisensory experience.[21] If previously the emphasis was on the exact representation of space, in the nineteenth century the interest shifted to lived experience and to the synchronization of gaze and hand, a prior demand of new working conditions in the industrial era. Walter Benjamin analysed the events and social transformations that shaped a new type of observer in the nineteenth-century metropolis, the flâneur.[22] This new experience of urban space is characterized by fragmentation and multiplicity, two notions that we find at the heart of the architecture of multimedia.

In their effort to bring art closer to everyday life, the avant-garde artistic movements of the twentieth century explored walking in the urban fabric or in the natural landscape.[23] The experience of the walker-observer in the nineteenth-century urban space has evolved from the Architectural Walk of the Modern Movement, through the spectator's movement in kinetic art and installation art, to the navigation in a digital environment. In the field of architectural theory, Kevin Lynch was one of the first to apply the concept of mental map, urban signage, based on the sensory cues along moving in the environment.[24]

In the context of late nineteenth- and early twentieth-century scientific discoveries, avant-garde movements implied post-perspective methods to achieve multiple spatial and temporal modes of representation. They experimented with (1) the multiplication of points of view, (2) the coexistence of multiple perspectives and (3) fragments of reality and different media. Modern architecture, in its turn, included in its vocabulary elements of post-perspective space conception and kinesthetic human space experience. The transparent external skin enabled multiple layers of views, fusing inside and outside spaces. Buildings were organized

around architectural trajectories (*promenade architecturale*) introducing human body movement as a factor of space production.

Digital space conception

With the advent of digital technologies an entirely new visual system was introduced. Contemporary computer screen environments offer an environment of multiple and overlapping windows. The 'page' and 'window' metaphors constitute key features shared by all modern human-computer interfaces. Hyperlinking became a new way of organizing and accessing media, constituting a mental mapping of digital space and constructing digital narration. Consequently, the fluid character of the digital space gives birth to a new mental experience, the one of interactive navigation. The virtual displacement in the multimedia environment is based on the organization of different possible paths. The codification of this displacement uses metaphors of space organization and has developed a new digital ergonomy. This first application of an interactive digital *flânerie* was created by Architecture Machine Group, MIT. In 1978, the Aspen Movie Map enabled the user to take a virtual tour through the city of Aspen, Colorado.

Antoine Picon, theoretician of architecture, argues that the production of contemporary architectural space is based on the sensory dimension of our experiences, which are often assimilated to events.[25] The contemporary design of the architectural space by means of events and scenarios has analogies with the structuring of interactive narration and navigation in the multimedia space. French theorist and artist Jean-Louis Boissier argues that a new conception of perspective emerges in the digital multimedia space: the *interactive perspective*.[26] This means that perspectivist depth is replaced by the thickness of the information.

The human-machine interface imposes its own logic and transforms the human experience and the design procedure. It operates according to principles such as direct manipulation of objects on the screen, overlapping windows, iconic representation and dynamic menus. Each medium has its own rules and metaphors and offers a particular physical interface. As a result, a designer has the opportunity to freely combine different forms of media and conventions, following organizational strategies available for use in new contexts. These operating conventions of the interface are now widely accepted and constitute a cultural language in itself.

Heraklion, the history of a city

The CVD-ROM 'Heraklion, the History of a City' will be presented as a case study of applied research in implying different space conception models in a digital

environment. It is a CVD-ROM, created in Greek and English, produced in 2004 by the Multimedia Laboratory of the University of Crete, funded by the Municipality of Heraklion and the European Union.[27] I participated in the creative team as an interactive multimedia director.[28]

Named after the Greek mythological hero Heracles, Heraklion is located on the north coast of the island of Crete, in the eastern Mediterranean. Founded in the archaic period, the city has gradually emerged as one of the important centres of the trade routes to the East. Therefore, it was particularly marked by the conflicts in the Mediterranean Sea from the Middle Ages up to modern times. In this context, a major characteristic of the city is its fortifications, which were built by the Byzantines, then renovated by the Ottomans and Venetians. Since the 1950s, the city has tripled in size and expanded beyond the walls.

General principles

The essential decision on the content was to give a general educational character and organize the interfaces into spatial environments, which the user could explore in a way that is both educational and entertaining. Each environment extends across multiple layers and thematic fragments. The history of the city unfolds before the viewer in six sections: 'History', 'Monuments', 'Memory Lane', 'Folk Culture', 'Gallery' and 'Panorama'.

The central questions related to the design of a cultural multimedia work are the following: information visualization policies, the question of representation of historical information, the establishment of the human-technology interaction experience and issues relating to the reception by a wider audience. Targeting is double. The questions that arise for each work are related to the production of a discourse on the perception of the historical time, as well as the production of meanings and identities through digital materialities.

The sociologist Alain Médam proposes a classification of cinematographic styles that offer a look at the city.[29] He distinguishes four filming modalities that produce 'discourses' on the city: the 'panoramic' discourse, the 'travelling' discourse, the 'overprint' discourse and the spectator's 'enveloping' discourse. The panoramic discourse imitates the gradual capture of the landscape by the viewer's moving gaze. Travelling is the movement in space with a means of transport. Superimposition of views refers to the multitude of views and events in an urban environment. The envelopment of the spectator by the city is linked to the immersion in space as it takes place in a panorama building. To the four modalities of Médam, we could add two others: the bird's-eye view and the free trajectory. Aerial view symbolizes both global perception and control. The trajectory is closer to the experience of the flâneur in the urban fabric.

The creative team opted for the use of different visual metaphors and types of cinematic experience in each content section. Each one uses a dominant spatial model also including secondary ones. In particular: (1) 'Panorama', is a linear video narration, (2) iconographic and textual collage for the 'History', (3) map of the city, perspective views and immersion in a 3D spatial modelling for the 'Monuments', (4) panorama, layers and superposition of images in 'Folk Culture', (5) virtual 3D museum in 'Gallery' and (6) walkscapes with sequence of viewpoints along selected paths in the urban fabric for the 'Memory Lane'. The graphic character of the work is based on the use of the imagery of each era of the city.

Screen types and spatial metaphors

The typical screens are conceived as environments where textual, iconographic and audiovisual content accumulate in layers and float in the digital space. They are organized into three main vertical zones, the central area consisting of the principal content of the thematic unit. On the left and right of the central area, images or titles represent complementary subjects. In the lower right corner of the screen is situated a triangle that is a composite button containing the main navigation functions (home, contents, volume control and exit). Iconographic elements are presented using a characteristic fragment of their surface. On rollover one fragment, the entire image appears and a few seconds after, the image caption follows (Figure 14.1).

'Panorama' is an aerial approach to the city, a seizure of the urban space through helicopter shooting, a moving panorama of Heraklion. The city overflight is alternated with views from below in the urban fabric presenting everyday life in the city's centre during both day and night. This approach refers to De Certeau's dual conception of urban space conception: the visual control from above and the fragmented conception of everyday life at ground level.[30]

'History' focuses on the many faces of the city that have changed name and shape several times over the centuries. In the left side the central surface ends in a curved form that represents a fragment of the city`s timeline containing additional historical events in the form of a pop-up ellipsis. In the upper-right corner of the screen an abstract representation of the city plan brings up the city map that corresponds to the period selected.

Thus, each subsection of 'History' is organized in a multitude of layers that can be called to the visible surface of the screen. Each surface is an electronic collage of information strata (textual, iconographical and audiovisual) creating a digital perspective depth.

The 'Monuments' section traces the history of the city. Particular attention is paid to the urban centre and the city walls from the time of the Venetian period

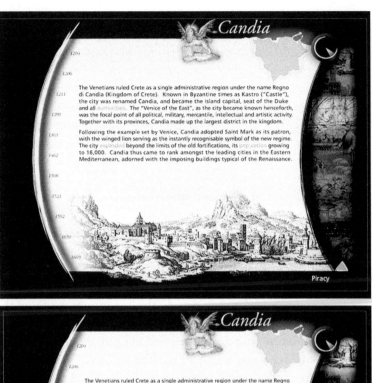

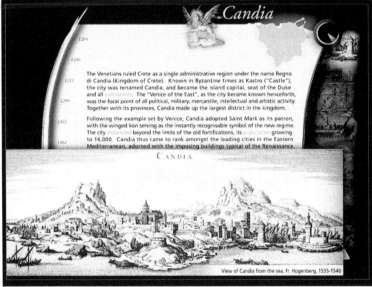

FIGURE 14.1: Screenshots of 'History' section. 'Heraklion, the History of a City.'

since they still constitute the city's main monuments. The central element of the section's interface is a city map in an abstract and stylized form of the urban fabric, with notable sites and landmarks of the Venetian era. There are six thematic units: Venetian Ramparts, Venetian Port, Historic Centre, Churches, Fountains

MULTIMEDIA ARCHITECTURES

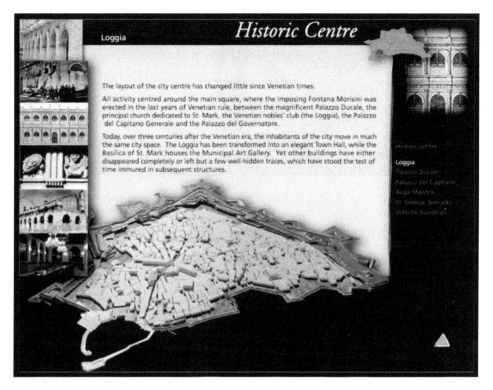

FIGURE 14.2: Screenshot of 'Monuments' section. 'Heraklion, the History of a City.'

and Architectural Styles. The screen space organization follows the concept of the John Roque's Garden Plan we have already referred to.

The screen area of the 'Monuments' section (Figure 14.2) is also divided into three zones. This section contains two 3D representations: that of the port, the 'Koules' fortress in the entrance of the port and that of the ramparts. These are emblematic parts of the Venetian period and landmarks of the contemporary Heraklion. Thus, in this section, electronic montages coexist with 3D environment immersions.

'Folk Culture' section reveals the rich living tapestry of Cretan folk tradition and culture. Clothing, Popular Architecture, Food, Crafts and Traditional Music, all convey the way of life shaped by the concerns of everyday life. The menu consists of a horizontal panoramic band that can slide left and right, containing floating icons representing the different themes (Figure 14.3). When a theme is selected, the band unfolds and changes to the background of the typical screen of the section that contains text and a stack of images (Figure 14.3). When the cursor moves over an image of the stack, the selected image comes to the front and with

FIGURE 14.3: Screenshot of 'Folk Culture' section. 'Heraklion, the History of a City.'

FIGURE 14.4: Screenshot of 'Memory Lane' section. 'Heraklion, the History of a City.'

a click the image expands and occupies a large part of the screen. 'Folk Culture' combines panoramic view and electronic montage codification.

In 'Memory Lane', the user is invited to visit modern Heraklion following three different itineraries (Figure 14.4). Each one is composed of a series of photographic images taken along the course to characteristic sites of the urban fabric. The photos are combined with archival material (photos, engravings, postcards), accompanied by narrations of texts written by eminent authors who have lived in the city or have visited it in the past. One trajectory goes around the ramparts of the city, a second leads from the port to the city centre and the third route connects the West Gate to the city centre. For the graphical representation of the three routes the classic symbolism of a subway network was chosen (Figure 14.4). Each fragment of the route is independent, and the user can stop and listen to the narration, continue his route, change fragment in the same itinerary or return to the 'Memory Lane' menu to choose another.

FIGURE 14.5: Screenshot of 'Gallery' section. 'Heraklion, the History of a City.'

Dominant models of a city (maps, panoramas) represent the city as a continuous, fixed and 2D bounded surface. Taking a walk involves an embodied, intersensorial, performative and reflexive process of creating alternative cartographies of the city that offer counter-hegemonic representations. 'Memory Lane' is a walkscape combined with multilayered electronic montage.

'Gallery' is a virtual museum organized in a 3D reproduction of the 'Koules', the fortress that stands at the entrance of the Venetian port that serves as an alternative way to visit the content of the application. A plan of the fortress is used as a key to guide visitors through the space. The rooms of the Koules are panoramic zones and the user can change place by clicking on the doors of adjacent rooms (Figure 14.5).

Conclusions

The study of the evolution of space conception, from Renaissance to the present day, is essential to understand the characteristics of the current digital paradigm and the manifestations of the 'multimedia phenomenon'. The devices of the nineteenth century, scientific and technical discoveries, and artistic research of the early twentieth century have helped to modify our spatio-temporal conception and have fostered the emergence of a changing and mobilized gaze. Relatively, contemporary architectural thought has moved from a conception of static forms and an objectively defined space to a subjective approach where the human experience becomes the fundamental element. Spatial qualities are designed through events and scenarios organized by an architectural program.

Multimedia architectures incorporate earlier modes of spatial representation, with a shift or change in meaning. New visual consciousness and perception regimes are gradually being installed. The nineteenth-century flâneur's strolling

through urban space has evolved to navigation in the digital environment. In the multimedia paradigm, the screen functions as a communication space for events and scenarios organized by an architectural program. In a digital environment, the osmosis of traditional (sketch, drawing, model, photography) as well as recent imaging technologies (video, digital design) affects important aspects of the design process. Various media maintain their original modularity by developing an interactive relation and connecting with local or distant networks. In this transformation, they lose a part of their state of autonomy and their materiality and acquire part of the state of the network. They are transformed into a new hybrid substance, a network object that refers to the quasi-object theory.[31]

Multimedia space allows the potentially unlimited combination of layers of information. The off-field space extends as well beyond the edges of the frame as in depth in the screen space thickness. Thus, the thickness of information replaces the perspectivist depth. The different levels of organization of the screen space create an environment of communication and representation in which the primacy of connectivity and interactivity displace the primacy of representation.

NOTES

1. Multimedia architecture has been the subject of our Ph.D. thesis 'Theoretical Approaches of "Spatial Organization" Modes in Multimedia Architectures', Université Paris 1 Panthéon-Sorbonne, Arts plastiques et Sciences de l'art, http://www.arch.uth.gr/uploads/users/20/files/PAPACONSTANTINOU_PhD.pdf.
2. Theoretical approach of this subject is rather restricted. For a comparison of the two first modes, see Antoine Picon, *Culture numérique et architecture – Une Introduction* (Paris: Birkhauser Fr., 2010).
3. The cultural multimedia work 'Heraklion, the History of a City' [Hiraklion, mia poli, mia istoria] is a DVD-ROM, in Greek and English, produced in 2003–2004 by the Multimedia Laboratory of the University of Crete, funded by the Municipality of Heraklion and the European Union.
4. As opposed to online applications on the internet.
5. In Europe, the field of cultural multimedia developed considerably due to the European Union funding programs to museums and cultural institutions, in order to enable them to digitize their collections, organize databases and create websites. The motto was the promotion and dissemination of European cultural heritage.
6. Brenda Laurel (ed.), *Computer as Theater* (Boston: Addison-Wesley, 1991).
7. Erkki Huhtamo, 'La résurrection du passé technologique', in *<Compacts> œuvres numériques sur cd-rom*, exposition catalog, ed. Bertrand Gauguet (Rennes: Presses Universitaires de Renne, 1998), 50.

8. Erkki Huhtamo and Jussi Parrika outline this approach in the introduction to their book *Media Archeology, Approaches, Applications, and Implications* (Berkeley: University of California Press, 2011).
9. Michel Foucault, *The Archaeology of Knowledge: And the Discourse on Language* (United Kingdom: Vintage, 1982) (first edition in french: *L'Archéologie du savoir*, Gallimard 1969).
10. Jay D. Bolter and Richard Grusin, *Remediation: Understanding New Media* (Cambridge: MIT Press, 2000).
11. See also Giorgos Papakonstantinou, 'Voyage around My Screen, Voyage around with My Screen: Space Perception from Physical, through Digital, to Hybrid', *International Journal of Arts and Technology (IJART)* 10, no. 3 (January 2017): 176–88.
12. Pierre Francastel, *Peinture et société: Naissance et destruction d'un espace plastique, de la Renaissance au cubisme* (Paris: Gallimard, 1965), 29.
13. The term 'veduta' refers to the point where the view falls.
14. Jacobo de Barbari created, in 1500, an aerial representation of Venice. To do this, he carried out extensive research and documented the city's roads and buildings, using its highest points.
15. Sergey Azenstein, *The Film Sense* (New York: Harcourt, 1942).
16. The central space in the painting is occupied by the perspective representation of the city. On the first level, the painter includes a map of Toledo, held by a young man (the painter's son). The lower-left corner shows the Tagus River, in the form of a young seated male figure, providing water and therefore prosperity to the city, following the model of the ancient sculptural representation of rivers. At the top of the painting is the Virgin Mary with the patron saint of San Ildefonso. On the first level, the city hospital emphatically appears on a cloud. Pedro Salazar de Mendoza, a friend of El Greco, was the manager of this hospital and probably the sponsor of the painting.
17. Erkki Huhtamo, *Illusions in Motion: Media Archeology of the Moving Panorama and Related Spectacles*, (Cambridge, MA: MIT Press, 2013).
18. The romantic fantasy of a panoramic vision is magnificently expressed by Caspar David Friedrich in *Wanderer above the Sea of Fog* (1818) as well as the magnificent poetic writings of Victor Hugo's *The Hunchback of Notre Dame* devoted to a bird's-eye view of Paris and Michelet's *Tableau chronologique*.
19. Roland Barthes, *The Eiffel Tower and Other Mythologies* (Berkeley: University of California Press, 1979).
20. Artists such as Jeffrey Shaw, Masaki Fujihata and others imply the panoramic prototype in their interactive installations: Anne-Marie Duguet, Heinrich Klotz and Peter Weibel (eds), *Jeffrey Shaw – a User's Manual, From Expanded Cinema to Virtual Reality* (Karlsruhe: Edition ZKM, Gantz, 1997).
21. For a detailed description of Mobile Panoramas, see Huhtamo, *Illusions in Motion*.
22. Susan Buck-Morss, *The Dialectics of Seeing: Walter Benjamin and the Arcades Project* (Cambridge, MA: MIT Press, 1991). For the emergence of a new type of observer in the

nineteenth century, see also Jonathan Crary, *The Art of the Observer: Vision and Modernity in the 19th Century* (Paris: Jacqueline Chambon Editions, 1998).
23. Francesco Careri, *Walkscapes, Walking as an Aesthetic Practice* (Barcelona: Gustavo Gili, 2002).
24. Kevin Lynch, *L'image de la cité* (Paris: Bordas, 1993; original MIT Press, 1960).
25. Picon, *Culture numérique et architecture*, 201.
26. Jean-Louis Boissier, *La relation comme forme, L'interactivité en art* (Dijon: Les Presses du réel, 2007).
27. In the site of the Municipality of Herakleion we can find today a simplified version of the CVD-ROM's content: http://history.heraklion.gr/index.php?lang=441.
28. The production lasted for two years and involved a multidisciplinary team consisting of historians, archaeologists, graphic designers, animators and computer scientists. The main members where Kyraikos Papadakis, executive producer and project coordinator; Ioulia Pentazou, historian and digital narration specialist; and Dimitris Mitsianis, art director.
29. Alain Médam, 'Être de ville, être de film. Miroirs et réflexions', in *Un nouvel art de voir la ville et de faire du cinéma. Du cinéma et des restes urbains*, ed. Charles Perraton and François Jost (Paris: L'Harmattan, 2003), 9–26.
30. Michel de Certeau, *The Practice of Everyday Life* (Berkeley: University of California Press, 1984).
31. Michel Serres, *Le Parasite* (Paris: Grasset, 1980)' and Bruno Latour, *Nous n'avons jamais été modernes. Essai d'anthropologie symétrique* (Paris: La Découverte, 1991).

BIBLIOGRAPHY

Barthes, Roland. *The Eiffel Tower and Other Mythologies*. Berkeley: University of California Press, 1979.

Boissier, Jean-Louis. *La relation comme forme, L'interactivité en art*. Dijon: Les Presses du réel, 2007.

Brenda, Laurel, ed. *The Art of Human – Computer Interface Design*. Boston: Addison-Wesley, 1990.

———, ed. *Computer as Theater*. Boston: Addison-Wesley, 1991.

Bruno, Guliana. *Atlas of Emotion, Journeys in Art, Architecture and Film*. New York: Verso, 2002.

Careri, Francesco. *Walkscapes, Walking as an Aesthetic Practice*. Barcelona: Gustavo Gili, 2002.

Couchot, Edmond. *Images, de l optique au numérique*. Paris: Hermès, 1988.

Crary, Jonathan, *The Art of the Observer: Vision and Modernity in the 19th Century*. Paris: Jacqueline Chambon Editions, 1998.

De Certeau, Michel. *L'Invention du quotidien*, 1. *Arts de faire* et 2. *Habiter, cuisiner*, presented by Luce Giard. Paris: Gallimard, 1980.

Duguet, Anne-Marie, Heinrich Klotz and Peter Weibel, eds. *Jeffrey Shaw – a User's Manual, from Expanded Cinema to Virtual Reality*. Kalsruhe: Edition ZKM, Gantz, 1997.

Eisenstein, Sergei. *The Film Sense*. New York: Hartcourt, 1942.

Foucault, Michel. *The Archaeology of Knowledge: And the Discourse on Language*. United Kingdom: Vintage, 1982. (First edition in French: *L'Archéologie du savoir* [Paris: Gallimard, 1969].)

Francastel, Pierre. *Peinture et société: Naissance et destruction d'un espace plastique, de la Renaissance au cubisme*. Paris: Gallimard, 1965.

Huhtamo, Erkki. *Illusions in Motion: Media Archeology of the Moving Panorama and Related Spectacles*. Cambridge, MA: MIT Press, 2013.

———. 'La résurrection du passé technologique'. In *<Compacts> œuvres numériques sur cd-rom*, catalogue d'exposition, edited by Bertrand Gauguet, 48–59. Rennes: Presses Universitaires de Rennes, 1998.

Huhtamo, Erkki, and Jussi Parrika. *Media Archeology, Approaches, Applications, and Implications*. Berkeley: University of California Press, 2011.

Kittler, Friedrich. *Gramophone, Film, Typewriter*. Stanford: Stanford University Press, 1999.

Manovich, Lev. *Software Takes Command: Extending the Language of New Media*, New York: Continuum, 2013.

Mitchell, William. *The Reconfigured Eye: Visual Truth in the Post-photographic Era*. Cambridge, MA: MIT Press, 1992.

Murray, Janet H. *Inventing the Medium: Principles of Interaction Design as a Cultural Practice*. Cambridge, MA: MIT Press, 2012.

Papakonstantinou, Giorgos. 'Voyage around My Screen, Voyage around with My Screen: Space Perception from Physical, through Digital, to Hybrid'. *International Journal of Arts and Technology (IJART)* 10, no. 3 (January 2017): 176–88.

Picon, Antoine. *Culture numérique et architecture – Une Introduction*. Paris: Birkhauser Fr., 2010.

Picon, Antoine, and Alessandra Ponte, eds. *Architecture and the Sciences: Exchanging Metaphors*. New York: Princeton Architectural Press, 2003.

Afterword:
Neo-formalism and the Architectural Lessons of Film

Graham Cairns

This book offers a fascinating and multifaceted view of film and its influence on design thinking, our understanding of the city, the creative imagination, the evolution of newer digital modes of moving image representation and, finally, socially orientated narrative and storytelling. In offering some final commentary to contribute to the debates outlined by the authors in the preceding pages, I will not attempt to cover the full range of issues they raise. Rather, I will highlight one theme implicit in much of their work that has fed into my own thinking about film and architectural design over several years, namely, how to best understand the ways in which the visual tropes of filmic representation have, may have and can inform architectural design.

In exploring this question in my own work in the past, I have posited the use of a mode of analysis loosely defined as 'neo-formalism'. In essence, it represents a methodology of filmic analysis intended to aid in identifying and explaining the influence of film's visual language (the cut, the fade, the dissolve, the moving point of view etc.) in the evolution of modern architectural and urban form and theory. In outline, this methodology harkens back to the *Wölfflinian tradition and an underlying* concern with the evolution of artistic style and human vision. More specifically, it builds on this tradition as applied in the filmic context by Rudolf Arnheim; principally, his understanding of the moving image as an 'artistic' form requiring viewing subjects to develop and apply a specific new set of perceptual modalities. However, it also encompasses ideas of post-formalism, as outlined by Whitney Davis, to underline the role that art forms and objects themselves have in the evolution of the artist's, designer's or architect's own particular 'way of seeing' and thus creating.

This neo-formalist modality of thought, then, is inspired by an architectural engagement with the discipline of film from the perspective of its early formalist theories, when its modes of spatial representation were still new and offered

architects representations of mobile and fragmented space for the first time. The visual technique that created these mobile and fragmented spaces – film's new visual language – is one that, as I have argued previously, architects used both implicitly and explicitly to inform the ways they designed the spaces they projected and the visual effects they created in the early twentieth century. It was this period after all that gave rise to theories which considered the practice of the cinema as analogous to that of architecture; a period in which Dziga Vertoz would call himself 'Kino Eye' – and define it as 'an eye that constructs'. It was also the time in which the influence of film on the kinetic concerns of architects such as Alexander Vesnin and Konstantin Melnikov in the 1920s or on Le Corbusier's cinematic reading of the 'promenade' can be discerned. Indeed, for Beatriz Colomina, Corbusier's promenade functioned as a spatial and temporal device resulting from 'modern eyes', that is, 'eyes that move'.

While the latter part of the twentieth century saw the emergence of Hollywood's continuity system as the standard mode of spatial and narrative representation across the film industry, the influence of film on architectural thinking remained, if not constant, at least in evidence. It was visible in the groundbreaking work of Robert Venturi, for whom film was a more ideal medium than photography (the one he used) to capture the spatial experience of American cities in the 1970s. Similarly, it helps understand the interest in film as a mode of spatial representation and documentation in the early works of Kevin Lynch, whose investigations into how contemporary America 'perceived' cites at speed was captured in his 1964 book *The View from the Road*.

A formal engagement with film's visual tropes and the spatial and optical effects they create also remained evident in the use of film by Bernard Tschumi at the end of the century and was central to the work of Jean Nouvel more recently. In the case of Tschumi, the filmic medium – and more specifically, the montage of Sergei Eisenstein – offered him the ideal visual simile on celluloid for the architecture of disjunction his theories and practice attempted to implement in built form. For Nouvel, the cut and the instant changes of perspective and scale it permits was an ideal visual trope to simulate through his own 'instantaneous' disruptions of scale in his architectural ensembles. Similarly, the fade and the dissolve, with their sequential blurring of scenes, was a specific filmic effect that Nouvel sought to mimic in architecture through his particular overlaying of glass walls and related architectural elements.

Thus, in sum, what neo-formalism seeks to do is present a form of analysis that helps understand how film's 'visual language' reframed architectural space on-screen, and through that, how the cinematic medium's new spatial conceptions and visual vocabulary influenced architectural theory and practice in the twentieth century. It is premised on an interpretation of film as a medium that 'freed

the photographic image from its state of stasis' and, in doing so, permits us to argue that it introduced a new set of visual tropes into the lexicon of the modern world that expanded the visual vocabulary of artists and architects alike. Expanding on this, it can be argued that film led to a questioning of how we perceive the space around us; offered new possibilities in our understanding and representation of buildings; and presented architects with a new platform for optical and spatial experimentation – at the scale of the interior, the building and the city.

From the neo-formalist perspective outlined here then, what I find most interesting about the chapters in this book is the way their variegated concerns for narrative and the evolution of newer technologies of sight leave space for the type of spatial-visual/technological analysis that ideas of neo-formalism are based on. In these pages, narrative representation through moving image technology does not totally divorce social readings of film from the technologies of its visual production, the spatial qualities of its architectural setting or the ways in which its formal traits and limitations inform our reading and thinking about space. Through our reading of the chapters collected here, the social contexts and narrative tropes of visual storytelling can be easily conjoined with considerations of the visual and formal influences of representation on architectural production – whether actualized or possible. It makes the chapters, and the book more generally, a rich and varied examination of narrative as a form of storytelling fully integrated into spatial design issues of both social and formal import.

Authors' Biographies

TANIA AHMADI, educated in Tehran, Berkeley and New York, holds a BA degree from the University of California, Berkeley, in Film and Media Studies and an MA from Columbia University in Film Studies. While at Columbia, she participated in a research project called 'Women Film Pioneers Project', in which she worked on an entry for Iran's first female director, Shahla Riahi. In 2019, Woodville Press published Godfrey Cheshire's *Conversations with Kiarostami*, which featured Tania's translations from Persian into English. Her translation of an interview with Iranian cinematographer Mahmoud Kalari appeared in *Film Comment*. She writes reviews of contemporary Iranian films for *Peyk* magazine.

Tania currently teaches and translates in New York City.

SEVERINO ALFONSO is an architect and an educator. He is the co-founder of PLB Studio, an architecture and research practice based in New York. He is a Visiting Assistant Professor at the College of Architecture and the Built Environment at Thomas Jefferson University in Philadelphia, where he co-directs the *Synesthetic Research and Design Lab*. He holds an MS in Advanced Architectural Design from Columbia University in New York and two MS in Urban Design and Advanced Architecture from the School of Architecture in Madrid (ETSAM) where he is currently a Ph.D. candidate researching on the *Genealogy of the Digital Space*.

KATARINA ANDJELKOVIC, Ph.D., M.Arch.Eng., is a theorist, practicing architect, researcher and a painter. She served as a Visiting Professor, Chair of Creative Architecture at University of Oklahoma, USA, Institute of Form Theory and History in Oslo, Institute of Urbanism and Landscape in Oslo, and University of Belgrade – Faculty of Architecture. Katarina has published her research widely in international journals (*Web of Science*) and won numerous awards for her architecture design and urban design competitions. She is a full author of *Preliminary Architectural Design*, a national project supported by the government of Serbia.

Katarina's artwork is regularly exhibited at international architectural, fine arts and photography exhibitions.

JEAN BOYD is a Senior Lecturer in History and Theory of Art and Design at the School of Arts, University of Gloucestershire. Her research and teaching focuses on the capacity for creative practice to articulate contemporary conditions, particularly our current experience of temporality, through and with the use of digital media. Art works are examined for their potential to offer critical interventions in the present by their use of speculative futures or potential histories, making visible the relationship between aesthetics and ethics.

SIMONE SHU-YENG CHUNG is an Assistant Professor at the Department of Architecture, National University of Singapore. She holds a Ph.D. in Architecture from the University of Cambridge and practiced as an architect in London after completing her studies at the Architectural Association London and Bartlett School of Architecture, University College London. A former Rome Scholar in Architecture, she is a Japan Foundation Asian Center fellow and recipient of the 2020 CCA Research Fellowship. Chung is co-editor of *The Hard State, Soft City of Singapore* (AUP, 2020) and a curator of the Singapore Pavilion at the 17th Venice Biennale International Architecture Exhibition.

Boyd graduated in Fine Art (Winchester School of Art) and Representation and Modernity (University of North London).

KIMBERLY CONNERTON, Ph.D., is a teacher, artist, writer and critic. Connerton works across the disciplines of architecture, art and design, teaches in USA and previously AU, publishes regularly in architecture books and art journals and convenes and speaks at architecture and art conferences. Her research includes the significance of engaging with art in architecture, how art benefits asylum seekers and architecture, film and cities. She is on the editorial board of the International Journal of Education of Architecture & Design (IJEAD). Now, she teaches at Parsons and is interviewing people who work in architecture and space but are not architects.

LOUIS D'ARCY-REED is a researcher, artist, curator and writer having recently completed his Ph.D. in Architectural Theory, Museology and Psychoanalysis at the University of Derby, UK, in 2019. Holding a B.Arch and a MA in Curating, D'Arcy-Reed's research interests work at the intersection of architecture and culture, with a view to *para-architectural* methods of working that include areas such as urbanism, politics, contemporary arts practice and museology, visual cultures and psychologies of place, space and society. Louis has written for *The Journal of*

Architecture and Urbanism and *Aesthetica Magazine*, and regularly features for the arts website *Corridor8*.

GÜL KAÇMAZ ERK, is a Senior Lecturer in Architecture, Queen's University Belfast. With work/life experience in Ireland, Netherlands, Turkey, UK and USA, Dr Gül Kaçmaz Erk has been conducting research in two interdisciplinary areas: 'architecture and cinema' and 'architecture and forced migration'. Before joining Queen's University Belfast in 2011, she worked professionally as an architect in Istanbul and Amsterdam, researched at the University of Pennsylvania and University College Dublin, and taught at Philadelphia University, Delft University of Technology and Izmir University of Economics in the areas of Architectural Design, and History, Theory and Criticism. Kacmaz leads CACity Research Group (http://www.cacity.org), organizes Walled Cities film festivals and conducts urban filmmaking workshops: https://pure.qub.ac.uk/en/persons/gul-kacmaz-erk.

SUSANNAH GENT is a filmmaker, artist and Senior Lecturer at Sheffield Hallam University where she teaches undergraduate and postgraduate film production. Her films that have gained awards at international festivals over the past twenty years explore experimental approaches to representing subjectivity. Her Ph.D., for which she obtained a full-pass in 2019, combines interdisciplinary research including philosophy, psychoanalysis, neuroscience and filmmaking to explore the uncanny and hauntology. Rather than representing reality, Susannah's current work seeks approaches to making films that represent ideas. Her work in development investigates methods of researching physical space, psychical space and cinematic space.

GIORGOS A. PAPACONSTANTINOU is an architect and director of documentary films and multimedia projects. He was born in Athens in 1953. He studied Architecture in Athens and Cinema and Multimedia in Paris. He completed his DEA (master) thesis in Fine Arts and Image Technology at University of Paris VIII and Ph.D. thesis in Arts and Sciences of Art at Paris I University-Panthéon Sorbonne. Since 1999, he teaches Representation Technologies at the Faculty of Architecture, University of Thessaly, Volos, Greece, and he is a member of LECAD laboratory. Since 1985, he works as a director of documentary films on art, architecture and the city as well as of cultural interactive multimedia: http://www.arch.uth.gr/en/staff/G_Papakonstantinou.

GRACIA RAMÍREZ is a media scholar based in the UK where she lectures at University of the Arts London. She is interested in the historical intersection between aesthetics and politics. Her research spans widely, from experimental and independent cinema to the history of newsreels and documentary formats. She also publishes

writings on artists and exhibitions reviews. She is currently working on a project on the visual culture of London's urban space and the dynamics of gentrification.

SHANA SANUSI is a Lecturer at the School of Media and Communication, Taylor's University, Malaysia. Aside from Asian horror cinema, her research interests include spatial theory and gender discourse.

MICHAEL SCHOFIELD is a Teaching Fellow in Film, Photography and Media, University of Leeds, UK. Working as a landscape photographer and digital artist under the name Michael C. Coldwell for over a decade, Dr Michael Schofield is now also a Teaching Fellow and practice-led researcher at the University of Leeds. Alongside documenting the changing city, his work interrogates the changing ontology of media technologies. In 2018, Schofield was awarded a Ph.D. for photographic research entitled 'Aura and Trace: The Hauntology of the Rephotographic Image', which deconstructed the practice of rephotography through the appropriation and projection of archival images of parts of the city which have disappeared. This work was presented as an immersive installation entitled 'The Remote Viewer' (2018) and a photography exhibition called 'Lost Leeds' (2019): http://www.michaelcoldwell.co.uk.

LOUKIA TSAFOULIA is an architect and an educator. She is the co-founder of PLB Studio, an architecture and research practice based in New York and Assistant Professor at the College of Architecture and the Built Environment, Thomas Jefferson University, where she has co-founded the *Synesthetic Research and Design Lab*. She is also the co-editor of the book publication *Transient Spaces*. She holds an MS in Advanced Architectural Design from Columbia University in New York, and she is a Ph.D. candidate at the National Polytechnic University of Athens, Greece. Focusing on the computational theory of design, her research explores the relationships between performative environments and early scientific cybernetic experiments.

WANG CHANGSONG is an Associate Professor at Xiamen University Malaysia, where he directed the Centre for ASEAN and Chinese Screen Studies. He is the author of *Genre Analysis: Chinese Youth on Screen* (2020) and *Chinese Youth Cinema: Youth Film as A Genre* (2015). His research interests include contemporary film theory and practice, media and cultural theory, film history and gender representation in film.

AUTHORS' BIOGRAPHIES

Editors' Biographies

TÜRKAN NİHAN HACIÖMEROĞLU is an Assistant Professor at Eskisehir Osmangazi University (ESOGU) Faculty of Engineering and Architecture, Department of Architecture. She has been working as an instructor for architectural design studios and various courses on architectural representation and narration in cinema and literature since 2011. She graduated from Gazi University with a Bachelor of Architecture degree in 2004. She completed her graduate and doctoral studies on architectural representation, architectural narration and adaptations in cinema and literature in METU in 2008 and 2015, respectively.

AYŞEGÜL AKÇAY KAVAKOĞLU is an Assistant Professor at Altınbaş University and the former Head of Department of Architecture (2017–2020). She is one of the editors of *AURUM Journal of Engineering Systems and Architecture* (A-JESA). Her research interests involve the design process, computational design, representation and moving image studies in general. She holds a bachelor's degree in architecture from Dokuz Eylül University. She has conducted her master studies at Middle East Technical University (METU) and Ecole Nationale Supérieure d'architecture de Paris-Belleville. She graduated from METU with her master thesis focused on the representation of city images in cinema. She got her Ph.D. in Architecture from METU by researching the contribution of moving images to the computational design process. She executed several workshops and curated exhibitions. Akçay Kavakoğlu has worked on various architectural design projects and has awarded in national architecture competitions.

LISA LANDRUM is an Associate Professor and Associate Dean Research in the Faculty of Architecture at the University of Manitoba in Winnipeg, Canada. She holds a Bachelor of Architecture from Carleton University in Ottawa, and a post-professional Master and Ph.D. in Architectural History and Theory from McGill University in Montreal. Her research on architectural agency is published in numerous journals and books, including *Architecture as a Performing Art* (2013), *Architecture and Justice* (2013), *Architecture's Appeal* (2015), *Filming the City* (2016), *Confabulations: Storytelling in Architecture* (2017), *Reading Architecture, Literary Imagination and Architectural Experience* (2019), and *Canadian Modern Architecture* (2019).